FRESH FLY FABULOUS

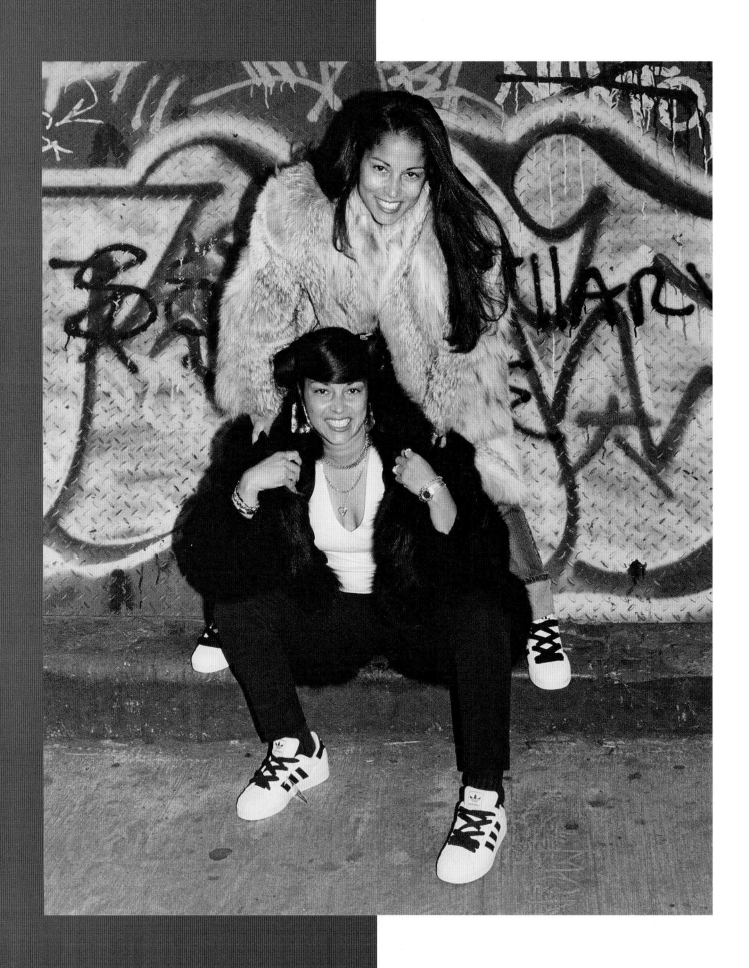

50 YEARS OF HIP HOP STYLE

FRESH FLY FABULOUS

RIZZOLI Electa The Museum at FIT

EDITED BY ELENA ROMERO & ELIZABETH WAY

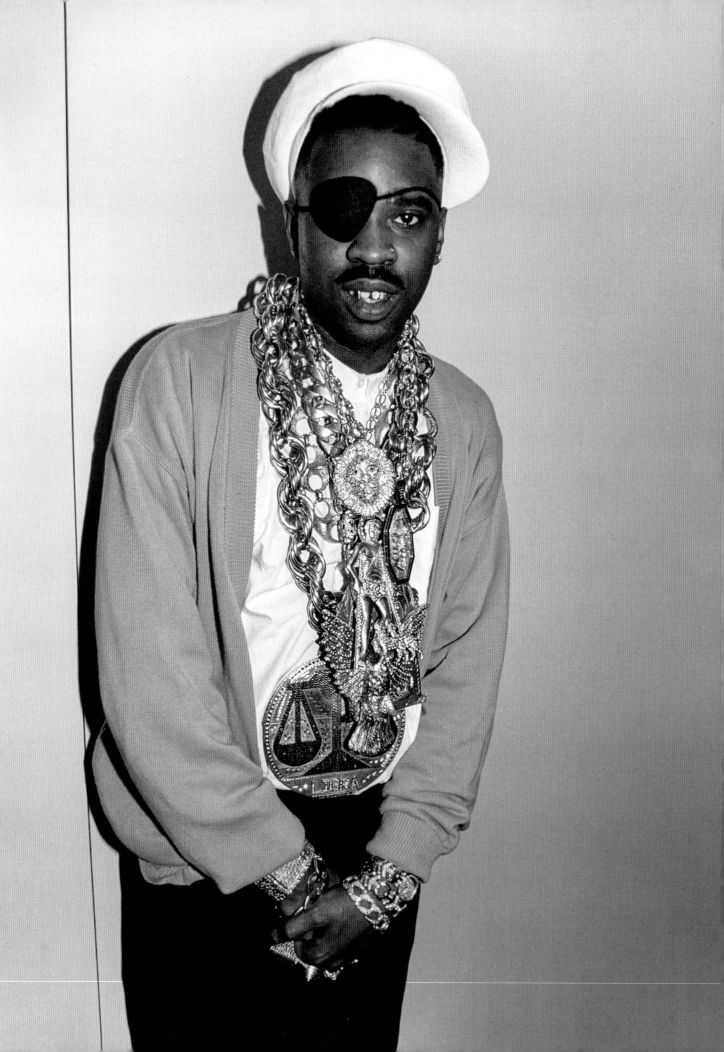

FOREWORD

Hip Hop's Superpower—Ourselves

From the desk of Ricky Walters, a.k.a. Slick Rick

Hi, my name is Slick Rick, and my nickname is Sir Fashion. As someone who's been equally devoted to rap music and hip hop fashion all my life, it brings me great joy to see New York's Fashion Institute of Technology salute hip hop's epic contribution to style as we mark the culture's fiftieth anniversary.

From head to toe, haircuts to footwear, and everything in between—jewelry, lapels, pocket squares, Timberland boots, and Kangol hats—hip hop's impact on fashion has rocketed from the hood to Hollywood to every corner of the globe. Think of it as the tanning of style on Earth.

Within the hip hop community, fashion has never been just about a look. Much more important is the euphoric feeling that results from being Fresh, Fly, and Fabulous.

Fresh means that you are hood-modern and well-dressed. You are up to date with fashion trends.

Fly is the measure of extreme hood-standout, unique appeal. Ahead of the norm. Above the bar. One of one.

And *Fabulous* is the result of your freshness and flyness and swag.

Bottom line: Style in hip hop has no blueprint. It is a pure do-what-we-want-to-do form of self-expression. Our style paints pictures and tells stories. Often, those stories are of kings and queens because our lineage is from royalty, not from poverty. Our style makes not only entrances but also exits. Being Fresh, Fly, and Fabulous is to live boldly in our own space.

My own tastes and adventures in the fashion world began quite early in my life. I remember watching Liberace on them piano keys with his wrists and fingers iced out, and I said to myself, "Yup, duly noted. I am going to take that up—not just one notch—but a thousand notches." I remember seeing the dapper Mr. Don King wearing not full-length pants, but a double-breasted short suit. Again, I said to myself, "Yup, duly noted." For my appearance on the twenty-fifth anniversary of the BET Awards show in 2015, I personally recreated DK's look, threw that hip hop swag all over it, and made it my own.

By the time I started rapping on record, my passion for fashion was a deep part of me. Remember my song "La Di Da Di" from 1985? Go back and dig it again, as I namecheck a hall of fame roster of some of my favorite brands: Oil of Olay, Polo cologne, Johnson's Baby Powder, and Bally shoes.

I was not alone in my passion for fashion. Just a year later, Run-DMC released "My Adidas," a love song to their favorite sneakers. Then, there was Cam'ron's all-pink Range Rover SUV, Lil' Kim's colorful wigs and matching furs (courtesy of stylist Misa Hylton) in her "Crush on You" video, and Ghostface Killah's four-finger ring and floor-length custom bathrobe! Need I say more?! These were total game-changing moments—as exciting as a fleeing car turning a corner during a highspeed police chase.

But let's face it. Hip hop is unique. Name another creative community that's been able to take virtually any piece of fabric or brand, reimagine its DNA, introduce the new version, and have it embraced around the world. Dapper Dan utterly transformed Gucci and Louis Vuitton handbags, using those logos to upholster the interiors of Jeep Wranglers. Salt-N-Pepa turned Spandex exercise outfits into high fashion. And Mary J. Blige did the same thing for baseball jerseys and blonde ponytails sticking out of a fitted baseball cap. The culture at large took a fresh look at the gold teeth used since ancient times to fill in cavities and upgraded them into diamonds. We even made Champagne bottles look like a fashion accessory.

Hip hop knows how to freak anything into a stylish masterpiece.

In fact, the culture's range is jaw-dropping. Hip hop fashion runs from Wu Wear to Karl Lagerfeld and Supreme to *Vogue*. Over the decades, established brands like Tom Ford, Louis Vuitton, Gucci, and Fendi went from ignoring the hip hoppers who were lawlessly messing with their products to collaborating with them. Hip hop has leveled the playing field in high-end brands. The collision of hip hop and fashion was undeniable, inevitable. Both elements are vibrant forms of pure expression, orbiting each other like powerful elements of an atom.

Ultimately, hip hop's vibe is always going to be fly and fab. We are risk takers without being aware that we are taking risks. Our superpower is knowing how to make diamonds and gold out of dirt and dust. And, fifty years on, this is what we do. All day, every day.

OPPOSITE: Slick Rick. Photo: Ernie Paniccioli

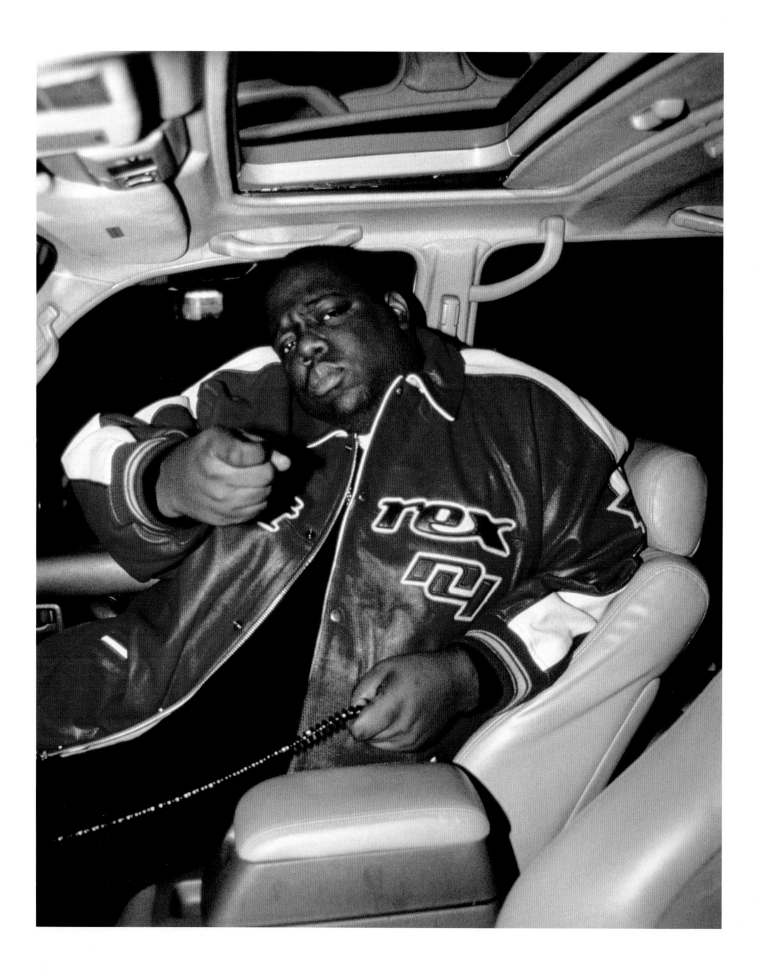

INTRO

BY ELENA ROMERO & ELIZABETH WAY

Fifteen minutes after sunset on May 21, 2022, the Empire State Building lit up in red and white colors with a rotating crown and the number "50" on the mast as a tribute to the late rapper Christopher "Notorious B.I.G." Wallace on what would have been his fiftieth birthday. The commemoration was marked with events throughout New York City and with an offering of limited-edition Biggie MetroCards.[1]

Wallace was born and raised in Brooklyn and signed on to Sean Combs's Bad Boy Records label in 1993. In four short years, before his murder at age 24, he left a legacy of lyrical storytelling and innovation, as well as fashionable moments and trends. Repping for the Big & Tall and young men's markets, Biggie's fashion influence covered a wide range of luxury and contemporary brands as well as looks. His versatile wardrobe consisted of Karl Kani, Kangol, Versace, and Coogi, as Biggie easily transitioned from casual to dress attire. From Karl Kani jeans and Versace Medusa sunglasses to Coogi sweaters and classic Timberland nubuck boots, these styles will always resonate with his hip hop fans the most.[2]

Hip hop and fashion took center stage months earlier on February 13, 2022, this time on a national scale. The Super Bowl LVI's halftime show at SoFi Stadium in Inglewood, California presented the powerful legends lineup of Dr. Dre, Snoop Dogg, Mary J. Blige, Kendrick Lamar, Eminem, and the guest appearance of 50 Cent. West Coast music icons Dr. Dre and Snoop Dogg dressed in signature monochromatic black (NWA's favorite color inspired by the Raiders) and a classic blue bandana-print tracksuit (a symbolic nod to the Crips affiliation), respectively. Compton's Kendrick Lamar wore a black double-breasted Louis Vuitton suit, part of the final menswear collection of the late Virgil Abloh.[3, 4] Midwest rapper Eminem wore a black hoodie, dark gray T-shirt, wallet chain, and his "Air Shady" Air Jordan 3 sneakers.[5] New York rapper 50 Cent donned both classic black and white tees and a white sweatband, while the Queen of Hip Hop and Soul, Mary J. Blige, wore a custom silver metallic bodysuit by Peter Dundas and matching thigh-high boots by Sergio Rossi for Dundas.[6, 7]

These two moments resonated with Elena Romero, coeditor of this book and cocurator of the accompanying exhibition at The Museum at FIT, who like hip hop, turns 50 years old in 2023. A Nuyorican hip hop girl who loves her hoop earrings, Romero conceived the idea for the exhibition and book drawing on her years as a fashion journalist from the mid-'90s. She was the only journalistic voice at the fashion trades during the golden age of hip hop to cover its style on a daily basis. The brands entrusted her with their stories and, in turn, she reported on their multimillion-dollar success. Romero is uniquely positioned to provide an insider/ outsider perspective of the hip hop fashion narrative. Considering the African proverb "If surviving lions don't tell their stories, the hunters will get all the credit," it is her responsibility to tell that story.

At 50 years old, hip hop has gained a level of respectability that was unimaginable during the early '70s in the Bronx when kids in a crumbling New York City borough first began crafting a new musical genre in parks, jams, and on neighborhood corners. Hip hop is an undeniable phenomenon that has changed American music, dance, and visual culture, and one that has been exported, co-opted, embraced, and adapted around the world. Hip hop artists have not only created a spectacular art form but also, for better or worse, a powerful commercial product. The most successful practitioners—arguably, the musicians who emerged as the most visible hip hop artists—have carved out ownership in the music industry and, like many other musicians, created brands of themselves that extend into other areas: acting, producing, and promoting all kinds of products. In the twenty-first century, hip hop artists make up some of the wealthiest and most recognized celebrities, including Kanye West, Jay-Z, and Sean Combs.[8] Hip hop music is regularly heard everywhere—from the dentist office to the Broadway stage.

Along with this cultural popularity has come a scholarly respectability. Tricia Rose is a vital early scholar of rap music and the first to have made an impact on Romero. Rose's 1994 book *Black Noise: Rap Music and Black Culture in Contemporary America* is an inspirational text for countless others as well. In the book, Rose writes:

Rap went relatively unnoticed by mainstream music and popular culture industries until independent music entrepreneur Sylvia Robinson released 'Rapper's Delight' in 1979. Over the next five years rap music was 'discovered' by the music industry, the print media, the fashion industry, and the film industry, each of which hurried to cash in on what was assumed to be a passing fad.[9]

Of course, hip hop lasted much longer than any of those people could have predicted. Rose notes that rap, as "a black idiom that prioritizes black culture … that articulates the problems of black urban life," is the expression and product of working-class people of color; however, hip hop in general "does not deny the pleasure and participation of others."[10] As with many other forms of American music that arose from Black and Latinx communities, hip hop has been subject to appropriation and a commercialization that does not always benefit its originators. Looking inward, hip hop culture, born of the segregation and oppression of communities of color within American urban centers, can reflect the violence, misogyny, and homophobia that is embedded in most areas of American society. Yet the genius and ingenuity, as well as the political dimensions, of hip hop are undeniable. Academic institutions—The Museum at FIT included—have just started to engage with this complex and deeply layered culture over the last two decades. Harvard University has housed The Hip Hop Archive and Research Institute since 2002 and Cornell University's Cornell Hip Hop Collection was established in 2007. In 2014 the Smithsonian National Museum of African American History and Culture acquired Slick Rick's birth certificate and added Rakim's microphone to its collection. Kendrick Lamar became the first rapper to win a Pulitzer Prize in 2018—a deserved and telling barometer of the state of hip hop's evolving place in cultural production.[11] The Universal Hip Hop Museum broke ground for its building in the Bronx in 2021.

Within this pool of academic study and recognition, The Museum at FIT delves into an aspect of hip hop that is even fresher to

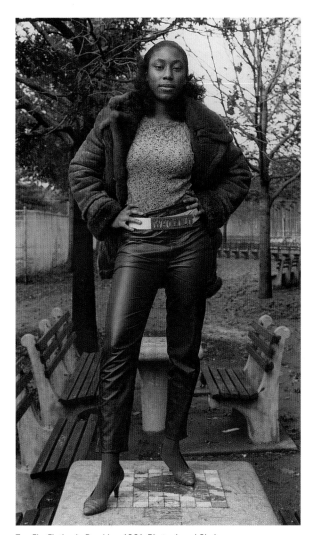

Too Fly, Flatbush, Brooklyn, 1981. Photo: Jamel Shabazz

examination. *Fresh Fly Fabulous: 50 Years of Hip Hop Style* argues that fashion is as important a site of cultural production as the music, dance, and aerosol art of hip hop. This exhibition is not the first on hip hop. In 1999, the Rock & Roll Hall of Fame presented *Roots, Rhymes and Rage: The Hip-Hop Story*. Curated by writer and activist Kevin Powell, the exhibition first debuted in Cleveland, Ohio, before traveling to the Brooklyn Museum in 2000. In 2001, the Bronx Museum of the Arts presented the exhibition *One Planet under a Groove: Hip Hop and Contemporary Art*. In 2006, the Museum of the City of New York focused specifically on hip hop style with *Black Style Now: Hip-Hop Fashion in New York City* and, more recently, the California African American Museum held an exhibition devoted to Cross Colours in 2019. This is not to mention the many other hip hop exhibitions that included fashion and style or the fashion exhibitions that touched on hip hop without making its style the central focus.

Documentary film has led the examination of hip hop style with *Fresh Dressed* (2015), directed by Sacha Jenkins, and *The Remix: Hip Hop X Fashion* (2019), directed by Farah X and Lisa Cortes. Elena Romero lent her voice to both films after establishing her expertise over a career in fashion journalism and distilling this knowledge and experience into the first scholarly and comprehensive book on hip hop fashion: *Free Stylin': How Hip Hop Changed the Fashion Industry* (2012). The *Fresh Fly Fabulous: 50 Years of Hip Hop Style* exhibition and book build on that work. The exhibition is one of the largest and widest-ranging to date, focusing on five decades of hip hop style—from its inception in the 1970s to the present—and examining hip hop's relationship to the fashion industry, as well as the innovative remixing, rebranding, and creative design that make up a polyvalent style that has disseminated into every area of fashion.

Hip hop style never goes unnoticed but is not as recognized as it should be as fundamental to hip hop's global impact. Fashion and style are inseparable from hip hop in all its forms, and it acts as a significant inroad for hip hop's influence. Fourteen years before Kendrick Lamar was awarded his Pulitzer, Sean Combs became the first Black designer to win a Council of Fashion Designers of America (CFDA) award. He proved to outsiders that hip hop style was more than athleisure and oversized sportswear. Hip hop style is diverse, relevant, and groundbreaking. But, like hip hop more broadly, the styles come from Black and Brown people for whom the fashion industry, like the music industry, represents a system to be worked into, worked around, and sometimes overcome. Combs described his first front-row experiences at European fashion shows during the late '90s and early 2000s:

> [Back then] there was no one in the front rows. We weren't invited to anything, and if you were black and you were hip-hop, it was dangerous. I think going out there as a statesman and letting them know, 'We cool; we're artists too.' We're the same thing [as] jazz artists or rock-and-roll artists, or punk artists. We're just a different type of artist, and I was able to see that and feel that energy.[12]

Sean John's 2004 CFDA menswear designer of the year win was a turning point for hip hop style because decades of design creativity—first from young and emerging artists and their fans, and then from a growing body of professional stylists, editors, and designers—had finally *officially* broken through to the mainstream fashion industry. A relationship among hip hop and mainstream and luxury designers had always existed. Hip hop artists and fans were adept at remixing, personalizing, and making existing styles and brands their own. This can be seen from the earliest moments: prominent gold jewelry worn with a preppy polo shirt, distinctively ironed and tied shoe laces, and real and knockoff designer goods—with visible logos—to show aspiration and upward mobility. Hip hop quickly moved downtown and into the city's other boroughs, melding with other subcultures. Independent designers and those in the Garment District, like Willi Smith, picked up on and expanded the styling, colors, and motifs. Artists outside of rap also adopted hip hop culture through music, dance, and style. There are examples in this book of hip hop style worn by artists who may not identify as rappers, yet this does not preclude their embrace and excellence in demonstrating hip hop style.

American and European brands like Ralph Lauren, Tommy Hilfiger, Versace, and Louis Vuitton were integrated into and transformed by hip hop style. Hilfiger's 1997 campaign featuring R&B singer Aaliyah in baggy jeans and a branded tube top is an iconic image illustrating the dissemination of hip hop style across the United States by this time. As early as the mid-'90s, hip hop reached high-end European luxury brands and fashion bastions like *Vogue,* which were creating parallel conduits of inspiration drawing from hip hop style, but hip hop artists were almost completely missing from mainstream luxury fashion's side of the conversation. Inroads and acknowledgment did occur. For example, Tupac Shakur was welcomed by Italian designers over the summer of 1996, when he attended several shows and walked the Romeo Gigli runway, but these events were rare.[13] More disturbing was that innovative designers, creating what we now call streetwear, were not even considered fashion designers. Dapper Dan, April Walker, Cross Colours, Karl Kani, and others were not recognized by the fashion establishment. They were othered into the "urban" category, the politically correct word given to brands once labeled ethnic, hip hop, or Black. Combs spoke of the term in 2016, stating, "Urban. I was always insulted by the word … I would get insulted when they put us into [that] classification, because they didn't do that with other designers … That 'street, hip-hop s—.' That's what was said behind closed doors."[14]

Hip hop style has come a long way in fifty years. In 2023, streetwear is a term that is virtually meaningless for its ubiquity, and many designers all over the world operate in this space. One objective at the forefront of the *Fresh Fly Fabulous: 50 Years of Hip Hop Style* exhibition and book is to tell the story from the point of view of those who were on this journey from hip hop style's beginnings to now. This book draws from a wide range of hip hop style experts, including stylists, journalists, educators, hip hop practitioners, designers, artists, and producers. Although this book traverses the five decades of hip hop style's history, it is not a comprehensive narrative. That is a feat beyond one exhibition or book. This is an anthology of personal

Sean John, Fall 2008.

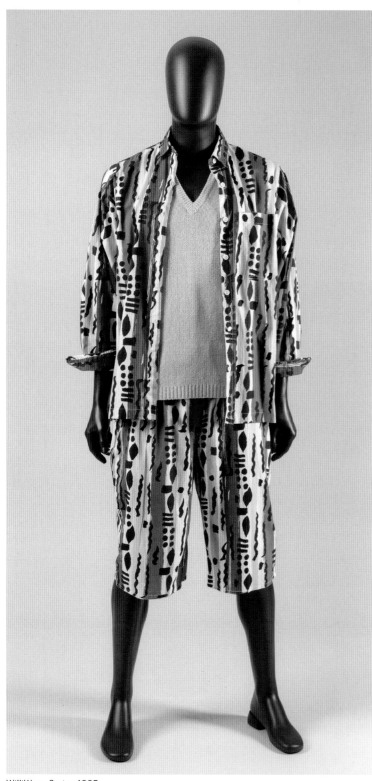

WilliWear, Spring 1985.

experiences, documented for the first time in many cases, in a book that serves as a time capsule and a necessary resource. This work contains chapters that take an overview of a particular fashion topic and "culture conversations" that take a deep dive into a moment, a style, or genre of hip hop fashion. The text is informed in large part by music and fashion journalism—the media, besides the music itself, that best documented hip hop style from the 1990s to the present. Much of the text is also informed by memory—of the authors and of interview subjects— in their authentic voices. The power of hip hop fashion comes alive through the recollections documented in these pages.

Journalist Elizabeth Wellington begins with an overview of hip hop style from the '70s to now, delving into its evolutions and intricacies, including the many brands created by hip hop artists. This is followed by a culture conversation by aerosol artist and fashion designer Claudia "Claw Money" Gold on the intersection of graffiti writing as an element of hip hop and fashionable expression. Sal Abbatiello, founder of the legendary Bronx club Disco Fever and Fever Records, shares his memories of hip hop's earliest days and the fashions worn not only by the artists, but by the fans who flocked to hear them. In chapter 2, Emil Wilbekin draws on his experience as a pioneering stylist and editor at *Vibe* magazine, recounting how the look of hip hop innovated through the work of stylists such as Misa Hylton. Following are three culture conversations based on interviews with hip hop style founders: Dapper Dan, April Walker, Cross Colours, and Karl Kani. All have gone too long without the massive credit they deserve for shaping fashion and style as we know it today and on an international scale.

In chapter 3, Romero, who is herself part of the hip hop generation and chronicled hip hop style extensively at fashion trade bibles *DNR* and *WWD*, traces how hip hop artists' love of fashion—particularly aspirational designer brands, from American sportswear companies to European luxury brands— are documented in music lyrics. Name-dropping fashion brands is more prevalent than ever in 2023, but its roots go back to the '80s. Stylist Rebecca Pietri takes a closer look at one of the most influential brands to shape hip hop style: Ralph Lauren.

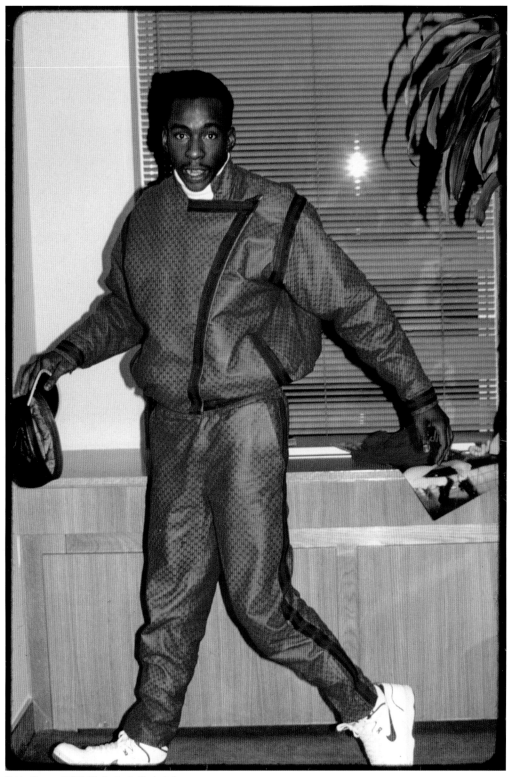

Bobby Brown, 1988. Photo: Ernie Paniccioli.

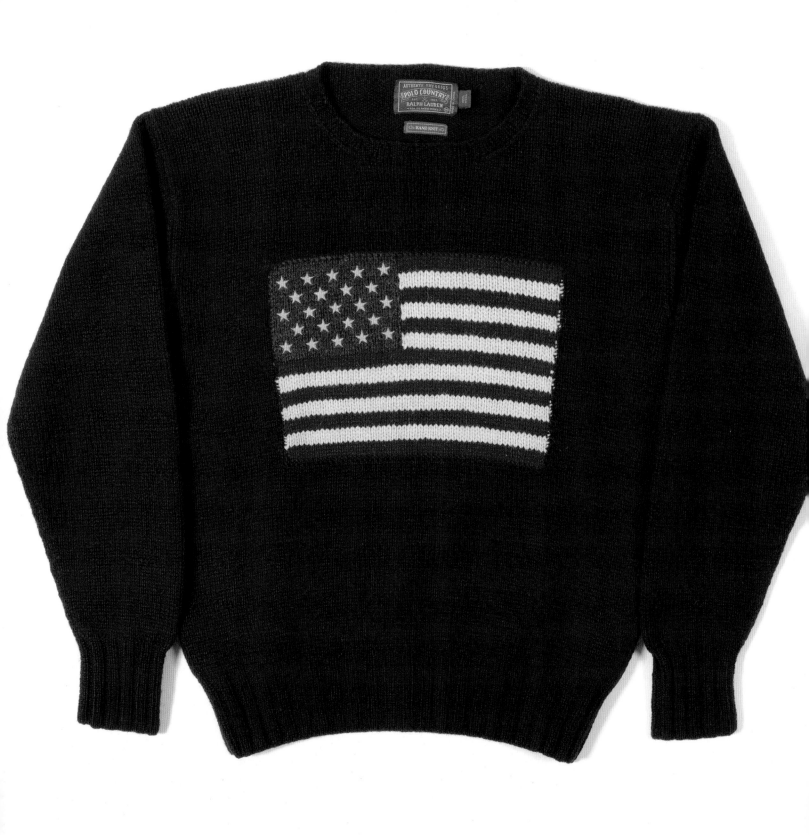

Polo by Ralph Lauren, late 1980s.

Gucci, circa 1975.

As a Jewish kid from the Bronx, Lauren was not privy to the WASP-y wealth and lifestyle that defined the American Dream, so he created it himself through his fashion brand. His story and the preppy styles he designed, based on posh sports like polo and skiing, resonated with the hip hop generation, particularly the Brooklyn-based Lo Life Crew. They transformed Ralph Lauren's vision into their own unique style. Kim Osorio picks up this thread, recalling her time as editor-in-chief of *The Source* magazine and her conversation with Kanye West (as he was known in 2003). West represents one peak, which continues to break boundaries to this day, of musicians and record companies venturing into fashion design. Some brands were more influential and longer-lived than others and many are returning in a fit of '90s nostalgia, but West set himself apart beginning in the early 2000s with his leadership in hip hop fashion change and with his wildly successful fashion collaborations. Romero and Monica Lynch explore how fashion

made a perfect bedfellow for hip hop music through the legendary Ralph McDaniels's Phat Fashion shows of the '90s and through Tommy Boy's rap and street-fashion label. As president of Tommy Boy Records, Lynch launched the careers of some of the most recognizable names in hip hop, including De La Soul, Queen Latifah, and Naughty by Nature. She also helped develop the label's fashion line, which was designed and overseen by Albee Ragusa, the label's rap marketing director.

Journalist and author Vikki Tobak resets the connection between style and hip hop in chapter 5, taking us back to 42nd Street during the '80s and '90s before hip hop fashion was discovered by corporations and conglomerates, before streetwear was a multibillion-dollar industry. She interviews hip hop style originators, including Thirstin Howl the 3rd, Shirt King Phade, Mighty Nike, April Walker, and Fab 5 Freddy on the Polaroids they had taken in Times Square. This exercise of self-documentation was prescient and speaks to how

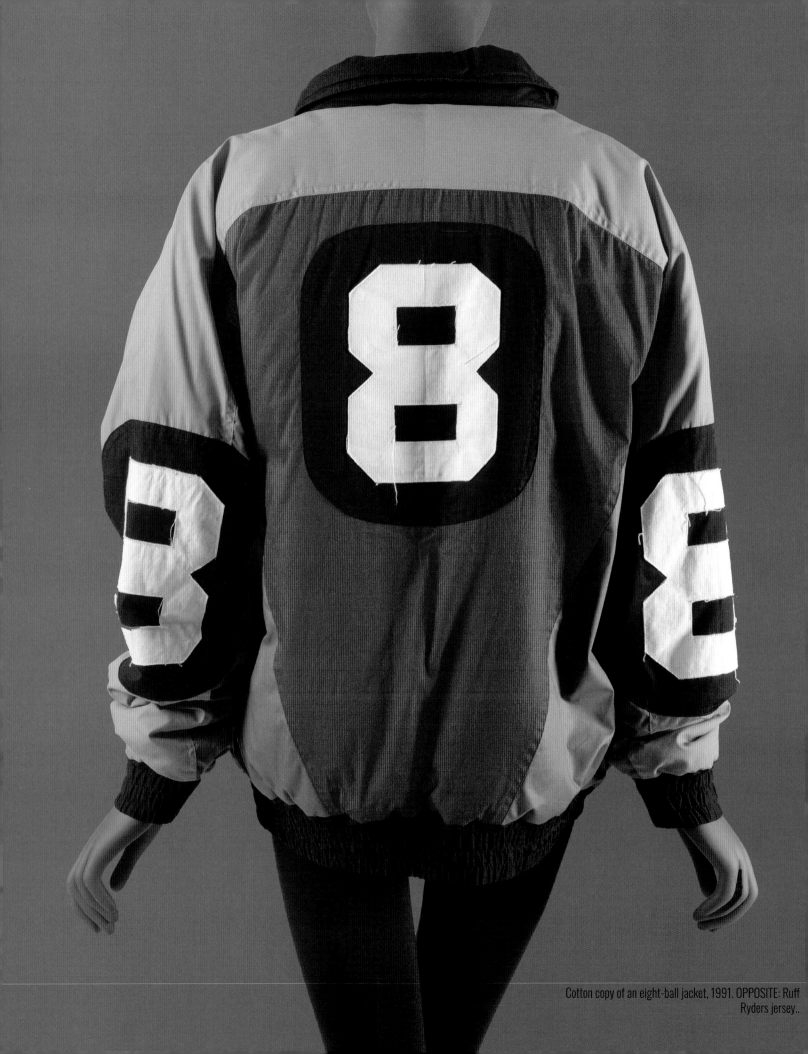

Cotton copy of an eight-ball jacket, 1991. OPPOSITE: Ruff
Ryders jersey..

the hip hop generation recognized the power of their own self-fashioning. Hip hop style is not a monolith but individual self-presentations. The deeply personal journey of discovering your own hip hop style is documented by professors Christopher Emdin and Alphonso McClendon, as well as archivist Syreeta Gates. In chapter 6, Emdin breaks down his "rachetdemic" style which is as much about stance and attitude as collegiate clothing with hip hop details. McClendon recalls the consciousness-raising power of hip hop music and style on HBCU campuses during the '90s. Gates, a powerful force in documenting and preserving hip hop material culture, chronicles her early relationship with hip hop style, which empowered her to forge her own path to preserving it. Isabel Flower and Marcel Rosa-Salas, a writer and editor and cultural anthropologist, respectively, delve into the nameplate as an expression of style that draws from a long lineage of human adornment, combines the multiethnic influences that shape hip hop style, and emphasizes two of the most important aspects of hip hop aesthetics: customization and individuality. Nameplates represent yet another style that has existed for generations, but one that has been adopted by hip hop and remade as its own, even as nameplate styles vary by region and have evolved aesthetically over the last half century.

This is followed by a culture conversation on hoop earrings—another jewelry form with ancient roots all over the world, but one made distinct by women in hip hop culture. Women in early hip hop had to blend in with the men in order to be taken seriously as artists, but they found ways to express their own feminine style, including through jewelry and makeup. Eventually, designers both inside and outside of hip hop caught on to how to cater to women, creating clothing that fit their bodies and riffing on gender-neutral accessories to make them even more appealing to female-identified practitioners of hip hop style. As two female editors/curators, an important focus of the *Fresh Fly Fabulous* project has been to center the contributions of women in hip hop that have existed from the beginning but are often overshadowed, even in conversations on fashion and style. As essential is acknowledging queer and LGBTQIA+

hip hop style contributions. Eric Darnell Pritchard traces the massive impact that queer communities in New York and elsewhere have made—not *on* hip hop style as a separate cultural force, but *within* hip hop as vital members of hip hop culture. Their chapter is followed by culture conversations on seemingly ancillary aspects of hip hop style—hair and nails—but these essays give a taste of how hip hop style is all about the details that make up the whole.

Monica L. Miller and Elena Romero examine the color pink in hip hop style in chapter 9. Although this may seem like a niche topic, both scholars show how, through this one color, hip hop and other artists express Afrodiasporic difference, defiant masculinity, independent femininity, power, strength, and Black joy. The book ends where it begins: on the street; Warren Orange takes an unexpected look at footwear, focusing not on sneakers, which have their own devoted following, academic and otherwise, but on the early shoes that defined hip hop style, including Clarks, Ballys, and British Walkers. These styles were just as indicative of hip hop swag as Adidas shell toes and Chuck Taylors, and are coming back in the 2010s and 2020s to reclaim their pride of place with design collaborations from artists like Slick Rick and Big Daddy Kane. Although sneakers are not the main focus of *Fresh Fly Fabulous*, they are an irresistible way to end the book. Romero tells two specific and very regional stories about the Nike Air Force 1 (a Baltimore success) and the Reebok 5411s (a New York tale) that illustrate the myriad personal and place-specific hip hop style narratives that can illuminate larger movements in American culture.

Ultimately, the story of hip hop style is the story of American style and how it conquered the world. It is a story of Black, Latinx, and other individuals, tastemakers, and trendsetters expressing themselves through invention and reinvention, and creating a look that dismissed the stereotypes mainstream society held against them. It is a story of an endlessly multifaceted style born of hip hop culture, whose authenticity and unapologetic cool changed the way nearly every person dresses. In the 2020s, both the defiance of hip hop culture and the ubiquity of its influence for the hip hop generation and those born after are

Manolo Blahnik Okla Alta ankle bootie, AW15 reissue of AW94.

clearly felt in fashion. When designer Beau McCall links Tupac Shakur's face to Black Lives Matter on his avant-garde 2021 T-shirt, the message is clearly understood. Just as political is the statement made when world-famous rappers—from Megan Thee Stallion to Lil Nas X and A$AP Ferg—carry a "Bushwick Birkin," an It bag from the Black-owned Telfar label. Designers like Telfar Clemons are unapologetically inspired by hip hop, among many other influences, and the mainstream fashion industry has embraced them for their talent and vision the way it should have embraced their predecessors. But as Dapper Dan outlines in his interview, the convergence of hip hop and fashion was inevitable.

Notes

[1] Thalia Perez, "Biggest Names in Hip-Hop Pay Tribute to Notorious B.I.G. to Mark 50th Birthday," *CBS News*, May 20, 2022, https://www.cbsnews.com /newyork/news/notorious-big-50th-birthday-empire-state-building/.

[2] AG William, "Biggie's 10 Greatest Fashion Moments: What Died and What Lived On," *High Snobiety*, 2015, https://www.highsnobiety.com/p/notorious -big-fashion-what-died-what-lived/.

[3] Ashley Rushford and Nikara Jones, "Here's How Mary J. Blige's Thigh-High Boots for the Super Bowl Halftime Show Were Made," *Footwear News*, February 17, 2022, https://footwearnews.com/2022/fashion/celebrity-style /mary-j-blige-super-bowl-halftime-show-outfit-boots-1203243443/.

[4] Liam Hess, "Kendrick Lamar's Super Bowl Suit Was a Pitch-Perfect Tribute to Virgil Abloh," *Vogue Hommes*, February 15, 2022, https://www.vogue.fr /vogue-hommes-en/article/kendrick-lamars-super-bowl-suit-tribute-virgil -abloh.

[5] Aaron Royce, "Eminem Performs in 'Slim Shady' Air Jordan 3 Sneakers at Super Bowl LVI Halftime Show," *Footwear News*, February 13, 2022, https://footwearnews.com/2022/focus/athletic-outdoor/eminem-air-jordan-3 -super-bowl-halftime-show-1203243445/.

[6] "2022 Super Bowl: The Performers' Looks," *Numero*, February 15, 2022, https://www.numero.com/en/fashion/superbowl-looks-eminem-dr-dre-snoop -dogg-mary-j-blige.

[7] Ashley Rushford, "Snoop Dogg Blazes the Super Bowl Halftime Show Stage in Blue & Yellow Bandana Tracksuit Outfit & Converse Sneakers," *Footwear News*, February 14, 2022, https://footwearnews.com/2022/fashion/celebrity-style/snopp-dogg-super-bowl-outfit-halftime-blue-tracksuit-1203243546/.

[8] Abdul Abdi, "The Richest Rappers in the World 2022," *University Magazine*, March 17, 2022, https://www.universitymagazine.ca/the-richest-rappers-in-the -world-2022/.

[9] Tricia Rose, *Black Noise: Rap Music and Black Culture in Contemporary America* (Middletown, CT: Wesleyan University Press, 1994), 3.

[10] Rose, *Black Noise*, 4.

[11] Joe Coscarelli, "Kendrick Lamar Wins Pulitzer in 'Big Moment for Hip-Hop,'" *New York Times*, April 16, 2018, https://www.nytimes.com/2018/04/16/arts /music/kendrick-lamar-pulitzer-prize-damn.html.

[12] Janelle Okwodu, "Diddy at 50: The Hip-Hop Legend on His Groundbreaking Fashion Career," *Vogue*, November 4, 2019, https://www. vogue.com/article/sean-diddy-combs-interview-fashion-legacy-puffy-takes -paris-anniversary.

[13] Gianni Poglio, "Tupac, Story of a Rebel: The Book," *Panorama*, September 7, 2021, https://www.panorama.it/lifestyle/Musica/tupac.

[14] Robin Givhan, "They Laughed When Diddy Launched a Fashion Line. Then He Changed the Industry," *The Washington Post*, April 21, 2016, https://www.washingtonpost.com/sf/style/2016/04/21/they-laughed-when -diddy-launched-a-fashion-line-then-he-changed-the-industry/.

Beau McCall Black Lives Matter T-shirt, 2021. RIGHT: Telfar vegan leather bag, 2021.

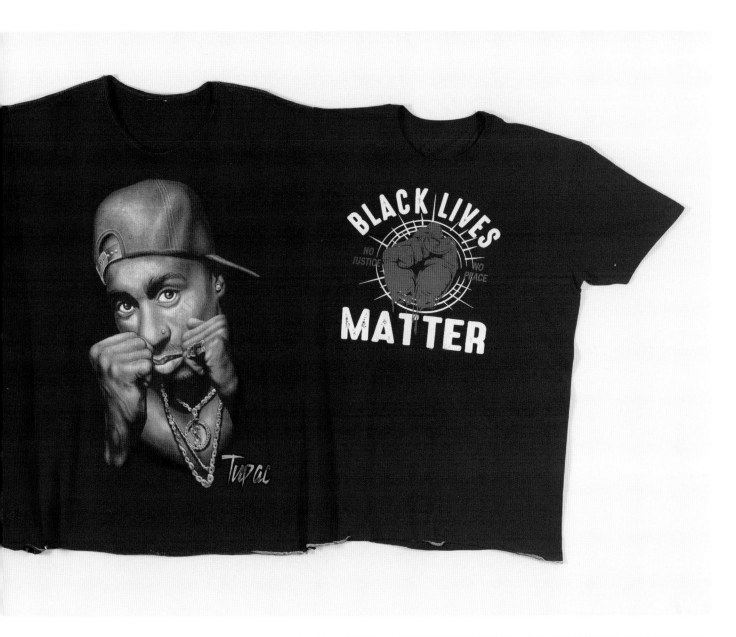

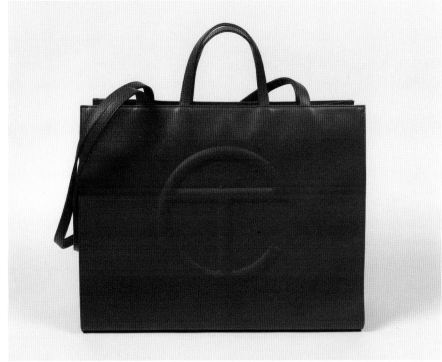

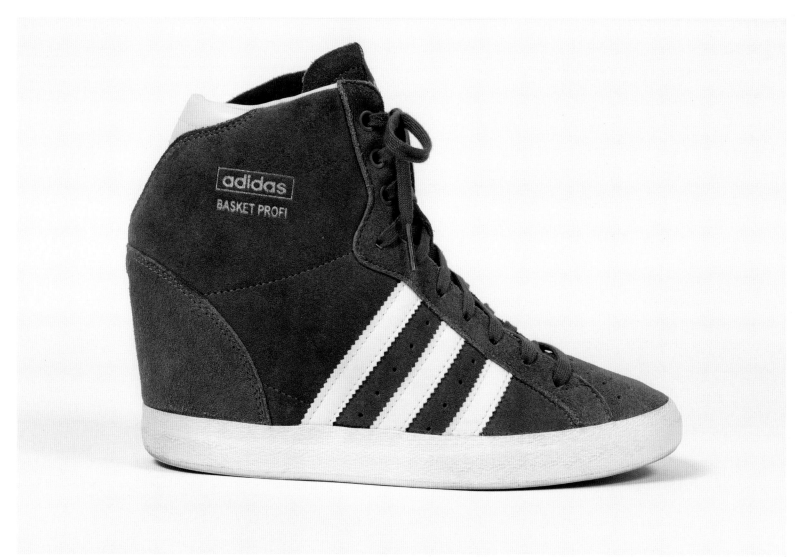

Adidas high-top wedge, 2015.

Balenciaga sneaker, 2018.

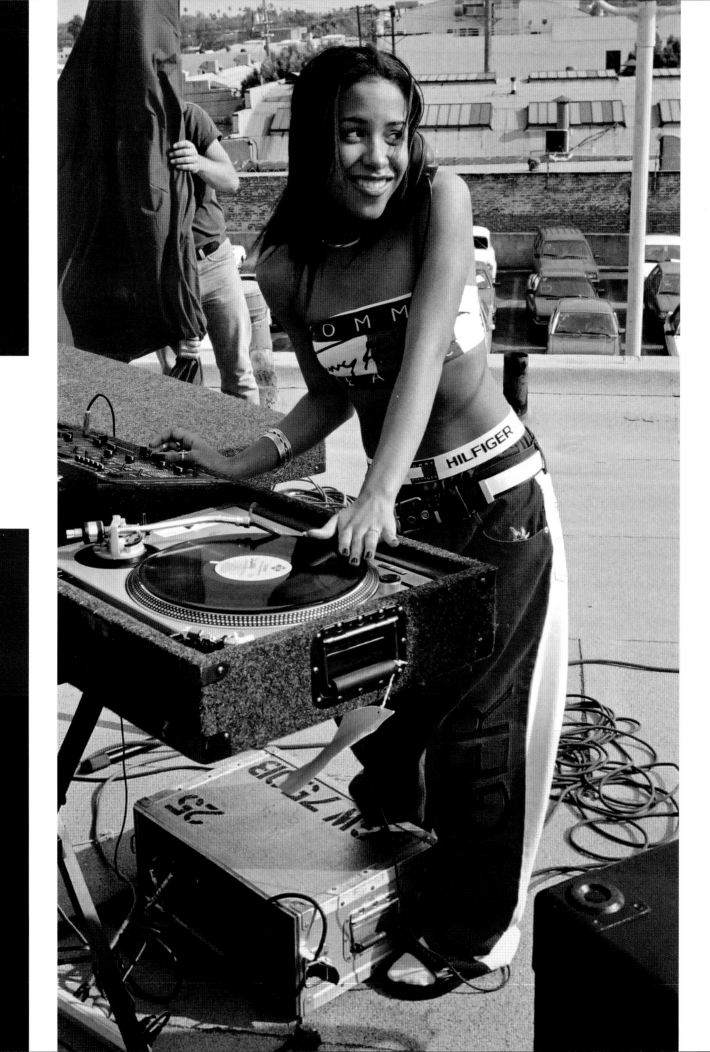

THE EVOLUTION OF HIP HOP STYLE

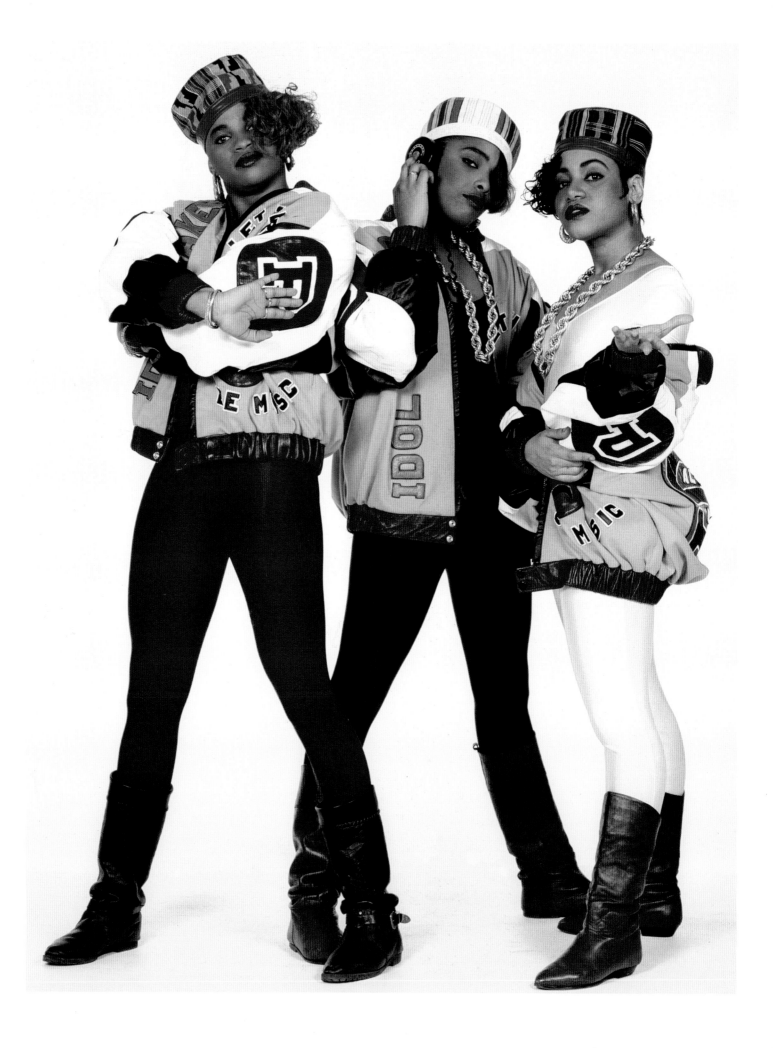

For my eighth-grade graduation dance, I planned to rock a graffiti sweatshirt, two-tone black-on-gray jeans, white Nikes, and a pair of quarter-sized gold bamboo earrings. My middle name was going to be "Fly." My mom squashed those fashion plans before I made it to Shirt Kings, the airbrush shop in the Jamaica Colosseum Mall in Queens. She insisted that I wear my floral drop-waist Easter Sunday dress to the dance. Oh, how I tried to look cool bobbing my head to Eric B. & Rakim's "Eric B. Is President" in that floral dress! Instead, I looked like a Black Disney princess, decades before there was a Princess Tiana. Wack!

As The Museum at FIT prepares to celebrate its exhibition *50 Years of Hip Hop Style*, I look back on that seminal moment in my history. It was the first time hip hop influenced my fashion choice, but it surely would not be the last. I am among the millions of Gen Xers who came of age during the golden age of hip hop, from the mid-'80s to mid-'90s. In the early years, we longed to have Run-DMC's Adidas and LL Cool J's gold chains. UTFO front man Shaun "Kangol Kid" Shiller Fequiere's brimmed Kangol is as much a part of American pop culture as James Dean's white T-shirt.

As hip hop evolved, so did its fashion. We copied the rappers' iconic styles in the 1980s and bought their clothing lines throughout the 1990s. Elite fashion brands partnered with rap artists in the 2000s, and in the 20-teens couture houses handed their creative reins over to industry stars, like Kanye West and Rihanna, and hip hop–loving designers, like Louis Vuitton's late menswear artistic director, Virgil Abloh, who grew up listening to rap.

Hip hop's impact on high fashion is painted into the graffiti details of skate wear, and it hangs out in athleisure's loose-yet-fitted silhouette. It made androgyny cool in the 1980s when lady emcees, like MC Lyte and Roxanne Shanté, threw their hats to the back and let their jeans sag. Decades later, A$AP Rocky and Lil Nas X performed in sold-out arenas in dresses and manicured nails, further challenging established gender norms.

The beats came first, but fashion made hip hop aspirational, turning its stars into the first lifestyle influencers. In 2006, eight years after he launched his Sean John label, Sean "Puffy" Combs (as he was then known) became the first rapper with his own luxury fragrance, "Unforgivable."[1] Today, colognes by Nicki Minaj, Drake, and Travis Scott sell out within hours of their debuts. Dr. Dre's "Beats by Dre" headphones make millions. Curtis "50 Cent" Jackson's *Power* is Starz's most popular television franchise, drawing millions of viewers each week. DJ Khaled and Juvenile dabble in furniture. Doja Cat has a makeup line. Wu-Tang Clan's RZA hawks TAZO teas. Countless artists, including Snoop Dogg and Brand Nubian's Sadat X, are in the wine business. This is all because hip hop infiltrated the fashion industry.

Early Rappers as Fashion Icons

Hip hop was born on August 11, 1973—the day DJ Kool Herc introduced the breakbeat to dance floors at his sister's back-to-school block party. Herc used two turntables to blend the instrumental section of disco or funk jam into itself, creating a continuous sound loop, or the breakbeat. Young men at basement parties and basketball courts rhymed over breakbeats because of their steady, staccato rhythm.[2] In 1979, the Sugarhill Gang released "Rapper's Delight," and when it cracked *Billboard's* Hot 100 chart later that fall, rap had its first hit. The Sugarhill Gang dressed in denim jackets, tight jeans, and tighter T-shirts—sort of like the real Fat Albert and the Cosby Kids. They were not setting any fashion trends.

Grandmaster Flash and the Furious Five performed "The Message" (1982) and "White Lines (Don't Do It)" (1983) in silky dress shirts and bell-bottom pants, accessorizing with leather vests, faux fur, studded belts, and feathers. It was all very 1970's-pimp-meets-the-Village People. The Village People did not set any fashion trends either. In fact,

Salt-N-Pepa, NYC, 1987. Photo: Janette Beckman.

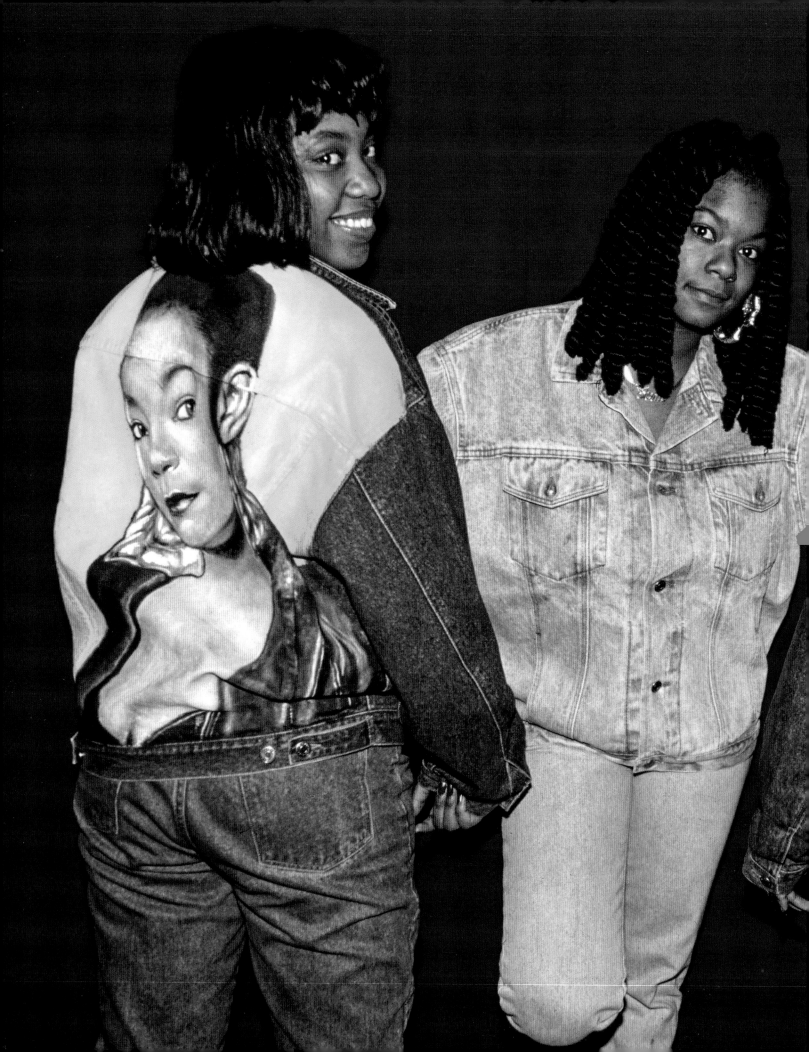

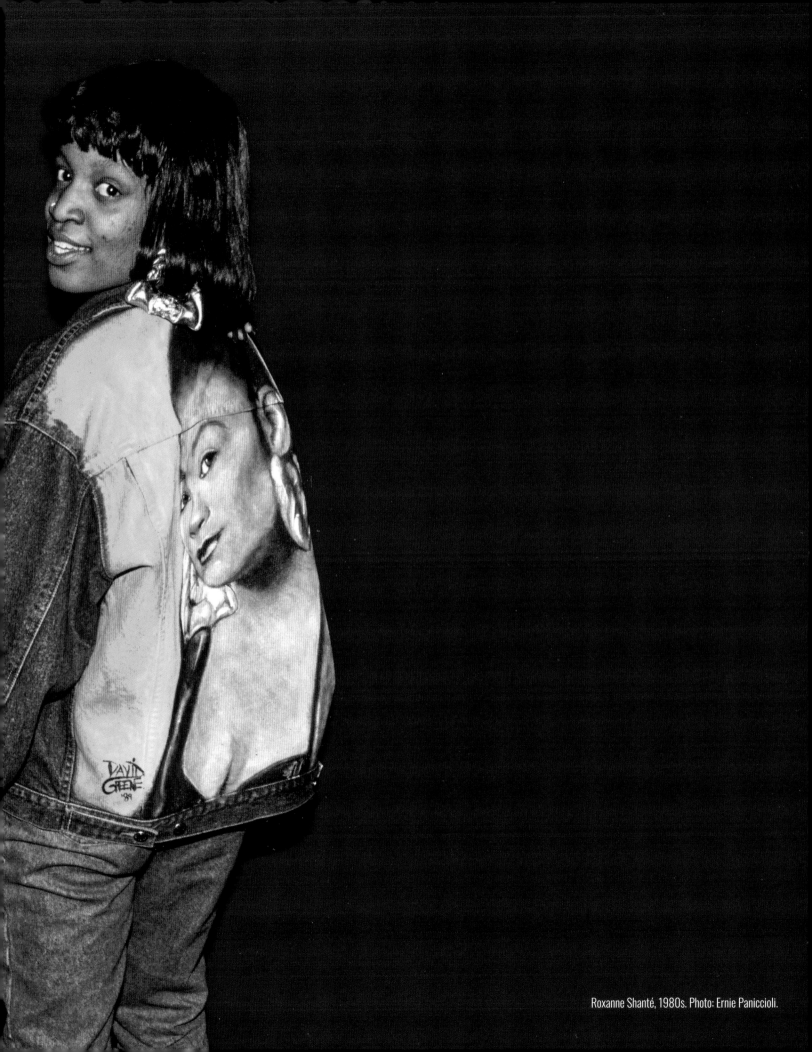

Roxanne Shanté, 1980s. Photo: Ernie Paniccioli.

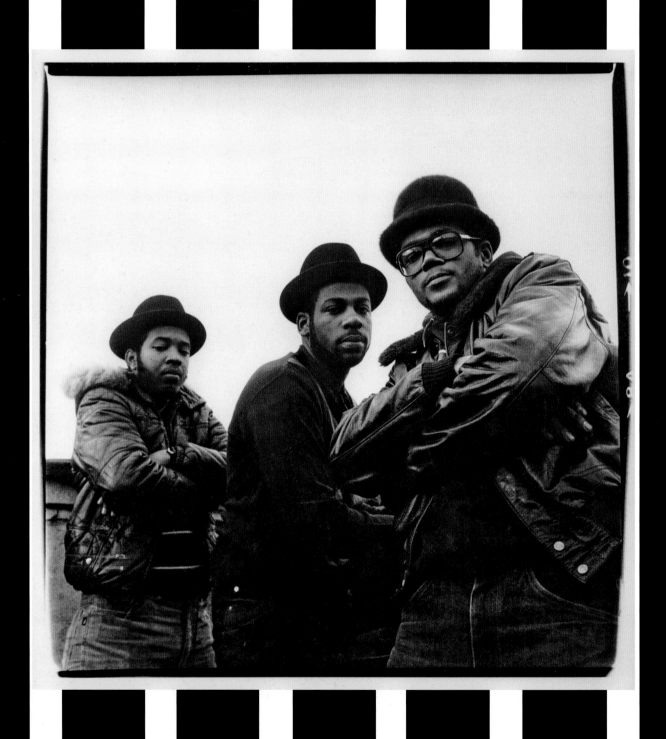

they sent quite the opposite message, as nobody wanted to be told they dressed like Flash and his crew. Run-DMC was the first rap group to have a gold album *and* an iconic look. They wore all-black everything: straight-leg Lee jeans, sweatshirts, Kangol caps, and Cazal glasses. The trio did not leave home without their shell-toe Adidas.

In 1986, Run-DMC released "My Adidas," a shout-out to the group's favorite footwear, and Joseph "Run" Simmons, Darryl "DMC" McDaniels, and Jason "Jam Master Jay" Mizell became the first nonathletes to receive an endorsement from a sports apparel company. "My Adidas" foreshadowed the impact a celebrity endorsement would have on a clothing brand's bottom line.[3] Since then, every chart-topping rap act has arrived on the scene with a must-have look. Thanks to Kool Moe Dee, many young brothers wore leather kufis. Salt-N-Pepa's asymmetrical bobs inspired B-girls to chop off their hair, and Christopher "Kid" Reid's high-top fade inspired B-boys to grow theirs up. Both Salt-N-Pepa and Kid 'n Play had us sweatin' in eight-ball jackets, and the late John "Ecstasy" Fletcher of Whodini wore a leather suit just a tad bit better than Eddie Murphy did in 1987's *Raw*. These then-emerging artists' styles defined them as much as their bars. Fashion mattered.

Hip Hop's Obsession with Labels

I did not know what a Gucci was until I heard Slick Rick rap about his drawers in "La Di Da Di" (1985). But as a young hip hop fan, I would quickly learn all about Gucci, Louis, Fendi, and every other designer label because emcees rhymed about three things: their flow, their finesse with the ladies, and how fresh they dressed.

Slick Rick, Doug E. Fresh, and many of the other rappers at the dawn of hip hop's golden age were on the come up, subscribing to the mantra "Dress like the person you want to become," which meant rich and powerful. Early rappers did not have yachts, but they could get their hands on designer labels. Sometimes it was from department stores. Sometimes it was a Fulton Street knock off, and sometimes boosted. What they had, they flaunted.

European designer names rolled off emcees' tongues with such ease that you thought they were perhaps intimate friends with heads of exclusive design houses. The reality was fashion industry execs were more likely to call the cops on these kids than collaborate with them. Hip hop royalty did not exist yet, but that did not stop artists from dreaming and creating trends.

Dapper Dan is considered the grandfather of haute couture in the hip hop community. In the early 1980s, Dan—whose real name is Daniel Day—screen printed luxe designer logos on bomber jackets, tracksuits, and backpacks to become the genre's first fashion superstar. His pieces may have boasted the logos of European design houses, but the slouchy apparel featuring pockets big enough to hold a drug dealer's gun was decidedly urban. Rap's biggest stars, including Heavy D and Big Daddy Kane, were walking Dapper Dan billboards, and European luxury brands became ubiquitous in the hood. The fashion houses caught on to Dan's hustle in the early 1990s. In 1992, Dan lost a trademark-infringement case brought against him by Fendi, which forced him to shut down.[4] By then, however, hip hop's affinity for high-end designers was etched in 18K gold. It would be decades before luxury brands acknowledged hip hop's contribution to their continued relevance.

Taking Ownership

In 1989, Queen Latifah released "Ladies First." The song's video—one of the first with a women's empowerment theme—featured Latifah and guest rapper Monie Love in Kente-cloth-trimmed pantsuits, African headwraps, and Egyptian crowns. The ladies' outfits paid homage to the Motherland instead of European brands. Latifah and Monie Love joined the New York–based hip hop collective Native Tongues the next year.[5] The Native Tongues ushered in the New School era of conscious hip hop that teemed with lyrics about Black pride and entrepreneurship. Tracks were laid over jazz-

Run-DMC (Joseph Simmons, Jam Master Jay, and Darryl McDaniels), circa 1986.

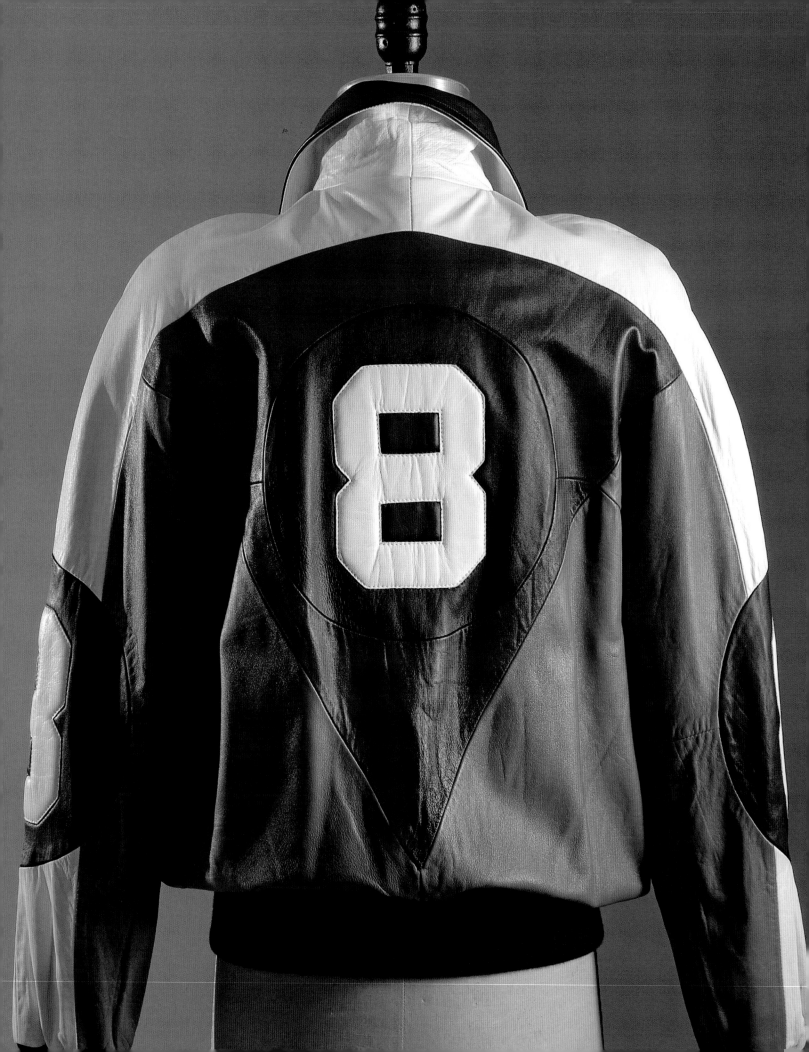

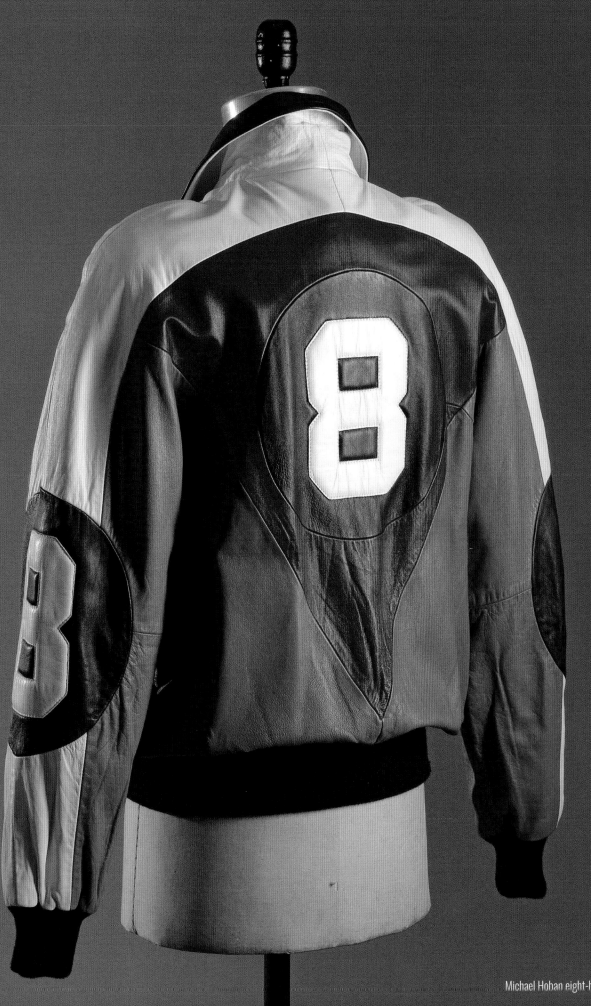

Michael Hoban eight-ball jacket, Fall 1989

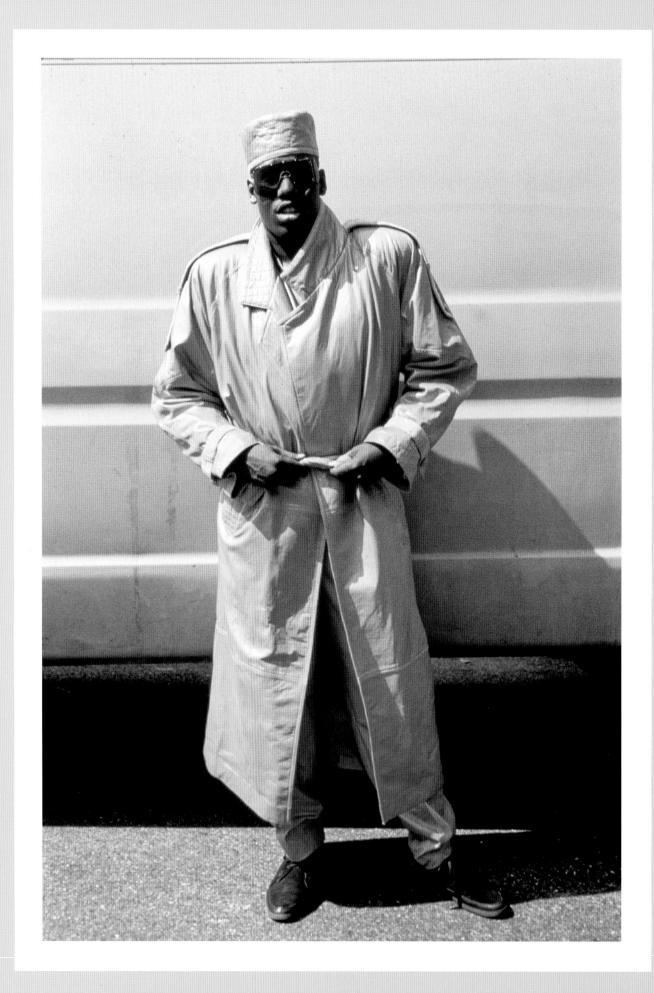

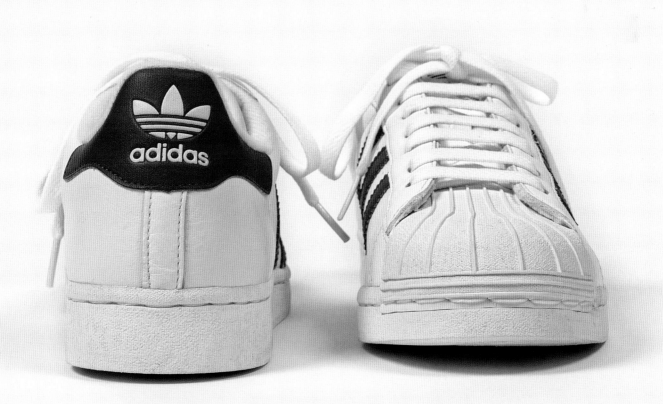

OPPOSITE: Kool Moe Dee, 1980s. Photo: Ernie Paniccioli. Adidas, 1998.

infused breakbeats for a mellow feel. The fashion reflected that vibe. The male groups in the Native Tongues—A Tribe Called Quest, Jungle Brothers, De La Soul, and Leaders of the New School— followed Latifah's Afrocentric fashion lead, but they were more casual with their opting of Baja hoodies, medallions, and drawstring knapsacks in red, black, and green—the colors of the Pan-African flag. The cornerstone of the look was denim—but not the jeans that moms would bring home from discount Jamaica Avenue spots. Only Gap, Polo, Tommy Hilfiger, and Marithé et François Girbaud would do. Grand Puba told us as much in his 1992 hit, "360 Degrees (What Goes Around)."

Here is the rub: $80 was a lot of money for a teen to spend on jeans and sporty collared shirts, so despite the music's do-the-right-thing messaging, shoplifting crews—like the Brooklyn-based Lo Lifes—robbed stores and delivery vans for Polo by Ralph Lauren merch, which they sold to fashion-hungry kids at bus stops and high school hallways. It was not all bad. Those who did not steal designed. Afrocentrism, coupled with a desire for jeans that fit Black people better, inspired young designers Carl Jones and Carl Williams to launch Cross Colours and Karl Kani, respectively, in 1989.[6] Both brands' bread and butter were the roomy red, black, green—and, yes, cobalt blue—jeans meant to be paired with a collared shirt in dancing primary colors. The urban streetwear category was born.

In 1992, Hollis, Queens entrepreneurs Daymond John, Keith Perrin, J. Alexander Martin, and Carlton Brown expressed their commitment to Black entrepreneurship with their menswear company's name, FUBU—an acronym for "For Us By Us." FUBU's founders leveraged their relationships with celebrities, especially LL Cool J, who wore and rapped about the brand in a Gap commercial. FUBU grossed $350 million a year in sales at its pop culture height and is still Black-owned today.[7]

Not to be outdone by emerging designers working in their basements, rappers took a piece of the fashion action. Russell Simmons, Joseph "Run" Simmons's older brother and founder of Def Jam, launched the fashion brand Phat Farm in 1992. The baggy but decidedly more preppy than Afrocentric menswear collection (its logo was a "P" encircled in

Gucci, circa 1980

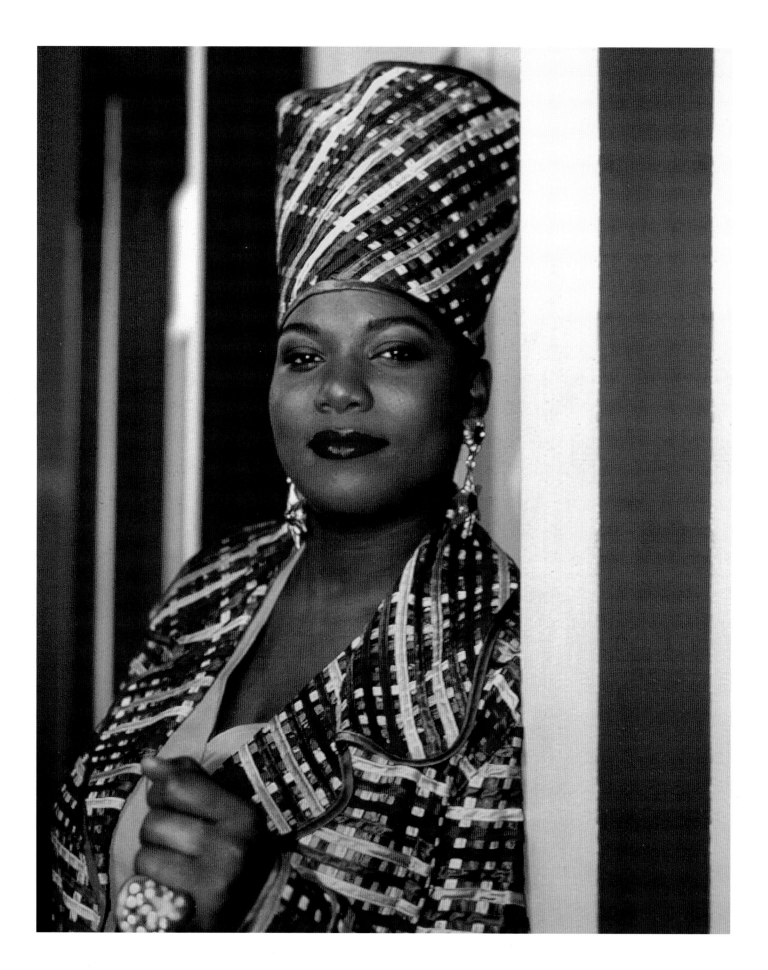

ivy) was a million-dollar-a-year company.[8] Phat Farm established a presence at Las Vegas's MAGIC trade show and was available at better department stores next to Hilfiger and Girbaud.

Women in hip hop improvised. They bought men's jeans that barely stayed up despite using thick belts. Sometimes, they would wear baggy T-shirts. Other times, they chose bodysuits or plaid button-ups over tiny T-shirts that revealed their midriffs. They topped the look off with a baseball cap, just like Mary J. Blige did in the video for "Real Love" (1992). That was until Simmons's wife, Kimora Lee Simmons, hooked them up with Baby Phat in 1998. A former model and Chanel muse, Kimora made it acceptable for girls in the hip hop life to be, well, girly. The all-about-the-bling collections featured fur-trimmed coats, velour tracksuits, and fitted T-shirts trimmed in rhinestones. In 2000, Kimora held her first New York Fashion Week runway show.[9] Catwalks would never be the same.

Hip Hop Goes Haute

Baby Phat's New York Fashion Week front rows were packed with industry A-listers, including Lil' Kim, Aaliyah, Mary J. Blige, Janet Jackson, and Naomi Campbell. With Baby Phat, Kimora Simmons cemented the connection between hip hop and celebrity. Baby Phat's crushed-velour tracksuits and midriff-grazing, zip-up hoodies were aspirational. The sparkling cat logo defined fabulosity.

The popularity of Baby Phat raised Kimora's profile. She starred in the 2007 Style Network reality show *Kimora: Life in the Fab Lane* with her family, friends, and two little girls. The show debuted two months before E!'s *Keeping Up with the Kardashians*.[10] Baby Phat set the fashion foundation for Bravo's *Real Housewives* franchise. And if it were not for the popularity of Kimora's slinky styles, designer Max Azria never would have brought back Hervé Léger's banded dress, which became the *Housewives'* unofficial uniform. Kimora gave the next generation of women emcees, including Nicki Minaj and Cardi B, permission to be as feminine and sexy as they wanted to be. Girls in the game wore pink, lace, and leather. Baby Phat

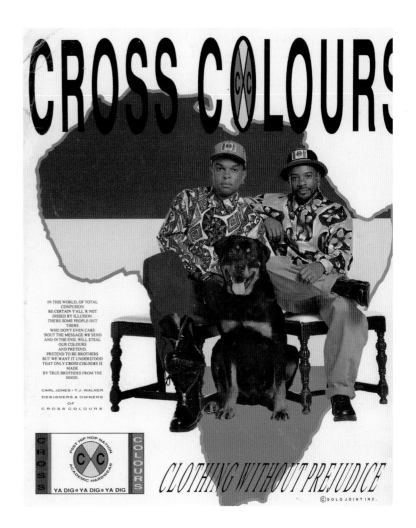

OPPOSITE: Queen Latifah in custom Todd Oldham, circa 1990. Cross Colours advertisement. Photo: Michael Segal.

added generous amounts of stretch to its low-rise jeans and tracksuits. These seemingly minor details helped women of all sizes celebrate their curves in a major way. Kimora was one of the few designers to put lots of women of color on her runway. The brand was inclusive, and it was a blueprint for contemporary women's brands. It paved the way for Juicy Couture to introduce its zip-up velour tracksuit in 2001 and Nelly to offer his stretchy AppleBottoms jeans in 2003.[11, 12]

The mainstream success of Russell Simmons's Phat Fashions conglomerate proved the hip hop generation was more than consumers. The company's revenues soared to $265 million from $30 million between 2001 and 2002.[13] Brands that focused on the young Black aesthetic not only set trends, but were bonafide money makers. Other artists followed happily in Phat Farm's footsteps. Shawn "Jay-Z" Carter and then business partner, Damon Dash, launched Rocawear in 1999. By 2007, Rocawear had made $700 million. Sean "Puffy" Combs's Sean John Collection debuted in 1998 as strictly streetwear but turned to custom suiting a few years later. In 2004, Combs received the Council of Fashion Designer of America's menswear designer of the year award, beating Ralph Lauren and Michael Kors.[14] Urban fashion had grown up. Jay-Z told us as much in *The Black Album* single "What More Can I Say" (2003). In five tight lines, throwback jerseys were tossed to the fashion giveaway pile and now-grown hip hop heads were fancying button-down shirts, plaid vests, and blazers. The legacy menswear designers that hip hop brands emulated were now their competition, and the urban brands were winning. It would, however, not last. Building a brand takes patience. Staying with it takes vision. Holding on to it means losing money when patience and vision run out. Russell, Jay, and Puff had arrived. What more could they say?

Simmons was the first to sell off his fashion interests. He turned Phat Farm and Baby Phat over to California-based clothing manufacturer Kellwood Company in 2004 for a reported $140 million.[15] After falling out with Dash, Jay-Z sold Rocawear to the Iconix Brand Group in 2007. He made $204 million in that licensing deal.[16] Combs held on to majority control at Sean John until 2016, when he sold 80 percent of his stake to Global Brands Group Holding for an estimated $70 million.[17] Combs bought back his stake in Sean John for $7.6 million in December 2021 after Global Brands Group filed for bankruptcy.[18]

Hip hop fashion was mainstream. We could buy the brands in Macy's right next to legacy brands thanks to generous licensing deals. The tradeoff: the biggest urban streetwear brands were not Black-owned anymore. Neither was hip hop.

Fashion's Hip Hop Foundation

By 2010, the menswear silhouette had slimmed down. Fitted blazers and flat-front pants replaced boxy jackets and pleated trousers. Hoodies stopped slouching and started hugging. Young men—gasp!—were comfortable in skinny jeans. Pharrell Williams's Billionaire Boys Club, which was a joint venture with Japanese designer Nigo, blended the hip hop aesthetic with the skinnier skater silhouette. By the 20-teens, streetwear no longer took all of its cues from the late '90s and was leaning toward androgyny. French designer Hedi Slimane popularized the skinny jogger on the Saint Laurent runways when he was the brand's creative director, kicking off athleisure's world domination of womenswear and menswear, both couture and off-the-rack. Comfort ruled. As the sleeker silhouette gained popularity in streetwear, old-school hip hop heads voiced betrayal. When Kanye West performed in a Givenchy pleated kilt and man leggings (aka meggings) during the 2011 "Watch the Throne" tour, his masculinity was challenged.[19] Later that same year, A$AP Rocky appeared on BET's music video show *106 & Park* in a tie-dyed tank dress and leggings. The siren had sounded; hip hop had gone soft. But had it really? Could it be that hip hop was simply continuing to evolve? Traditional roles of gender expression were in the midst of a global shift. Why did hip hop think it would be exempt?

Lil Nas X would prove how much it was not exempt a few years later. He created a new sound when he married country and hip hop with his smash debut single, "Old Town Road" (2018).

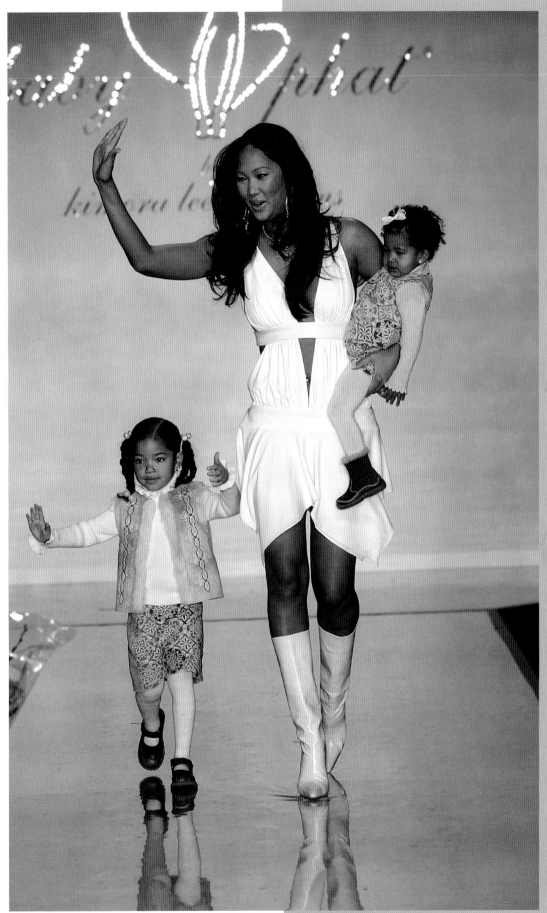

Kimora Lee Simmons and her daughters on the Baby Phat runway, Fall 2004.

Gucci slippers, Spring 2017

His style—sparkling, wide-legged jumpsuits, fire manicures, and designer ball gowns—speaks to the evolution of hip hop. Hip hop's Gen Zers renewed hip hop's love for European designers. The success of Migos's 2013 debut single, "Versace," is evidence of that. In Migos's case, it was the clothes that made the men. Nothing else seemed to matter.

Hip hop continued to maintain an uneasy relationship with luxury brands. Hip hop supported them through a recession despite people of color not being represented on the runways. There were even straight-up slights: Givenchy models walked the 2015 catwalk with baby hair, a unique hairstyle in the Black community. Talk about cultural appropriation! A few years later, Gucci released a turtleneck that when unfolded made the bottom half of a white person's face look like it was covered in blackface. In 2017, Gucci's creative director Alessandro Michele designed a balloon-sleeved, fur-paneled bomber jacket that was an homage to Dapper Dan, which did not fly with Dapper Dan or his fans who remembered how the luxury label had treated him. Nearly thirty years after luxury houses ran Dan out of business, Gucci hired Dan as a consultant.[20]

The fashion industry needs hip hop to remain relevant, and hip hop needs fashion to remain aspirational. As hip hop prepares to celebrate its half-century, it is hard to tell where one stops and the other starts. Today, well-known artists are able to take advantage of the deep pockets of international luxury houses. Savage X Fenty, the lingerie brand that Rihanna owns with LVMH, is worth $1 billion and is in the midst of opening stand-alone stores worldwide.[21] Beyoncé's Ivy Park and Kanye West's Yeezy labels have netted hundreds of millions of dollars collaborating with Adidas. Niche designers who grew up in the shadow of old-school hip hop, like Pyer Moss's Kerby Jean-Raymond and bespoke tailor Davidson Petit-Frère, influence the sartorial choices of people around the world. Former industry stylist Edward Enninful is the top editor at *British Vogue*, one of the world's most influential magazines. Misa Hylton, another former stylist, has an eponymous clothing collection at Macy's. Whether we are gazing at a Kehinde Wiley painting or watching Snoop Dogg make grilled cheese and

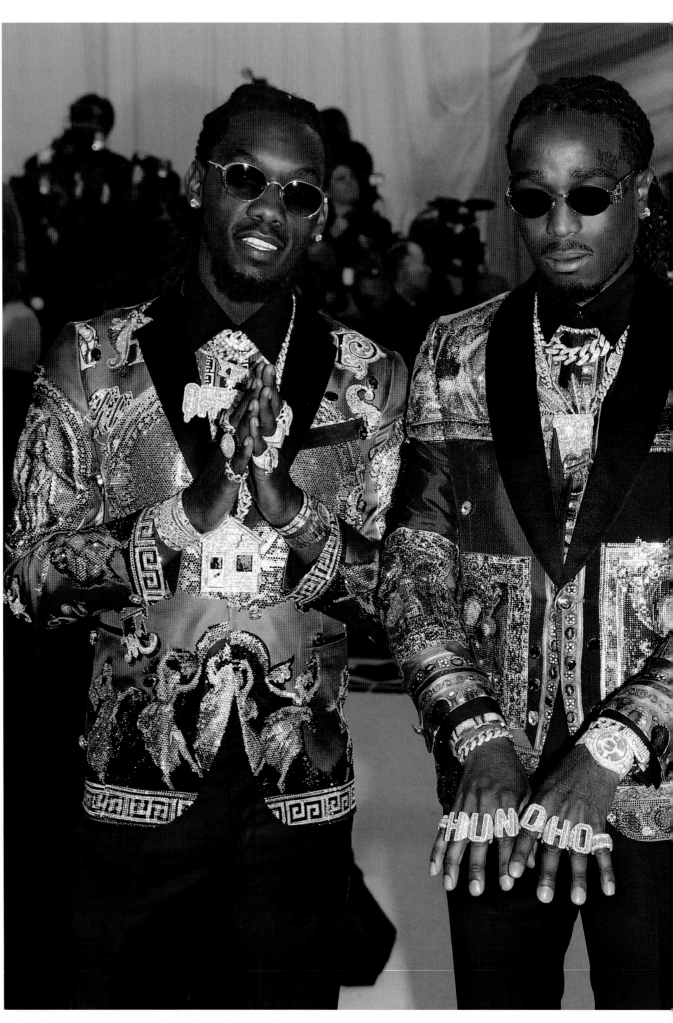

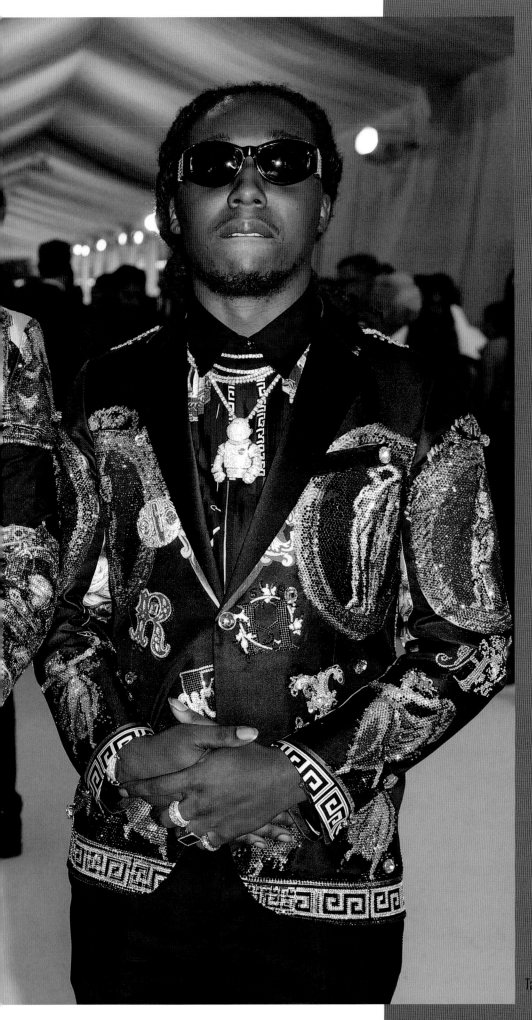

Takeoff, Quavo, and Offset of Migos at the Met Gala, 2018.

bologna sandwiches with Martha Stewart, the truth remains: hip hop shapes our aesthetics. Period. It is true that the beats came first—we love the beats!—but it was fashion that gave hip hop its oversized brick in the foundation of American style where it will remain forever.

Notes

[1] Layla Ilchi, "Sean Combs' Fragrance Legacy," *Women's Wear Daily,* February 18, 2018, https://wwd.com/beauty-industry-news/fragrance/sean-combs -celebrity-fragrance-legacy-11136013/.

[2] Tricia Rose, *Black Noise: Rap Music and Black Culture in Contemporary America* (Middletown, CT: Wesleyan University Press, 1994).

[3] Seb Joseph, "Adidas and Run-DMC Revive Partnership for Music Video," *Marketing Week,* July 1, 2013, https://www.marketingweek.com/adidas-and -run-dmc-revive-partnership-for-music-video/.

[4] Ariele Elia, "Dapper Dan: The Original Streetwear Designer and Influencer," in *Black Designers in American Fashion,* ed. Elizabeth Way (London: Bloomsbury, 2021), 167–92.

[5] Julian Kimble, "Daisies, Aged: A Tribe Called Quest, De La Soul, and the End of the Native Tongues Era," *The Ringer,* August 6, 2021, https://www. theringer.com/2021/8/6/22610585/tribe-called-quest-beats-rhymes-life-de-la -soul-stakes-is-high.

[6] Elena Romero, *Free Stylin': How Hip Hop Changed the Fashion Industry* (Santa Barbara, CA: Praeger, 2012).

[7] Romero, *Free Stylin'.*

[8] Romero, *Free Stylin'.*

[9] Romero, *Free Stylin'.*

[10] Amina Akhtar, "'Life in the Fab Lane': We Want to Be Kimora Lee Simmons," *Vulture,* August 3, 2007, https://www.vulture.com/2007/08/life_in_the_fab _lane_we_want_t.html.

[11] Maura Brannigan, "Return of the Juicy Tracksuit: How the Noughties' Era-Defining Outfit Rose from the Dead," *The Zoe Report,* October 29, 2020, https://www.thezoereport.com/p/juicy-coutures-tracksuit-oral-history-of-the -blinged-out-era-defining-outfit-40078559.

[12] Romero, *Free Stylin'.*

[13] Hazel Mangurali, "Baby Phat Case Study: How They Made Their Comeback," *440 Industries,* February 16, 2022, https://440industries.com /baby-phat-case-study-how-they-made-their-comeback/.

[14] Romero, *Free Stylin'.*

[15] Romero, *Free Stylin'.*

[16] Romero, *Free Stylin'.*

[17] Zack O'Malley Greenburg, "Why Diddy Is No. 1 on the 2017 Celebrity 100 List," *Forbes,* June 12, 2017, https://www.forbes.com/sites /zackomalleygreenburg/2017/06/12/why-diddy-is-no-1-on-the-2017-celebrity -100-list/?sh=69efc5c33faf.

[18] Jean E. Palmeiri, "Sean Combs Regains Control of Sean John Brand," *Women's Wear Daily,* December 21, 2021, https://wwd.com/business-news /mergers-acquisitions/exclusive-sean-combs-regains-control-of-sean-john -brand-1235022144/.

[19] Jake Woolf, "The Boldest Outfit Kanye West Ever Wore," *GQ,* August 8, 2016, https://www.gq.com/story/kanye-west-watch-the-throne-kilt.

[20] Elia, "Dapper Dan."

[21] Bethany Biron, "Rihanna's $1 Billion Savage X Fenty Lingerie Brand Is Opening Its First-Ever Physical Stores in Five Major US Cities Early This Year," *Business Insider,* January 8, 2022, https://www.businessinsider.in/retail/news /rihannas-1-billion-savage-x-fenty-lingerie-brand-is-opening-its-first-ever -physical -stores-in-five-major-us-cities-early-this-year/articleshow/88765330 .cms.

Fenty x Puma, Spring 2017.

HERE FOR IT: Graffiti and Hip Hop
Fashion by Claudia Gold

Hip hop and graffiti are often viewed as one expression or parallel expressions. Although both exploded in the same era, they would take exponentially different but intersecting paths. Indisputable similarities exist between the two. Both are birthed from New York City's uptown urban sprawl. Graffiti and hip hop were packaged together. Graffiti's ethos and imagery quickly began to migrate from walls and trains onto clothing and other physical goods. It was not long before graffiti became indicative of the emergent hip hop culture, inspiring logos, providing backdrops, gracing record covers, and generally serving as a cornerstone of merchandise design.

The 1970s saw the rise of painted jackets alongside a wave of personalization and customization in clothing, introduced via unison gang colors and logos, and popularized in the mainstream by various rock and punk youth subcultures. Some of the earliest forms of graffiti that made their way from trains and walls onto clothing were pioneered by artists who did not necessarily identify as hip hop. As history has shown, subcultures often cross-pollinate, taking what works for them and discarding the ineffective. Hip hop styling drew inferences from other genres to create a new fashion and musical reality, sampling and mashing them all together with uptown New York panache.

The explosion of breakdancing in the late '70s had crews all over the five boroughs battling it out and rocking custom uniforms to represent. B-boys joined street gang flair with the accessibility of sports shop iron-ons, bringing their individuality to the forefront. From ironing fat laces for sneakers to hand-painting graffiti on jackets and down the legs of jeans, break-dance crews were the kings and queens of do-it-yourself fly fits.

From hip hop culture's humble beginnings, in which customization and individualization were key, a group of graffiti artists became the architects of hip hop graphic design. These artists—West FC, Futura, Haze, Stash 2, KEL1ST, Mare 139, and Shirt

King Phade, just to name a few—broke the ground between hip hop and mainstream, moving past their customized banners, paint addendum, airbrushed or hand-drawn T-shirts into the design of manufactured garments for mass consumption. Using rappers as influencers, this clothing was sold as the hip hop ideal and moved away from individualized personal style to the neat packaging and sale of what both hip hop artists and fans should look like.

The aforementioned graffiti artists and their collectives birthed modern streetwear. Commonplace was the use of established logos. Artists would "visually sample" them, similar to musical sampling in rap. Brands like PNB Nation, HAZE Clothing, and GFS Clothing Co. in New York City were all revolutionary, as were Conart, Third Rail, and Gypsies and Thieves on the West Coast. All of these brands took cues from surf and skate brands' new take on the humble T-shirt as a personal billboard.

Now, fifty years later, after having learned from Keith Haring and all of the previously mentioned pioneers about printing T-shirts, hip hop clothing is moving back to its custom roots. With Dapper Dan's significant resurgence and the late Virgil Abloh's success bringing B-boy looks to the Louis Vuitton runway, we realize that hip hop style is ever-evolving across both commercial and individual outputs. And we are here for it.

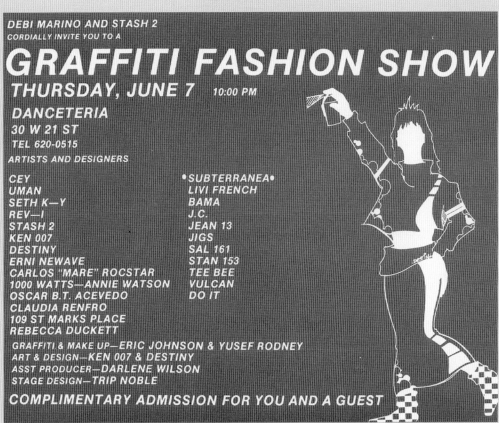

DEBI MARINO AND STASH 2
CORDIALLY INVITE YOU TO A

GRAFFITI FASHION SHOW

THURSDAY, JUNE 7 10:00 PM

DANCETERIA
30 W 21 ST
TEL 620-0515

ARTISTS AND DESIGNERS

CEY
UMAN
SETH K—Y
REV—I
STASH 2
KEN 007
DESTINY
ERNI NEWAVE
CARLOS "MARE" ROCSTAR
1000 WATTS—ANNIE WATSON
OSCAR B.T. ACEVEDO
CLAUDIA RENFRO
109 ST MARKS PLACE
REBECCA DUCKETT

•SUBTERRANEA•
LIVI FRENCH
BAMA
J.C.
JEAN 13
JIGS
SAL 161
STAN 153
TEE BEE
VULCAN
DO IT

GRAFFITI & MAKE UP—ERIC JOHNSON & YUSEF RODNEY
ART & DESIGN—KEN 007 & DESTINY
ASST PRODUCER—DARLENE WILSON
STAGE DESIGN—TRIP NOBLE

COMPLIMENTARY ADMISSION FOR YOU AND A GUEST

OPPOSITE West Rubinstein graffiti piece on NYC subway. Flyer for Graffiti Fashion Show at Danceteria night club, New York, 1984. Flyer for Graffiti Fashion Show at Danceteria night club, New York, 1984.

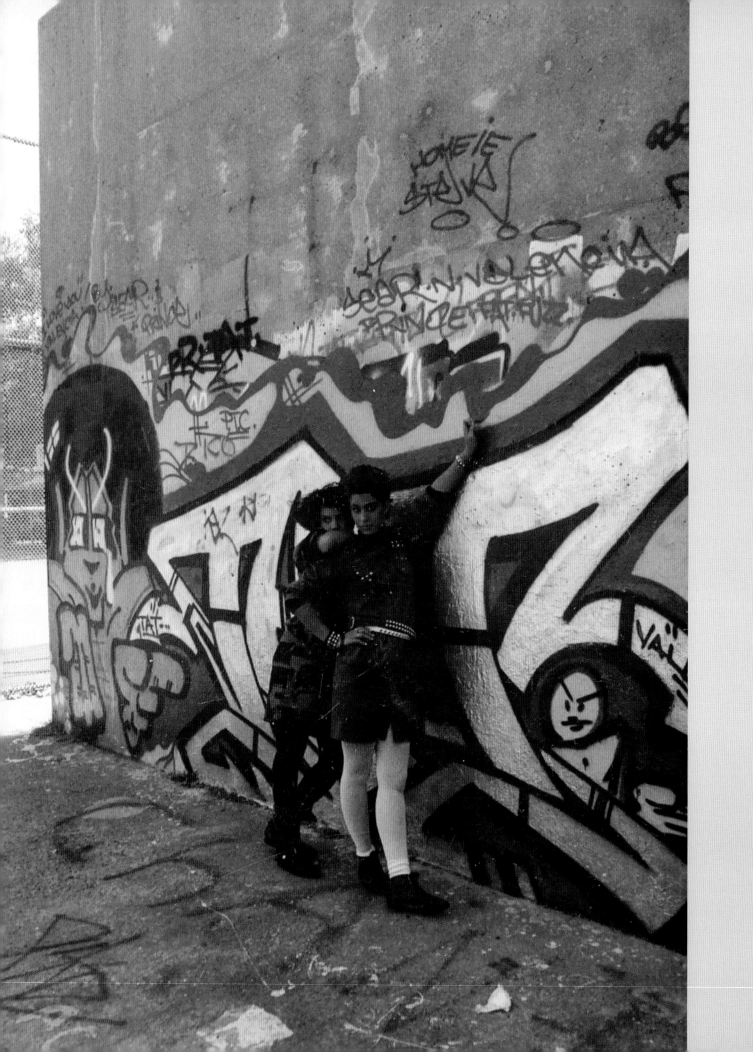

OPPOSITE: Tracy Daniels and April Cargill against a graffiti wall in Brooklyn, circa 1982.

THE KING OF THE FEVER: Sal Abbatiello
by Elizabeth Way

During the late 1970s, the Bronx was undergoing an epidemic of poverty. Born and raised in the borough, record executive Sal Abbatiello remembers the abandoned buildings, homelessness, drug addiction, and unemployment. Despite the hardships and lack of opportunity, young Black and Brown kids in these neighborhoods harnessed their creativity and ingenuity to birth a musical movement that has since taken over the world. Abbatiello was a vital part of making that happen. His family was well-experienced in clubs and the entertainment business in the city, but he had the vision to recognize rap as the next big thing. He convinced his father to let him try the new music—judged as redundant noise by critics from the older generation—in his Disco Fever nightclub on Jerome Avenue and 167th Street in the South Bronx. Starting with just one night a week—Tuesday—Abbatiello recruited an incredible deejay whom he saw spinning in a local park. He told Grandmaster Flash, "I'm going to make you a star." Seven hundred people showed up that first night at Disco Fever, overwhelming the four staff members on duty.

The Fever, as the club came to be known, played three thousand nights of hip hop from 1977 to 1986, and Abbatiello's influence and support of the earliest rappers was a key element in their exposure and success. Lovebug Starski, Run-DMC, DJ Junebug, Kurtis Blow, Sweet Gee, Roxanne Shanté, The Fat Boys, and countless others either made their public debut at The Fever, or played some of their earliest shows there. It was also a meeting spot for the most successful producers, including Andre Harrell and Russell Simmons. More important, however, The Fever, with its gun check and hidden recesses for less-than-legal activities, was neutral territory and a relatively safe space for young people in the Bronx to listen to their music, dance, socialize, and show out. Soon, video crews from as far away as Germany and Japan were drawn to the club to report on this new phenomenon. The Fever was where you went to hear what hip hop sounded like—and to see what it looked like.

Abbatiello recalls the fashions showcased there: "These kids, they started every trend in the world." From Pumas and Adidas sneakers to sheepskin coats, Kangol hats, furs, and leather all over, "everything hip hop touched just went crazy," said Abbatiello. When Run-DMC played The Fever—their first show ever—the crowd laughed at their plaid sports jackets, but Run-DMC soon adopted the black leather and Adidas uniform that was heavily emulated by their fans, creating one of the most recognizable images of early hip hop. When rappers like Kurtis Blow started wearing designer jeans—Sergio Valente, Jordache, and Calvin Klein—so did the kids in the Bronx.

Abbatiello was, and continues to be, deeply invested in his community, and The Fever was a pivotal part of meeting its needs. The racism that New York Black and Latinx youth faced in their daily lives might make them suspicious of Abbatiello who is Italian American, but his initiatives, from hiring the formerly incarcerated to local park clean-ups and fundraisers for the United Negro College Fund, were aimed at building up the borough and opportunities for its residents. Mentorship around clothing and dress was a part of this. He offered discounted or free door covers for kids in shoes, sports jackets, and dresses. "I wanted to show them … [how to] dress up in life … for an occasion, a wedding, to go to a job," explained Abbatiello. Whether expressing the most culturally relevant trends born of hip hop or practicing the dress that would help them function in mainstream society, fashion was an undeniable presence at The Fever, including through the club's own branded merchandise. Abbatiello commissioned the beloved thermometer logo from a sign painter. "When people see it, it means something to them. It's legendary," said Abbatiello.

From the late 1970s through the 2000s and into the present, Abbatiello has promoted, produced, and mentored generations of hip hop artists. After five decades, hip hop has exceeded the limits of not only the Bronx but also of New York City and the United States. But without fail, wearing a Fever jacket or hat prompts people in the street to stop, give a double take, and ask, "Where'd you get that? What do you know about The Fever?"

Styles worn at Disco Fever, 1980s.

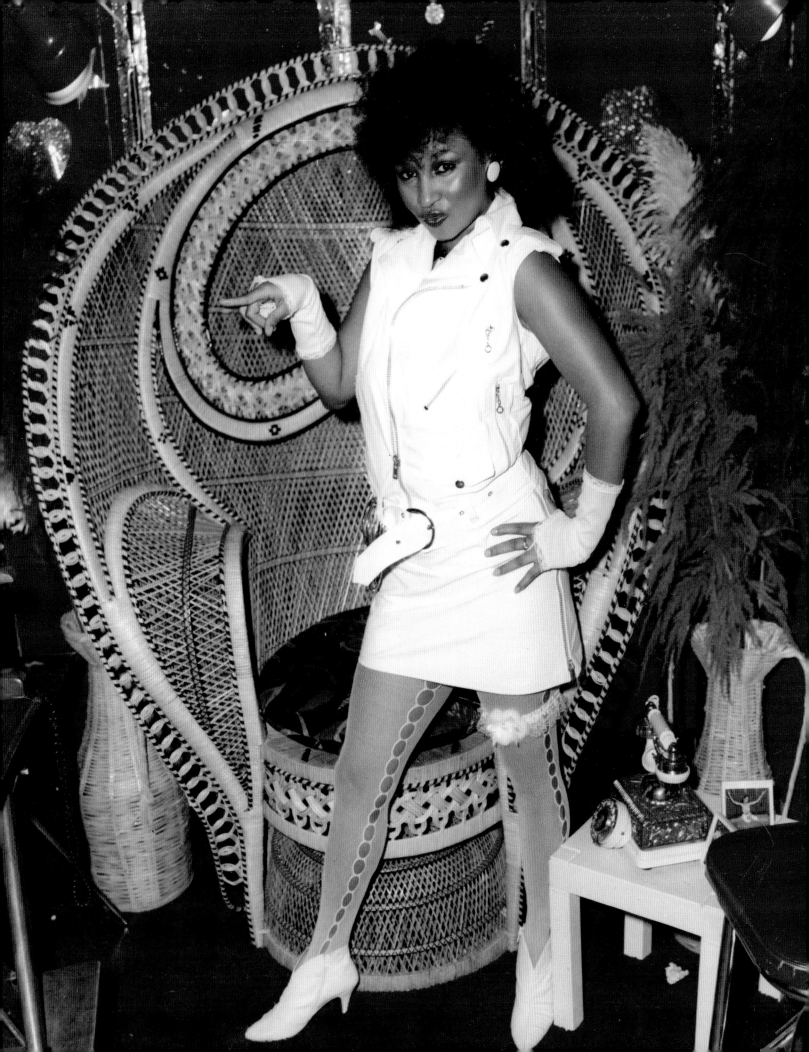

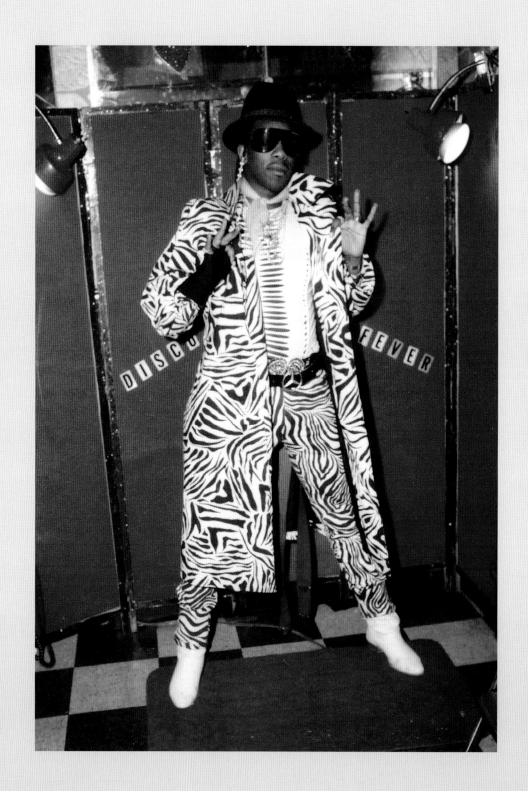

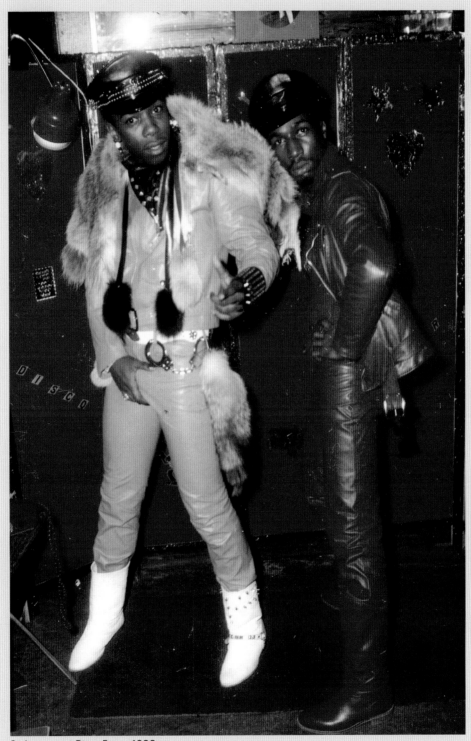

Styles worn at Disco Fever, 1980s.

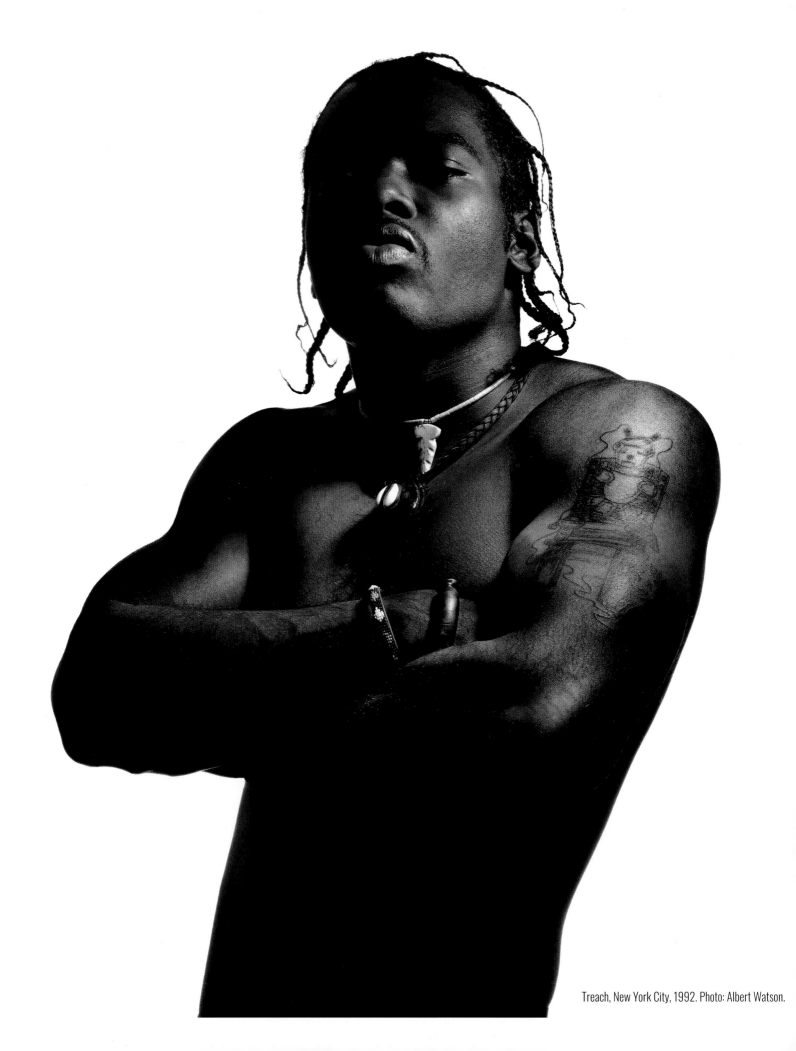

Treach, New York City, 1992. Photo: Albert Watson.

THE STYLIST IN THE GOLDEN ERA OF HIP HOP

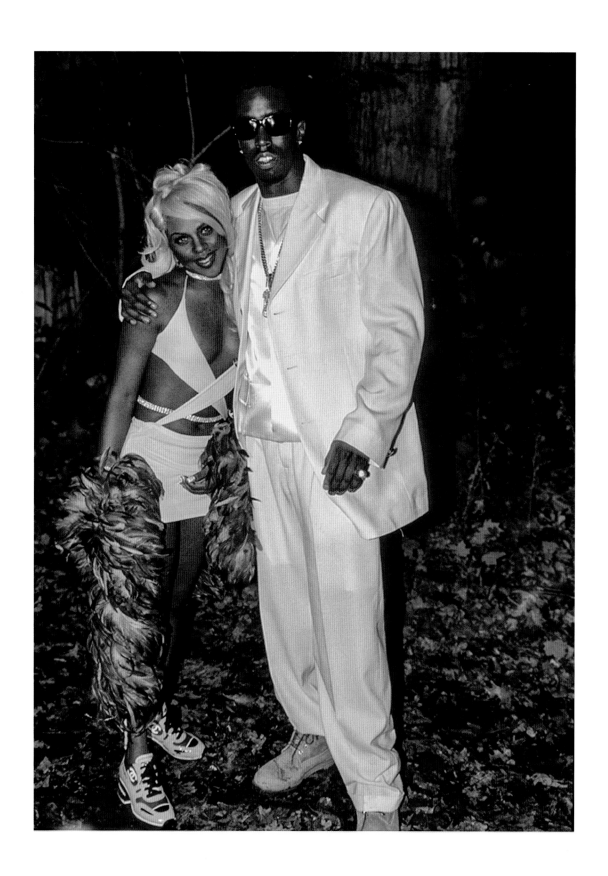

"**I** want to have a cultural impact. I want to be an inspiration, to show people what can be done."[1]
— Sean "Puffy" Combs

The Golden Era of Hip Hop

The 1990s are often referred to as the golden era of hip hop. In 1992, I had the privilege of being an associate editor at a start-up publication that was the love child of a joint venture between Time Inc. and Warner Brothers. Robert Miller, a high-ranking executive at Time Warner, asked the music impresario Quincy Jones if he could create a music-based magazine, what would it look like? Jones—a visionary, maverick, and musical genius—believed that rap music was the new rock 'n' roll and that there could be a magazine focused on Black music and culture in the same way *Rolling Stone* had treated rock and with the same elegance and elevated style as *Vanity Fair*.

The publication began with editor-in-chief Jonathan Van Meter, who curated a staff of young music and culture writers (Scott Poulson-Bryant, Joan Morgan, Greg Tate, Kevin Powell, and Hilton Als), up-and-coming editors (Alan Light, Ben Mapp, Rob Kenner, Diane Cardwell, and me), future mavericks like Mimi Valdés and Tiarra Mukherjee, photography visionary George Pitts, design wizard Gary Koepke, and fashionista Michaela Angela Davis. The publication was initially called *Volume*, but because of copyright issues a few weeks before printing, it was changed to *Vibe* (thanks to Poulson-Bryant's wordsmithing). The magazine was oversized, the images were bold and in-your-face, the typography was modern and sleek, the presentation of photography was sublime, and the journalism and writing—taking its cues from the *Village Voice*—were best in class. *Vibe* would change the visage and verve of hip hop and amplify its aesthetic.

Vibe's debut cover in fall 1992 featured a striking black-and-white portrait of Treach from Naughty by Nature, whose song "O.P.P."

(1991) had become an anthem on the streets. Appearing shirtless with tousled braids, Treach was the epitome of the Black male body. He wore an industrial chain and padlock—a nod to all his homies who had been locked down. It was pure magic. The photograph, taken by legendary British lensman Albert Watson, looked like a fashion campaign. Single-handedly, *Vibe* revolutionized the face of hip hop, elevating its music and presentation to a high-art realm that would shape its look and feel forever.

Inside the magazine, stylist Phillip Bloch took brands like Emporio Armani and emboldened them, making them feel culturally relevant to the streets and high fashion at the same time. Supermodel Naomi Campbell posed in a photo spread wearing Gianni Versace's designs embellished with the brand's hallmark sexy bondage references and romantic Italian Baroque prints. *Vibe* understood the amalgamation of hood style and high-end fashion and the art of the remix that created a cultural conversation, focusing the spotlight on hip hop: the revolutionary resilience of the Black community and the renaissance of rap.

Vibe helped lead the way for the next phase of hip hop fashion, working with many top stylists, including Stefan Campbell, Derick Procope, Patti Wilson, and Kevin Stewart, among others. I was so enamored with their work that I decided to become a stylist. My point of difference was a combination of my journalistic background and my passion for fashion. I fused the two to tell strong narratives through style.

My first photo shoot for *Vibe* in 1993 featured model Tyson Beckford. It accompanied a feature by Poulson-Bryant about the historic moment when Beckford became the first Black male model to receive a contract with Ralph Lauren. The photos taken by Christian Witkin are heroic, spare, and celebrate the Black body. My first cover shoot for *Vibe* was of Biggie Smalls and Faith Evans posing with a blue convertible, photographed by Eric Johnson under the Brooklyn Bridge. The image

Lil' Kim and P. Diddy, 1997. Photo: Ernie Paniccioli.

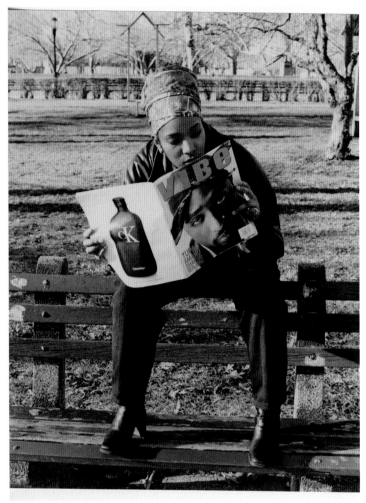

Untitled, NYC, 1996. Photo: Jamel Shabazz. OPPOSITE: June Ambrose, Misa Hylton-Brim, and Mary J. Blige during New York Fashion Week, Fall 2015.

used on the October 1995 *Vibe* cover has become iconic. The styling was inspired by the films *Pulp Fiction* (1994) and *Bonnie and Clyde* (1967). For me, styling was a way of empowering the oppressed, shifting the visual narrative of marginalized people and celebrating the radical resistance of BIPOC folks through the love of fashion. For people of color, presentation is power.

The Stylist

A stylist is a person who helps imagine, curate, and execute a creative vision through the lens of fashion. The stylist typically collaborates with a celebrity, artist, actor, model, magazine, fashion brand, recording label, film studio, talent agent, management team, marketing professionals, creative director, art director, photographer, or video director to help bring to life a desired look, presentation, or persona for the client. A stylist can also serve as a creative director. These imagineers come up with creative concepts based on fashion trends, street style, vintage film references, sociopolitical moments, the economy, archival fashion imagery from designer runway collections, famous fashion shoots, iconic celebrity portraiture, visual art, music, and popular culture. No specific skill set is required to become a stylist. All you need is love for fashion, a great sense of style, a strong work ethic, hustle, a desire to do the work, and a fierce and fearless imagination. Working well with others and good communication skills preferred! Styling is not for the faint of heart because you must bring your whole heart to the job.

The stylist's influence on hip hop culture is an important one because it aligns with the explosive impact that rap music had on the American music scene, record sales, and music charts. Stylists helped the Black community to see itself and illuminated how the world viewed Black people, encompassing culture, race, identity, diversity, equity and inclusion of Black bodies, LGBTQ representation, and social justice. With the seismic growth of rap music and hip hop, a lifestyle was born and fashion became an integral part of the expression, visibility, business, and mainstreaming

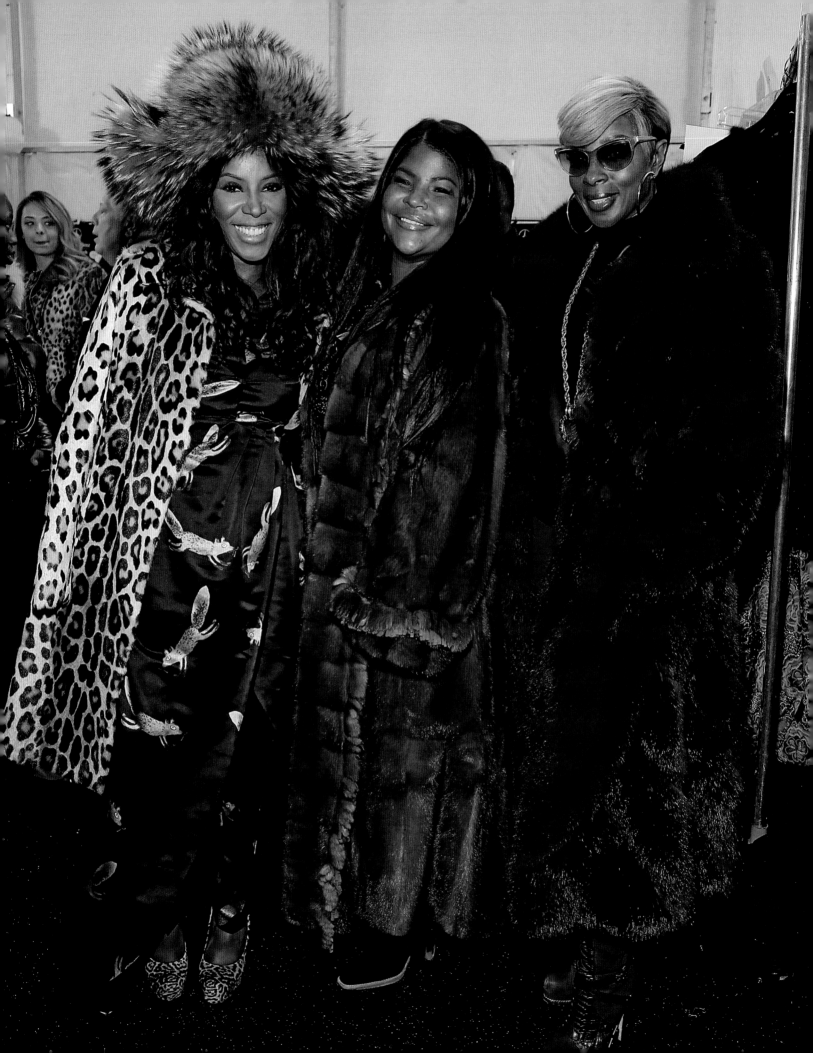

of Black culture. The stylist conspired with the music, film, television, media, and fashion industries to create the look of the Black musical art form that was born in the Bronx but would take over the world. Mic drop.

Historically, the role of the stylist was one of a hidden figure who worked behind the scenes, creating a particular look for a celebrity and crafting a persona that would appeal to the public. These roles were most notably held in the old Hollywood studio system during the 1930s, when movie stars were reimagined and even given new names by executives. The wardrobe department, along with hair and makeup teams, would create a new appearance for the actor or actress to better appeal to consumers and give them more star power. Record executive Berry Gordy brought this concept to the music industry at Motown Records during the 1960s. Gordy's incredible taste in music and his careful attention to artists' development and image helped elevate the label's talent roster with stars such as The Supremes, Marvin Gaye, Four Tops, Gladys Knight & the Pips, The Commodores, and The Jackson 5. Gordy and his colleague Suzanne de Passe were able to change the way Black musical artists were portrayed on their album covers, public relations materials, and in public appearances and performances, which would impact the way Black America saw itself and how the world viewed Black people.

You cannot talk about the visual language of hip hop without paying respect to the Black R&B and pop stars whose colorful, dramatic, and super-stylized videos preceded hip hop culture's shifting style. Michael Jackson, Prince, Whitney Houston, Tina Turner, and Sade represented Black style through their pop music videos, which would set the stage for the ultimate remix that is rap music and hip hop culture. Music videos also opened the door for a broad range of rap music and allowed female performers like Salt-N-Pepa and Queen Latifah to rock the mic with feminine themes and perspectives. They gave space to Will Smith (aka The Fresh Prince) and MC Hammer, who brought humor and choreography with a mass appeal to the genre.

From an editorial perspective, stylists were originally magazine editors who would "edit" or choose specific looks from fashion designers to show in their magazines and curate fashion stories that would influence store buyers and magazine readers on the latest trends. The editors would collaborate with photographers to create the aspirational look and feel of fashion and style for the masses. The freelance stylist emerged during the '80s with the introduction of new niche magazines that did not have budgets for full-time editors.

Ray Petri was regarded as the "original stylist." He is known for his work with the British magazine The Face. Petri is credited for Buffalo style—a mix of tailored clothing and street style fashion with Jamaican flair. In his photo shoots, he used real people who were ethnically diverse instead of professional models. This shift in creative vision was the precursor to the modern and cutting-edge fashion editorials with which we are familiar today.

The world was shifting in the '80s. Conspicuous consumption was at an all-time high: Wall Street, luxury, and opulence were in style; the crack epidemic was taking over America's inner cities; the AIDS crisis was wiping out the gay community and a generation of artists and creatives with it; disco was dying; and an innovative musical form called rap was turning up the volume in the Bronx.

Rewind: Hip Hop Fashion's Beginnings

Rap music changed the world with two turntables and a microphone. It was inspired by Jamaican sound systems, which were parties where reggae music was played by a selector or DJ who would literally talk over the music. On August 11, 1973, Cindy Campbell reimagined this experience for her birthday party at 1520 Sedgwick Avenue in the Bronx. She asked her brother Clive (aka DJ Kool Herc) to spin while his friend Coke La Rock shouted out names over the bass-heavy music. This was the moment when rap became recognizable. With it came the birth of hip hop music, culture, and lifestyle.

The four elements of hip hop—deejaying, rapping or emceeing, graffiti painting or writing, and B-boying or breakdancing—truly created the foundation for the cultural movement and its fashion aesthetics. These fundamental elements all needed

agility and mobility to create poetry in motion that was reflective of each artistic form. Many people have made the argument that styling could or should have been considered the fifth element because of its importance to the powerful presentation, performance, and presence in hip hop.

The fashion of the day and on the scene was a mix of fitted designer jeans, polo-style shirts, Members Only jackets, tracksuits, Kangol hats, sheepskin coats, Cazal glasses, and big gold jewelry (fat gold chains, name-plates, nugget rings, and bamboo earrings). Afrocentricity was very popular and many African Americans were embracing their Blackness by wearing dashikis, kufis, leather medallions, and Kente-cloth fabrics from Africa. Much of this was a response to the Anti-Apartheid Movement in South Africa, which was at its tipping point, inspiring global sanctions against the country to end the segregationist laws. The look was also inspired by West Indian culture and color-ways, hypermasculine sensibilities, and athleticism. It was young, it was cool, and it was the Black and Brown folks' response to, and remix of, the sexy disco fever fashions and the WASP-y stylings of the prep-school influence. Hip hop style was made for the streets, movement of the body, affluence, and armor against the elements. It was the competitive spirit of the rap game and the hood.

The early days of hip hop, like rap music itself, were self-actualized, and the fashion associated with the burgeoning music genre reflected that. Like the brilliant and eloquent rhymes that poured over heavy bass-driven breakbeats and lush music samples, the style was a collage of youthful energy imagined through the lens of Black and Brown folks who saw their own power, beauty, and creativity in themselves and were ready to change the world with their Pan-African-inspired ideology. They were the post–civil rights generation who wanted equality and liberation. They wanted to have a voice by any means necessary. The hip hop generation's presentation would be a style revolution like jazz and rock 'n' roll before it— rebellious, radical, and revolutionary. The style informed and emboldened by rap music would transform fashion, entrepreneurship, women's empowerment, and popular culture in its wake.

Kangol caps.

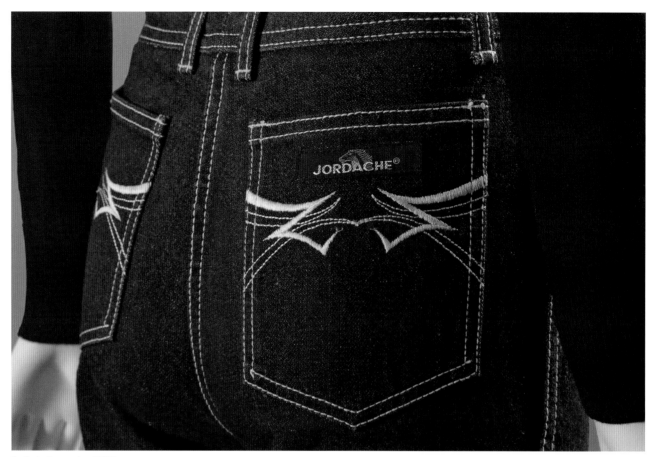

Jordache jeans, circa 1979.

The music began to flourish uptown and simultaneously disco began to die downtown. In 1979, the Sugarhill Gang released "Rapper's Delight" a fifteen-minute, feel-good record with rap layered over a sample of Chic's "Good Times" (1979), creating the first crossover moment. This was the beginning of the mainstreaming of rap. Cut to the '80s and the New School Era of hip hop led by Run-DMC, LL Cool J, Beastie Boys, and Public Enemy. They were the foundational artists who helped transition rap music from the underground to the recording charts and the airwaves, thanks in part to another revolution: the advent of MTV in 1981 and the music video. This great expansion took the bombastic sound of rappers rhyming about life, love, and lawlessness over breakbeats, a contagious cacophony of samples, and electrifying beats from the live music experience to the radio and to the televisions in people's homes nationwide— and then globally. Hip hop was crossing over, and so was its sartorial styling.

In the mid-'80s, hip hop took to the big screen and introduced the music, culture, fashion, and lifestyle to a wider audience. Hollywood took notice of the burgeoning rap music genre and quickly created seminal films that would capture the music, lifestyle, and the narrative of hip hop and urban life, including the fashion. In 1984, Orion Pictures released *Beat Street*, which was produced by Harry Belafonte and David V. Picker and directed by Stan Latham. The dramatic dance film, set in the South Bronx, follows two brothers and their friends who are all engaged in the four elements of hip hop. That same year, MGM Studios released *Breakin'*, a breakdancing-themed musical, featuring a debut performance by Ice-T. The film centered on a multiracial hip hop club called Radio-Tron, located near MacArthur Park in Los Angeles. *Breakin'* received bad critical reviews but achieved box office success. The people had spoken, and the appetite for hip hop culture and style was growing in the United States. These films showcased the fashion of hip hop from ultra-modern leather suitings in

jewel tones to colorful tracksuits, Kangol hats, shearlings and jeans, and fat gold jewelry. Hip hop's style vocabulary was building and expanding and influencing popular culture, the fashion industry, and mainstream youth culture.

Run-DMC went a step further and literally kicked down the door in 1986 with their hit single "My Adidas" from the *Raising Hell* album. The song was an homage to the beloved shell-toe sneakers favored by the hip hop community. The song, which was produced by Russell Simmons and Rick Rubin, represents the moment when fashion and hip hop became synonymous. The song led to the first-ever endorsement deal—brokered by Def Jam's Lyor Cohen—between a rap group and an athletic brand. It became the blueprint for celebrity brand partnerships, while simultaneously proving the power of rap music and fashion consumer engagement. The second single from *Raising Hell* was "Walk This Way" (1986), a cover and collaboration with the rock band Aerosmith. The music video helped propel the song to double platinum status, and it became an instant classic merging rap and rock.

The beautiful thing about *Vibe* in the early '90s was it was part of this cultural explosion and the community that redefined hip hop. The magazine participated in the commodification of rap that moved the genre from underground to pop culture. *Vibe* was not alone in this movement. There were others feeling the same vibration who understood the power of the streets but also appreciated the savoir faire of style and the finer things in life, understanding that the two could live in harmony. The message was what the late Uptown Records President Andre Harrell would dub "ghetto fabulous."[2]

Misa Hylton and Sean "Puffy" Combs

Bronx-born Andre Harrell became the arbiter of style for hip hop and eventually Black culture when he became vice president and general manager of Def Jam Recordings in the mid-'80s. Harrell, who was a former member of the rap group Dr. Jeckyll

Door knocker earrings. Shearling jacket, 1970s–1980s.

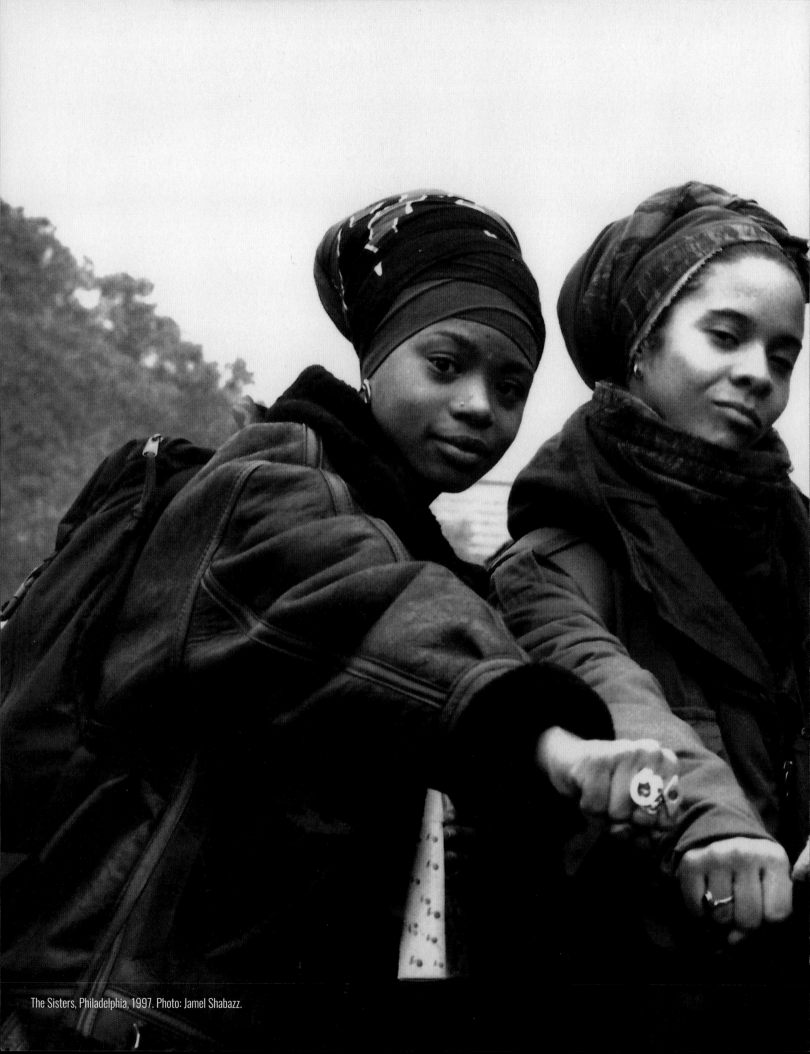

The Sisters, Philadelphia, 1997. Photo: Jamel Shabazz.

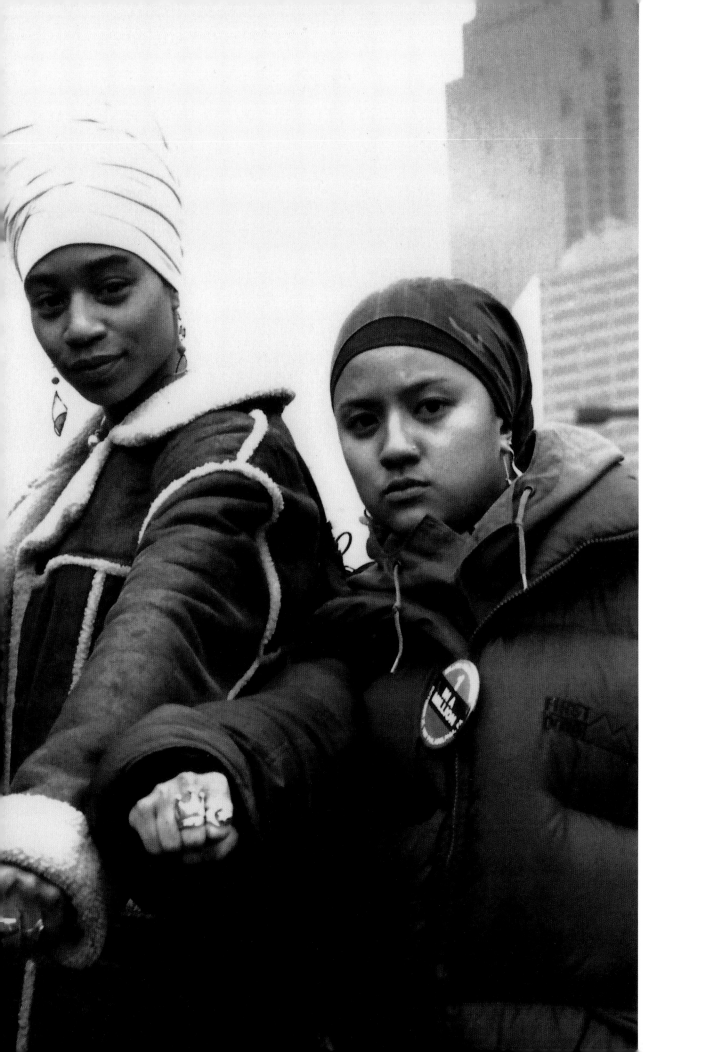

& Mr. Hyde, later formed Uptown Records in 1986. At Uptown Records, he merged the sounds of rap and R&B to create hip hop soul and New Jack Swing with artists such as Heavy D. & the Boyz, Al B. Sure!, Christopher Williams, and Guy featuring Teddy Riley. These acts created a sound that was culturally relevant and would align with the new sound of rap music. It was a clever idea because most hip hop heads love rap music but are also steeped in the Black tradition of the rhythm and blues and soul music they grew up on.[3] Harrell also had the wherewithal to understand the nuanced conversation around Black folks' love affair with love songs and the desire to shake their asses and find a groove on the dance floor.

While rap music was brewing in the Bronx and spreading to the West Coast, there was a resurrection of R&B music that was experiencing a parallel sonic explosion. It was not your parents' or grandparents' R&B. It was edgy, aggressive, and liberated music fueled by a renaissance of Black culture. Artists like Michael Jackson, Diana Ross, Prince, Whitney Houston, Stevie Wonder, Tina Turner, Luther Vandross, Teddy Pendergrass, Ashford & Simpson, New Edition, Soul II Soul, and Bobby Brown were making R&B edgy and aspirational, celebrating Black love and the Black experience. In terms of respectability politics, the new wave of R&B was more acceptable than rap, but Harrell saw an amalgamation of the two that would change the sounds and the styling of hip hop.

While Harrell was ushering in the new soundtrack of Black music, he also made a hire that would dramatically change the way hip hop dressed, presented itself, and would be perceived globally: he hired Sean "Puffy" Combs as an intern at Uptown Records. As legend has it, Combs, a native of Harlem and student at Howard University, commuted back and forth between classes in Washington, DC, and the Uptown offices in Midtown Manhattan. Allegedly, Combs discovered a box of discarded demo tapes and unearthed one submitted by Mary J. Blige—a young woman from Yonkers with a voice that was perfectly imperfect and infused with emotion, pain, and yearning. Combs convinced Harrell to let him A&R Blige's project, and the "Queen of Hip Hop Soul" was born.

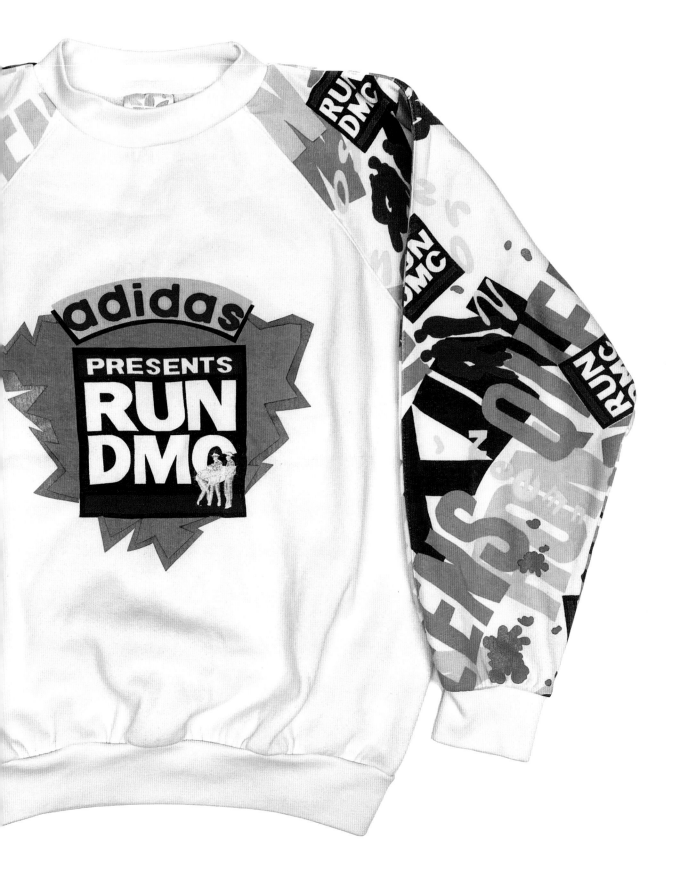

Adidas and Run-DMC sweatshirt.

Combs brought a new youthful energy to Uptown Records with the hustle of Harlem and the hip hop attitude that "the world is mine." He also brought his girlfriend Misa Hylton, a young stylist who was beautiful and super-creative. Combs and Hylton had a vision of dressing R&B singers, including Jodeci and Mary J. Blige, like rap stars with a rock 'n' roll edge. The look was fresh and exciting and pushed back on the traditional presentation of R&B singers. The men typically wore suits and dress shoes, and the women wore evening gowns and heels. Once Harrell agreed to explore this new fashion aesthetic, the look and feel of "ghetto fabulous" would become not just a trend but a new style for hip hop. Combs and Hylton's vision altered the way Black musical artists dressed and presented themselves in the early '90s. The aesthetic, attention to detail, and mix of street-inspired looks and high fashion is still relevant today. It informs the way modern luxury is presented and styled. Combs also enlisted the skills of stylists Groovey Lew, Sybil Pennix, and Mike B., who brought their imaginations, creativity, and hip hop swag to the look and feel of Uptown Records. Their style, along with Hylton's, literally changed the game for fashion and created the blueprint for future fashion stylists. It is no wonder Hylton refers to herself as "The Architect."

Hylton brought her vision, love for rap music, passion for fashion, and the cultural influences of her Black and Japanese heritage to her creative styling. Working with Mary J. Blige at Uptown Records, Hylton wanted to emphasize Blige's tomboy tendencies. Hylton took the masculine-infused hip hop flavor and then added a distinct femininity to the look. During the early '90s, hip hop style was still considered hypermasculine. Hylton saw this as an opportunity to soften the look, amping up the glam with bold hair and makeup choices—which were part of Blige's personal style—and adding tennis skirts and leather shorts to accentuate her curves and her legs. Blige was the catalyst that liberated women in hip hop to tap into their beauty while still being able to rock with the fellas.

It was, however, Hylton's collaboration with Kimberly Jones (aka Lil' Kim) that would change the way women in hip hop dress forever. Lil' Kim was a member of The Notorious B.I.G.'s protégé group Junior M.A.F.I.A. Lil' Kim was an anomaly at the time because, like predecessors—including MC Sha-Rock, Roxanne Shanté, MC Lyte, and Salt-N-Pepa—she could spit rhymes as hard as her male counterparts. The difference was Lil' Kim infused a distinctly feminist perspective into her lyrics that stated she was as good as a man, but she was also a strong woman with a Black body and sexual needs and desires. Lil' Kim is credited with emancipating the Black female form in hip hop to a place of power. She proved that if her body was going to be objectified, she would be the one doing so. Hylton was the mastermind behind bringing Lil' Kim's "Original Queen Bee" look to life. Lil' Kim wore lingerie, sheer lace dresses, and luxe fur coats with panties. The look was provocative, sexualized, and empowering.

Crush on You

Lil' Kim's song "Crush on You" (1996) represents an iconic moment in hip hop. The second single from her debut album *Hard Core* featured Lil' Cease from Junior M.A.F.I.A. and The Notorious B.I.G. on the hook. The music video was a turning point for styling in hip hop thanks to the imagination of Hylton and her muse Lil' Kim. The concept for the video was inspired by the Emerald City scene in *The Wiz* (1978), directed by Sidney Lumet for Motown Films. The music video for "Crush on You," which was directed by Lance "Un" Rivera, featured changing-color floors like the classic fashion scene in *The Wiz*. Hylton and Lil' Kim decided on outfits and corresponding wigs that would match the colors: red, yellow, green, and blue. The video also features a cast of backup dancers, Lil' Cease, and cameos from the rapper Luke Skyywalker and R&B princess Aaliyah. In the video, Lil' Kim is powerful in a red bra and fur coat with a matching asymmetrical bobbed wig. She is playful in a yellow cropped T-shirt and matching curly wig. She is decadent in a green sheer top and matching pixie wig. She is commanding in a blue jumper and matching wig. It was the matching wigs and the makeup that revolutionized how Black women defined their glamour, breaking down patriarchal and often sexist beauty tropes.

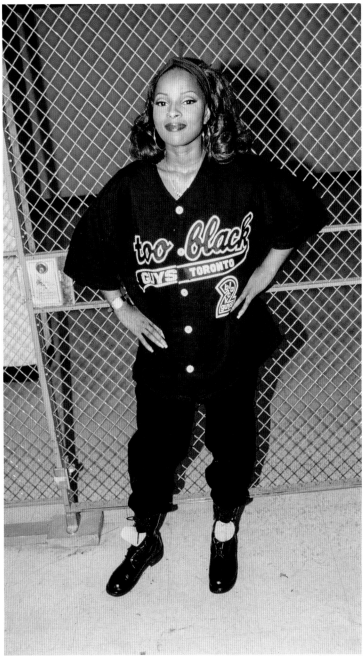

Tracy Daniels on the set of the film New Jack City, 1990.
Mary J. Blige, 1989. Photo: Ernie Paniccioli.

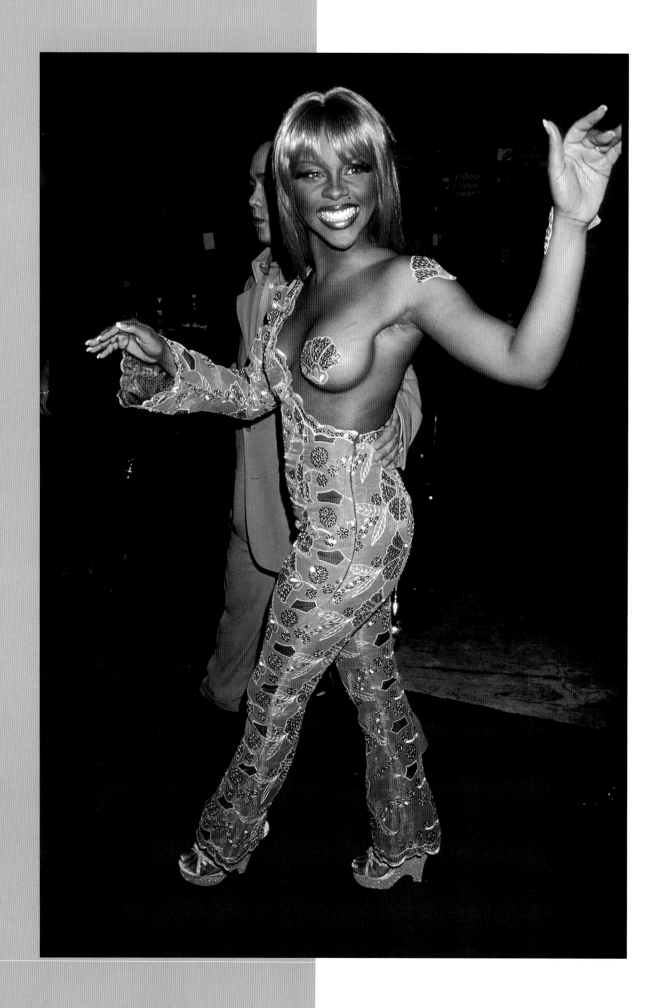

The "Crush on You" video is a watershed moment in hip hop styling history. It knocked down the fourth wall in music videos and styling overall, and created the space for June Ambrose to conceive of the iconic Afrofuturist styling of Missy Elliott in "The Rain (Supa Dupa Fly)" (1997). It allowed OutKast's André 3000 and Big Boi to explore and expand the boundaries of men's fashion. "Crush on You" allowed video director Hype Williams to reimagine how hip hop could be taken from the hood to a technicolor fantasy world of Black futurism and possibilities in his music videos.

Because of the groundbreaking work of so many incredible stylists and imagineers, hip hop was able to crash through the exclusive doors and glass ceilings of high fashion, allowing a new generation of Black stylists to drive the conversation between music and fashion. *Vibe* gave space for me to create fashion spreads that spoke truth to power, combining street style, urban sportswear, athletic wear, and high fashion, and to remix the narrative. Now, Kanye West, Cardi B., Megan Thee Stallion, A$AP Rocky, and so many other rap stars are amplifying style and fashion globally through the help of social media and a new crew of stylists like Law Roach, Jason Bolden, Kollin Carter, Jason Rembert, Carlos Nazario, Wayman and Micah, and so many more. Indeed, it is a new day. To Sean Combs's point, cultural impact has been made and the possibilities are infinite thanks in part to the stylists who changed our perspective.

Notes
[1] "Oprah Talks to Sean Combs." *O, the Oprah Magazine*, November 2006, https://www.oprah.com/omagazine/Oprah-Interviews-Sean-Combs-P-Diddy -Puff-Daddy.
[2] Danyel Smith, "Ghetto-Fabulous," *New Yorker*, April 29, 1996, 50.
[3] Jon Caramanica, "Andre Harrell, Executive Who Bridged Hip-Hop and R&B, Dies at 59," *New York Times*, May 9, 2020, https://www.nytimes.com /2020/05/09/arts/music/andre-harrell-dead.html.

Lil' Kim arriving at the 1999 MTV Video Music Awards in New York City.

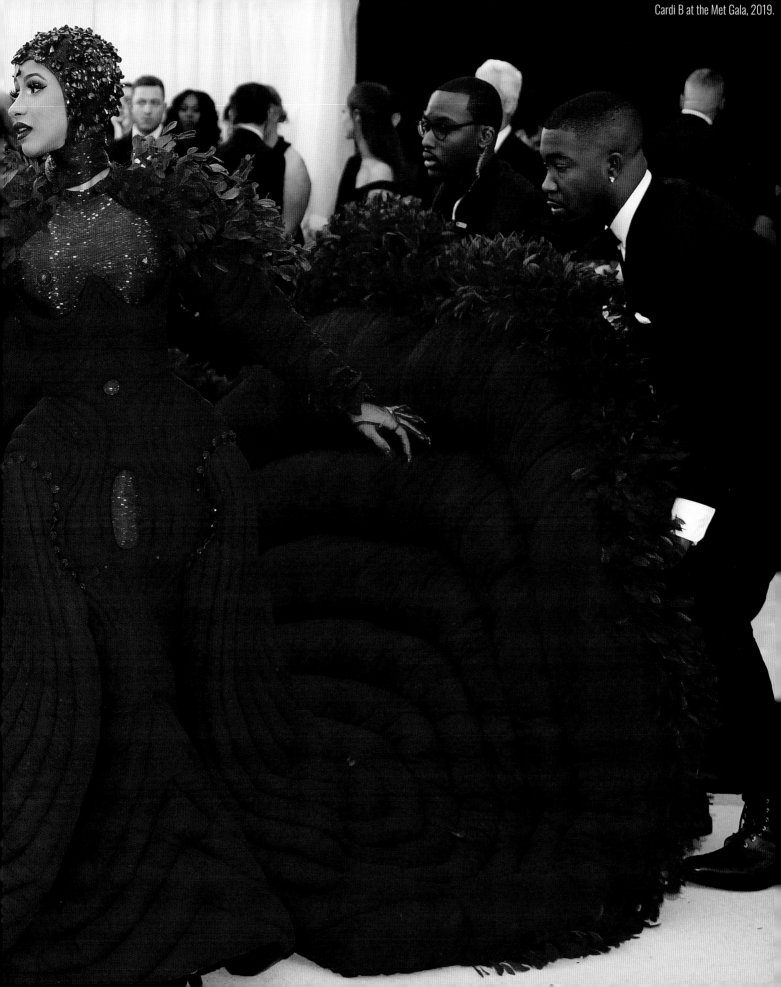

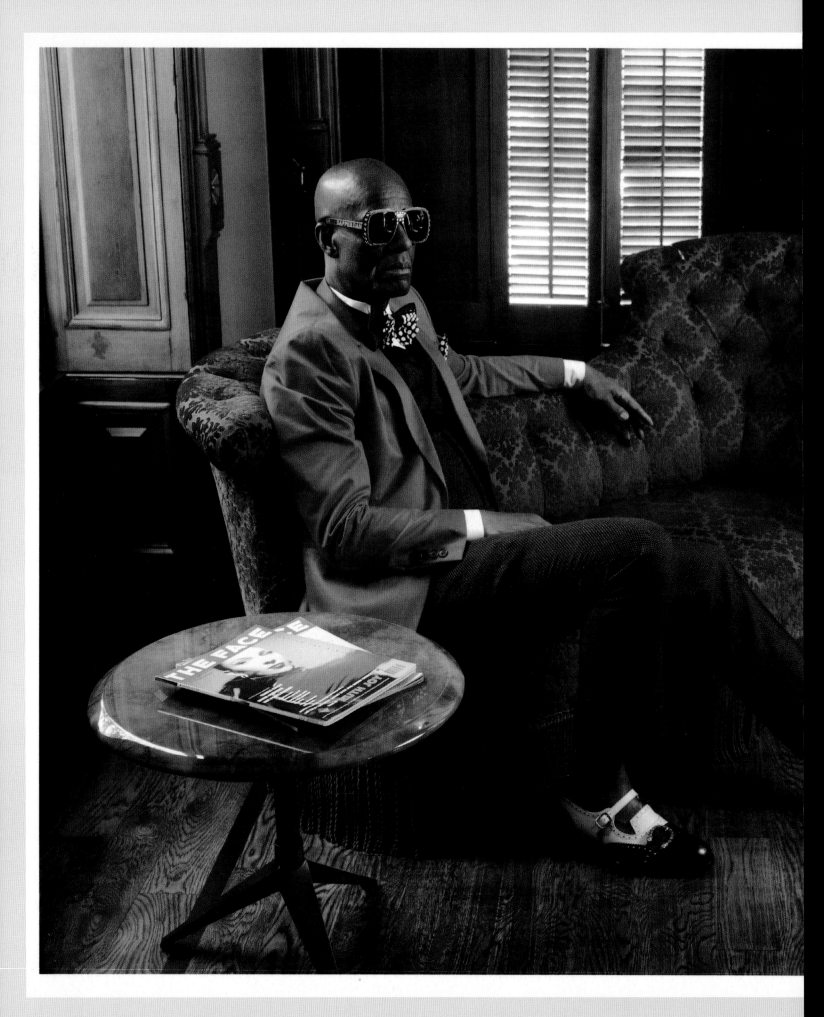

DANIEL DAY: The Original
by Elizabeth Way

It is difficult to overstate how influential Daniel Robert Day has been on fashion—not only hip hop fashion, which in itself has been enormously influential in shaping twenty-first-century fashion around the world, but also on fashion full stop. The completely self-taught designer, who is better known as Dapper Dan, hails from Harlem and defines his work thus: "I do not dictate fashion. I translate culture."

The idea of culture and individuality is key for Day. Long before he opened his legendary atelier in 1982, he realized the power that fashion carried for transformation, altering how people saw you—but ultimately, the best fashion is an expression of the self. Day prides himself on the care he takes with his customers. They may have been viewed as criminals and disrespected in stores on Fifth Avenue during the 1980s, but he greeted each of them as they entered his shop and started a conversation. "I find out how they feel about themselves," said Day.

From his deeply intellectual point of view, Day dressed his customers as the best version of themselves, creating the image they wanted to project. When rappers such as Eric B. and Rakim or the Jungle Brothers came in, he considered their music and their personalities and designed accordingly. An attentive historian, Day knew, like the jazz musicians and rock artists before them, rappers "need their own look for their own music."

Day's design style is rooted in the glamour of Harlem. His earliest forays into fashion were selling furs and leather goods—the more exotic, the better—made of alligator, crocodile, and lizard. "The key to luxury fashion in Harlem at that time was what would inspire admiration," said Day.

The story of one of Day's clients, a gangster with a Louis Vuitton pouch, sparking the transformative idea of Dapper Dan's luxury logo designs is now hip hop fashion legend. What is

Dapper Dan in his Harlem home, 2019. Photo: Jamel Shabazz.

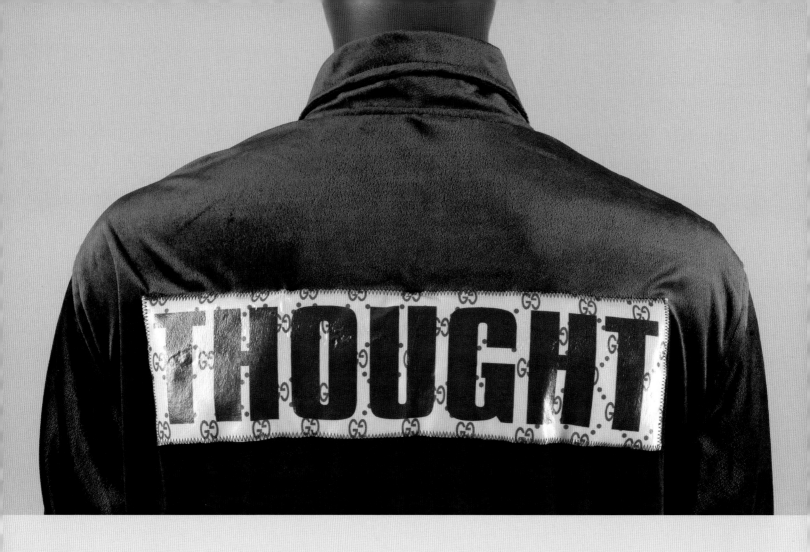

less discussed is the influence of Day's religious scholarship and his recognition of the power of symbols in his designs. He knew how to translate this concept into fashion and introduced European labels to his community, from Louis Vuitton to Gucci and Fendi—"MCM was huge back then"—expanding the aspirational worldview of Black and Brown people on the come up.

The story of Mike Tyson's inadvertent exposure of Day's atelier is also folklore by now, but Day did not stop designing after the repeated raids, prompted by the European brands he incorporated into his work, ravaged his business. He spent two decades serving his client base in Black city centers from Chicago to Atlanta—those in the know still wanted Dapper Dan. In 2017, Day partnered with Gucci and reemerged onto a fashion scene that he had shaped significantly. Alessandro Michele, Gucci's creative director, told him what was evident from the runways: "All the designers had Dapper Dan stuff on their mood board." Day's

relevance has only increased as hip hop and Black culture has expanded its influence on American and international culture. He notes that his blueprint is still to create garments that reflect how his customers feel about themselves. He asserts that death for a designer is self-identification: "As a designer, you are entitled to be all the greatness you want, but if you're not connecting to that river of fashion that keeps moving, then you'll drown where you are."

In considering the traditional fashion gatekeepers' enthusiasm for hip hop style, Day references one of his favorite authors, Flannery O'Connor, and her 1962 short story "Everything That Rises Must Converge." "To me, it was inevitable," said Day. He cites Virgil Abloh as a groundbreaking designer who ascended into European luxury design, but high fashion's embrace of Abloh evolved from a familiarity with the designs of those before him, including Day:

If people study fashion, they need to study what Virgil did and what I did. It's two different staircases that came together, eventually … I came up a Black staircase. Virgil came up a white staircase. He couldn't have come up that white staircase if there wasn't first a Black staircase that influenced the white staircase. It's amazing that he was able to do that without losing that identity from which he came.

In 2022, on the verge of hip hop's fiftieth year, Day knows what he has always known: fashion and hip hop are two sides of the same coin that forms a powerful nucleus of cultural production. Hip hop has exploded over the decades, drawing interest from all corners, but he believes that you cannot study hip hop culture without studying hip hop fashion. Dapper Dan is a cornerstone of that history.

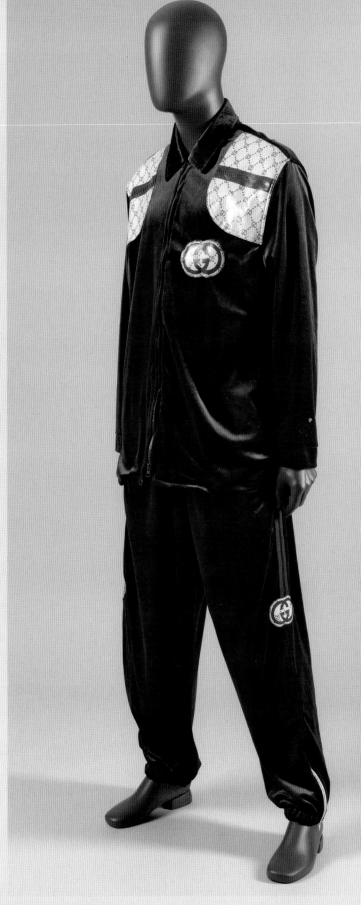

Dapper Dan for the 2006 VH1 Hip Hop Honors.

81

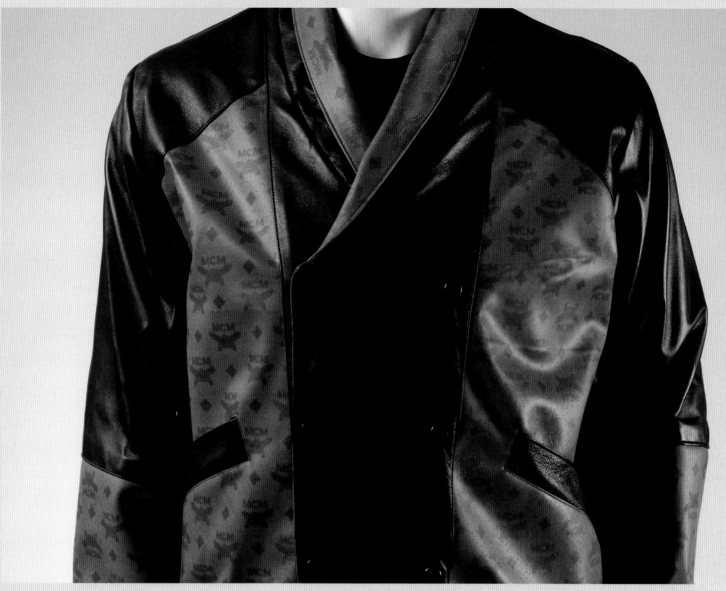

Dapper Dan of Harlem jacket, 1987.

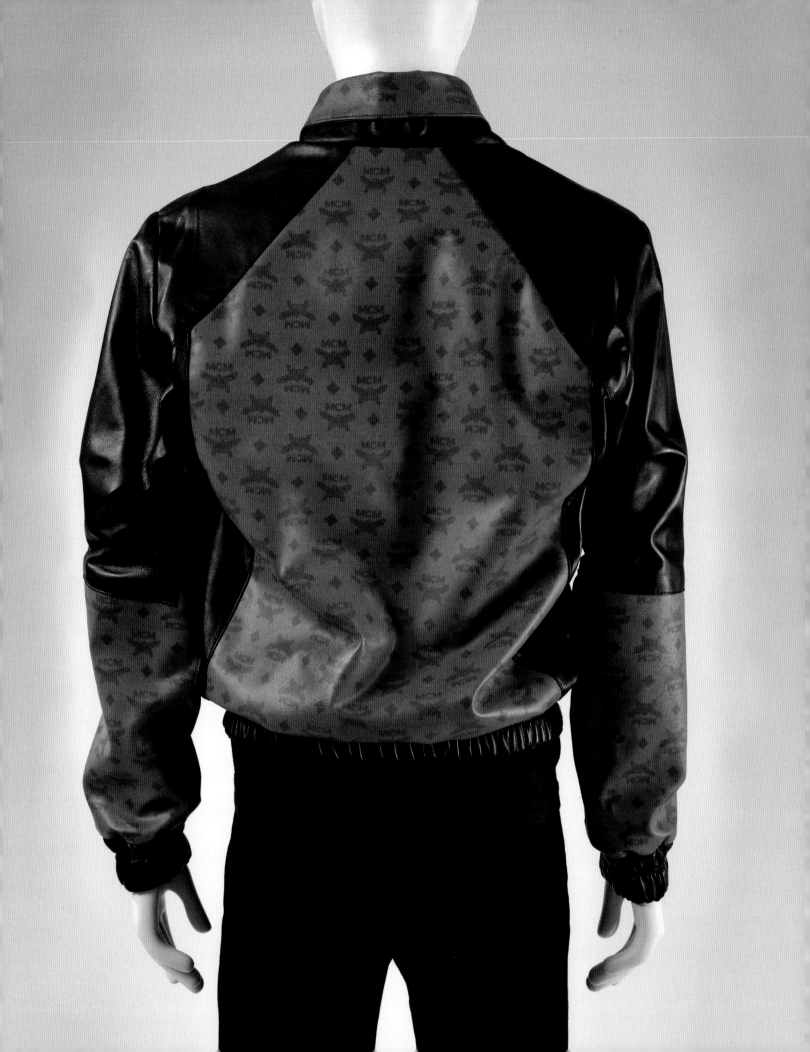

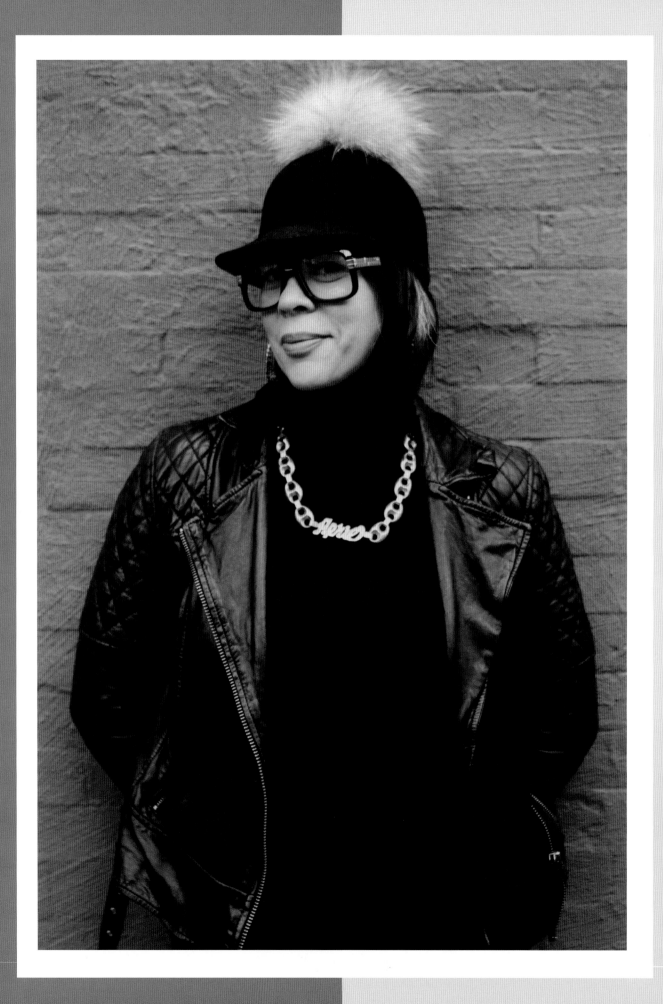

APRIL WALKER, Fashion Royalty
by Elizabeth Way

When April Walker and her team attended their first MAGIC fashion trade show in Las Vegas—one of the most important places for design brands to connect with retailers—the organizers did not know what to do with her. During the early 1990s, they had no understanding about what would become the "urban" fashion or streetwear category. They placed Walker Wear, Karl Kani, and Cross Colours in a conference room away from the main floor and its vital foot traffic, which necessitated Walker get creative. Walker and her team designed the room to look like a jail cell and invited retailers to "Come serve your sentence." With hip hop as her driving force, Walker created looks that her community wanted. "I saw something others couldn't see. There was a demand and we weren't being served, and I wanted to see *us* in the stores, but it wasn't there yet," said Walker. After she received more than two million dollars in orders that year, MAGIC gave her a spot on the main floor the next year.[1]

Founding Walker Wear between 1989 and 1990, April Walker was a harbinger of the most important development in fashion in the late twentieth century. It was a shift that has come into full effect in the twenty-first. Streetwear was fueled by hip hop, but streetwear is a meaningless term at this point because what *isn't* streetwear? The Council of Fashion Designers of America calls Walker "hip hop royalty."[2] But she is *fashion* royalty.

A member of the hip hop generation, the Brooklyn native remembers the first time she heard Sugarhill Gang on the radio. She had been listening to underground rap at parks and parties since the 1970s, but at that moment, she knew that hip hop had arrived. "I felt like it was me on the radio," said Walker.[3]

After studying business and communications in college, Walker knew she wanted to work for herself, but it was Dapper Dan who inspired her to pursue fashion. "I remember the day I walked into Dapper Dan's and I had this epiphany—this ah-ha! moment—there are people that look like me, that are my lifestyle, that are doing this? I want in," recalled Walker.[4] She opened Fashion in Effect in 1987, designing custom clothes, from tuxedos and ball gowns to denim. She listened to the adjustments her clients requested: deeper pockets, a lower crotch, or the perfect oversized silhouette to work with Timberland boots.[5] The popularity of her contrast-stitched, bull denim "rough and rugged" suit, worn by Run-DMC and comedians on *Def Comedy Jam*, led Jam Master Jay to encourage Walker to start a ready-to-wear line. Although Walker Wear could not compete in terms of money or advertising with Tommy Hilfiger or Ralph Lauren, it was authentic and nimble. "What we did know was the people, the places, the things because we were part of that culture … We could turn things around faster, we could deliver faster. We knew what people wanted because we were those people," said Walker.[6] Walker Wear hit a cord in the hip hop community. It has been worn by MC Lyte, Biggie Smalls, Tupac Shakur, LL Cool J, Queen Latifah, Naughty by Nature, Wu-Tang Clan, and many other artists who set the trends in the culture.

Establishing her brand as a mainstream fashion company was not easy. Just like her first MAGIC show, Walker found creative ways throughout her career to overcome the challenges of not only creating one of the first hip hop streetwear brands, but navigating both the fashion industry and the world of hip hop as a woman of color. She got the idea of cold-calling stores to request Walker Wear from witnessing the practice at the music labels, where she styled artists. She offered her designs to stores on consignment and sent her friends in to buy them to build enthusiasm for the brand. She let the clothes stand front and center. For many years, no one knew that April Walker—the only woman designing streetwear at that time—was the creative power behind Walker Wear.

Fifty years of hip hop has left an indelible mark, not only on music and fashion, but on global culture. Yet, the position of the original Black and Brown streetwear designers has consistently been in question in the fashion canon. Walker notes the difficulty in getting early press because the fashion industry did not respect hip hop or "urban" fashion:

April Walker, Brooklyn, 2014. Photo: Jamel Shabazz.

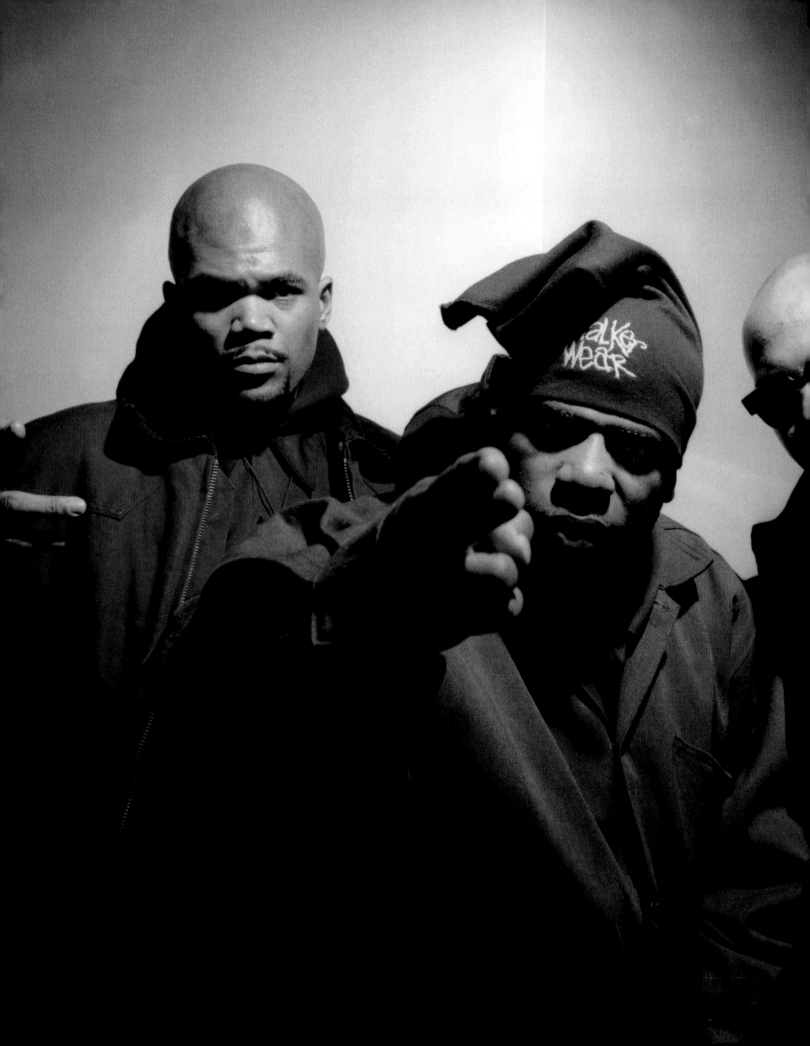

The only thing worse than racism in this industry is sexism. Had I been worried about the fashion industry—needing the fashion industry to validate my dopeness—I would be out of business. I didn't come in this for them. I came in this to serve a tribe, and to do something that wasn't there. That vision really helped me to stay in the game.[7]

Walker Wear changed fashion, and references to it, which are uncredited, are seen in every level of fashion today. Walker continues to draw in loyal customers, especially in the hip hop community because the brand is authentic and the people feel that.

Notes
[1] April Walker, interview with author, October 4, 2021.
[2] Karyl J. Truesdale, "Making My Mark: April Walker of Walker Wear," *CFDA*, October 8, 2020, https://cfda.com/news/making-my-mark-april-walker-of -walker-wear.
[3] Walker interview.
[4] Walker interview.
[5] Truesdale, "Making My Mark."
[6] Walker interview.
[7] Walker interview.

Run-DMC, 1993.

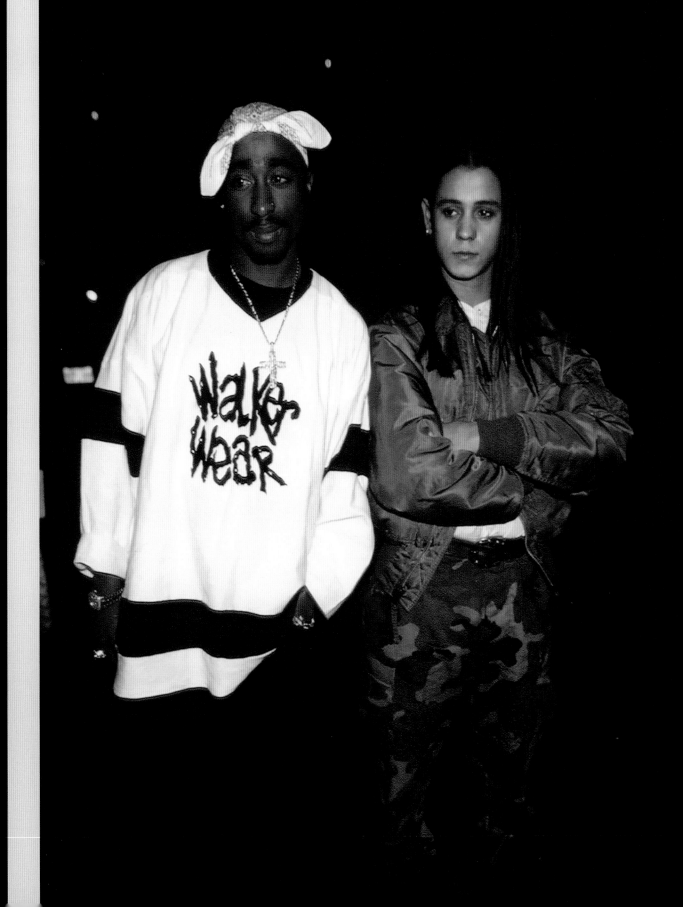

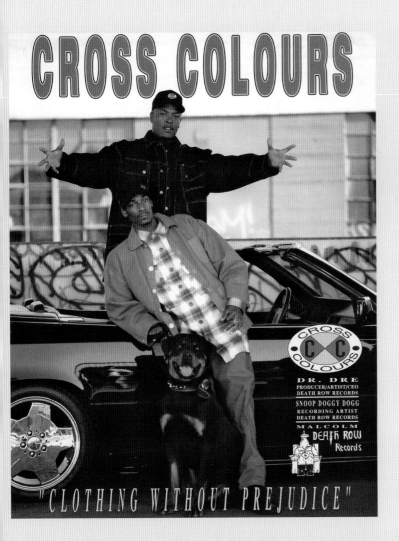

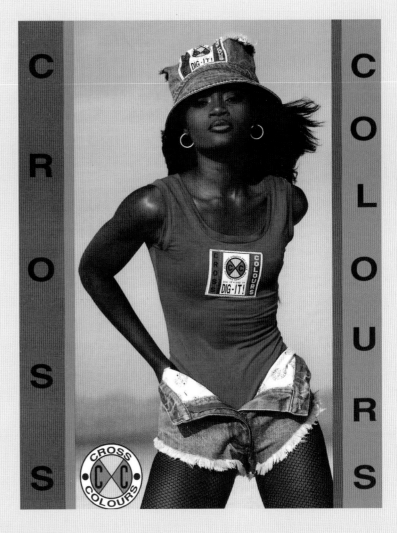

WEST COAST: Cross Colours & Karl Kani by Elena Romero

Although hip hop started on the East Coast, it was the West Coast that put hip hop style on the map. We have Cross Colours and designer Karl Kani to thank for that. Carl Jones, Cross Colours cofounder with TJ Walker, made a name for himself in the surf business with a beach streetwear brand that he launched in the mid-'80s called Surf Fetish. Although he did not know it at the time, a conversation about African prints would plant the seed for his next apparel line:

A fabric guy came to me and showed me these African prints from Senegal. And I'm like, 'what am I going to do with these?'...

I started thinking about African Americans. There are maybe ten to fifteen prints done in Senegal. I thought about it. How can I make this more commercial where it's not a uniform? Something that represents Black America and make it commercial and that everybody could wear. I didn't know where to go with it, how to take it, or how to style it. It was just an evolution.[1]

According to Jones, who was good friends with buyers from the national Merry-Go-Round clothing retailers at the time, "They schooled me about retail and the urban business." Those experiences, along

OPPOSITE: Tupac Shakur (left), 1994. Cross Colours advertisements. Photos: Michael Segal.

89

with a trip to New York to visit Spike Lee's Spike's Joint, the director's retail outlet, helped spark the launch of Cross Colours in 1989. "We spelled it the British way, so it's not related to the movie *Colors*. We didn't want it to appear gang-related so that's how the name came about."

The brand helped establish a fashion market around Black youth and used its baggy and brightly colored apparel to broadcast political and social messages. Cross Colours promoted anti-gang violence, unity, and Black pride:

> We changed the whole spec of the young men's fashion industry … Basically, our [size] medium was a large, and our large was an extra-large, and so on. Our pants were the same way. Our [size] 32 was like a 34 or 36 spec, but not the waist. The waist was fitted, but the body was a 36.

Merry-Go-Round became its first retail vendor with a $200,000 order. Other specialty retailers such as Edison Bros. followed. "We had 100 percent sell-throughs," said Jones.[2] The brand became an instant success as a result of strategic product placement on celebrities, in music videos, and on TV shows like *The Fresh Prince of Bel-Air* and *The Arsenio Hall Show*:

> It had not been done before. We sort of created that concept via taking the clothes to *Fresh Prince* and, after seeing the results, that makes sense. So, let's call up every stylist that we know that is doing something with a TV show and is African American oriented, and every record executive we know that is in the rap business, and let them know we are giving away free clothes.

Cross Colours, through its Threadz 4 Life corporate umbrella, brought the designer Karl Kani into its company. "We set up another division that had the same interest in mind and same distribution but related to another customer. It worked with Karl. His look was a little more street, hardcore than ours," said Jones. Karl Kani, who had been operating his business for two years, met Cross Colours right before Martin Luther King Day in

1991 and a deal was struck shortly thereafter. Kani, considered the godfather of hip hop fashion, was part of Cross Colours for about three years before making a deal with Skechers.

Kani was born Carl Williams in Costa Rica and raised in Panama until the age of three. He called Brooklyn home before moving to California to grow his apparel company. Kani credits his father for putting him onto tailor-made clothes, but it was deejaying that actually got Kani his early start in the fashion business:

> Being that I was more behind-the-scenes and hip hop was really exploding at the time, I wanted to be a part of the culture in a big way … My father always had a sense of style; it kind of gave me the idea. I can start making clothes for some of the emcees out there and be more in the forefront and start putting out some of these styles I had in my mind.[3]

One day, Karl asked his dad if he could get an outfit made at his tailor:

> Back then, we were wearing a lot of Lee jeans and camper shirts … I took my Lee suit and bought five yards of linen and told the tailor to make me this jean suit out of linen. When I wore that, everybody was like 'Man, that was so fresh! Where did you get it from?' I was getting so much attention from it because we always tried to out-compete each other and buy stuff no one else had to show off.[4]

Kani started out by making clothes for himself and by age 16, he began making fashion for friends and people in the neighborhood. He sold clothes under the name "Seasons" and later changed his label (and his fashion persona) to Karl with a "K" and Kani, as in the question, "Can I?" Kani said:

> The 'Can I?' was a question I always used to ask myself: Can I really make this happen? I was just writing the words 'Can I?' on this piece of paper. I kept writing it over and over and over and over. I just started writing 'Can I?' I wrote "Carl." For some strange reason, I said Karl Kani.[5] I went to a couple of friends and asked how they felt about the name.

Cross Colours beanie, 2016.

Everybody said the name sounds kind of cool—the same sounds kind of slick. So, after a decent response from everybody, I said, 'You know what? That's my name from now on. That's what you are going to call me.

He wondered if he could build a fashion brand and make it global. "I didn't know the answer to that, but I knew if I quote myself, 'Can I?,' I have to have an answer to that question every day," said Kani. He moved his business from Brooklyn to California in 1989 and set up a 1,000-square-foot shop at 4312 Crenshaw Boulevard, Los Angeles, with his right-hand man, AZ. "We didn't have enough money to get our own apartment, so we ended up living in the store," recalled Kani. What started as a business sold out of the trunk of his car and at nightclubs would expand to stores like Simon's in Brooklyn, Up Against the Wall in Washington, DC, and the Village Hut and Love People in Manhattan. "When we used to go to the MAGIC trade show, there were no Black people there, no urban people there. We opened the door for every urban company out there—FUBU, Phat Farm, Enyce, you name them. A lot of those people all used to work for me at some point and branched off and started working at these companies," explained Kani.[6]

Kani attributes several things, including product, well-placed ads, and a strong celebrity following for his success. Everybody cool wore Kani, including Sean "Puffy" Combs, the late Tupac Shakur, Biggie Smalls (who wore Kani jeans the day he died), and the late Aaliyah. Biggie paid homage to Kani on his *Ready to Die* album in his track "One More Chance" (1994), while Aaliyah wore Kani on her first album cover, *Age Ain't Nothing but a Number* (1994).

Kani placed ads with a 1-800-221-Kani phone number in *Right On!* magazine and *The Source* to promote his brand and got excellent results. "That's how we started getting into stores. Kids started calling up from all over saying, 'Man, those jeans are hot. Where can I get them?'" said Kani. Tupac Shakur was among the first hip hop celebrities to be featured in Kani ads. According to Kani, Shakur did the ads for free. "He said 'Yo, I ain't charging you. You're Black. Yo, you want to do this, let's make it

happen. I ain't charging my people for nothing,'" recalled Kani.[7] Shakur came up with the idea for the ad and decided he wanted to sit on top of a basketball rim. The ad, which features Shakur shirtless and wearing a black bandana, was shot in New York and styled by June Ambrose. The rest you can say is history.

Notes
1 Carl Jones, interview with author, August 4, 2011.
2 Jones interview.
3 Karl Kani, interview with author, March 17, 2010.
4 Kani interview.
5 Kani interview.
6 "Karl Kani on 2Pac Not Charging Him for Ad, Biggie Wearing Kani Jeans When He Died." Youtube video, July 1, 2017, https://youtu.be /NHk5Mm0sxjA.
7 "Karl Kani on 2Pac Not Charging Him."

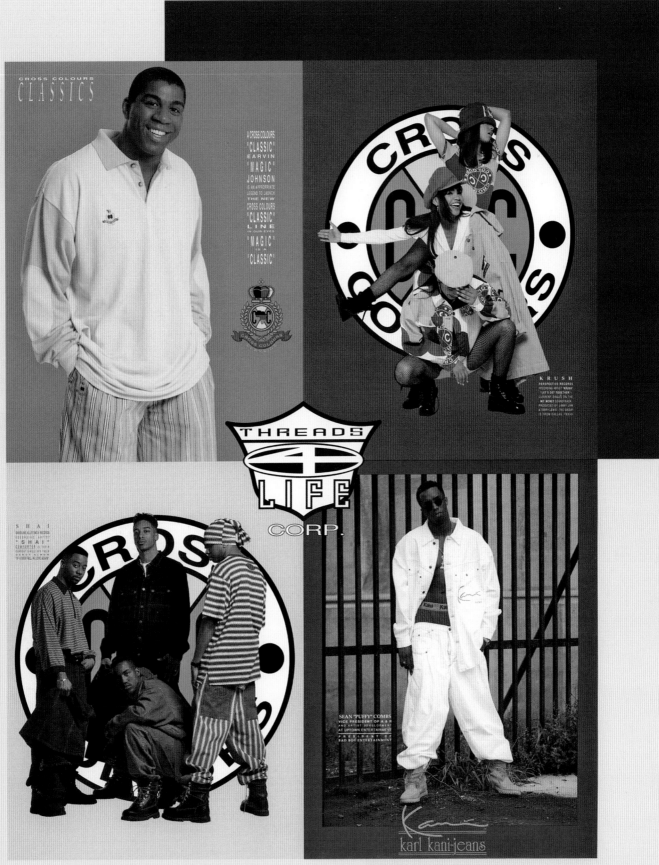

Cross Colours advertisement. Photos: Michael Segal.

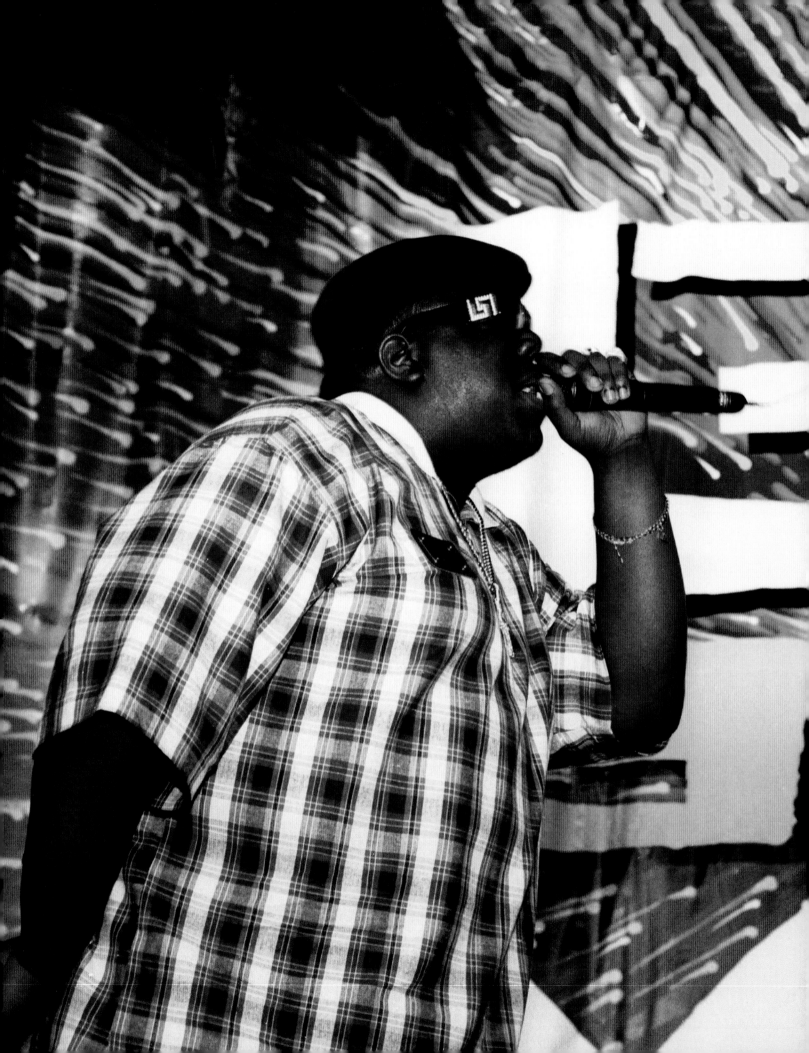

NAME DROPPIN' THE STORYTELLING OF HIP HOP THROUGH FASHION LYRICS

The Notorious B.I.G., 1995.

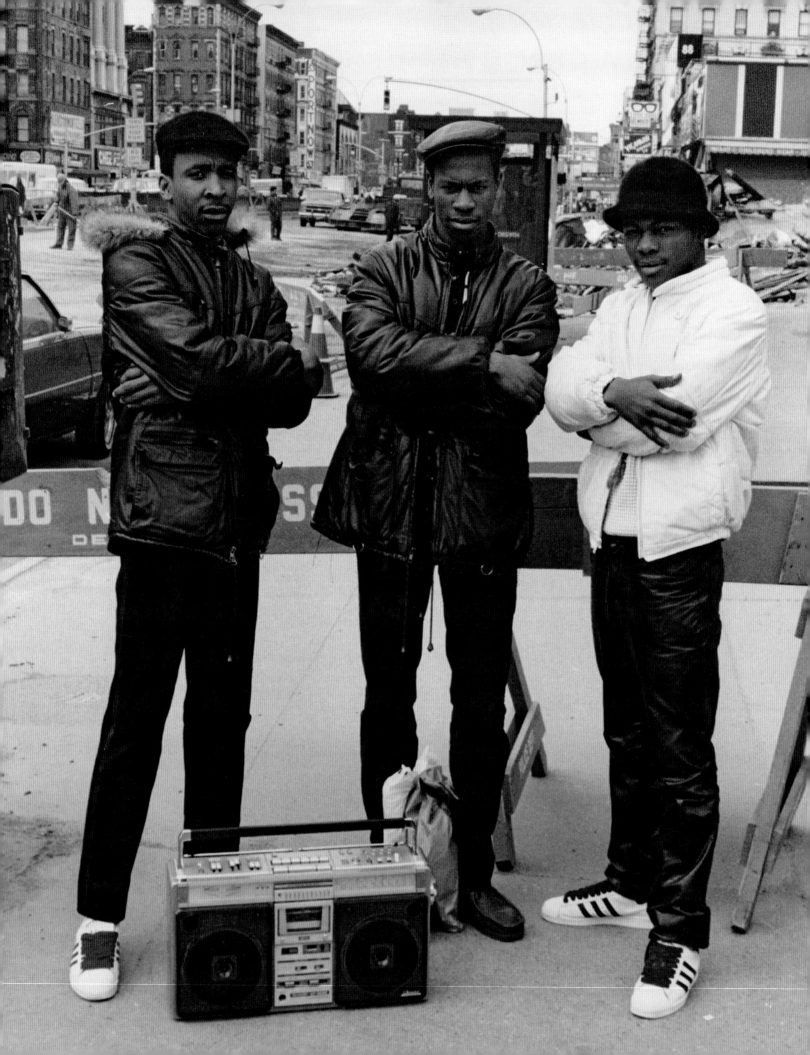

Fashion has always been considered an unofficial element of hip hop culture. Style has been a part of hip hop's DNA as an outlet of expression, status, and identity. "Fashion has always been an important part of the hip hop identity because fashion has always been an important part of Black identity in America," filmmaker Sacha Jenkins told the *Los Angeles Times*.[1] Jenkins, who directed the hip hop fashion documentary *Fresh Dressed* (2015), believes "… when you don't have much ownership over where you can land in society, your financial situation, your educational situation, the one thing you can control is the way you look."[2]

Early hip hop was considered "feel good" rap. It maintained an upbeat rhythm that kept parties jamming. Fashion references soon began appearing in raps, providing social and cultural context.[3] The Get Fresh Crew were among the earliest rap groups to infuse apparel brands in their lyrics. The group, which was comprised of Doug E. Fresh, DJs Chill Will and Barry B., and MC Ricky D (later known as Slick Rick), created hip hop classics including "La Di Da Di" (1985), one of the most sampled songs in history.[4] In the song, the group references a series of brands, including Polo cologne—a nod to designer Ralph Lauren and the popular fragrance of the time—and Bally shoes and Kangol hats.

Dr. Don C. Sawyer III, vice president of equity, inclusion, and leadership development and associate professor of sociology at Quinnipiac University, grew up in the Lincoln Projects in Harlem and recalls The Get Fresh Crew and the statement their fashion lyrics made during the '80s. He notes the significant role fashion has played in rap lyrics:

Name droppin' happened to show that you are on a different level than someone else … We would go to 125th Street and go to the African brothers with the bootleg joints to just have it. The fashion meant something. We had to adorn ourselves. We found respect. Barry B of The Get Fresh Crew lived over there [Harlem]. I don't remember the brand name of what they were wearing—the tracksuits—but everybody wanted that fashion.[5]

While it was B-boys and B-girls that rocked Kangol hats during the early '80s, it would be a Queens teenage rapper by the name of LL Cool J who would become synonymous with the headwear brand. Cool J wore the red Kangol Bermuda Casual on the cover of his 1985 debut album, *Radio*, and brought his signature style to the masses in a variety of colors including red, black, and white.[6] In Cool J's song "I'm Bad" (1987), he defines himself by his look, which included an ensemble of a sweat suit and sneakers, accessorized with a black Kangol and gold chain.

Hip hop fashion produced strong reactions in the culture, both positive and negative. In 1985, Gerald Deas, who went by the rap name Dr. Deas, dropped the anti-sneaker song "Felon Sneakers." The song was meant to be a direct message to the fellas who wore sneakers and a warning about the trouble associated with them (felony crimes, prison, and death). Queens rap trio Run-DMC created a rebuttal to the diss track called "My Adidas" (1986), the first single off their third album *Raising Hell*. "My Adidas" pays homage to the striped "Superstar" shell-toe Adidas sneaker. It was meant to counter or "flip" the message of "Felon Sneakers." The Adidas Superstar sneaker would become part of hip hop culture as Run-DMC adopted the shoe into their style, wearing them without laces and with the tongue pushed out. "My Adidas" would lead to the first million-dollar endorsement deal between a musical act and an athletic company.[7] The deal was a result of a meeting between Adidas executive Angelo Anastasio and the group's road manager Lyor Cohen at the Run-DMC Madison Square Garden concert on July 19, 1986.[8] During the performance, Run-DMC asked 40,000 fans to hold their Adidas shoes in the air. The rest of the story is history. The deal between Run-DMC and Adidas is credited with jump-starting future endorsement deals between hip hop and brands of all kinds.[9]

Standing on the Square, Lower East Side, Manhattan, 1982. Photo: Jamel Shabazz.

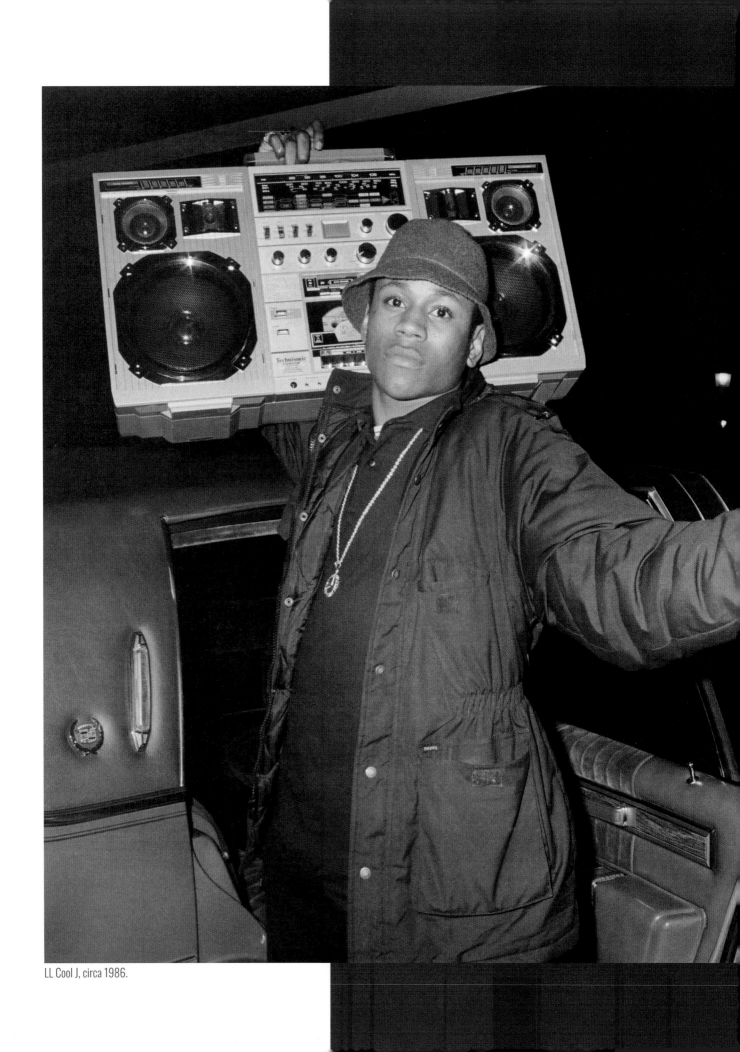

LL Cool J, circa 1986.

Kangol cap, 2022.

According to Sawyer, Run-DMC had already made powerful fashion statements prior to their 1986 cult classic with their song "Rock Box" (1984), which mentions Calvin Klein and Lee jeans:

> Listening to the song and single, it was telling us what we were supposed to wear … We were seeing people around the block wearing what they were wearing on 125th Street and Lenox. Later, it was known as hip hop fashion. It was the first time we were hearing a fashion line or direct lyric on what was supposed to be fresh at that moment in time.[10]

Sawyer turns to the theory of interest convergence by Derrick Bell, law professor and godfather of the study of critical race theory, to explain the convergence of white and Black fashion interests:

> Before we were kept out—but the benefit was that [high-end fashion] people saw that, by having us there, we give their fashion edge and street credibility. We are the producers of the culture. We made it and, in the spaces, they get the endorsement just by our presence. How interests converge and designers benefit from our presence is that we [Black people] determine what's cool.[11]

Hip hop artists did not only rap about what they wore, they also paid tribute to the objects of their affection. Grandmaster Flash, who is known for the 1982 classic rap song "The Message," was among the early rappers to pay homage to the fly girl, her body, and all her favorite jeans in "Them Jeans" (1987). Popular denim brands, such as Jordache, Sasson, Calvin Klein, Gloria Vanderbilt, Wrangler, Levi's, Paisley, Ju Ju, Jag, Lee, Alessio, and Guess, are described by the admirer who is fixed on the denim labels and on the girl. Three years later, LL Cool J celebrated girls from around the way with his song "Around the Way Girl" (1990). He eloquently described their look—from the bamboo earrings to the designer handbag.

Rap lyrics told fans what was cool and started fashion trends. A 16-year-old named Kwamé Holland, who went by the rap name Kwamé the Boy Genius, set polka dots in motion as a hip hop fashion trend when he dropped his album *Kwamé the Boy Genius: Featuring a New Beginning* (1989). It featured the single "The Rhythm." The song's accompanying music video presented Kwamé in a white suit and black polka-dotted shirt, complete with an oversized matching pocket square. This look marked the beginning of his signature polka-dot style. Fans immediately followed in his footsteps rocking polka dots in various sizes and colors. "I wore it on my album cover, the back of my album cover, and my single cover," said Kwamé. "From that, people took those images of the same shirt and said, 'Oh, he wears polka dots.' After the first video drop, I would do shows and everybody in the audience would have on polka dots."[12, 13] Kwamé and the polka-dot trend would last another two years before he ditched the look altogether. His short-lived fashion trend became a one-liner lyric in The Notorious B.I.G's song "Unbelievable" (1994), in which the rapper cites Kwamé's polka dots as "played out." Sawyer was among the dedicated Kwamé polka-dot followers:

> I had a mixture of Kwamé polka dots and MC Hammer pants. I had a black and lime-green polka-dot suit with Hammer pants. I think about it now and how it was terrible. It wasn't just the clothes, but also his flat-top on one

Calvin Klein jeans, 1979.

side, his glasses, the gold joint in the front, the cane, and the polka dots.[14]

By the early '90s and into the 2000s, the commercialization of hip hop created a shift to referencing major status designer brands—both sportswear and luxury—by the likes of The Notorious B.I.G., Jay-Z, and Lil' Kim. This marked a significant change from the "feel good" rap of the '80s and entered the product endorsement era of luxury designers. During this period, Tommy Hilfiger began to dominate the wardrobes of some of hip hop's biggest stars, thanks in large part to the dynamic duo comprised of his younger brother Andy Hilfiger and Peter Paul Scott, former director of marketing at Tommy Jeans. Among Hilfiger's fans were Snoop Dogg, Aaliyah, Q-Tip, Naughty by Nature's Treach, Wu-Tang Clan's Raekwon, and Grand Puba, who bragged about his Tommy Hilfiger shirt on

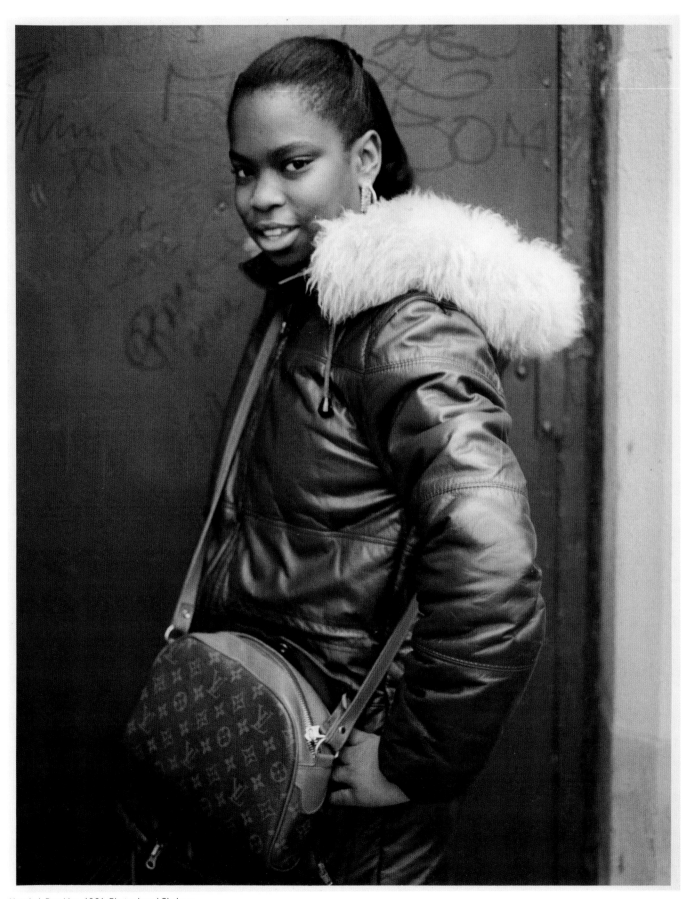

Untitled, Brooklyn, 1981. Photo: Jamel Shabazz.

Guess jeans, circa 1986. OPPOSITE: Kwamé, 1989. Photo: Ernie Paniccioli.

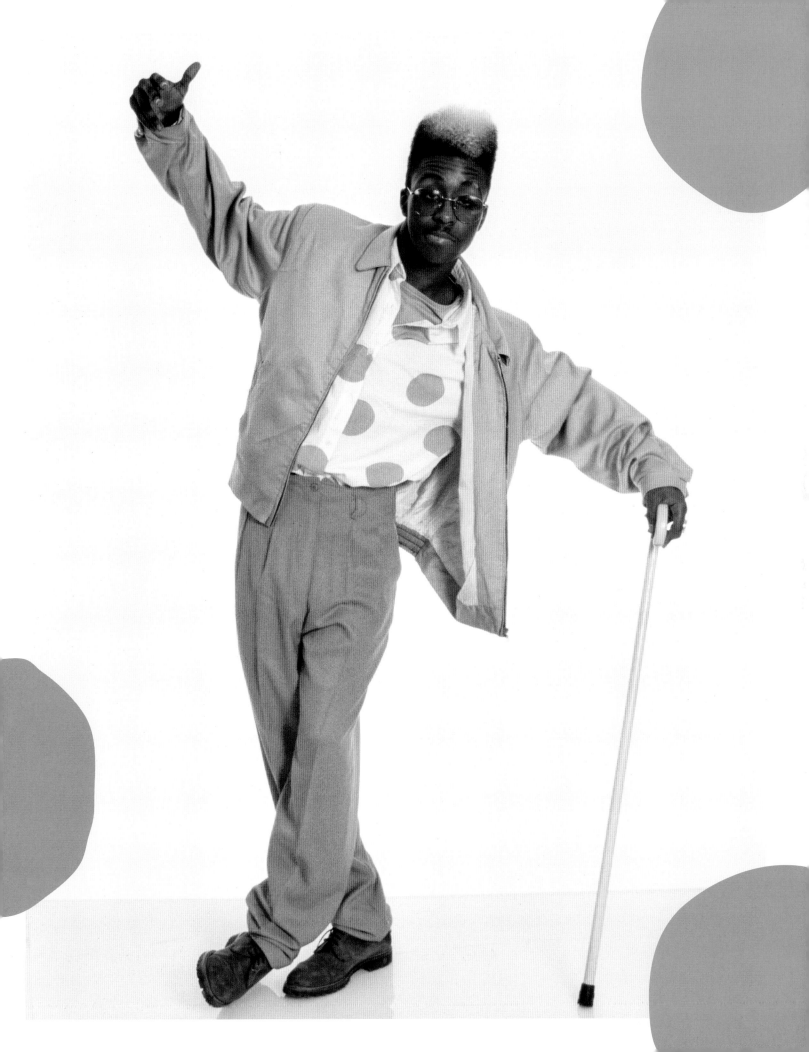

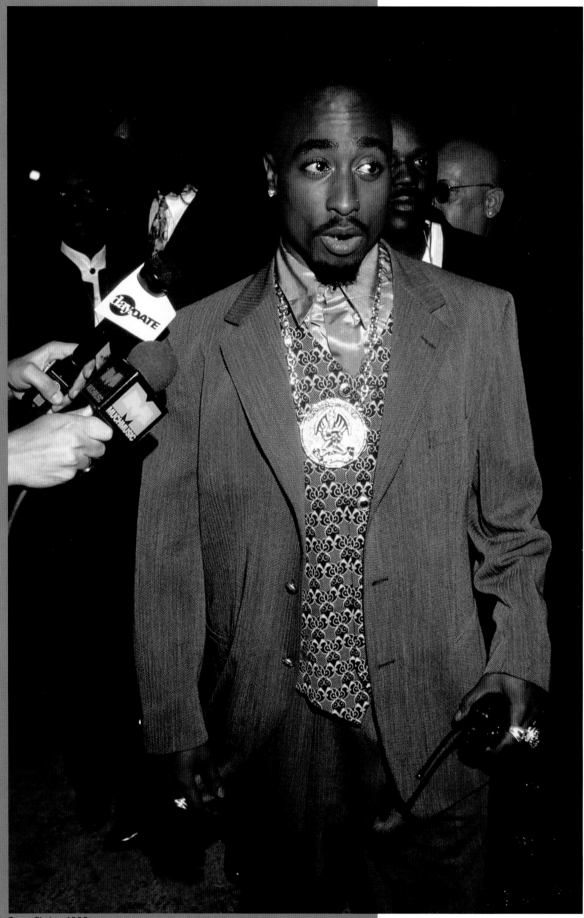

Tupac Shakur, 1996.

the title track of Mary J. Blige's debut album *What's the 411?* (1992). Rappers also honored the designers who had been catering to their style all along, like Brooklyn's own Karl Kani, who had celebrities like Sean "Puffy" Combs and Tupac Shakur cement his fashion reputation into music history. From Biggie to Kool Keith, rappers paid respect to the hip hop fashion originator in their lyrics.

As hip hop artists started their own fashion brands, these too made an appearance in rap lyrics. In 2003, Grammy award-winning artist Nelly launched AppleBottoms, a juniors' denim fashion brand designed specifically for women of various shapes and sizes. The popular song "Low" (2007) by Flo Rida featuring T-Pain gave the denim brand its own feature song. Fashion is arguably Kanye West's (known in 2022 as Ye) most rapped-about subject. The self-proclaimed "don of Louis Vuitton" has consistently spit fashion lyrics for more than a decade. In his song "All Falls Down" (2004), West comments on the insider knowledge required to pronounce foreign brand names like Versace. Yet, he quickly adapted to fashionable style and the fashion business with numerous collaborations and brands, including his influential and sometimes notorious Yeezy styles.

As rappers attained commercial and international fame, it became more common to flaunt their wealth and success by name-dropping what they could now easily afford, wear, or obtain for free. Versace scores high on the list of popular brands among the hip hop elite. Both the late Tupac Shakur and Biggie Smalls made Versace part of their fashion statements.[15] Shakur will forever be remembered in his Versace shirts, and The Notorious B.I.G. is remembered for his Versace Medusa sunglasses. The Versace brand would go on to appear in countless rap songs and videos across the country, including "Versace" (2013) by Migos featuring Drake. The rapper Father focused his song "Please Stop Making Fake Versace" (2015) specifically on knockoffs, hoping fans would stop wearing Versace imposters.[16]

These lyrics traced hip hop culture's infatuation with fashion as a symbol of success, but they could also mark personal and cultural developments. Many have claimed that Jay-Z single-handedly disrupted the popularity of the Mitchell & Ness throwback jersey with his song

"What More Can I Say" (2003) and his own style makeover, ditching jerseys for button-up shirts. As a maturing Jay-Z navigated his personal sense of style, he wrote about the brands and fashions that he admired in his songs. He rapped on songs like "Suit & Tie" (2013) by Justin Timberlake and shouted out luxury designers from Tom Ford to Vera Wang. He even dedicated a complete song to Ford in 2013. Jay-Z's fashion evolution can be followed through his lyrics. They show a man coming into his own style. However, coming full circle as fashion does, Jay-Z was among the investors who bought Mitchell & Ness in 2022.[17]

While men took the lead in bragging about their swagger during the '80s and '90s, women soon carved their own space for fashion storytelling and label lyrics. Lil' Kim would not only change the game with her femme power lyrics, but also with her designer sense of style, which impacted the world of hip hop and the world of fashion. The pink Versace hot pants, bra, boots, and fur ensemble that she wore to the 1999 Met Gala is remembered by *Vogue* "as one of the event's all-time best … But more than that, it helped to kickstart the trend for fearless and body-conscious style on the Met Gala red carpet."[18] Lil' Kim not only wore and wrote about designer fashion, she also was tapped into elite fashion circles. She attended the 1999 Met Gala as designer Donatella Versace's guest and muse. Versace loved the rapper's energy and how she personified her designs. In turn, Lil' Kim said, "Versace was one of my favorite designers. She knew that and would always create things tailor-made just for me."[19] Later that year, photographer David LaChappelle's portrait of Lil' Kim, in which she appeared nude with the Louis Vuitton monogram scattered across her body, featured on the cover of *Interview* magazine, unequivocally establishing Lil' Kim as a fashion icon.

In 2005, Lil' Kim again attended the Met Gala with her close friend Marc Jacobs in a gown that he custom-designed for her.[20] Other fashionable hip hop leading ladies like Foxy Brown, who was a close friend and emphatic follower of designer John Galliano, would follow suit.[21] Brown declared her love for Christian Dior in her song "Oh Yeah" (2001), when Galliano designed for the brand.

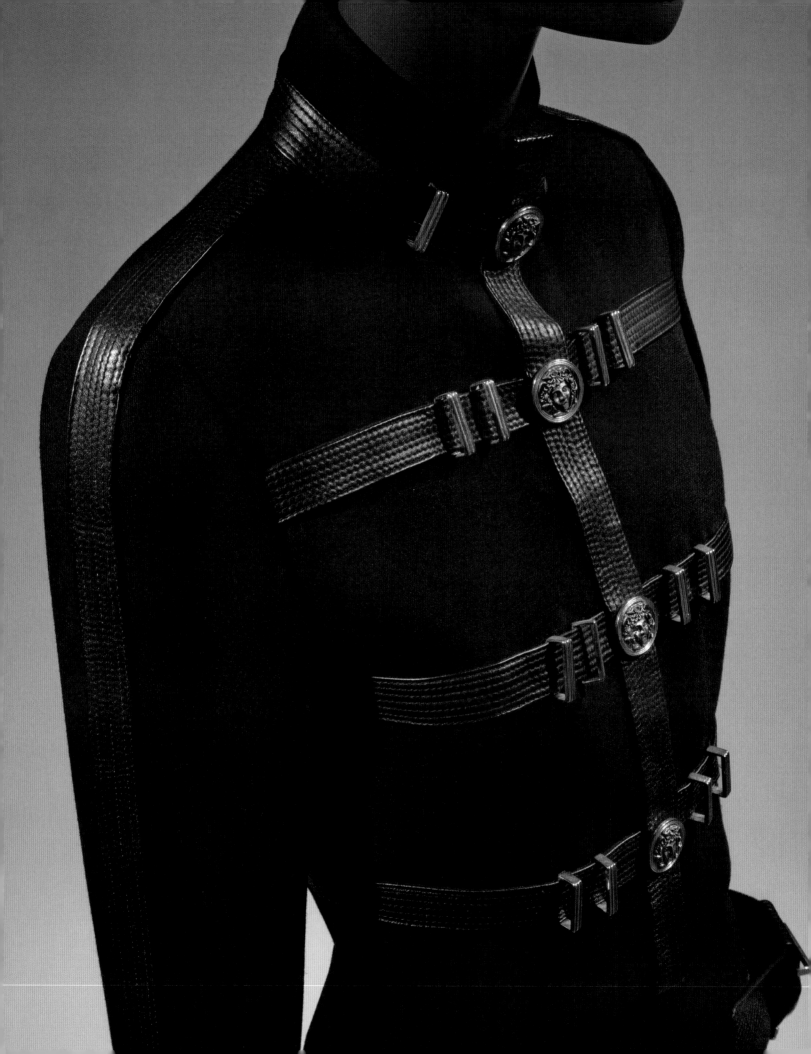

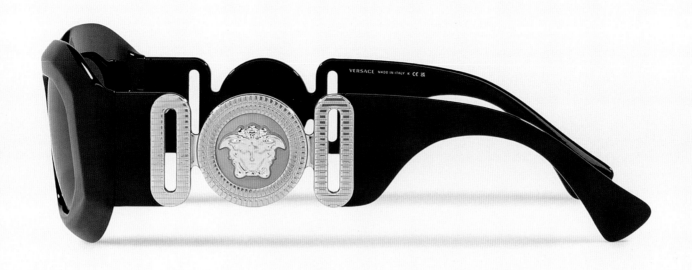

OPPOSITE: Versace jacket, 1992. Versace Medusa Biggie sunglasses, 2018.
Moschino earrings, 2018.

Lil' Kim and Marc Jacobs, 2004.

Known for her pink passion, Nicki Minaj has stunned not only with her fast-flowing rap but also with her eccentric sense of style. She is never bashful speaking her mind and bragging about her fashion status. In her song "Come on a Cone" (2012) from her album *Pink Friday: Roman Reloaded*, she brags about sitting front row at fashion shows next to Anna Wintour, editor and chief of *Vogue*.

As hip hop turns fifty years old, Cardi B may be the rapper who is most associated with high fashion. She appears frequently at fashion shows, on red carpets, and on Instagram in bold and covetable styles—from vintage Thierry Mugler to glittering Versace gowns and directional Thom Browne. She continues rap's homage to designer brands in hit songs that name-drop Balenciaga, Gucci, and Christian Louboutin.

In the 2020s, fashion lyrics have become commonplace and have helped hip hop artists break into the fashion world, simultaneously documenting their process along the way and giving their favorite brands millions in free advertising. A$AP Rocky, for example, is a bonafide fashion star. His self-proclaimed "ghetto hipster" style has attracted accolades, endorsement deals, and collaborations with a number of brands and designers, including Adidas, Guess, Raf Simons, and JW Anderson. He was the face of DKNY in 2014 and a spokesmodel for Dior Homme in 2016.[22, 23, 24] A$AP Rocky has not only expressed enviable style himself, he also has continued the immortalization of Black female style that Grandmaster Flash ("Them Jeans") and LL Cool J ("Around the Way Girl") pioneered in the '80s and '90s. Codirected by designer Virgil Abloh and himself, A$AP Rocky's "Fashion Killa" (2013) video features musician, fashionista, and designer Rihanna as Rocky's love interest—a relationship that was manifested into real life in 2020.[25, 26] The song is an ode to all those who slay. Among the fashion brands it name-drops are Prada, Dolce & Gabbana, Escada, and Balenciaga. A$AP Rocky is one example of many fashion stars in hip hop. Sawyer sees longevity in dropping fashion lyrics to express style, success, and affiliation. "It still comes back to the place that shows I have arrived," said Sawyer. "I have so much fun and money that I can do all the things they're doing and keep it street. There will always be braggadocio to show that we have access."[27]

Notes

1 Max Berlinger, "How Hip-Hop Fashion Went from the Streets to High Fashion," *Los Angeles Times,* January 26, 2018, https://www.latimes.com/entertainment/la-et-ms-ig-hip-hop-fashion-streets-couture-20180125-htmlstory.html.

2 Berlinger, "How Hip-Hop Fashion Went from the Streets to High Fashion."

3 Ravi Rao, "The Color Code: Messages in Music Regarding Social Marginality," *Clark University Archive*, November 9, 2018, https://wordpress.clarku.edu/musc099-04/origin-and-success-of-hip-hop-and-rap-genres-and-lyrical-content/.

4 Scott Simon, "The Art of Sampling: Stolen, Not Copied," *NPR.org*, June 28, 2014, https://www.npr.org/2014/06/28/326406737/the-art-of-sampling-stolen-not-copied.

5 Don C. Sawyer III, interview with author, April 29, 2022.

6 Wendy Heisler, "The Five Most Important LL Cool J Hats," *MTV.com*, January 24, 2014, https://www.mtv.com/news/2520167/ll-cool-j-hats/.

7 Elena Romero, *Free Stylin': How Hip Hop Changed the Fashion Industry* (Santa Barbara, CA: Praeger, 2012).

8 Gary Warnett, "How Run-D.M.C. Earned Their Adidas Stripes," *MrPorter.com*, May 27, 2016, https://www.mrporter.com/en-us/journal/lifestyle/how-run-dmc-earned-their-adidas-stripes-826882.

9 Warnett, "How Run-D.M.C. Earned Their Adidas Stripes."

10 Sawyer interview.

11 Sawyer interview.

12 Leschea Show, "Kwamé—Getting the Famous Blond Streak and Wearing Polka Dots," video, April 7, 2019, https://www.youtube.com/watch?v=00VIW-g261E.

13 MJ Sovino, "In 1989, Kwamé Rocked Polka Dots with Style & Rhythm," video, August 2, 2018, https://ambrosiaforheads.com/2018/08/in-1989-kwame-rocked-polka-dots-with-style-rhythm-video/.

14 Sawyer interview.

15 Alexandre Marain, "Do You Remember When 2Pac Walked for Versace Back in 1995?" *Vogue France*, June 18, 2018, https://www.vogue.fr/vogue-hommes/culture/articles/tupac-2pac-versace-runway-performance/65397.

16 Nicole Saunders, "5 Times Rappers Name-Dropped High Fashion Clothing Brands," *Billboard*, October 9, 2016, https://www.billboard.com/music/music-news/fashion-clothing-rap-lyrics-7534249/.

17 Trace William Cowen, "Michael Rubin's Fanatics, Jay-Z, Meek Mill, Lil Baby, and More Acquire Mitchell & Ness for $250 Million," *Complex*, February 8, 2022, https://www.complex.com/style/michael-rubin-fanatics-jay-z-meek-mill-lil-baby-acquire-mitchell-and-ness.

18 Janelle Okwodu, "Lil' Kim Shares the Story behind Her Iconic '90s Met Gala Looks," *Vogue*, May 4, 2020, https://www.vogue.com/article/met-gala-lil-kim-1999-versace-iconic-outfit.

19 Okwodu, "Lil' Kim Shares the Story."

20 Okwodu, "Lil' Kim Shares the Story."

21 Hannah Tindle, "John Galliano and Foxy Brown, the 00s' Most Fabulous Muse," *Anothermag.com*, September 6, 2017, https://www.anothermag.com/fashion-beauty/10129/john-galliano-and-foxy-brown-the-1990s-most-fabulous-muse.

22 Natalie Robehmed, "A$AP Rocky: The Fashion Prince on Styling Out and Cashing In," *Forbes*, September 24, 2013, https://www.forbes.com/sites/natalierobehmed/2013/09/24/aap-rocky-the-fashion-prince-on-styling-out-and-cashing-in/?sh=6108c22171d1.

23 John Jannuzzi, "A$AP Rocky Stars in DKNY's Ad Campaign," *GQ*, January 10, 2014, https://www.gq.com/story/asap-rocky-dkny.

24 Lorelei Marfil, "A$AP Rocky, Larry Clark Pose for Dior Homme," *Women's Wear Daily*, June 14, 2016, https://wwd.com/business-news/media/aap-rocky-robert-pattinson-kris-van-assche-dior-homme-10454746/.

25 Chioma Nnadi, "Oh, Baby! Rihanna's Plus One," *Vogue,* April 12, 2022, https://www.vogue.com/article/rihanna-cover-may-2022.

26 Tom Cramp, "Virgil Abloh's Most Influential Moments in Music," *Don't Die Wondering*, December 1, 2021, https://www.dontdiewondering.com/virgil-ablohs-most-influential-moments-in-music/.

27 Sawyer interview.

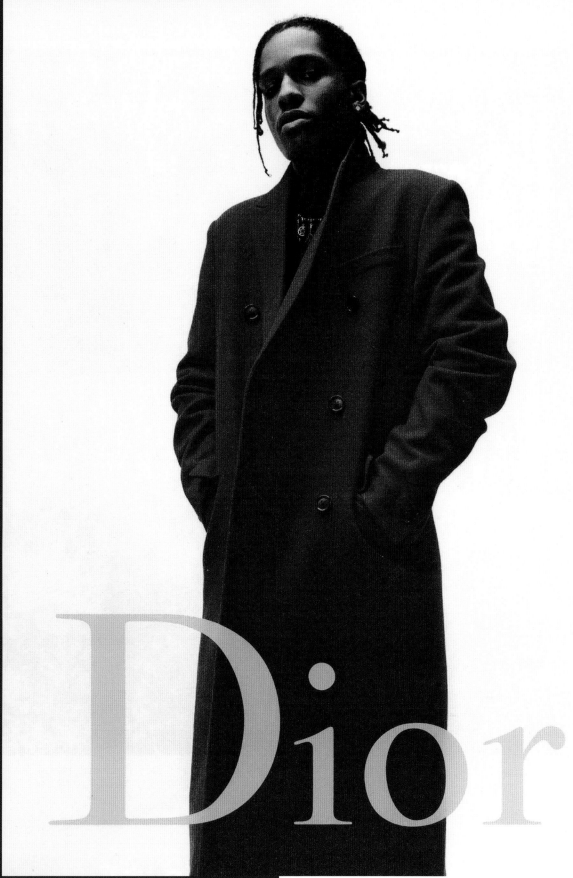

ASAP Rocky in a Christian Dior advertisement, circa 2010.

Dior

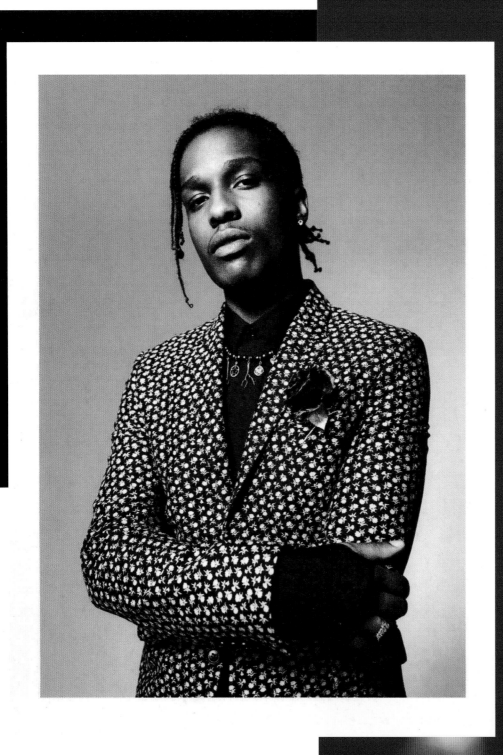

ASAP Rocky in a Christian Dior advertisement, circa 2010.
OPPOSITE: Jay-Z, 2013.

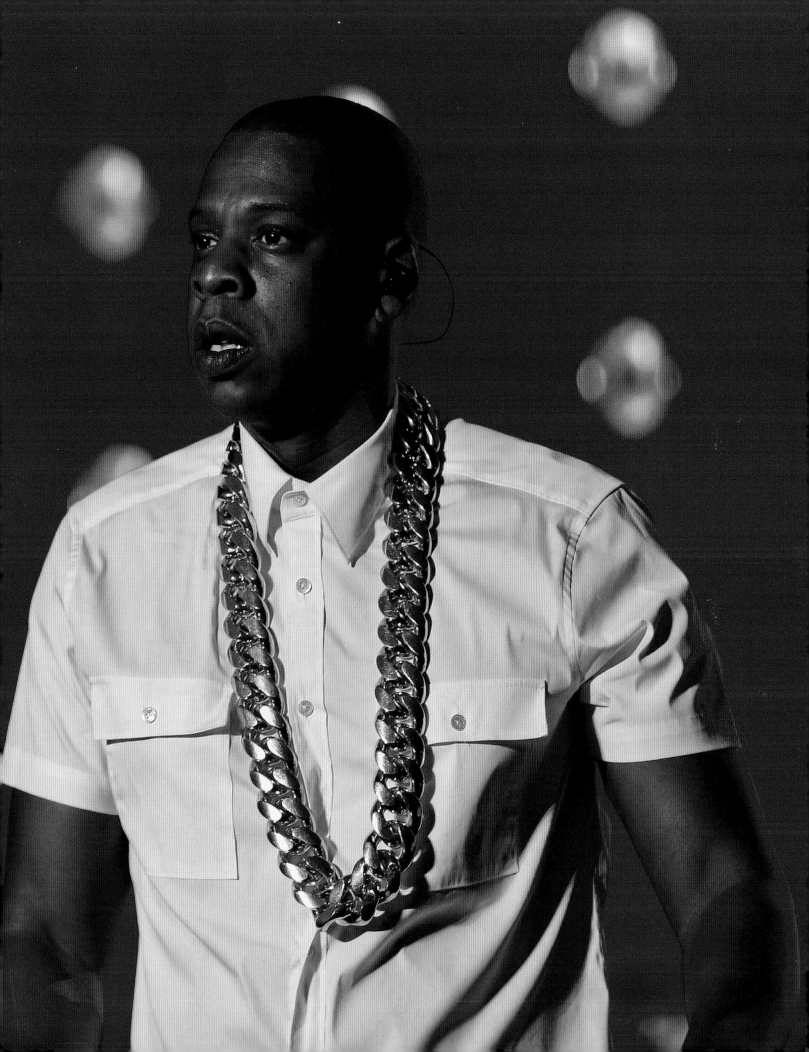

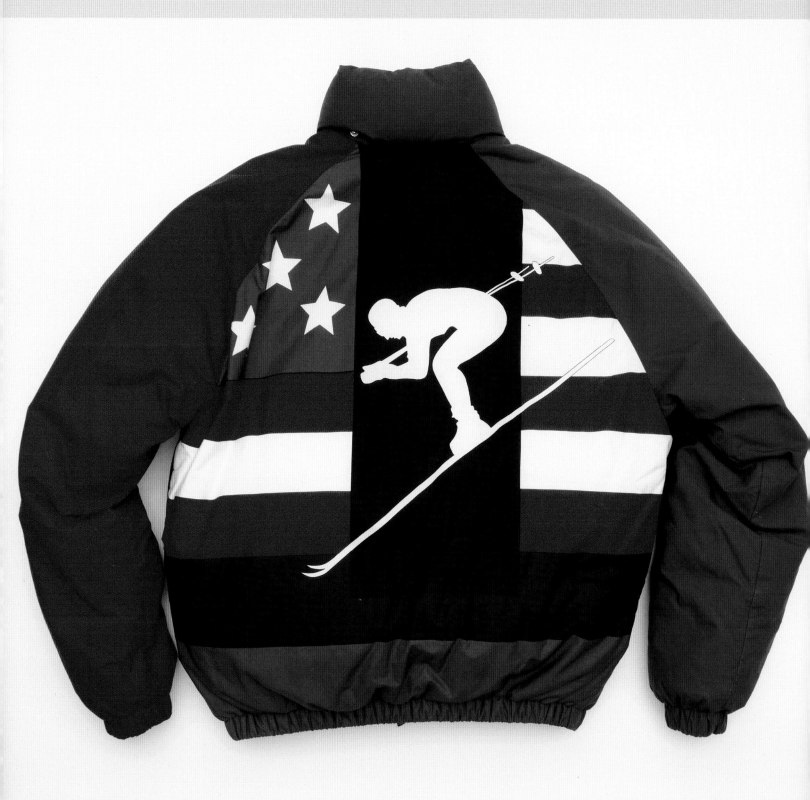

Polo downhill ski jacket, Fall 1989.

HIP HOP & THE AMERICAN DREAM:
Polo Ralph Lauren by Rebecca Pietri

As I moved from the fashion editorial world to styling and designing for entertainers in hip hop, I realized that I needed to understand the history and importance of different eras of Black American style and its roots. I learned the hip hop lexicon to create authentic looks and outfits for my clients. The nuances of color, color choices, brands, and even how laces are tied on sneakers informed people of not just where someone was in the culture but also their origin.

The Polo brand, created by the Bronx-born designer Ralph Lauren, epitomized the American dream of wealth and luxury. It is commonly known that this was not the lifestyle Lauren grew up in, but rather the one he aspired to, even changing his last name. Ralph Lauren represents creating the life you want to live.

In the 1980s, Polo Ralph Lauren did not market to young Black Americans, which prompted a group of teenagers from Brooklyn's Crown Heights and Brownsville neighborhoods to form the Lo Life Crew. What is most interesting about this relationship between two very different worlds is their capacity for self-invention. Rack-Lo, a Lo Life cofounder, said in a 2016 interview in *Fader*:

> By seeing the clothing it inspired us to know that there was more to life than being in Brooklyn and being stuck here, living at this limited pace. It inspired us to pursue those things: to go yachting, to be on Fifth Avenue, to be a part of the rich and the elite, and to try and acquire the American dream the way we know how to do it. And that was through fashion and boosting.[1]

The "Lo" in the group's name comes from "Polo," and the crew's style of dress, called "lo-down," was Ralph Lauren from head to toe. They stole thousands of dollars' worth of the product. Their inspiration was to take ownership of something that was not theirs and a lifestyle that was not *for* them. The Lo Lifes reimagined the brand in ways

Only Kings Wear Crowns, Luis "Scrams" Vasquez.

Lauren could not have anticipated, expanding its audience. In the 1994 video for the Wu-Tang Clan's "Can It Be All So Simple," Raekwon wore the Polo Snow Beach pullover. Kanye West wore a Polo bear sweater on the album cover of *The College Dropout* (2004). Lo Life cofounder Thirstin Howl the 3rd and photographer Tom Gould's book *Bury Me with the Lo On* (Victory, 2017) documents this culture that inspired hip hop artists and went global. Vintage Polo Ralph Lauren sells for thousands of dollars on sites like eBay to collectors worldwide. The Polo Ralph American flag sweater, made famous by the Lo Life Crew, is in the Metropolitan Museum of Art and was featured in the Costume Institute's 2021–2022 exhibition *In America: A Lexicon of Fashion*. Hip hop fashion started in urban neighborhoods, and even in its evolution, it is important to ensure that the Black American community's contribution to it is not forgotten or erased. Polo Ralph Lauren exploded on the streets of Brooklyn in 1988 because of the Lo Life Crew. They inspired hip hop fashion, and as a result, Polo Ralph Lauren became one of the most influential streetwear brands of all time.

Note
[1] Kemet High, "The Real and Raucous Story of the Lo Life Crew," *Fader*, December 7, 2016, https://www.thefader.com/2016/12/07/lo-life-crew-interview.

116

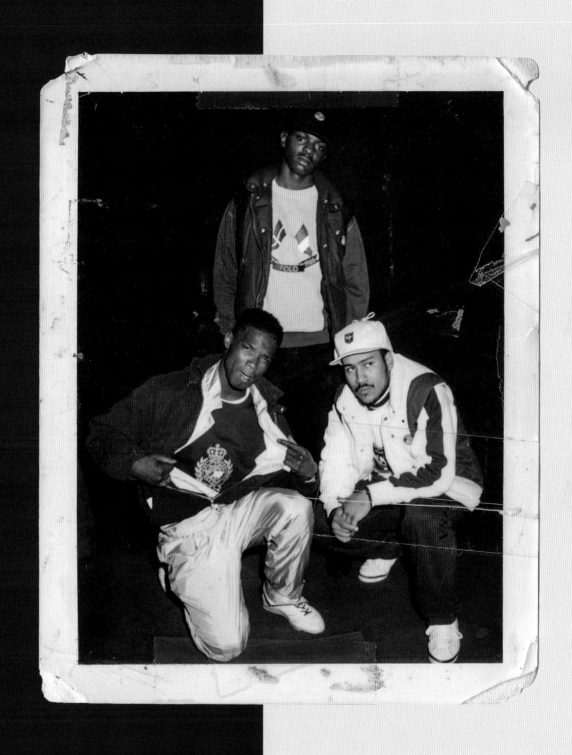

OPPOSITE: Ralph Lauren Country flag sweater, Fall 1989.
The Holy Trinity, 1989.

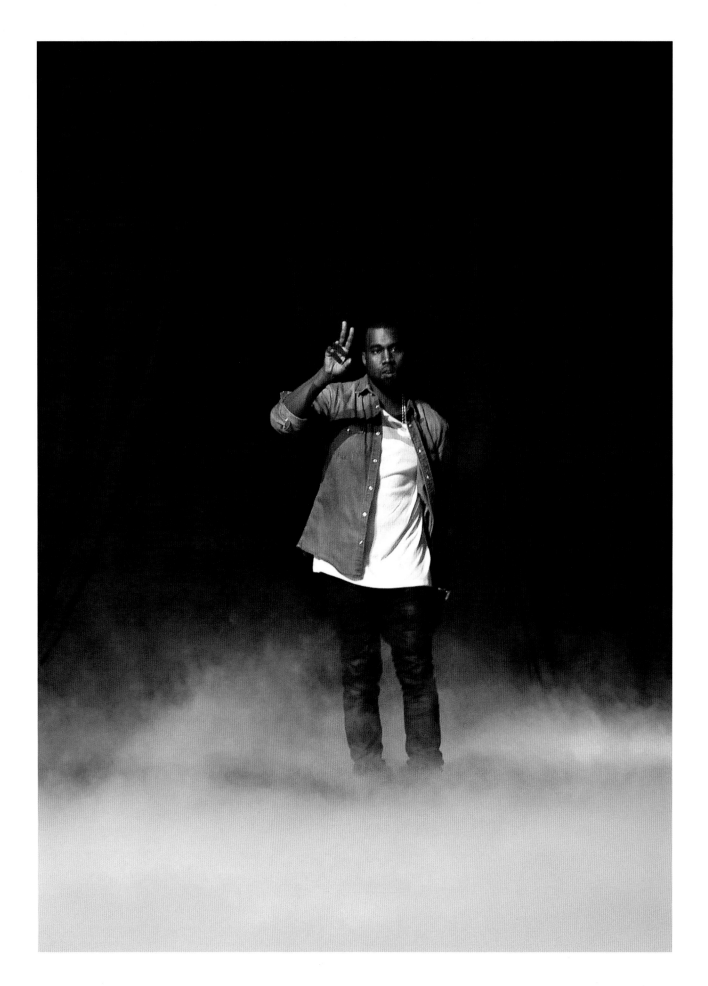

CHANGE CLOTHES & GO

Kanye West runway show, Fall 2012.

It has been Yeezy season for quite a while, but before releasing his debut album *The College Dropout* in 2003, and gracing the cover of *The Source* magazine in April 2004, a little-known Kanye West said he was going to be the biggest fashion mogul to come out of hip hop. Anything is possible, I believed, but sitting across from me at Mr. Chow's wearing a Ralph Lauren teddy bear sweater, West was not emanating the style of dress associated with your average emcee at that time. He had recently signed to Roc-A-Fella Records, where the dress code for the majority of its roster consisted of chunky jewelry, oversized jerseys, fitted caps, and big logos—mostly from its own Rocawear line. By the turn of the millennium, record labels and designer fashion houses had figured out the one thing that people like Russell Simmons, Karl Kani, and April Walker knew back when they started their own clothing businesses: hip hop's influence over fashion was undeniably a cash cow and where mainstream fashion was headed. Whether it was Run-DMC in Phat Farm, Tupac in Karl Kani, or The Notorious B.I.G. in Walker Wear, a cosign from who's who in hip hop translated into revenue for clothing brands. Streetwear had gone mainstream, and it was starting to infiltrate couture. At the beginning of the 2000s, Kanye West was on the verge of something big.

As the editor-in-chief of the biggest hip hop magazine of that era, I oversaw a fashion department comprised of fashion editors, stylists, and photographers who all were knee-deep in the business of fashion. But in truth, growing up in the Bronx in the '80s was the only real experience that I had in style. In elementary school, I wore Cazal glasses, Lee patch jeans, and leather bomber jackets—simply because it was the dress code for a Bronx hip hop chic. Occasionally, I would venture down to Delancey Street and pick up the latest knockoff MCM bag to rock on Easter Sunday. Around the way in the '80s, wardrobe said more about you than anything. The sneakers you wore on your feet could either get you robbed or get you roasted, so you had to dress defensively. But none of this really prepared me for overseeing a

department responsible for eight to ten vital pages in *The Source* every month. What did I really know about fashion?

I knew enough. Although confidence in my own two eyes was not enough for me to make firm decisions back then, I was confident enough in my ability to select a few key people whose work I knew forecasted hip hop style the way I liked it. Fashion played a major role in *The Source*'s business—primarily because fashion dominated its advertising dollars—so the editorial coverage of fashion needed to be on point. We brought on Misa Hylton, Groovey Lew, and Mike Bogard to help dictate the trends and looks on *The Source*'s pages. These were stylists known for putting together some of the most iconic looks in hip hop history. In my opinion, Sean Combs and his Bad Boy team were the best dressed back in the '90s when hip hop came of age. Who could deny the flyness rocked by The Notorious B.I.G. in his heyday? Whose idea was it to put a pastie over Lil' Kim's breast at that awards show? That was the team I wanted to drive hip hop fashion in *The Source*. By the time I saw their pages every month, I had few questions to ask. Most of the time, I just made sure the copy that accompanied the style was clever and there were no typos in the text. I did not pride myself on knowing what was going to be the next trend; I simply trusted in the team. Still, I had my own particular style and eye for what I liked. It mostly went along with individuals who owned their own style or who tailored their looks to their identity. In my mind, it had to fit well, and it had to define you. And it always spoke to originality if you were the first one to wear it. So, when I pulled up to the Polo store to see the looks that stylist and American streetwear designer Don Crawley (aka Don C) was picking out for Kanye to wear on his first *Source* cover, I was not necessarily convinced that a white and pink button-up Polo shirt was going to go over well with my bosses. But I had a good feeling about seeing something different on

Polo bear sweater, Holiday Collection 2007.

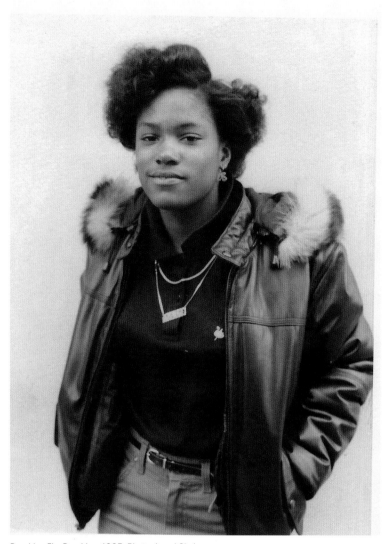

Brooklyn Fly, Brooklyn, 1985. Photo: Jamel Shabazz.

the cover. It was not that polo shirts had not been rocked in hip hop before—Kanye did not invent the preppy, college look—it was just that it was in stark contrast to everything dominating the culture at that time. In a sea of New Era caps and Mitchell & Ness jerseys, Kanye's pink Polos coupled with Louis Vuitton backpacks stood out. It turned out that it was the formula for how to win in hip hop. It started by keeping it real, but it continued with keeping it original.

Since the days when Run-DMC married their shell-toe Adidas to their thick rope chains, or Salt-N-Pepa sported asymmetrical hair with their oversized eight-ball jackets, hip hop has gone against the grain when it comes to fashion, creating looks that defined eras. Artists back then were not embraced by clothing designers—much less recognized by

the haute couture labels. It led to the emergence of fashion moguls such as Dapper Dan, who took high-end brands like Gucci and Louis Vuitton and created his own empire. This was inevitable though, especially as hip hop started to dominate fashion. Years later, people like Tommy Hilfiger would claim to be the first in streetwear and Timberland would try to disassociate its brand from the culture.[1,2] And while a Grand Puba shout-out or Aaliyah's signature underwear-bearing look definitely earned Hilfiger his place in hip hop's fashion vaults, the "c'mon now" attitude of Black Twitter was not having it.

Hip hop fashion was around for decades before it got the acknowledgment from mainstream tastemakers, evolving and forcing the fashion industry to pay attention. So, for the artists who were frankly just giving away millions of dollars by endorsing certain labels in their music videos or in their songs, crossing over into fashion made perfect sense. Whether it was Wu Wear, Rocawear, or Sean John, artists endorsing their own brands became the new norm for record labels and how they did business. They demanded their own product placement, and contracts eventually started to reflect that. When 2000 hit, hip hop had more clothing lines than you could count, and ads in *The Source* tripled the number of editorial pages. Struggling brands, such as Lugz and Southpole, paid to put their boots and clothes on the hottest in rap music. Everyone wanted a piece, the look was everywhere, and it was time for hip hop fashion to reinvent itself once again.

Kanye blew up quickly after his *Source* magazine cover and eventually met his fashion idol, Ralph Lauren. Climbing to the top of the charts in music was only one goal. After the groundwork had been laid by the architects of hip hop fashion before him, the door was open for Kanye to spread his influence in fashion. Mr. West took a bit of a different approach to launching his own brand by doing an actual internship at Fendi with his friend Virgil Abloh, who would later go on to become one of the biggest names in fashion, creating Off-White and heading Louis Vuitton menswear. Working with the brands from the inside, Kanye began designing shoes for A Bathing Ape, Louis Vuitton, and Giuseppe Zanotti. He then teamed up with Nike

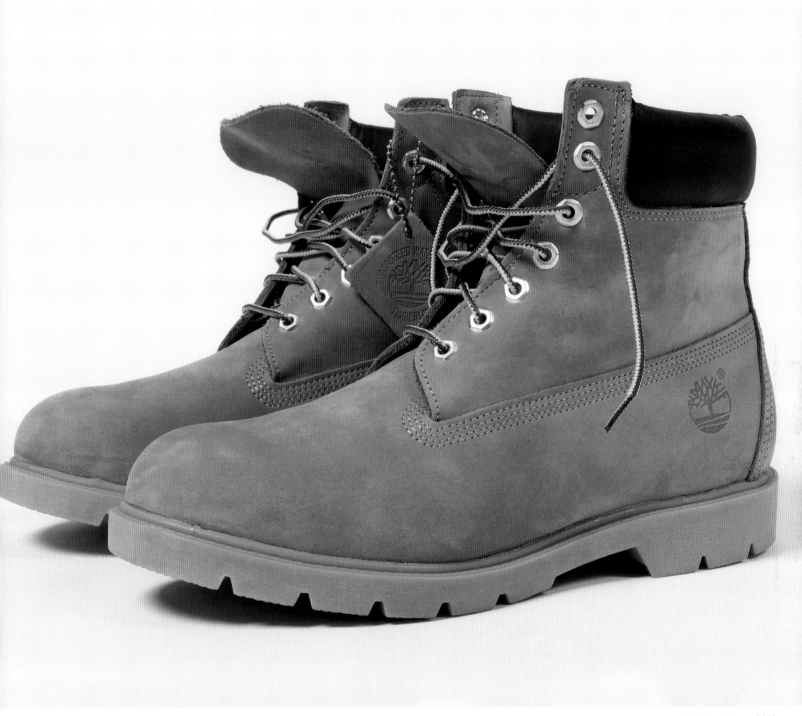

Timberland boots, 2013.

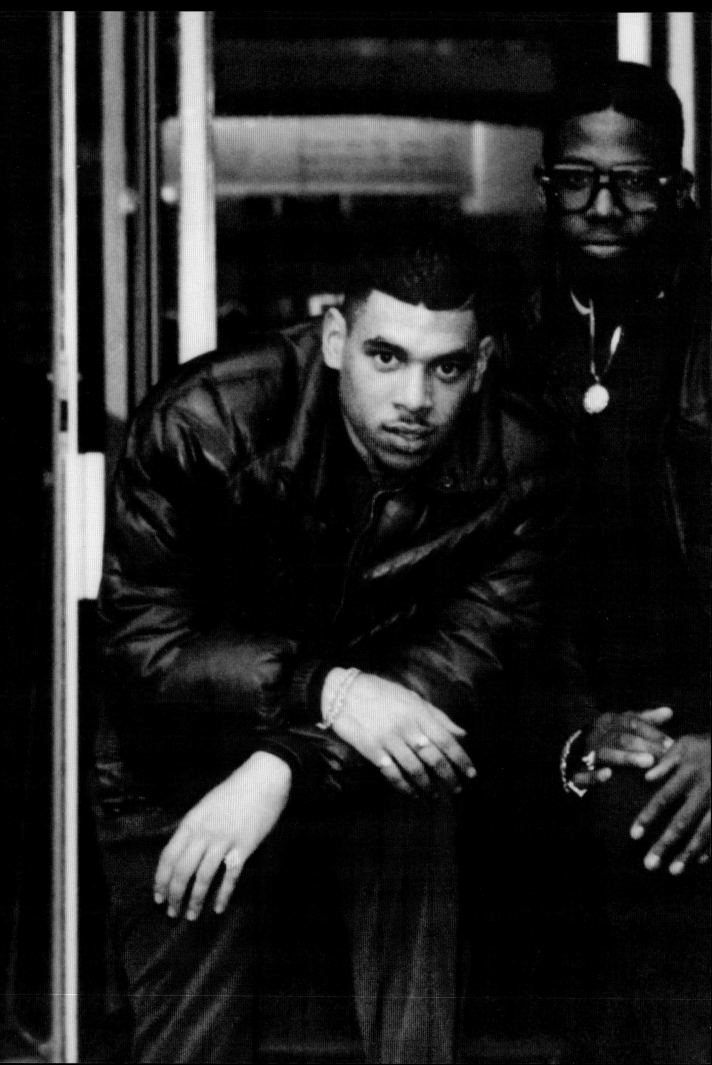

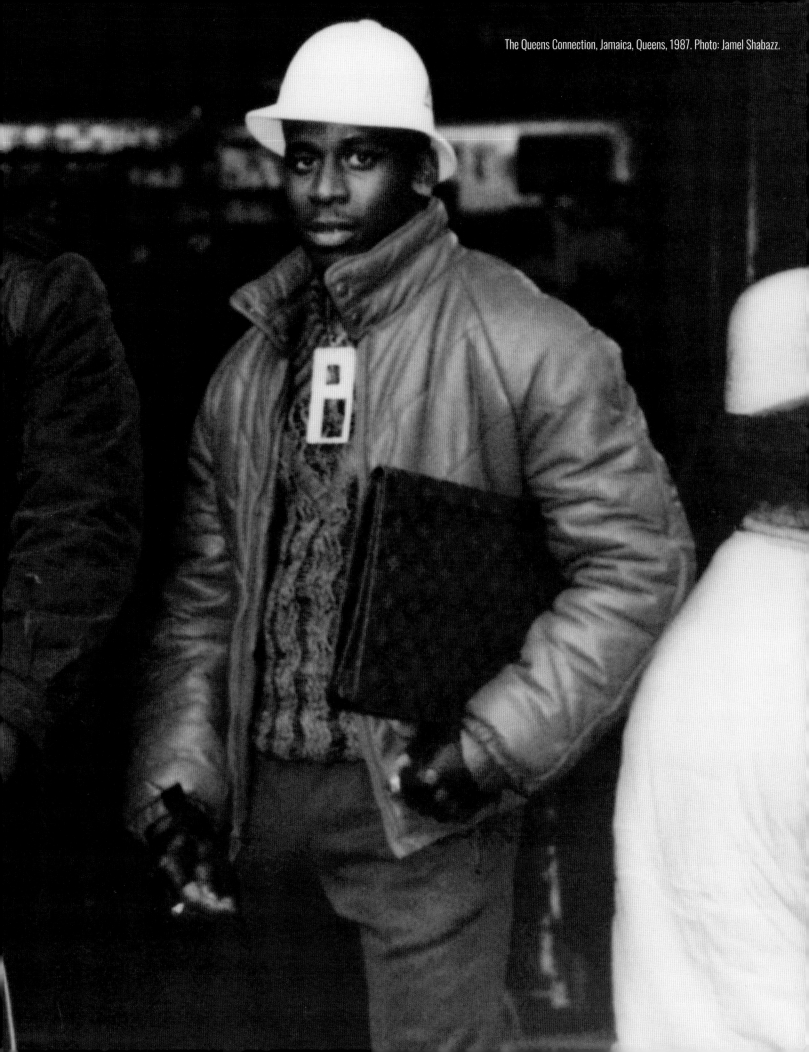

The Queens Connection, Jamaica, Queens, 1987. Photo: Jamel Shabazz.

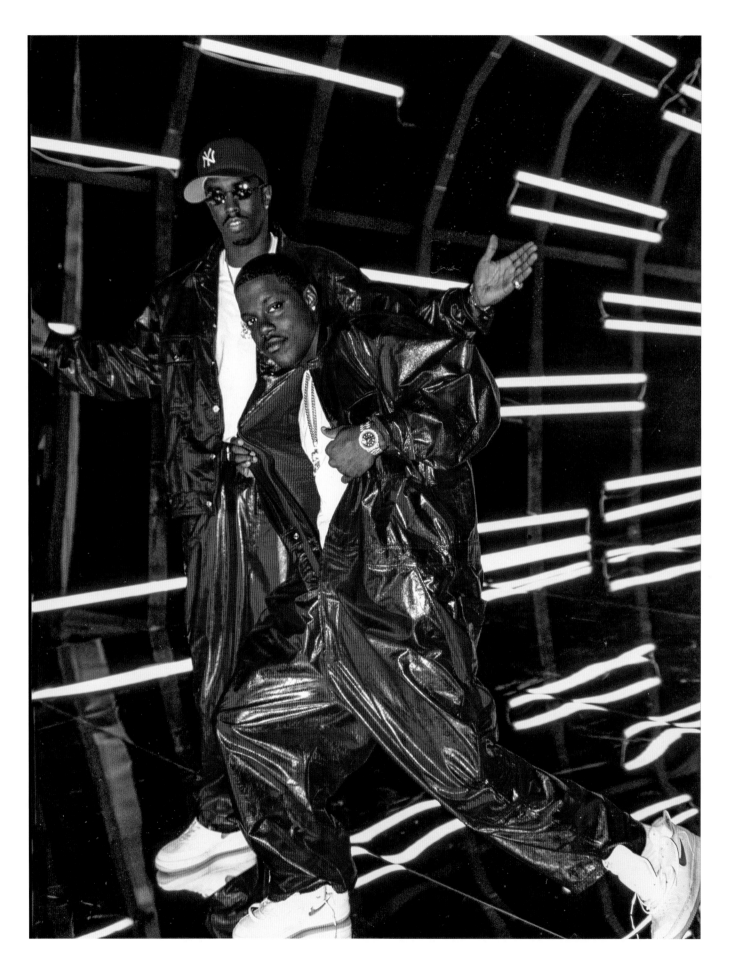

for his first official shoe. And when that brief stint with Nike did not go his way, Kanye went to Adidas to level up his business. He launched his Yeezy brand soon after, where he retained 100 percent ownership of his brand and full creative control. In 2020, sales for Yeezy reached nearly 1.7 billion in annual revenue. It is the most successful sneaker brand in hip hop.

In 2020, when Ye announced that he was collaborating with Gap to develop a clothing line for men, women, and kids, Gap shares soared as much as 40 percent just from a photo that he posted. Described as "modern, elevated basics" sold at "accessible price points," the brand, which debuted its first piece from the collection in 2021, got a much-needed boost of cool factor, thanks to one of their former sales employees.[3] (West has repeatedly referred to his early days working retail at Gap in his music.)

The influence of Kanye in fashion is undeniable. From the dark mysterious draping of models on the Balenciaga runway in 2022 to the ripped clothes memes on Instagram that jokingly refer to Kanye's pricing—like it or not—Ye is the fashion industry's most revered hip hop artist. Hanging alongside Anna Wintour at exclusive events, or being referred to as the stylist for his estranged ex-wife Kim Kardashian, Ye's fashion vision is memorialized by the most renowned celebrities. Whether it is denim, leather, combat boots, black hoodies, or all-out face masks, the trends that come from a Kanye paparazzi moment prove that the industry is paying close attention to how and what Chi-town's finest wears. As he predicted, he has indeed become the biggest fashion mogul to come out of hip hop.

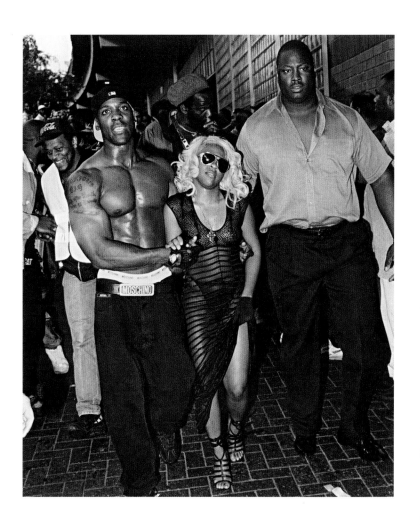

Notes
[1] Tayler Willson, "Tommy Hilfiger Reflects on His Legacy," *Hypebeast*, December 7, 2021, https://hypebeast.com/2021/12/tommy-hilfiger-streetwear-preppy-hip-hop-interview.
[2] Michel Marriott, "Out of the Woods: The Inner City Loves Timberland. Does Timberland Love the Inner City?" *New York Times*, November 7, 1991, V1.
[3] "Kanye West Teams with Gap," Gap Inc. *Newsroom*, June 26, 2020, https://www.gapinc.com/de-de/articles/2020/06/kanye-west-teams-with-gap.
see https://www.nytimes.com/1993/11/07/style/out-of-the-woods.

OPPOSITE: P. Diddy and Mase, 1997. Photo: Ernie Paniccioli.
Lil' Kim, 1997.

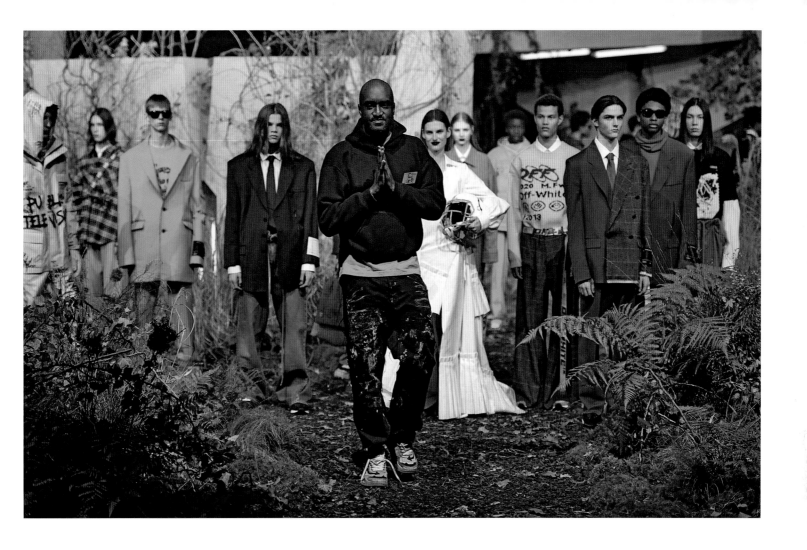

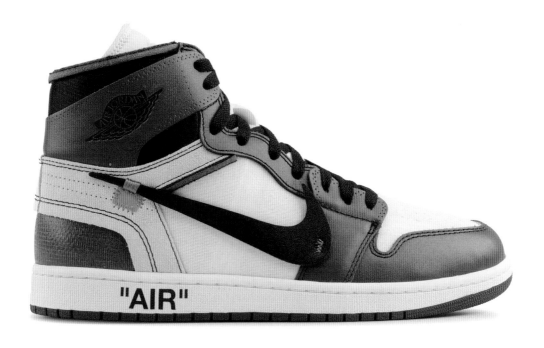

OPPOSITE: Sean John, Fall 2008.
Virgil Abloh, Off White runway show, Fall 2019.
The 10: Air Jordan 1 x Off-White "Chicago" high-top sneaker, 2017.

129

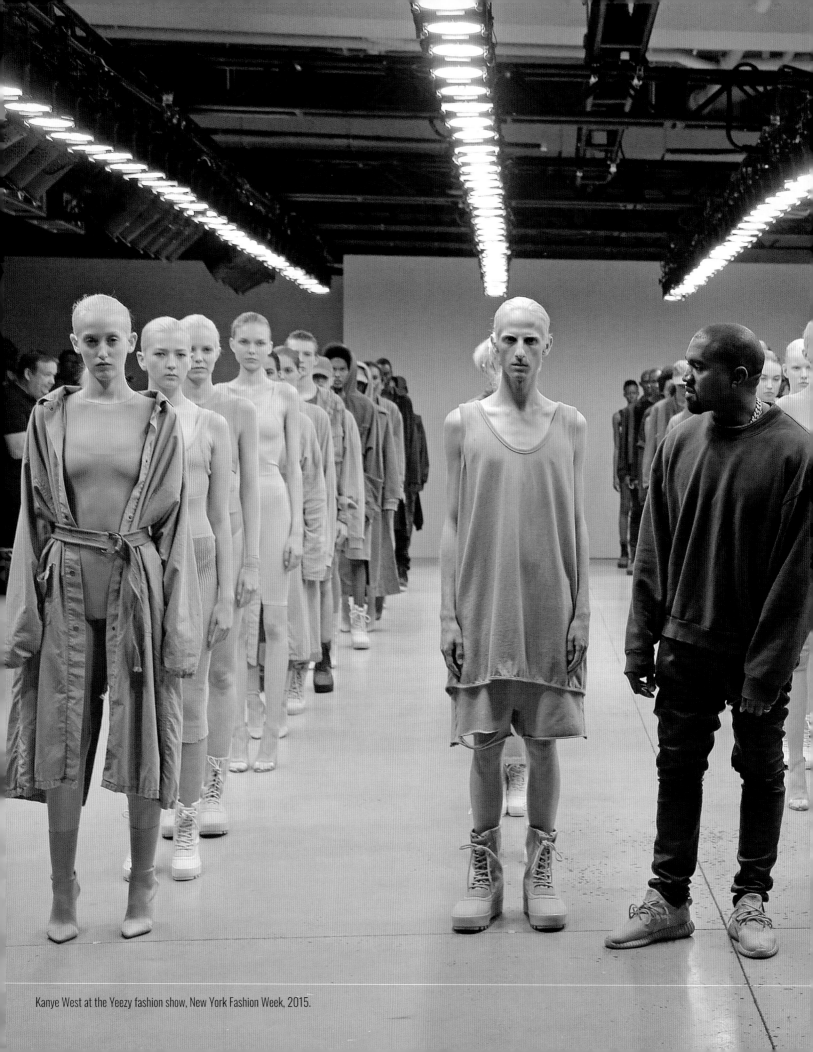

Kanye West at the Yeezy fashion show, New York Fashion Week, 2015.

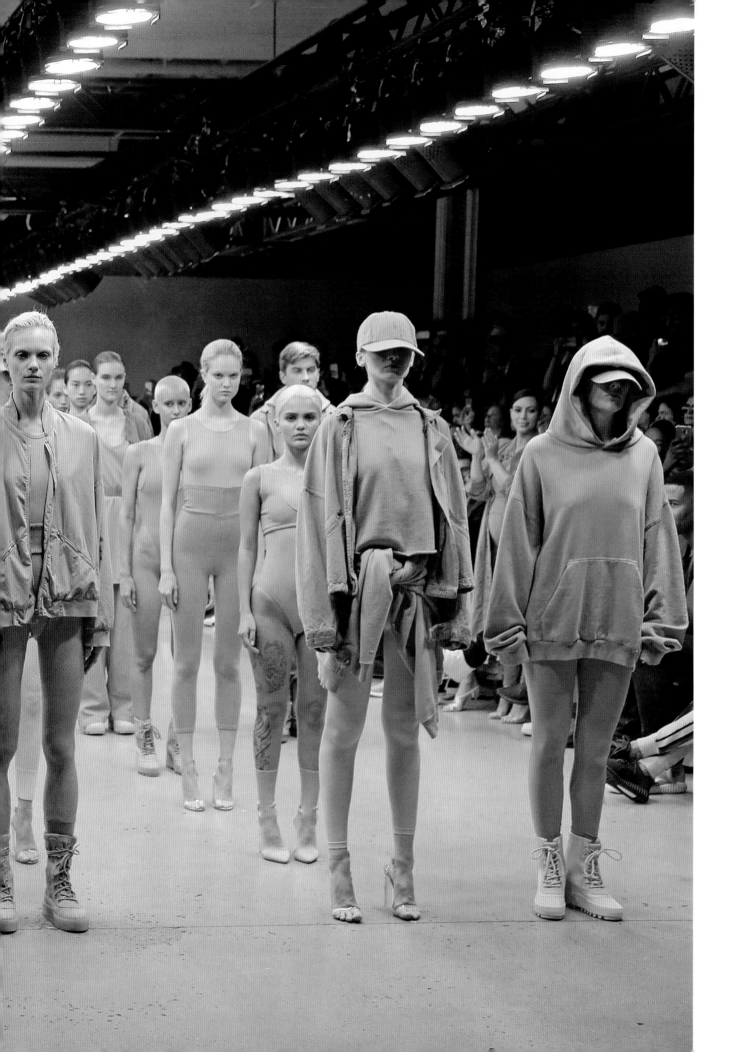

RALPH MCDANIELS: Hip Hop Fashion's First Runway by Elena Romero

Before hip hop hit the New York Fashion Week runway of "Seventh on Sixth," it was veejay Ralph McDaniels who placed young Black designers and hip hop at center stage. The man who started the TV show *Video Music Box*, which originally broadcast on New York's WNYC in 1984, decided to launch his Phat Fashions fashion show after brands like FUBU approached him about product placement:

> While all of this was going on and the energy that I saw in FUBU, I was like, there has to be a place to do a fashion show, a store, or something … Come to find out, FUBU was in two stores, and everything else—they were just giving it away. So, we're promoting it on TV, and there's nowhere to sell the stuff?[1]

McDaniels's entré into the fashion industry came via Phat Fashions in 1993, a biannual, two-hour fashion show, meant to specifically showcase Black designers and promote hip hop culture. McDaniels's fashion show's premise was "street fashion and models that were fly" with artist showcase performances and a deejay:

> I didn't want to do these corny fashion shows that I saw people doing—where it's real tight and people sitting around. It's got to be like the culture. I wanted to have deejays playing and it would be almost like a party, because we were good at doing parties.[2]

Originally held at small venues like Club Exit, The Supper Club, and Roxy, McDaniels's shows were later held at larger venues, including New York City's Jacob Javits Center, to crowds of 1,500 people. Participating brands included Karl Kani, FUBU, Damani Dada, Dada Supreme, PNB Nation, and Miguel Navarro. The shows later expanded to include commercial fashion brands such as Levi's and Tommy Hilfiger.[3, 4]

McDaniels explains:

The fashion designers that were coming up in the early '90s reminded me of the hip hop artists coming up in the early '80s. It was the same feeling I got. I was whipped. I couldn't wait to see what the next design was going to be. I couldn't wait to see what kind of jeans they were going to do. I couldn't wait to see that leather that people were going to put out. It was like waiting for the next Eric B. and Rakim record [5]

During his successful fashion show run, McDaniels decided to get into the retail business. "We knew that the majority of the stuff you saw in the show, you couldn't just get anywhere. You could only get at a particular place so we said let's open up a store where you can sell this stuff. Karl Kani was a big help to me at that time," said McDaniels.[6]

In 1997, McDaniels launched Uncle Ralph's Urban Gear at 1622 Bedford Avenue in Crown Heights, Brooklyn.[7] To celebrate the store and the community, McDaniels threw an annual old-school block party event in front of his store with a live concert made up of unknown, emerging, and legendary artists.[8] Unfortunately, the store was short-lived:

> The downfall of Uncle Ralph's Urban Gear was as designers got bigger, everybody started to get their stuff. Macy's was buying it now. All these different people were buying stuff we had exclusively at one point. And then, bootlegging came out. People began buying knockoffs for half the price. We couldn't compete after a while. Sales began to drop, and that's when we got out of the retail business.[9]

Notes
[1] Ralph McDaniels, interview with author, August 5, 2002.
[2] McDaniels interview, 2002.
[3] Marie Redding, "Say Phat? A Show Dedicated to Street Fashion by Young Urban," *New York Daily News*, July 19, 1998, https://www.nydailynews.com/phat-show-dedicated-street-fashion-young-urban-designers-hit-runway-article-1.815773.
[4] Elena Romero, *Free Stylin': How Hip Hop Changed the Fashion Industry* (Santa Barbara, CA: Praeger, 2012).
[5] McDaniels interview, 2002.
[6] McDaniels interview, 2002.
[7] Ralph McDaniels, interview with author, November 18, 2010.
[8] Tom Constabile, "Uncle Ralph's Old School Block Party: New York Uncle Ralph's Urban Gear," *NME*, September 12, 2005, https://www.nme.com/reviews/reviews-nme-5090-333045.
[9] McDaniels interview, 2002.

Ralph McDaniels, Video Music Box, 1988.

OFFICIAL: Tommy Boy Records & Hip Hop Fashion by Monica Lynch

Style has always been the unofficial fifth element of hip hop—the others being emceeing, breakdancing, deejaying, and graffiti writing. Shortly after being hired as Tommy Boy's first employee in 1981, I was introduced to the sounds and styles that were winding their way downtown from the Bronx to clubs like Negril, The Roxy, and Danceteria—forcing even the most blasé, black-clad, post-punk posers to crane their necks. Having done ample time in the disco and punk scenes, this was entirely new to me. Like disco and punk, hip hop style was intertwined and inseparable from the music itself, although it inadvertently borrowed elements from both. From disco, there was the aspirational desire for status names—even if those names had shifted from Pucci and Fiorucci (Gucci never really went away) to Lee, Adidas, Kangol, and Cazal. From punk, there was the highly personalized do-it-yourself element, which translated to Olde English iron-on letters announcing you and your crew on a sweatshirt, bespoke aerosol art on the back of denim Levi jackets, personalized 10K door knockers, and nameplate necklaces. These pieces were assembled while-you-wait in a Times Square shop, the Albee Square Mall in Downtown Brooklyn, or the Colosseum Mall in Queens with your name spelled out in "Chinese" letters or perhaps customized in cursive. But whatever style cues it may have absorbed from the previous decade, hip hop's early '80s pose, posture, and attitude were entirely new.

Early hip hop fashion was inventive, witty, and accessible with enormous pride in its stride. What made a legend most was not bougie Blackglama, but shearlings bought on Sunday down on Orchard Street or a three-quarter leather put on layaway at Canadian's on 34th Street. "Savoir faire in your derriere" could be had via a quick trip to VIM for a pair of Vanderbilts or Valentes. And, of course, Modell's was the move for kicks, tracksuits, and more. It was a time when Shirt Kings ruled and Zulu Queens reigned. As proclaimed by The Cold Crush Brothers, this was the era of the "Fresh, Wild, Fly & Bold" (1984). Although money was still too tight to mention and bling was not yet a thing, early hip hop fashion was already dressed to impress and was doing much more with way less.

At Tommy Boy, it was always huge fun to create promo items that gave a wink to whatever trends were running at the time. In the early '90s, Tommy Boy also produced a clothing line that embraced and played off what was becoming the early streetwear industry. In 1983, we made oversized ski hats with the TB logo and dancing boys as a nod to the then-popular "ski" appendage that appeared in various emcee names. We did leather beeper cases in the late '80s when PINs were the only way to reach artists and their managers. In '89, when De La Soul was breaking the mold and making history with *3 Feet High and Rising*, I located a fantastic guy (through Fab 5 Freddy) on 125th Street who made leather pendants. We did a small run of *3 Feet High and Rising* leather pendants that reflected the Afrocentric vibe of the Native Tongues collective. We produced thousands of lanyards in countless colorways during the era of street teams and industry conventions like the New Music Seminar, Rucker tournaments, and Rock Steady anniversaries, among others. It was a time when everyone wanted to be put on and be "official." Lanyards suggested that you had been there and had access. Tommy Boy owned the lanyard game for sure.

And, of course there is the iconic Tommy Boy Carhartt jacket from 1992 with Stüssy-designed embroidery. It was through Albee Ragusa, a young Tommy Boy A&R guy, that the relationship with Stüssy came together and the design elements for the jacket merged. Eight hundred were made and given to industry tastemakers. It became a must-have item that was written up in *The New York Times*. I can assure you that Carhartt was surprised.

Tommy Boy lanyards, early-to-mid 1990s; Tommy Boy lanyards with laminates for various events and releases, early-to-mid 1990s; De La Soul leather pendants, circa 1989; Tommy Boy deluxe leather embroidered lanyard with burlap case and heavy logo pendant, mid-1990s.

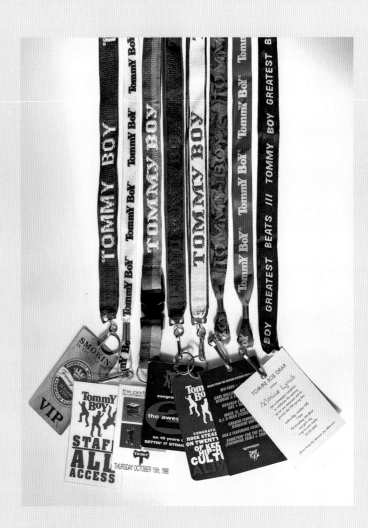

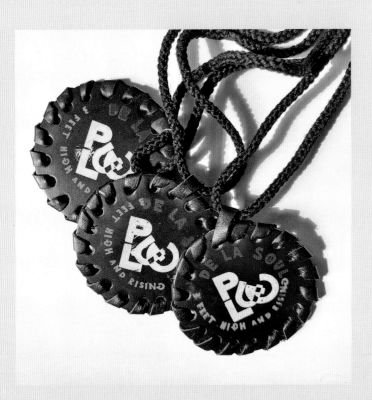

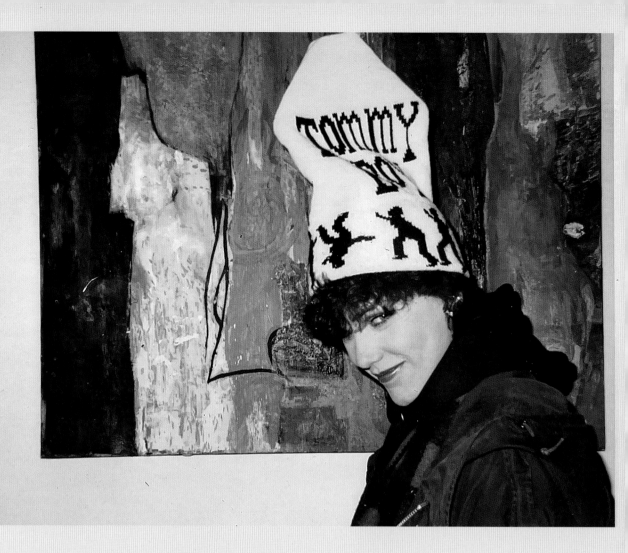

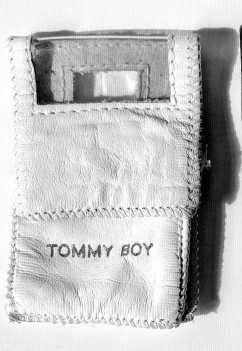
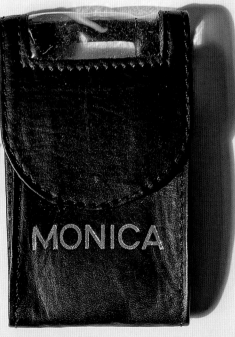
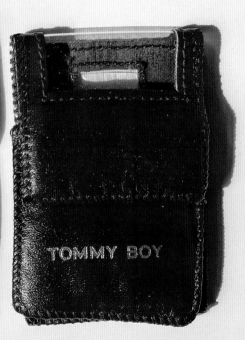

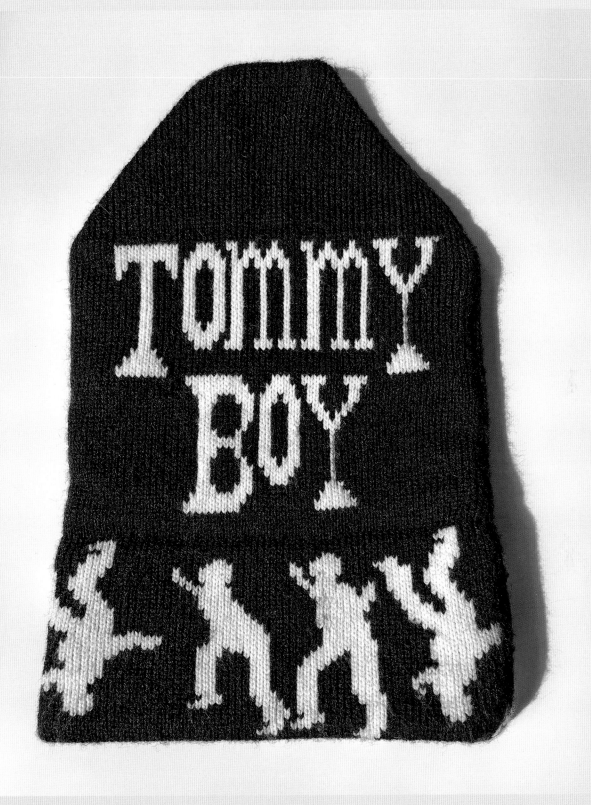

137

OPPOSITE,: Monica Lynch wearing a Tommy Boy ski hat, circa 1982.
Prototypes of Tommy Boy beeper cases, late 1980s.
Tommy Boy ski hat, circa 1982.

SHOWING OUT ON THE DEUCE

April Walker at the 42nd Street wall, 1983.

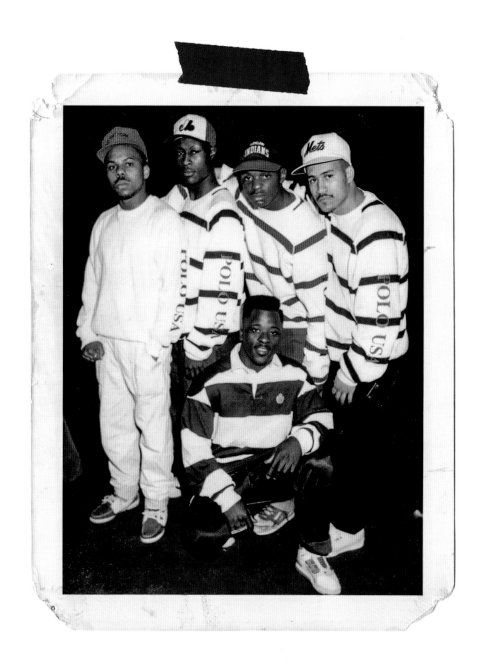

I n the moment, 42nd Street seemed like the center of the world. Not far from where the Times Square ball drops every New Year's Eve and a stone's throw from the nearby NYPD Times Square station, a row of phone booths lined the outside. Times Square was an entire universe, complete with its own rules and visual signifiers. Starting in the late '70s and on through the '90s, kids from as far as the Bronx, Brooklyn, and Harlem came to walk the makeshift runways of Times Square, dressed in street fashion's finest and ready to "show up and show out" on "the Deuce."

The stretch of 42nd Street between Seventh Avenue and Eighth Avenue, nicknamed "Forty Deuce," was both Manhattan's cultural life force and its seedy epicenter. It was known for peep show theaters, chain snatchers, junkies, hustlers, and just about any diversion and perversion one could dream up. Grindhouse theaters showing kung fu flicks drew young teens like Wu-Tang Clan's RZA to get lost in the otherworldly possibilities of the Deuce. The films that RZA watched instilled a sense of brotherhood and an honor code in him. They allowed him to imagine a world beyond that was equally transgressive. Early hip hop clubs like The Latin Quarter were nearby as well. In the mid-to-late '80s, The Latin Quarter, located at 47th Street and Broadway, was where legendary battles and performances from Public Enemy, LL Cool J, and many other artists laid the foundation for something that would change the world: hip hop.

Naturally, the Deuce was the place to be seen. It was also the place to be photographed. Perhaps most important, it was a place to see yourself. For the growing movement of hip hop style, seeing yourself and your peers was a statement of identity: "Here we are. Look at us. See our power pose and take our photo." Being photographed would be important in years to come; the photographs would serve as a living document.

Street photographers and the folks within the culture, armed with Polaroid cameras, set up airbrushed backdrops on the gates of shuttered and abandoned storefronts along the Deuce and invited people to pose and take away a photo. Many would set up wicker chairs in a classic style that became synonymous with hip hop portraiture.

If you don't have a picture on the classic Deuce wall, you are not official like that," said Thirstin Howl the 3rd, the rapper and entrepreneur from Brownsville, Brooklyn, and founding member of the Lo Life Crew. "The wall still remains to this day. It's crazy. I got pictures from my uncles in the '70s on the same wall in their '70s gangsta style. That same wall, that wall is tremendous."[1]

The tremendous wall in Times Square became the makeshift photo studio for hip hop's early style makers. When the media and mainstream had yet to recognize hip hop's potential as a style maker and trendsetter, kids from all boroughs "self-documented" their looks by posing for the handful of photographers who would set up makeshift portrait studios. Explained Mighty Nike, one of the founders of the early streetwear collective Shirt Kings:

> We would pay to pose in front of the backdrops and take away a Polaroid picture of the moment … Before the age of digital photography and Instagram, that's how you showed off and remembered your looks and fun with friends. It was the '80s so the style was Cazals, the jewelry, the sheepskin coats, the Nike suits, Pumas, Kangol hats. Either you had a short Afro or the waves in your hair … gold teeth—the usual '80s stuff. We wanted to look good, especially if we were going out that night. We would go to the Deuce and take pictures, see a movie, or go to a club if someone was rockin' that night. We did what we had to do to look fly. And we documented ourselves doing it.[2]

Moe, Bck Live, Disco, Thirstin Howl The 3rd, and Goo Money, Forty Deuce, 1988.

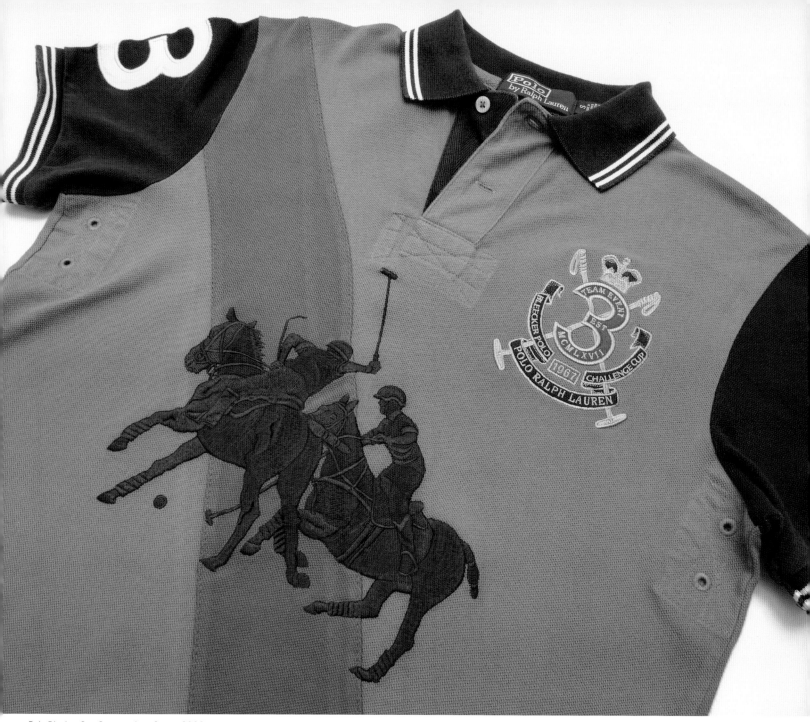

Polo Bleeker Cup Contest shirt, Spring 2009.

Fashion, art, and music were all coming together in front of their eyes. It was a different time, as hip hop style—the precursor to street style—was being born in a way that was quintessentially New York. Only kids in the greatest city could do it. Still largely isolated from the eyes of brands, influencers, and marketing strategists, hip hop style developed organically based on being "fresh to death" and a spirit of individuality. You wanted to be asked, "Where did you get those?" but—and sneakerheads will understand—you did not want to be asked, "What size are you?" by a dude pointing at your sneakers. Before the likes of Virgil Abloh, Supreme, Yeezy, and the multimillion dollar American streetwear industry of today, kids in the Polaroid pictures on the Deuce were laying the foundation for something big and global, even if they did not realize it at the time. This idea of documenting from within the culture—"self-documenting," to be precise—was a practice born out of instinct and the need for memory and historical writing. The photos command a respect, and the poses themselves, which were common among young inner-city youth, announced an arrival. A presence. "Here we are. Now look at us." It was a way of crafting their origin story and remembering a fleeting moment.

For collectives like the infamous Lo Life Crew, posing for and collecting Polaroids was a way of writing their own history. Comprised of mostly kids from the Brownsville and Crown Heights sections of Brooklyn, the Lo Lifes turned aspiration and upward mobility on its head and became notorious for stealing large amounts of Polo clothing from department stores.[3] Those who wore head-to-toe 'Lo became known as Lo Lifes. They were riffing on something seemingly unattainable. Starting in the early '80s and through the early '90s, Ralph Lauren marketed its Polo brand as the uniform of the elite class—wealthy white guys who played in polo matches and spent weekends on their yachts. That exclusivity had an unintentional effect on hip hop style. Recalled Thirstin Howl the 3rd:

> I lived on the Deuce like every Friday and Saturday night. Lo Lifes was born on the Deuce. That's where we would congregate.

And that's where we were letting the rest of New York know that we're out here doing us. And we coming through one hundred deep. I got the whole Brownsville coming with me, my whole project, you know—all everybody from Crown Heights. So this is what made the Lo Life presence so heavy. And of course, we had to always take a picture.[4]

The backdrops, often created by the graffiti and street-art legends of their day, evoked an aesthetic that was decidedly hip hop with airbrushed Mercedes logos and city skylines accompanied by slogans like "Living Large" or "Business as Usual." Shirt King Phade, of the Mighty Shirt Kings collective, along with his tight-knit group of graffiti-writer friends and artists made airbrushed backdrops that spoke to the culture. They featured colorful Mickey Mouse and Bugs Bunny characters wearing giant rope chain truck jewelry or holding a boombox. Like early street art murals, the backdrops served as the focal point for street-style stars of the day. In fact, the Polaroid phenomenon corresponded with a wave of entrepreneurs from the culture. Luxury brands were yet to recognize hip hop's ability to market and sell product, and even luxury stores did not always treat their Black customers with dignity. That recognition would come years later and, some say, at a cost. Streetwear's origins in Black culture grappled with major growing pains as the music started to dominate pop culture. Although the intersection of hip hop and branding was still light-years away, one can easily draw a through line right from the Polaroids taken on 42nd Street to the fashion world's current obsession with streetwear.

Said Fab 5 Freddy, cultural icon, artist and filmmaker who was instrumental in hip hop's evolution:

> I recall there would be these guys who would set up these little backdrops and wicker chairs where you'd sit and pose and capture that moment. And oftentimes with your homies, you get into these cool poses. That was a New York thing. A couple of guys in the front would squat down—you know, arms up—and do different little things. You had your best

gear on. You're with your close friends—your homies. And so, I think the tradition begins there. And then as folks began to develop their look, their swag, and all of that within hip hop music, you begin to photograph from within the culture. And so, that's where it begins.[5]

Said Thirstin Howl the 3rd:

> On any given Friday or Saturday night on the Deuce, there were photographers everywhere outside with their backdrops taped to the buildings and the gates. They usually had phrases from popular songs or they would have the design, the backdrops like the Gucci, the Polo. And it was only five dollars a picture. I'm always fly, and I always want to have a picture to show you that I'm fly. One of my biggest reasons for always taking pictures and getting fly was because I went to prison a lot. And every time you go to prison and everybody's wearing the same uniform now, so everybody's the flyest guy in the street and has a band. But what is your evidence? Like people don't have those pictures to show you how true and factual that was. So, any time I would get locked up, the first thing I'd tell my mom and my sister would be, 'Bring all my pictures up here.' I hung them up everywhere—all in the cells—and that's me out there.[6] The Polaroids were the proof that you were fly, so everybody wanted a picture. By the end of the night, everyone had a Polaroid. Even if you look in the picture, you could see some of the dudes are actually holding their Polaroids because once you and your homies took a picture, you get it, look at it, and then you pose for another one.[7]

Shirt King Phade recalled:

> The camera was not as ubiquitous as it is now, and besides the media and mainstream were not looking at us yet. Today, everybody has a high-definition camera in their pocket, and Instagram allows you to document yourself and tell your story. We didn't have that back in the early days.[8]

"It's really important to overstate the fact that we all had the foresight to pick up a camera," said historian and curator Koe Rodriguez:

> To go to the Deuce, Harlem, and other epicenters to document our young lives, which is ultimately our legacies, I think it was dope we knew back then that we had to record our lives as we were living it. For us to go home and say, 'Damn, I look great!' and share it with our people in jail or even give it to a home girl you were trying to push up on. And that was more of a reason to catch a flick and bump into somebody by surprise, like a girl or a crew. Like 'Y'all, let's get this shot!' It was your way of memorializing that particular evening.[9]

"That's true. Can we get a picture? Can I take a picture?" recalled designer April Walker, looking back to the self-documenting on the Deuce. As a young burgeoning designer and Brooklyn-bred style queen, Walker says the photographic memories hold the history.[10]

For the Polaroids that remain, tucked in closets or under beds, collecting a patina in home photobook collections, there is a story that was written. In looking at the images, we see a confidence—a swagger that belies the importance of believing in and documenting a nascent culture. The Polaroids suggest greatness and declare their presence. And all the while, the phenomenon of self-documenting through Polaroids fell to the wayside as cameras became ubiquitous and Times Square went through a Disneyfication that now sells the brands that were influenced by the very kids posing in front of the backdrops on the Deuce.

And you don't stop.

Notes
[1] Thirstin Howl The 3rd, interview with author, August 15, 2021.
[2] Clyde A. Harewood (aka Mighty Nike), interview with author, July 18, 2021.
[3] Cassidy George, "How a NYC Gang Took Ralph Lauren from Country Club Uniform to Streetwear Staple," *Indie*, December 11, 2018. https://indie-mag.com/2018/12/lo-life-crew/.
[4] Thirstin Howl The 3rd interview.
[5] Fred Brathwaite (aka Fab 5 Freddy), interview with author, August 15, 2021.
[6] Thirstin Howl The 3rd interview.
[7] Thirstin Howl The 3rd interview.
[8] Edwin Sacasa (aka Shirt King Phade), interview with author, August 15, 2021.
[9] Koe Rodriguez, interview with author, August 15, 2021.
[10] April Walker, interview with author, August 15, 2021.

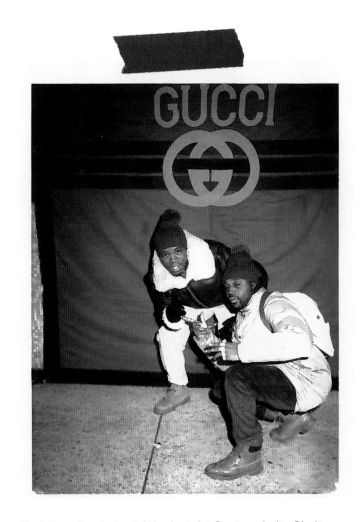

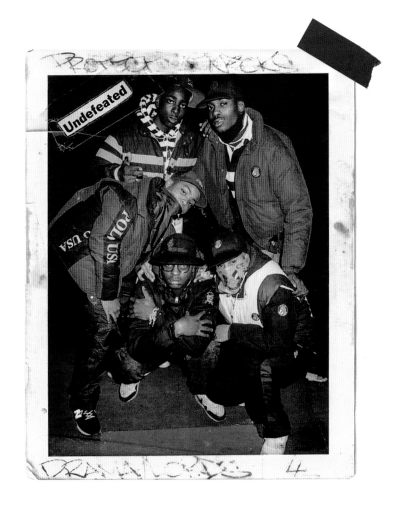

Nike (left) wearing a leather flight bomber jacket, Benetton polo shirt, Fila ski cap, and classic Timberlands, Phade (right) wearing a Fila ski cap, Woolrich down feather coat, Benetton backpack, suede pants, and caramel Timberlands. 1986.

Undefeated Mask Men, Forty Deuce, 1989.

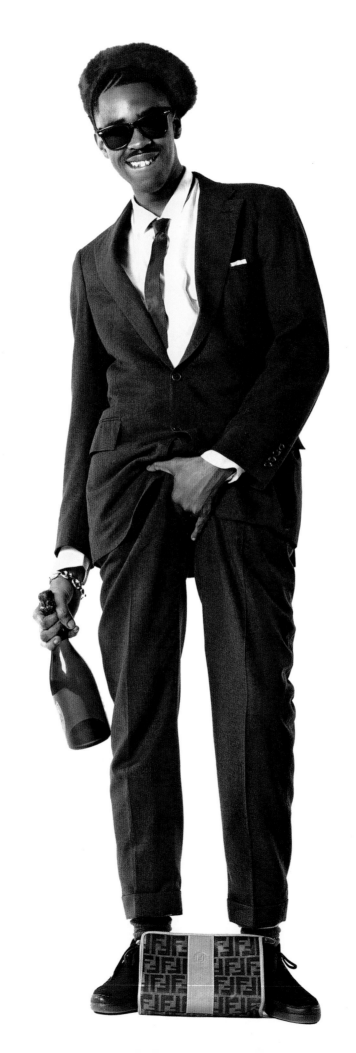

RATCHETDEMIC: THE ULTIMATE COLLIDER

Slick Rick, New York City, 1988. Photo: Janette Beckman.

The dopest emcee I have ever heard rocked meticulously shined penny loafers and a Ralph Lauren tweed blazer and paperboy hat, perfectly tilted to the left. As he stood against the backdrop of the Fort Greene projects in Brooklyn, he projected a bravado and energy that dared anyone to question his credibility. His lyrics were like a screenplay and, somehow, his style fit them perfectly. He held traditions in his style—old school, new school, and a little bit of the present. In it were dimensions of both the past and the future. The look had generations crashing against each other. I did not have the words to describe it back in 1993, but today, I would call that brother "a collider." In science, a collider is a machine that crashes opposing particle beams together to create energy. Hip hop is the ultimate collider. It crashes together particles of culture from people across the globe and creates new energy that is manifested in music, dance, expression, and, most importantly, style. To be hip hop is to be a collider. When collisions happen in the culture, new style is produced.

Biggie Smalls opens up the first song on his 1994 debut album *Ready to Die* with a reference to *Word Up!* magazine. The magazine was where many young people could get a peek into the lives and clothes of their favorite artists. I would admire the bright colors and gold rope chains in *Word Up!*, but I also used to read *GQ* magazine. The perfectly tailored suits spoke to me just as much as the Cross Colours and Karl Kani. I could always spot the people who allowed those worlds to collide in their own iteration of hip hop style. I would see the *Word Up!*–*GQ* hybrids who were distinctly hip hop and who made something magical of their own. The jacket on page thirteen of the Brooks Brothers catalog, plus the trousers on page twenty-three of *GQ*, with a baseball cap was a collision that blew my mind and that I wanted for myself. I saw many other collisions—skater pants and rugby shirts with Africa medallions, African prints with dress shoes and fedoras—but of all the style collisions that happen in hip hop, the one that resonates most deeply with me is the one with which I opened this chapter. It is the one that happens when the

"ratchet" and "academic" come together. It is the merging of what society deems to be lowbrow or uncultured with what is seen as elite and highbrow. These collisions are what I call "ratchetdemic." To be ratchetdemic is to be equal parts ratchet and academic. The ratchet part embodies the attributes too often associated with the urban poor—the population that birthed hip hop. It is defined as unrefined and viewed as too current to have a lasting tradition. Stylistically, it is tagged as concerned only with flair or flash as it shows up in accessories such as the chain, gold fronts, and a bulky watch. It says, "Look at me!" because for too long it has been overlooked, demeaned, and silenced.

The academic part of ratchetdemic has its own style. It is deeply rooted in tradition and has access to power, so it does not have to be too loud. It is the vision of the American dream that brands are built on: the uniforms of Ivy League institutions and the style of those with wealth and success, the aspirational aesthetics of Ralph Lauren advertisements, and clothes that were not designed for Black bodies but have proven to be most valuable in the current era when they adorn skin infused with melanin.

Academic style is perfectly captured in the blazers and khakis of elite prep schools. Ratchetdemic style is literally the turning of the metaphorical blazer inside out. Think of the scenes from the TV show *The Fresh Prince of Bel-Air*, in which Will turned his prep-school blazer inside out to reveal a colorful pattern. Academic style was also vividly captured in the classic Janette Beckman photograph of Slick Rick grabbing his crotch as he stood wearing a Ralph Lauren suit and Kangol hat with a Fendi bag at his feet. Will Smith and Slick Rick were embodying ratchetdemic collisions. Will kept the jacket but wore it differently. Slick Rick somehow melded high fashion, classic American Ivy style, and the British Kangol into a pure expression

André 3000, 2004.

of hip hop. Each piece of the outfit belonged to a different culture. Each seemed to be made for a different body and yet all together on the body of Slick Rick, it became hip hop.

Ratchetdemic style is most apparent in the details that allow the hip hop to spill out of what could otherwise be seen as traditional and Eurocentric well-dressed, or as dandy style. As a variation on this understanding, the Black dandy is a powerful conceptual framework for making sense of Black male style traditions. According to scholar Shantrelle P. Lewis, "Black men in the United States have set numerous fashion trends, from the zoot suits of Cab Calloway to the tight leather jackets of the Black Power movement's Huey Newton and Bobby Seal."[1] These traditions represented dressing well or being stylish, but also stood out distinctly from the more traditional style choices associated with an Ivy League or aristocratic aesthetic. Tweed blazers, rep ties, and well-fitting tailored jackets are associated with the dandy.

I have deep reverence for the historical roots of the Black male dandy that was birthed out of a desire to be seen as having value in a world intent on extracting self-confidence and worth. The histories of Black male dandy style in the United States are brilliantly articulated by Monica L. Miller in *Slaves to Fashion: Black Dandyism and the Styling of Black Diasporic Identity* (Duke University Press, 2009). The book, and others like it, speak to the ways that Black style is essential to Black identity. A ratchetdemic style comes from this lineage but draws deeply from where it was birthed: hip hop style. Hip hop, and the ratchetdemic style it creates, is not an adoption of dandyism or Ivy traditional style. It is born out of what emerges when they crash against each other and then also collide with the cultural expressions and styles of the ratchet and the academic within the hip hop collider. This creates a style and sensibility that pairs the tweed blazers of old-school professors with Japanese denim, wing-tips, argyle socks, and African prints in pocket squares. It reimagines boundaries and bridges them in ways unrecognizable to the original cultures before they met hip hop.

Ratchetdemic style may hold a prep-school formal structure that leans into a certain rawness in what is worn and how, or it can be street fashion paired with traditionally elite style. I believe that being ratchetdemic is about intentionally pushing back against tradition and respectability with a passion for knowledge—the pursuit of it and showing it to the world. The essence of ratchetdemic style can sometimes be in the kicks one wears with a three-piece suit or the walk, talk, gestures, and aesthetics that can draw equally from the club and the lecture hall. Ratchetdemic style pulls from W.E.B. Du Bois's style and Dapper Dan's designs to create something like André 3000 at the Sundance party in 2004. It is Brooks Brothers and Jordans—with some Louis Vuitton on the side. It is sophisticated elegance meets urban authenticity.

When ratchtetdemic style shows up everywhere and on all bodies—especially bodies that engage in hip hop—power or value is not just held by white folks with advanced degrees. The clothes reimagine one's relationship to value and worth. When rapper and singer Jidenna draws from and reimagines traditional GQ-esque aesthetics in the video for his song "Classic Man" (2015) and in his performances, the tailored suits, ties, and pocket squares pair with Afrocentric patterns and prints. Through his aesthetic choices and words, he affirms his worth in powerful ways. As an educator and emcee, I believe the essence of my existence is communicating words, concepts, and ideas to people. I have come to understand that those two titles are one and the same because the best teachers know how to emcee and the best emcees use their platforms to teach. I have also come to understand that style is how emcees communicate beyond words and express the fullness of our beings. The glasses enhance the eyes and brows, and the bracelet and watch on that wrist speak. The body teaches, and what adorns the body is the co-teacher. The pocket square that sheepishly peeks from the breast pocket of the blazer says pay attention. The soft crease at the hem of deep blue jeans that show my argyle socks says "I care about the details." The goal is to be ratchetdemic—to look like an academic and intellectual *and* be hip hop.

Literature professor and public intellectual Edward Said once said, "I think only a serious intellectual can take an interest in appearances,

because appearances are very important. And only somebody who is seriously interested in appearances can be a serious intellectual, and care about things of the mind."[2] To be hip hop is to be an intellectual, and that is why so many in hip hop take the uniform of the intellectual and repurpose it. It is why Ralph Lauren's 2022 campaign centers on Spelman and Morehouse Colleges. American fashion has had to evolve and embrace the beautiful ways that Black bodies fit into the traditional American aesthetic. The drivers behind that evolution are the collisions that hip hop creates and the ratchetdemic style it produces.

Notes
[1] Shantrelle P. Lewis, "Fashioning Black Masculinity: The Origins of the Dandy Lion Project," *Journal of Contemporary African Art*: 54–61.
[2] Tariq Ali and Edward W. Said, *Conversations with Edward Said* (Kolkata, India: Seagull Books, 2006), 128.

Jidenna, 2016. OPPOSITE: Jidenna, 2015.

Kanye West performs at Dave Chappelle's Block Party in Brooklyn, 2005.
Photo: Jamel Shabazz.

BLACK BY POPULAR DEMAND AT HBCUS by Alphonso McClendon

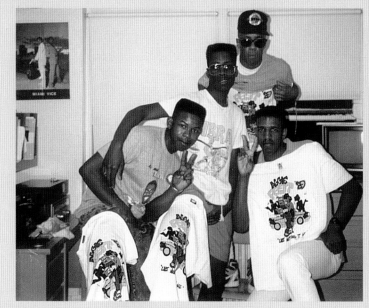

"We're trying to raise at least 5,000 Black leaders in this country. We're trying to raise the consciousness of Black people."[1]
—James Allen (Public Enemy)

It's a Black Thing

Years before the Black Lives Matter movement, historically Black colleges and universities (HBCUs) heralded the ideology of "Black by popular demand" and "It's a Black thing you wouldn't understand." This cultural upsurge of the late 1980s and early 1990s, expressed in knowledge, dress, and mannerism, was progeny of James Brown's "Say It Loud—I'm Black and I'm Proud" (1968). Now, rhythm and blues and funk were succeeded by a musical score of hip hop, rap, and house music that fused cultural beliefs with Black-owned style. Through alternative knowledge sources and evangelizing rap lyrics, Black students were guided to "reject the selfishness and individualism of the 'Me Generation' and confront serious life issues."[2] Academic excellence, campus engagement, cultural elevation, and political influence were adjacent to this grassroots Black philosophy.

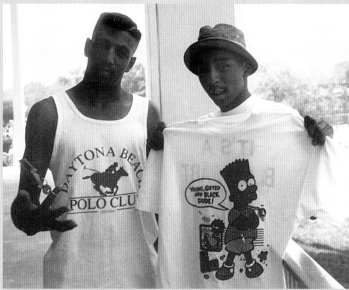

At North Carolina A&T, Hampton, Howard, Morgan, Florida A&M, North Carolina Central, South Carolina State, and other HBCUs, students received this experience through homecomings and spring fests, where hip hop and rap performers by invitation ministered their urban doctrines and aesthetics on Black struggle, liberation, and advancement with the dopest lyrics and beats. Kid 'n Play, Queen Latifah, Rob Base, Public Enemy, Big Daddy Kane, Run-DMC, Naughty by Nature, KRS-One, and others traveled from New York City and New Jersey to disseminate their art throughout the South and Southwest. The word "Black," removed of oppressive negativity, was reclaimed as code for cultural membership, consciousness, and street intellectualism. To utter the phrase "It's a Black thing you wouldn't understand" was to embrace

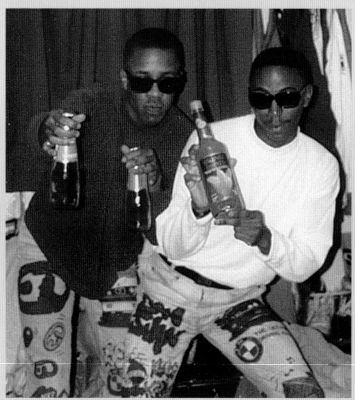

THE A&T REGISTER

Homecoming — "COMPLETE AWARENESS FOR COMPLETE COMMITMENT" — Supplement

Volume LXII Number 6 NORTH CAROLINA AGRICULTURAL AND TECHNICAL STATE UNIVERSITY, GREENSBORO Wednesday, October 11, 1989

Exclusive Interview

Public Enemy Urges Student Awareness

LaVonne McIver
Editor-In-Chief
and
Shermonica Scott
Staff Writer

After much criticism surrounding their Homecoming appearance, a controversial dance, rap group incorporated a message of black empowerment through their performance at the Homecoming pre-dawn appearance. Public Enemy, who recently topped the charts with the song "Fight the Power" encouraged students to be conscious of their curriculum and to know whose making the decisions about the books they are required to read.

They also encouraged students to be pro-black, "and not anti anyone."

James Allen, a member of the group spoke with The A&T Register Editor-in-Chief, LaVonne D. McIver and Staff Writer, Shermonica E. Scott in this exclusive interview.

Register: Why do you carry guns during your performances? Is this advocating violence to the youth?

Allen: No. We see violence everyday. If you understand what the uzis represent—the way we were brought over here—under bondage and with guns.

Register: Why do you think that white America is afraid of you?

Allen: Because, if you notice, in our shows we do our steps in order. We are synchronized. This means that we represent order in our schools, hospitals and in our communities, and with order we can change things. That's what scares them.

Register: In the song "Channel Zero" the group expresses its perception of a disillusionment on the part of blacks. Would you explain?

Allen: Well, "Channel Zero" means we watch foolishness on T.V. None of it has significance to our everyday living. The reason we say she is because if we get the black woman we will get the black man. She will tell it to him.

Register: What is Public Enemy trying to accomplish through its music?

Allen: We're trying to raise at least 5,000 black leaders in this country. We're trying to raise the consciousness of black people.

Register: How do you see the future of blacks in America?

Allen: I see us coming together, and the only way we will come together will be through chastisement.

Register: How do you see the black male in America?

Allen: The black man is in a shallow grave. He is almost conscious and all it takes is a doctor who can apply the right medicine.

Register: What is the source of the material for your lyrics?

Allen: From the books we read. Like "Message to the Black Man" by Elijah Mohammed and "How Europe Under-developed Africa" by Walter Rodney. There are so many other books.

Register: What, if anything do you feel your

Public Enemy cont. on p. 2

Public Enemy entertains an excited A&T crowd, Friday, at A&T's Homecoming Pre-dawn dance, the group challenged students to be socially and politically conscious.

Speaker Urges Teachers To Nurture Students

Robin B. Alston
Special to the Register

The Afro-American community is constantly "losing ground" said the president of Bowie St. University, James E. Lyons.

While speaking at the 98th Annual Founders Day Convocation, Thursday, October 5, Lyons encouraged blacks to continue to strive for the things that make them successful.

"We may be falling behind straightway by the direction started by our founders," Lyons said.

According to Lyons, many African American youth focus on the wrong issues.

"Your problem is that you are suffering from the Big Daddy Kane, Kool Moe Dee syndrome," said Lyons. "That's why we are loosing ground."

Lyons said that teachers must aid students if students are to be successful.

"The faculty must plan for the future and put in the time to help students avoid pitfalls," said Lyons.

"Lest we loose ground and fall behind, we better get back on the stick," said Lyons. "And go to the things that make us strong."

"There are other Ron McNairs and Jesse Jacksons that can be nurtured and brought along," said Lyons. "It's up to the faculty to bring them up like these great leaders."

Lyons also said that alumni should give more than money to support their institutions.

"The alumni must support the institution with time, energy and direction and not just financially," Lyons said. "We have the resources to support our institutions."

Lyons who is the second president of Bowie State University. At Kentucky State University he served in the Peace Corps and also in the public school system.

He was once the vice-president of Barber Scotia College and Delaware State University.

State University is from New Haven, Conn.

He has been involved in numerous academic pursuits as well as with administrative services.

served as the vice-president of academic affairs.

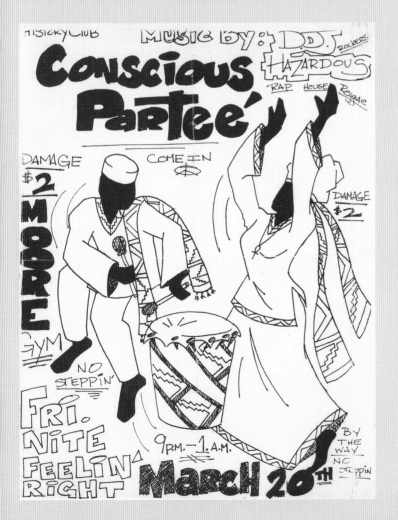

African ancestry, beauty, love, adversity, and the unique experiences of people of color in America. Black college students seized this adage to signify their collective power at HBCUs and celebrate their generation's music, art, and literature. Dressin', stylin', and posin' was agency to proclaim this identity. Colorful graphic tees and caps with messages on Black greatness, neck medallions and buttons of the African continent, and graffiti-art jeans displayed empowerment and pathways to economic freedom. Even Hollywood got remixed with Bart Simpson, the fictional character on the animated series *The Simpsons*, transformed into Black Bart on T-shirts, proclaiming "young, gifted, and Black, dude!"

You Wouldn't Understand

A union of cultural knowledge, hip hop music, and style defined the new Black consciousness. Scholarly pursuits were bolstered by external publications that preached of the miseducation of Black people. *The Black Student's Guide to Positive Education* (Nubia Press, 1996), *Introduction to African Civilizations* (Citadel, 2001), *Black Men: Obsolete, Single, Dangerous?* (Third Word Press, 1991), and other narratives disseminated wisdom, Afrocentricity, "history from his-story," and individual responsibility.[3] In a late-80s post-performance interview at A&T, James Allen, a member of Public Enemy, professed that the inspiration for the group's lyrics and storytelling came "from the books we read like *Message to the Black Man* by Elijah Mohammed [sic] and *How Europe Under-developed Africa* by Walter Rodney."[4] The cultural pulse at HBCUs was nourished by albums like *Fear of a Black Planet* (Public Enemy, 1990), *All Hail the Queen* (Queen Latifah, 1989), *Long Live the Kane* (Big Daddy Kane, 1988), and many more riveting

OPPOSITE: Photos from North Carolina A&T State University, Greensboro. TOP: Four freshman guys in Scott Hall (left to right, Sam Bryant, Edward Fullwood, Joseph Wilkerson, and Leonardo Ballard), May 1989. MIDDLE: Sophomores Alphonso McClendon (left) and Sam Bryant (right, with Black Bart T-shirt), May 1990. BOTTOM: Two freshman guys in Scott Hall (left, Alphonso McClendon; right, Edward Fullwood), May 1989.

releases that freed students from status quo and Eurocentric norms, imparting a modern Black revolution. From the Bronx, Queens, Brooklyn, and Compton, this youthful vigor ignited consciousness, improvisation, and affirmation of "Black by popular demand."

Notes
[1] LaVonne McIver and Shermonica Scott, "Public Enemy Urges Student Awareness," *The A&T Register* 62, no. 6 (October 11, 1989): 1-2.
[2] Baba Zak A. Kondo, *The Black Students Guide to Positive Education* (Washington, D.C.: Nubia Press, 1987).
[3] Kondo, *The Black Students Guide.*
[4] McIver and Scott, "Public Enemy Urges Student Awareness."

I HAD TO BE DOWN: The Making of a Hip Hop Archivist by Syreeta Gates

It was all a dream. Not really, but it felt like it. I remember the exact moment when I fell in love with hip hop. It had to be '95 or '96 because my uncle had a cream SC400 Lexus Coupe. Sitting in my grandparents' house, I could hear his speakers blasting the song "Jeeps, Lex Coups, Bimaz & Benz" (1995). I would learn later that my uncle was bumping Queens' finest: Lost Boyz.

And then they walk in. Imagine in slow motion: my uncle is rocking a gold and black Versace silk shirt (it's flowing) with matching shades, and my cousin is killin' 'em in a DKNY bodysuit. End slow mo. I was too young to know about Biggie Smalls and Lil' Kim, but the streets had seen the hip hop icons in the same outfits. For young Syreeta, one thing was crystal clear: I needed to be down.

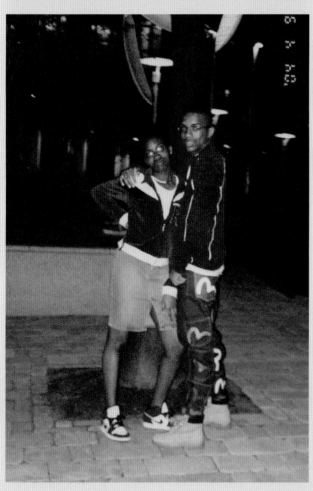

OPPOSITE: Syreeta Gates on her 2nd birthday with her uncle's rope chain.
Syreeta Gates with friend, wearing custom pieces she designed inspired by Jeff Hamilton jackets.
Syreeta Gates in Polo Rugby hat, shirt, bag, and socks with Evisu jeans and Duck boots.
Syreeta Gates in Jordan 1s and Rocawear velour jacket and friend "Diddy" in classic Tims and Evisu jeans.

159

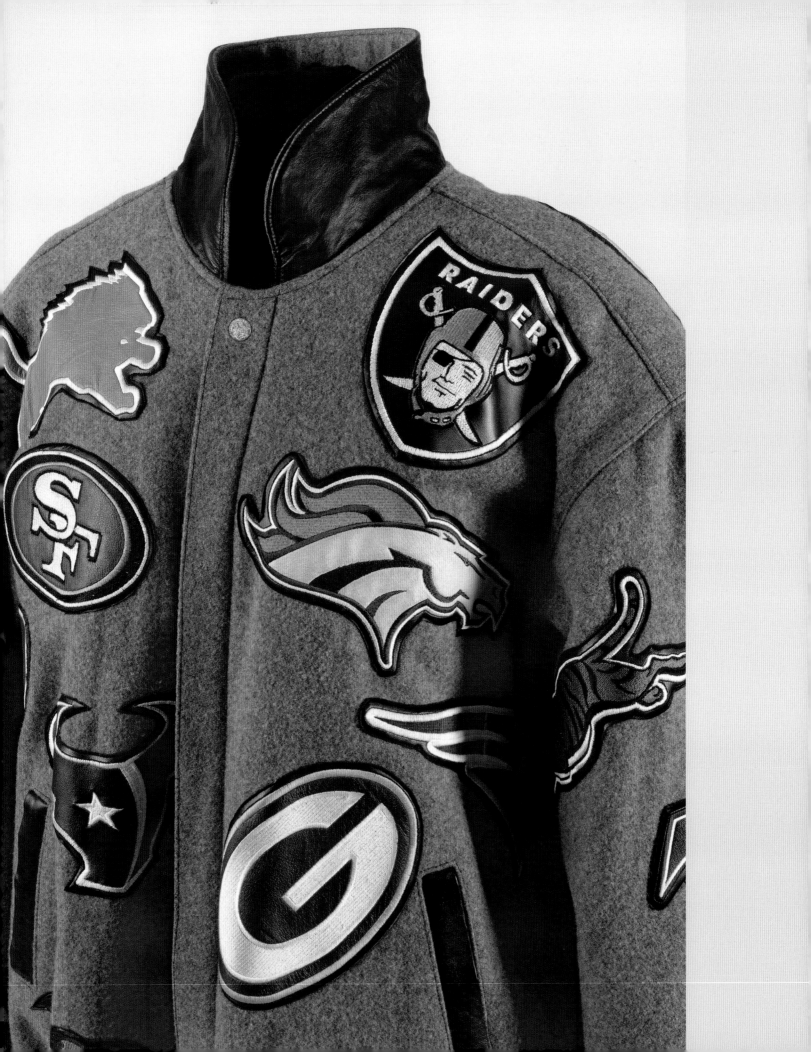

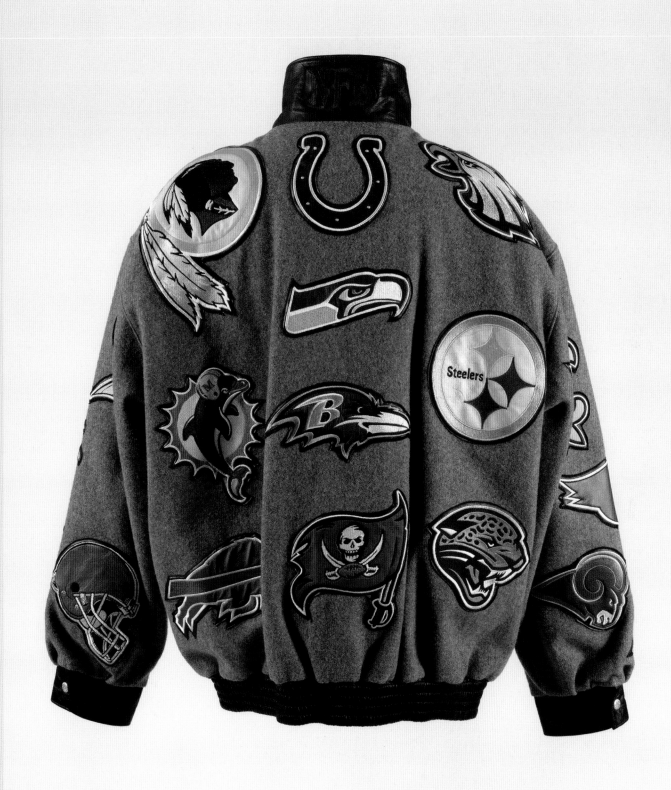

Jeff Hamilton x Reebok NFL, 1990s.

I was immersed in hip hop fashion. Even in my Catholic school uniform, I tried to get jiggy. I wore Polo every day. Next, I added Rugby, thanks to Kanye West. In high school, I went to Genesis on 59th and Lex to buy my Vansons. I was running around New York City with my student Metrocard looking for the new EVISU jeans. I was selling custom pieces with the NBA patches on them. (The Jeff Hamilton jackets were poppin' at that time.) I knew I wanted to do something in fashion. Exactly what? No clue.

My uncle would have me call luxury stores to make orders. "Hey Ce, call the Gucci store and order me the loafers in a 10.5." Or, "Let's go to Apollo Express on 125th Street to get the new America's Cup Pradas." Mind you, this was late 2001, early 2002, before Ashanti wore them in the "Happy" music video.

By the time I graduated high school, my friend Sinceré Armani and I had really gotten serious about fashion. We would drive down the FDR from Harlem to Brooklyn and I would say, "Yo! You gotta style, Nicki. You gotta style, Drake." I had to do my homework in regards to who was styling whom in the culture. The names that consistently popped up were Misa Hylton and June Ambrose.

After years of calling brands, I called Polo's corporate office and got to work with Rugby's marketing department. I went through a year-long program with Polo Ralph Lauren and cocreated a limited-edition jacket. Ralph personally offered me a job after our final presentation. And after interning for June Ambrose, my girl Sinceré went on to style Nicki Minaj, Puffy, Rick Ross, and a host of others.

Even as a youngin', I knew that fashion was a vital element in the culture—but never acknowledged as such. I started collecting and discovered that archiving is a statement of value. Founding The Gates Preserve has been one of the most rewarding things I've ever done. I think back to little Ce sitting in her grandparents' house, who could never imagine that I would support Misa Hylton in creating her archive—the one who put Lil' Kim in the DKNY bodysuit for my cousin to mimic. I could not fathom building a Lo Life archive. It all just feels like home.

Who ever thought that hip hop would take us this far?

Converse All-Star, 1999.

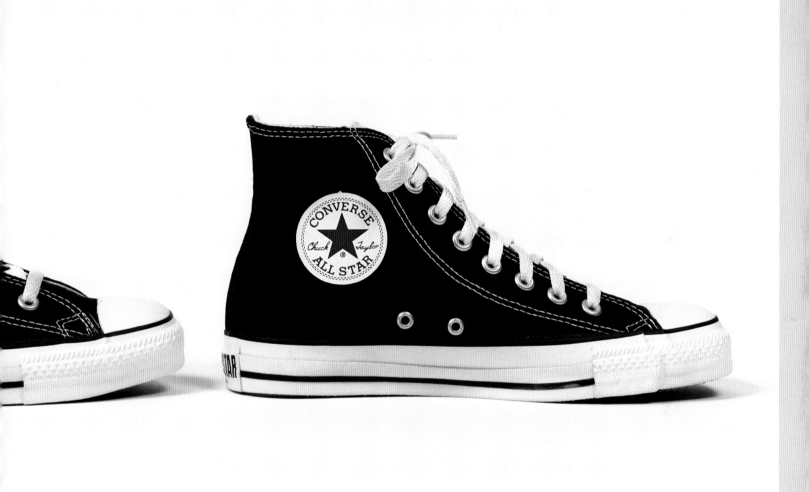

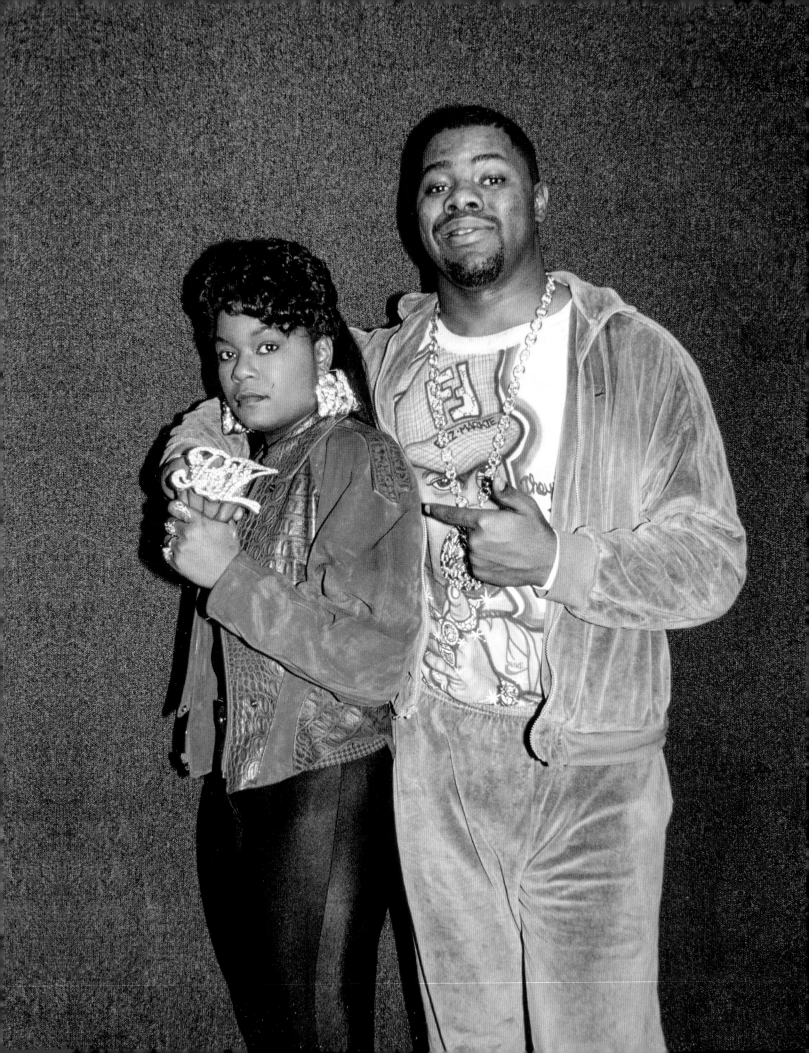

NAME GAME: THE HIP HOP NAMEPLATE

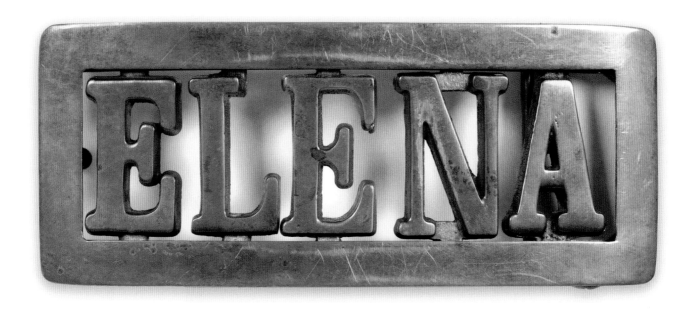

WRITTEN BY ISABEL FLOWER & MARCEL ROSA-SALAS

In September of 1989, Biz Markie released a single just a few weeks ahead of his second studio album, *The Biz Never Sleeps*. His song "Just a Friend," which divulges the late New York rapper's frustrations with a woman he's crushing on, was an instant hit, landing on "Top 40" charts around the world. The song remains consecrated as groundbreaking to the at-the-time fledgling genre of hip hop. In the iconic music video directed by Lionel C. Martin, nameplates are the crux of a love triangle as well as a symbol of both devotion and betrayal. Biz ceremoniously gifts his dream girl a nameplate pendant set in a thick gold curb chain. She soon leaves for college, where a phone call from Biz is visibly intercepted by the hand of her so-called friend, who is stacked with gold bracelets and name rings, while the necklace that Biz gave her lies discarded next to the phone.

The choice of the nameplate as a cornerstone of the storyline and the sartorial epitome of infatuation in the "Just a Friend" video exemplifies the age-old link between romance and jewelry in the form of one of the biggest trends of the era. (Biz also wears his own diamond-studded three-finger name ring on the single's cover art.) It also perfectly encapsulates the nameplate as not only synonymous with the birth of hip hop style but also inseparable from the transformation of the once-niche art form into a global cultural movement.

The tradition of wearing text—specifically, names—is as old as human language. In fact, the historical origins of nameplates extend back centuries—even millennia. Ancient Egyptians incorporated hieroglyphic writing into their jewelry. Pharaohs and members of the upper classes dipped gold signet rings engraved with their names and titles into wax as a way to sign official documents.[1] During the late medieval period, the English inscribed gold rings with poems, religious texts, and names. These objects, called "poesy jewelry," were exchanged between loved ones and spouses.[2] By the early 1830s, jewelry featuring the Hebrew word "mizpah" (meaning "watchtower") was produced predominantly in England and the

United States, and was exchanged between people as a sentimental token of love and protection.[3]

Wearing names and phrases to memorialize a close relationship or to mourn the deceased continued into the turn of the twentieth century. During both world wars, charm bracelets and brooches adorned with words such as "Mother" and "Sweetheart" were worn by women as a symbol of connection to their loved ones fighting overseas.[4] Personalized jewelry has even been discovered in seemingly unexpected locales. One of several objects salvaged from the ruins of the R.M.S. *Titanic* wreck of 1912 was a rose gold and silver bracelet with the name "Amy" written in script and set with diamondettes.[5]

Imperialism, migration, and other forms of global movement brought regional styles of name jewelry to new locales, where hybrid cultural interpretations were born. Upon the death of her husband Prince Albert in 1861, the United Kingdom's Queen Victoria popularized mourning jewelry, which bore names and phrases to acknowledge the deceased.[6] Hawaii's Princess Lili'uokalani had several bangles made for herself in the mourning jewelry aesthetic, embossed with names and messages in Old English lettering. One of the bracelets spelled out the Hawaiian phrase "Hoomanao Mau" ("Lasting Remembrance"), and another, which was made of silver, was inscribed with "Liluonamoku" ("Lili'u of the Islands").[7] When Queen Lili'uokalani traveled to England in 1887, Queen Victoria presented her and the Hawaiian royals with bangles engraved with their names as a token of diplomacy. Upon their return, members of the royal court had bracelets like the ones they had received made for friends and family members, which soon became must-have items for Hawaii's elite.[8] For more than a century since, Hawaiian heirloom jewelry has been treasured across the archipelago and exchanged on birthdays, graduations, and weddings.

Nameplate belt buckle, circa 1986.

Today, thanks both to this rich and varied history and to the surge in popularity catalyzed by the rise of hip hop, nameplate jewelry encapsulates a wide range of styles of personalized necklaces, earrings, rings, belt buckles, and bracelets that display names and other written words. A nameplate is typically fabricated from a single piece of precious, semiprecious, or base metal that is either hand-carved or cut using specialty laser machinery. Wearers can tailor nearly every aspect of their jewelry design, including the size, materials, the font used to spell the name, the style of chain or earring, and the embellishments that frame the name, which often include details such as hearts, stars, doves, swooping underlines, and cartoon characters.

Although nameplate jewelry's popularity has taken shape within a vast array of communities and contexts, it is most widely recognized today as a fashion staple that is part and parcel of the multilayered creative phenomenon of hip hop. As cultural historian Jeff Chang and others have argued, hip hop's modes of expression declared the presence of its inventors—primarily Black and Puerto Rican youth in New York City's South Bronx—within a sociopolitical context that enforced their marginalization through systemic poverty, displacement, and other targeted austerity measures.[9] Established through its four founding pillars—deejaying, emceeing, break dancing, and graffiti writing—the importance of a singular identity and style is at the core of hip hop's ethos and often communicated through customization—from original nicknames and ways of dressing to unique musical cadences and dance moves.

According to historian and journalist Elena Romero, nameplate jewelry was a popular way for early emcees to show off their monikers. This aesthetic also caught on among the break dancers of the late '70s and early '80s. B-boys and B-girls favored oversized single-plated gold necklaces designed with a Chinese calligraphy–inspired font colloquially known as "Kung Fu," which was lifted from the graphics of martial arts action films popular at the time.[10] Former break dancer and graffiti artist Willy Perez (aka "Almighty Chillski") nostalgically recalled the core elements of the classic B-boy

Fly Girl, East Flatbush, Brooklyn, 1982. Photo: Jamel Shabazz.

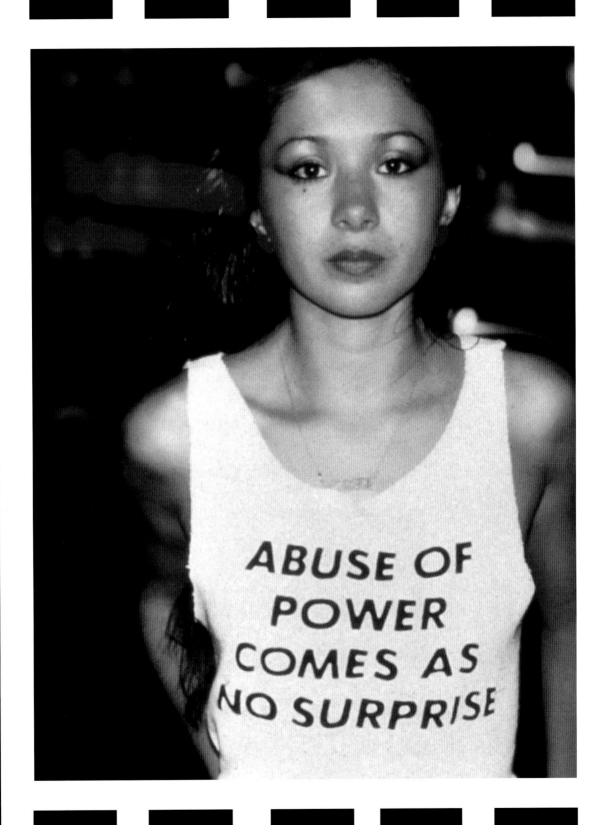

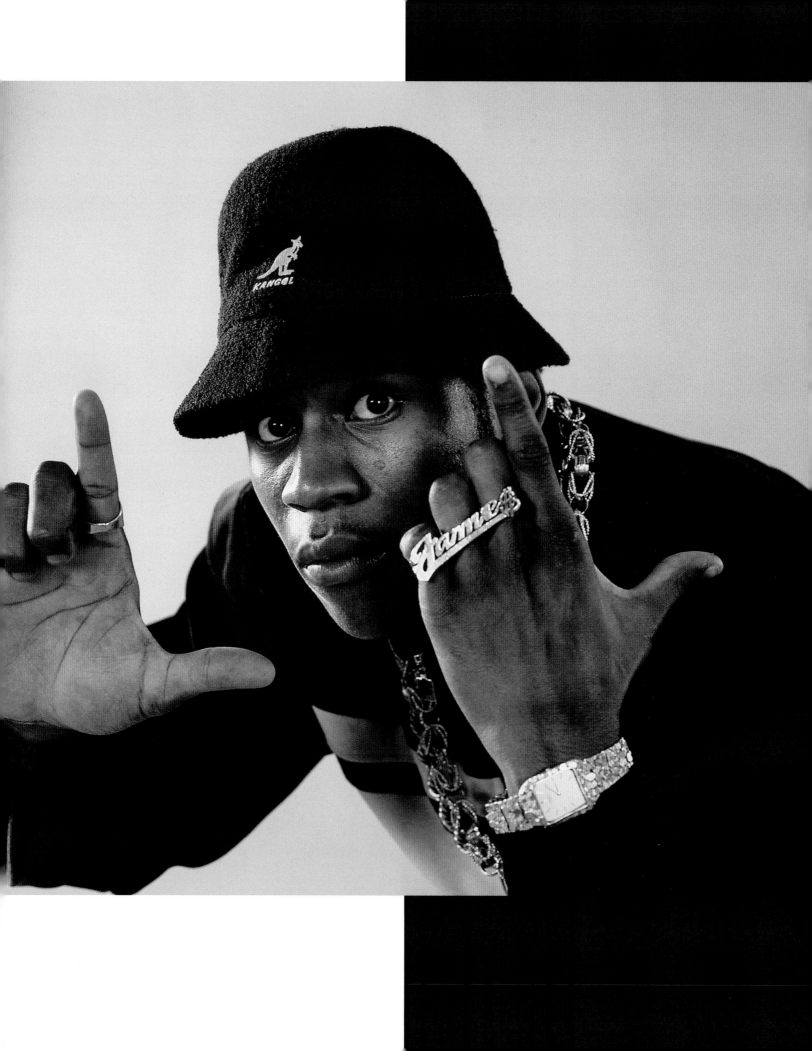

get-up in the caption of a 2019 Instagram post, which featured a snapshot from 1985: "Simple mathematics: Big nameplate + Perro t shirt + Permanent creased up Lee Jeans + A Pair of Adidas Shelltoes = B Boy 4Eva."

The nameplate's place in hip hop style was quickly cemented by early rap lyrics, in the 1985 song "A Fly Guy" by Pebblee Poo of the Harlem rap trio Master Don Committee. In the song, she assures her audience that her nameplate chain and earrings are not electroplated but made of real gold. Known for his storied collection of ten four-finger nameplate rings, LL Cool J rapped about his nameplate that read "I wish you would" in his 1987 hit song "I'm Bad." Pebblee Poo and LL Cool J's jewelry choices were part of the "truck jewelry" aesthetic, which emerged in parallel with crack cocaine in the mid-1980s, when hip hop was heavily influenced by the sensibilities of street personalities like pimps and people trafficking narcotics—from kingpins to local dealers.[11] Set against a stark urban landscape, the opulent gold jewelry worn by these neighborhood figures was an aspirational symbol of financial and social status. Their fashion senses were also influenced by those with whom they did business.

In a 2019 interview, cultural historian and archivist Professor Q, who runs the popular Instagram account @albeesquare87, recounted that "A lot of the influences for [gold jewelry] in hip hop came from specific kingpins who were emulating the Italians they were doing business with."[12] Here, he references particular trends such as Figaro and Mariner links, as well as gold pinky rings. Truck jewelry's grandiose pieces were a product of New York City's multiethnic cultural influences—from the oversized gold sported by popular Jamaican ragga and dancehall artists to Italian Americans' tradition of exchanging gold chains, including nameplates, between family members.[13]

Hip hop's pioneers drew inspiration from everyday urban life, in which business transactions, street corners, and nightlife were spheres of cultural contact, exchange, and hybridity. As a result, their

LL Cool J, New York City, 1987. Photo: Janette Beckman.

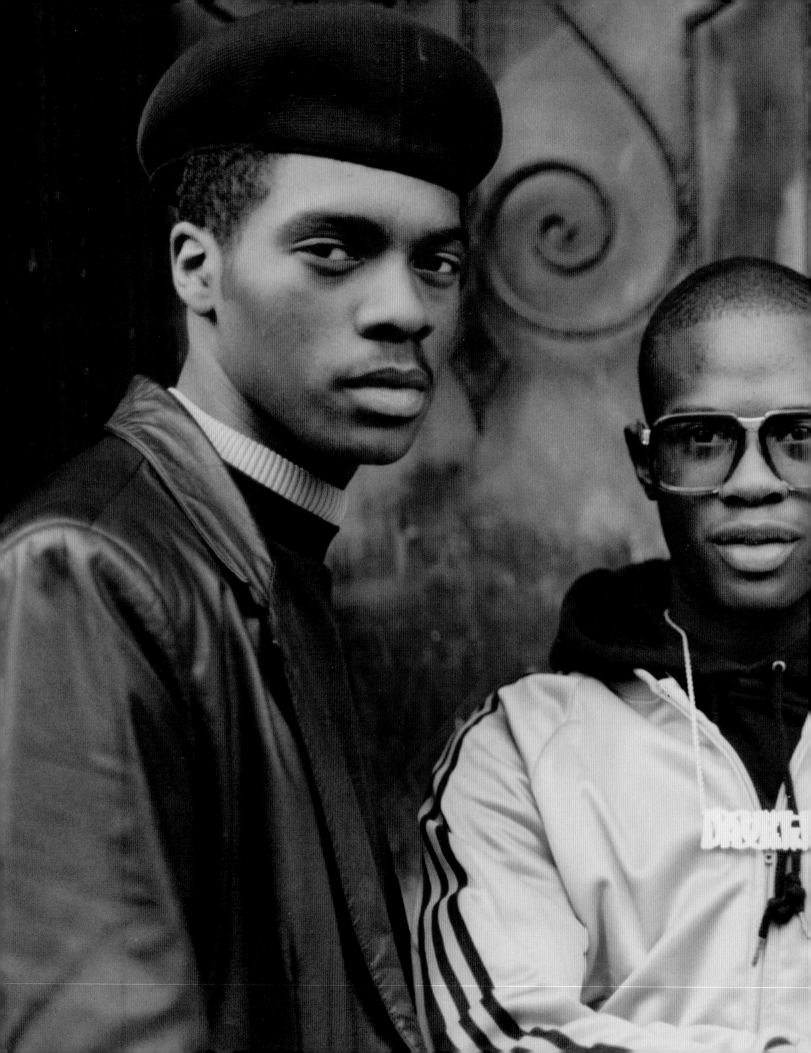

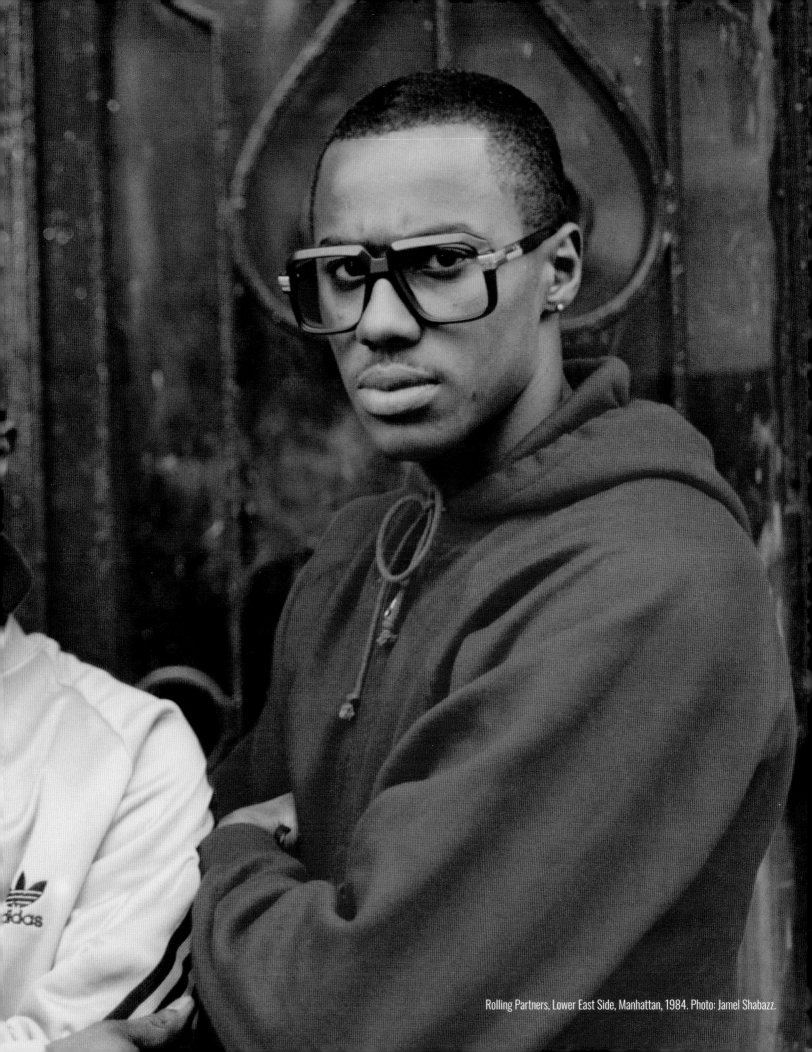

Rolling Partners, Lower East Side, Manhattan, 1984. Photo: Jamel Shabazz.

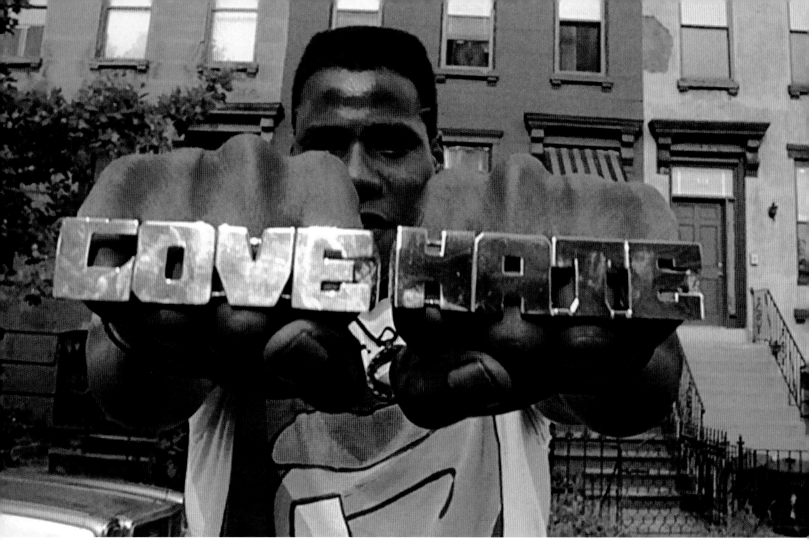

Film still from Spike Lee's Do the Right Thing.

interpretations of nameplate jewelry evolved to incorporate ornate design elements such as multifinger rings, bamboo hoop earrings, thick rope and XO chains, and double-plated pendants. With this larger-than-life aesthetic, New York City and hip hop changed the nameplate for good.

Beginning in the '80s, television became pivotal to nameplates' visibility and popularization as foundational to hip hop style—from *Graffiti Rock*, the first ever hip hop–centered TV pilot, which aired in June 1984, to shows such as Ralph McDaniels's legendary New York local music program *Video Music Box*, which aired from 1984 to 1996; *Yo! MTV Raps*; and *Rap City* on BET, which premiered in 1988 and 1989, respectively. Pendants, belt buckles, and multifinger rings began to appear in popular movies of the era. They were perhaps best exemplified in the oeuvre of Atlanta-born, Brooklyn-raised director Spike Lee. In Lee's 1986 feature debut, *She's Gotta Have It*, the lead character, portrayed by Lee, sports a single-plated necklace with "MARS" spelled out in the standout B-boy aesthetic. A Nike advertising campaign from the following year, featuring Lee as the character Mars Blackmon alongside basketball superstar Michael Jordan, styled the director in this signature pendant with a brass nameplate belt cinched around his waist. In 1989, an iconic scene from what would become his best-known film, *Do the Right Thing*, used nameplate jewelry as a narrative driver. Radio Raheem, played by Bill Nunn, performs a rousing monologue about humanity's enduring battle between love and hate, using his four-finger nameplate rings to animate his philosophy.

As hip hop music, fashion, and lifestyle were broadcast to a growing global audience throughout the '90s and into the 2000s, emerging superstars and local legends alike donned their nameplates for music videos, album covers, magazine photo shoots, and award shows. Just a few of the artists frequently spotted in their signature pieces include Kool DJ Red Alert; Grandmaster Flash, and GrandMixer DST, members of Queensbridge rap collective Juice Crew, including Biz Markie, MC Shan, DJ Polo, and Big Daddy Kane; Ghostface Killah and Redman of Wu-Tang Clan; DJ Jazzy Jeff and the Fresh Prince; groundbreaking female rappers MC Lyte, Da Brat, Remy Ma, Mia X, and Missy Elliott; and beloved singer Aaliyah. Houston legend DJ Screw and UGK cofounder Bun B rocked unique diamond-embellished chains, Los Angeles gangster rap icon Eazy-E had a rare silver name bracelet forged in a Miami Cuban link, and St. Louis native chart-toppers Chingy and Nelly wore bespoke pendants in curling cursives. These artists' jewelry often announced their personal monikers as well as their music collectives, record labels, group affiliations, hometowns, and even specific neighborhoods and blocks, such as the "41st Side" and "57th Ave" chains belonging to Capone-N-Noreaga, which referenced the 41st Avenue perimeter of the 96-building Queensbridge housing complex and 57th Avenue border of Lefrak City, where the duo respectively grew up.

At the 2000 Source Hip Hop Music Awards, Junior M.A.F.I.A. star Lil' Kim performed in a matching "CHANEL" pendant and earrings—a prescient gesture in her massively influential take on hip hop's relationship to luxury fashion. Ruff Ryders Entertainment's first lady Eve wore a nameplate that read "PHILLY." Coke Boys Records founder French Montana is the owner of a nameplate rendered in Arabic, and the trademark "COKE BOYS" pendant of his late friend and collaborator Chinx Drugz was notably both encrusted in diamonds and set in a chain of gold music notes. Although the nameplates of the '70s, '80s, and early '90s were typically forged in gold, sometimes with gemstones, artists' preferences as of late—and partially due to the influence of Southern hip hop—have favored an all-over iced-out style, in which the entire surface of a necklace and chain is covered in diamonds. Owners of this type of nameplate—which also tend toward thick, bubbly scripts or handwriting-style fonts accentuated with drips—include Nicki Minaj, Cardi B, Megan Thee Stallion, Da Baby, Lil Durk, Lil Baby, Saweetie, Asian Doll, Chief Keef, and the late Pop Smoke. With time, celebrities' nameplates have become bigger, bolder, and more intricate than ever, as these objects continue to convey hip hop's inherent celebration of the individual, as well as its insistence on every person's ability to invent—and reinvent—how one expresses oneself to the world. Hip hop's contributions to nameplate jewelry's

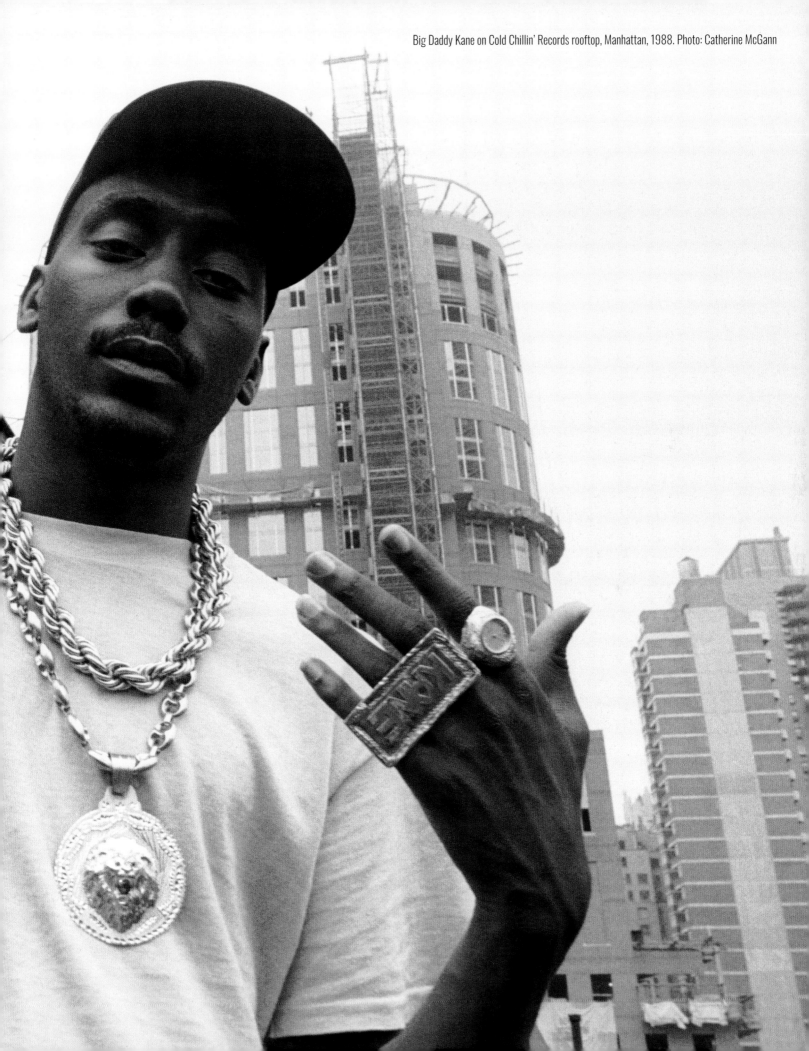

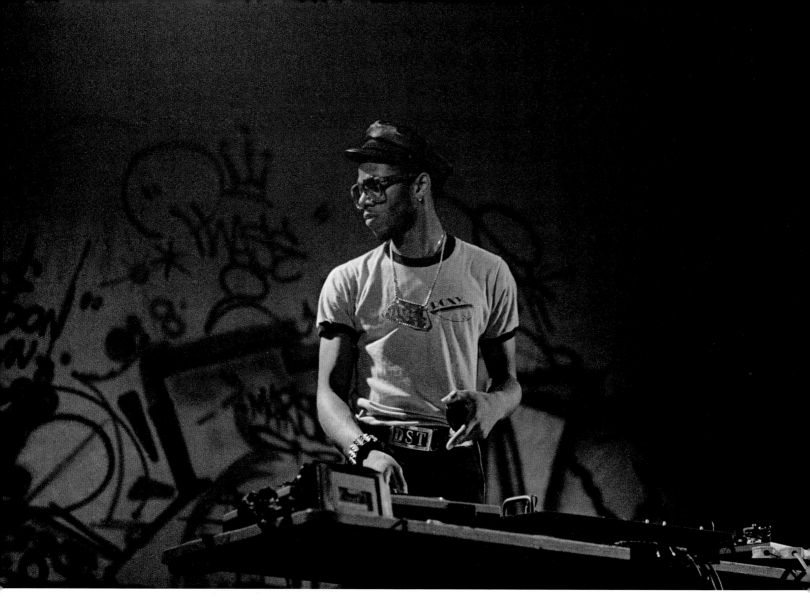

history and reach cannot be overstated. As the genre has ascended over the past nearly five decades to become the most revered and instrumental creative culture in the world, its practitioners and fans have been key ambassadors of the style, inspiring countless people to don nameplates as gleaming badges of selfhood and belonging. Although nameplates have no sole origin or innovator, every one of hip hop's generations and subcultures has contributed pivotal design evolutions and sartorial traditions that have kept this cultural phenomenon relevant and dynamic through to the present day. Nameplate jewelry's ever-unfolding history is indicative of the constant cultural intermixing and exchange that remain central to hip hop fashion in general, and to nameplates in particular. From the voyage of the *Titanic* to the streets of the

Bronx, Brooklyn, and Queens, the phenomenon of nameplate jewelry transforms to reflect the context and creativity of the communities that make the style their own. Hip hop adopted the nameplate as a symbol of prosperity, individuality, and pride of place. This style's continued resonance, even in the midst of consumerism's fickle trend cycles, underscores the enduring importance of adornment in the creation of self. Across time and place, nameplate jewelry is a treasured symbol for the value we have in ourselves and the connections that make us whole.

GrandMixer DST, London, 1982. Photo: Janette Beckman.
OPPOSITE: Megan Thee Stallion, 2019.

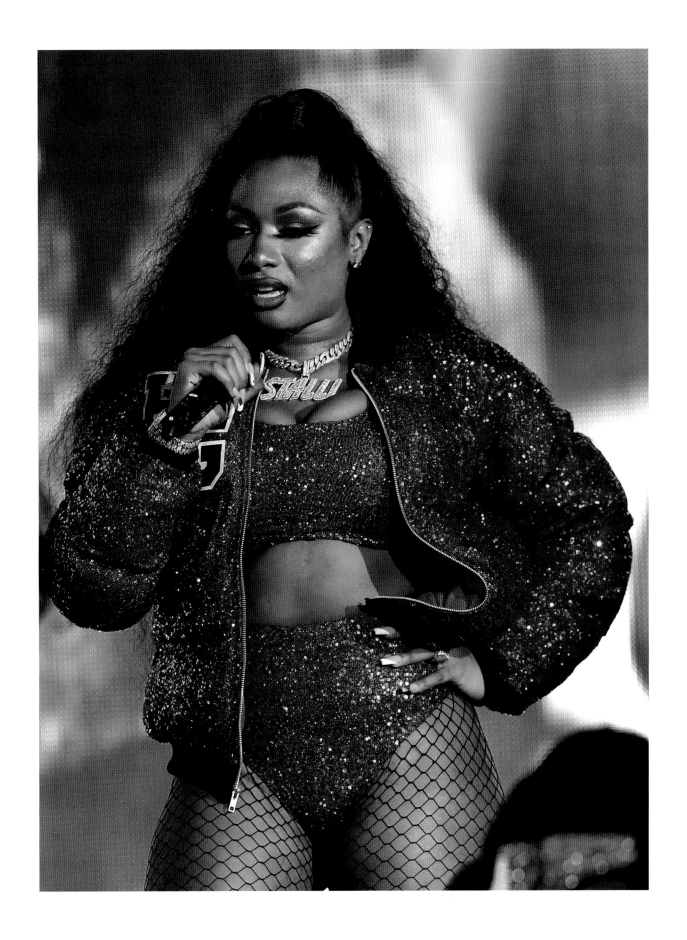

Notes

[1] "Ancient Egyptian Jewelry," Ancient Egyptian Online, no date, https://www.ancient-egypt-online.com/ancient-egyptian-jewelry.html.

[2] Michelle Graff, "The History Behind … Posy Rings," *National Jeweler*, February 10, 2016, https://www.nationaljeweler.com/fashion/antique-estate-jewelry/3785-the-history-behind-posy-rings.

[3] Michelle Graff, "The History Behind … Mizpah Jewelry," *National Jeweler*, July 23, 2014, https://www.nationaljeweler.com/articles/9119-the-history-behind-mizpah-jewelry.

[4] Beth Bernstein, "A History of Brooches: The Evolution of Style," *The Jewelry Editor*, October 9, 2016, http://www.thejewelleryeditor.com/jewellery/vintage/know-how/history-of-brooches-evolution-of-style/.

[5] John Mulgrew, "Relative's fury over 'ghoulish' Titanic sale," *Belfast Telegraph*, February 29, 2012, https://www.belfasttelegraph.co.uk/archive/titanic/relatives-fury-over-ghoulish-titanic-sale-28720651.html#:~:text=Included%20in%20the%20vast%20haul,salvor%2Din%2Dpossession%E2%80%9D.

[6] Mark Lewis, "Victorian Names and Jewelry," *Costume Jewelry Collectors*, August 24, 2019, https://www.costumejewelrycollectors.com/vintage-costume-jewelry-research/designers-manufaturers-and-styles/jewelry-styles/victorian-names-and-jewelry-2/.

[7] Lewis, "Victorian Names and Jewelry."

[8] Leilehua Yuen, "Ho'omana'o Mau: A Lasting Remembrance Etched in Gold," *Ke Ola Magazine*, January 19, 2016, https://keolamagazine.com/culture/hoomanao-mau/.

[9] Jeff Chang, *Can't Stop Won't Stop: A History of the Hip Hop Generation* (New York: St. Martin's Press, 2005).

[10] Elena Romero, *Free Stylin': How Hip Hop Changed the Fashion Industry* (Santa Barbara, CA: Praeger, 2012).

[11] Gabriel Tolliver and Reggie Osse, *Bling: The Hip-Hop Jewellery Book* (London: Bloomsbury Publishing PLC, 2006).

[12] Professor Q, interview with authors, October 5, 2019.

[13] Donald Tricarico, *Guido Culture and Italian American Youth: From Bensonhurst to Jersey Shore* (Cham, Switzerland: Springer International Publishing, 2018).

Lil' Kim The Source Hip Hop Music Awards 2000. Photo: Kevin Winter.

HIP HOP HOOPS by Elizabeth Way

When stylist Misa Hylton was asked what makes a style hip hop, she responded, "You got to have that hip hop energy, you have to understand hip hop culture, and you have to understand those certain nuances, like a bamboo earring."[1] Hoops—bamboo, door-knockers, triangles, trapezoids, and beyond—have been a significant and consistent accessory for women in hip hop from the 1980s. Fashion scholar Stephanie Kramer notes that gold and silver jewelry is an important marker of coming-of-age for Black and Latinx youth, and journalist Ivette Feliciano points to jewelry as an embodiment of wealth that could be passed down in families that could not invest in property or leave trust funds.[2] Although both men and women could rock chains and pendants, hoops were for the ladies. For fashion scholar Tanisha C. Ford, bamboo earrings represented the iconic style of rappers like Salt-N-Pepa, MC Lyte, and Roxanne Shanté: the cool, talented, fashionable Black women of her childhood that she wanted to emulate.[3]

In 2019, designer and fashion entrepreneur Shara McHayle founded Hoop88Dreams with her daughter Jade Everett, a veteran of the fashion business. The brand produces elevated hoops that McHayle cannot separate from her early love of hip hop culture. Coming of age during the 1980s in Coney Island, she fell in love with all aspects of hip hop, including the "truck jewelry" worn by drug dealers, their girlfriends, and hip hop artists.[4] She worked to save up money as a young teen and went to Canal Street to buy her first pair: gold nugget shrimp shells. Hip hop and hip hop style were how McHayle identified with her Blackness, and this often stood in conflict with her Chinese mother's preference for understated looks that did not draw attention. Hoops were pivotal to McHayle's young self-expression. They were the last thing she put on before she headed out the door. When she broke curfew, her mother took her earrings as punishment, prompting McHayle to continually buy another pair. "For me, culturally, the hoop earring are what sneakers are to guys. In streetwear culture, you have multiples," said McHayle.[5]

Although the hip hop generation did not originate hoop earrings (they date back to antiquity across cultures), in true hip hop fashion, women in hip hop culture remixed and emphasized hoops in a unique style that has inevitably been appropriated by mainstream fashion. Ford recalls the *Sex in the City* moment of the early 2000s when costume designer Patricia Field dressed the TV show's main character in gold nameplate hoops:

> So here were White women now flocking to designer boutiques and high-end department stores to get the looks that Black girls, like my friends and me, had been dogged out for wearing. On us, to outsiders, the earrings were tasteless, cheap, sleazy even. But once a White woman like Patricia Field said it was fashion, the ghetto gold look was now a vintage something to emulate.[6]

More recently Black women are putting themselves back into focus as the authors of hip hop style, lending *their* authenticity and clout to designer brands. Rapper Megan Thee Stallion was signed as a brand ambassador for the American accessories company Coach in 2019 and starred in their spring 2022 campaign.[7] She was photographed at New York Fashion Week in unmistakable hip hop style, including hoops branded with "Coach." That mainstream fashion has appropriated from hip hop is nothing new, however these companies embracing hip hop artists as creative muses and even partners shows the undeniable impact of hip hop styles like hoop earrings and the women who made them fashion.

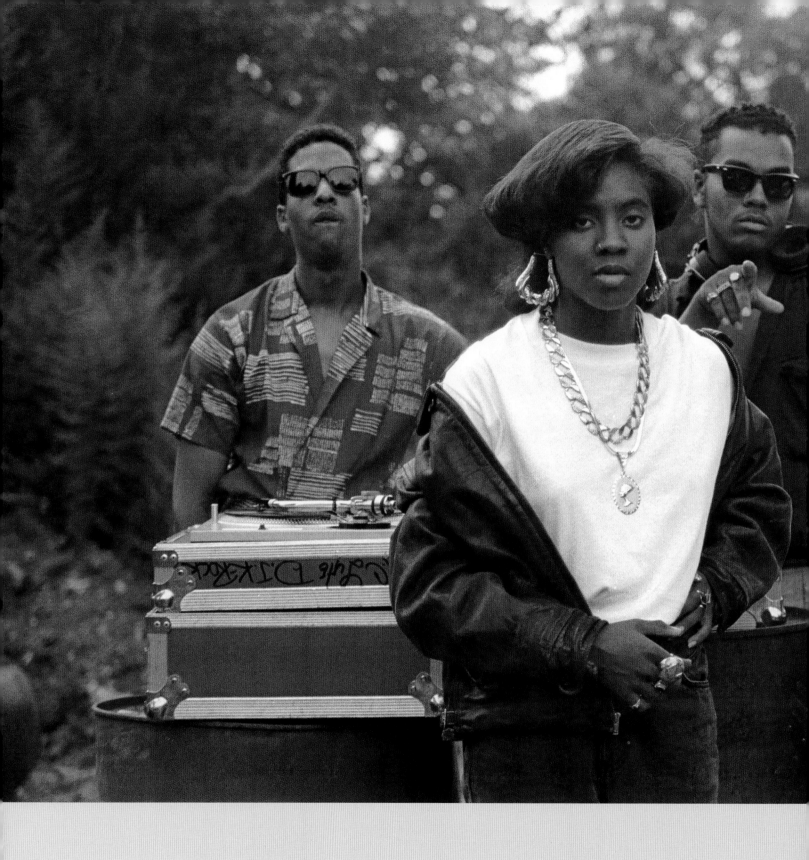

Notes
[1] Misa Hylton interview with Elena Romero, February 28, 2022.
[2] Stephanie Kramer, "Door-Knocker Earrings" in *Items: Is Fashion Modern?* eds. Paola Antonelli and Michelle Millar Fisher (New York: The Museum of Modern Art, 2017.)
[3] Tanisha Ford, "How Bamboo Earrings Became Iconic," *Zora*, July 3, 2019, https://zora.medium.com/in-praise-of-bamboo-earrings-9239731db066.
[4] Elena Romero, "Black Entrepreneurship: A Mother-Daughter Conversation," Fashion Institute of Technology video, March 1, 2021, https://www.youtube.com/watch?v=yR3wOECgBfU.
[5] Romero, "Black Entrepreneurship."
[6] Ford, "How Bamboo Earrings Became Iconic."
[7] Layla Ilchi, "Megan Thee Stallion and Friends Star in Coach x Schott NYC Campaign," *Women's Wear Daily*, September 28, 2021, https://wwd.com/fashion-news/fashion-scoops/megan-thee-stallion-coach-schott-nyc-campaign-1234952434/.

MC Lyte, 1989. Photo: Al Pereira.

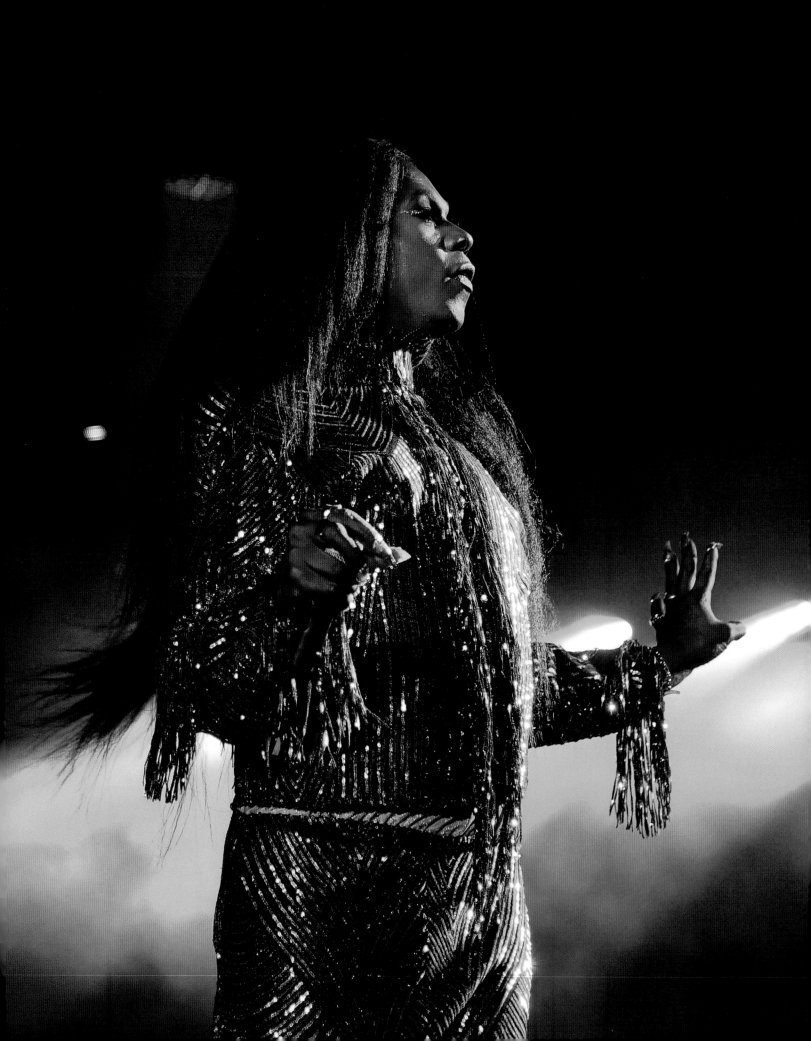

CALL US BY OUR NAMES: QUEER GENDER & HIP HOP FASHION

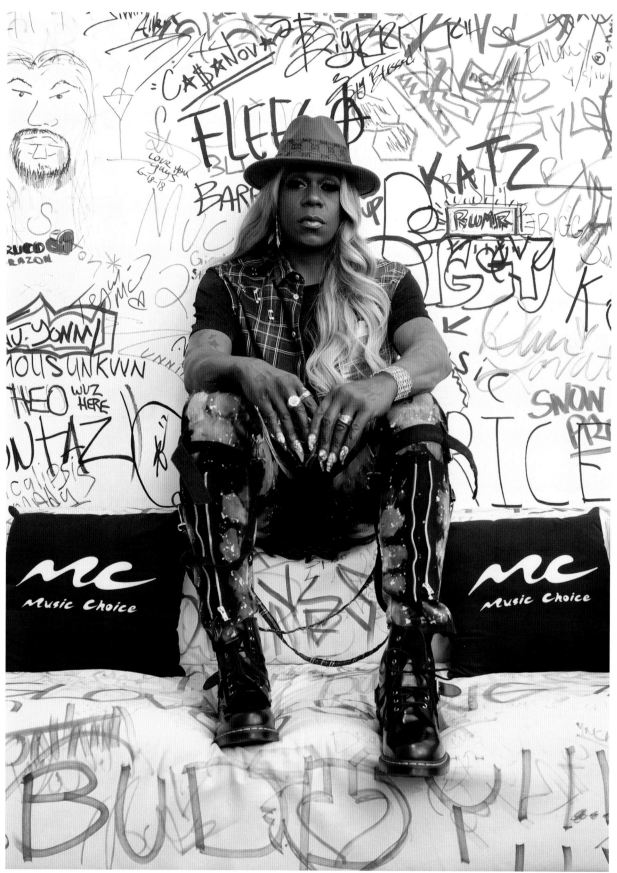

Big Freedia, 2020.

Nothing is more hip hop than a Black genderqueer superstar from the South rocking a stiletto manicure. The tip of each razor-sharp nail appears to have been dipped into one of ten neon-hued paint cans, double-basted with a clear topcoat of polish, and then sprinkled with a rainbow of circle foils that make each nail look like nonpareils atop an extravagant birthday cake. Underneath her red Gucci fedora, and framing her fiercely beat cocoa-colored face, lies a mane of no less than twenty-two inches of loosely tousled strawberry blonde curls with platinum highlights. Her stunning glamour is amplified by the stylistic contrast of her more edgy fashions. She wears a sleeveless, tartan button-down shirt worn over a glitter-speckled black T-shirt. This style highlights her tattoo-covered arms and hands. Her acid-wash charcoal gray and black jeans, coated in white paint splatter, are adorned with black straps wrapped onto the pants and fastened with metal hooks, and then tucked into black leather combat boots. It is the 2020 Music Choice Awards, but it is giving Afro-punk. She is the undisputed "Queen Diva" of New Orleans Bounce: the one and only Big Freedia. But *you already know.*[1]

What you may *not* know is that, like Big Freedia, hip hop generation Black and Latinx lesbian, gay, bisexual, trans, and queer (LGBTQ) people, as well as their pop culture progeny, have long-enacted gender creativity in ways that the larger hip hop culture—heteronormative and cisnormative—have leveraged for greater freedom of self-expression through fashion, beauty, and style.[2] Historically, such freedoms have not led to greater visibility and success for hip hop generation Black and Latinx LGBTQ artists. Indeed, from the myriad ways Black and Latinx LGBTQ artists have sometimes been used as a Trojan horse for their heterosexual and cisgender counterparts to carve out more space for gender play and sexual freedom, to the countless Black and Latinx LGBTQ and genderqueer stylists, makeup artists, hairstylists, nail artists, choreographers, and photographers whose genius has been essential to the numerous artists, executives, and other professionals, the debt hip hop owes to Black and Latinx LGBTQ image makers is substantial.

Reflecting on the 2012 Harvard University symposium "The Queerness of Hip Hop/The Hip Hop of Queerness," C. Riley Snorton writes, "Hip hop's sonic promiscuity wantonly invites queer rumination just as queer theory's fascination with ephemeral culture has made room for critical thinking about the queer affects produced in such fleeting moments as when the DJ transitions to the next hip hop track," leading the symposium conveners, Snorton and Scott Poulson-Bryant, "to stage an encounter—a more formal meeting—between two fields that had already made each other's acquaintance."[3] Like that symposium, this chapter stages an encounter between old acquaintances: hip hop, queerness, gender, and fashion.

As fashion historian Valerie Steele writes, "Fashion and style have played an important role within the LGBTQ community … Yet surprisingly little has been published about high fashion as a site of [queer] cultural production. But if we look at the history of fashion through a queer lens, exploring the aesthetic sensibilities and unconventional dress choices made by LGBTQ people, we see how central [queer] culture has been to the creation of modern fashion."[4] What Steele aptly notes as true for LGBTQ people and fashion writ large is true for LGBTQ people in hip hop.

Within the constellation of ways that LGBTQ people have contributed to what Elena Romero described as hip hop fashion's "roots, history, and the power moves" that created a style that "went from the hood to the runway," queer gender and fashion perhaps most epitomizes the heart of hip hop aesthetics.[5] Like hip hop, genderqueerness insists on being itself even at the risk of going against the grain. Just as hip hop emerged as a wholly new culture—one that echoes cultural traditions that preceded, anticipated, but did not completely subsume it—genderqueer hip hop fashion and style, while also having antecedents, has blossomed as an act of freedom that represents myriad gender identities and expressions in the culture. These sartorially represented identities and expressions were not acknowledged or made central in early hip hop culture but were nonetheless

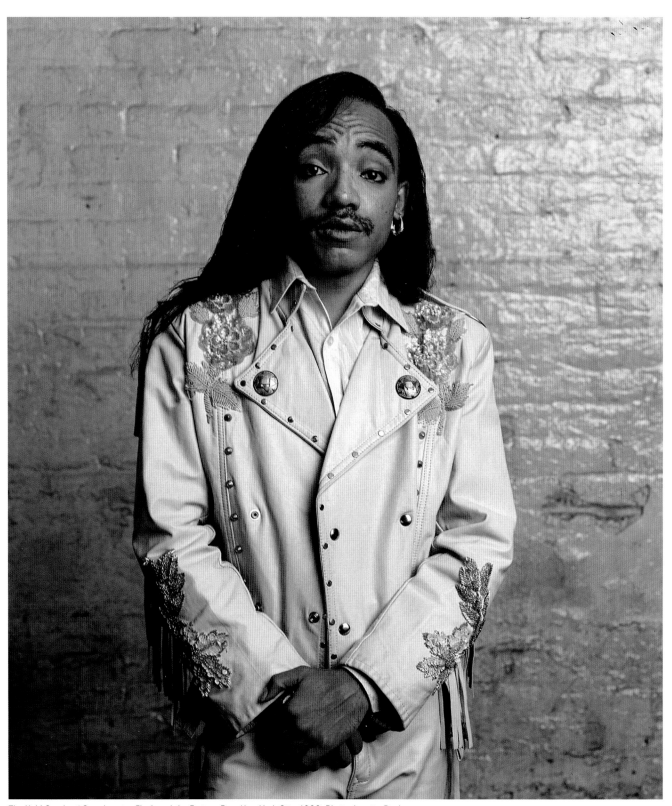

The Kidd Creole of Grandmaster Flash and the Furious Five, New York City, 1980. Photo: Janette Beckman.

always present among the Black, Latinx, and other LGBTQ people of color who make up what Bakara Kitwana calls "the hip hop generation."[6] This moniker characterizes the Black youth culture of the first generation to come of age in post-segregated America.

Further, genderqueer hip hop fashion epitomizes hip hop aesthetics in its inherent courageousness and disrespectability; that is, just as hip hop persists despite being regarded in the past and sometimes today as a problem to be solved by the politics of respectability, genderqueer hip hop fashion has bravely persisted, announcing itself on stages both literal and metaphorical that have historically been cisgender-identified. LGBTQ people, including those queering gender through hip hop fashion, carry on in the work of self-possession over everything, much in the way that hip hop has valued "the culture" as belonging to itself and not being deterred by those who in the decades since its creation have sought to silence it.

Fashioning Hip Hop through House-Ballroom Culture

With roots as far back as the late nineteenth century, the queer cultural space called "drag balls" were popularized in major cities all over the United States. These balls consisted of gay and lesbian people carving out free cultural space wherein their sexual and gender identity and expression were not maligned or demonized but invited and celebrated. Drag balls consisted of queer people transgressing gender norms through competitions built around genderqueer dress and artistic performance. Such nonnormativity also included racially integrated gatherings.[7, 8] Despite the racial integration of many of these early spaces, Black and other drag queens, gay men, and lesbians of color often found the spaces to be racist. By the 1970s, Black and Latinx drag queens came together and created their own drag ball system, which was most often called "house ballroom" or "ball culture." They were organized around families called "houses" that made up the scene.[9, 10, 11]

As with genderqueer fashion, house ballroom culture *is* hip hop. Houses and the entire ballroom scene are made up of Black and Latinx people from the same South Bronx, Harlem, Queens, and Brooklyn neighborhoods that created the culture known as hip hop. They may or may not have been *out* or made their gender and sexuality legible in the ways some LGBTQ people do today, but they were there. Only a history centered on heteronormativity and cisnormativity would deny that fact. Thus, hip hop is every bit as much a co-creation of people of the house ballroom culture's hip hop generation as it is a cocreation of the cultural spaces of their cisgender and heterosexual counterparts.

One point of connection is the music. While representations of ballroom rightfully center such ball scene–defining tracks as Cheryl Lynn's "Got to Be Real" (1978), George Kranz's "Din Daa Daa" (1983), and Malcolm McLaren's "Deep in Vogue" (1989), some rap songs were solid favorites and thus part of the soundtrack of the '70s, '80s and '90s ball scenes, including Treacherous Three's "Feel the Heartbeat" (1981), Eric B. & Rakim's "Paid in Full" (1987), and Heavy D. & The Boyz featuring Aaron Hall's "Now That We Found Love" (1991).[12] House ballroom and hip hop shared the natural spirit of competitiveness, where all creatives—rappers, deejays, and dancers—work to establish themselves as the greatest in their respective fields.

Within all these connections between house ballroom and hip hop culture is fashion and style. It is here where the relationship between the two, and the importance of queer gender, is perhaps best displayed. Within house ballroom, contests consist of houses competing by "walking" against one another in several categories. These categories, which have grown exponentially over time, are replete with race, class, gender, and sexual identity performances implicit to the category.[13]

In categories such as Labels or Runway, luxury fashion and the other markers of financial prowess are heavily featured and the key to victory. We see it in hip hop—from The Lox featuring Lil' Kim and DMX's "Money, Power, Respect" (1998), Jay-Z's "Tom Ford" (2013), and Migos's "Bad and Boujee" (2016) to The Carters' "Apeshit" (2018) and

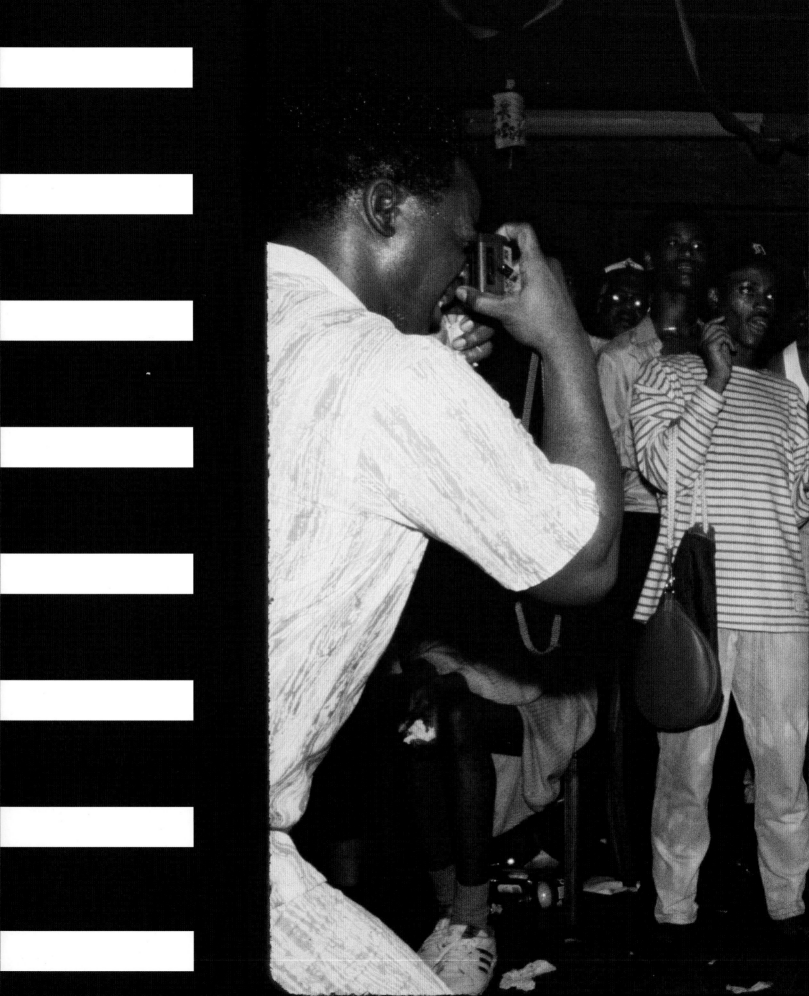

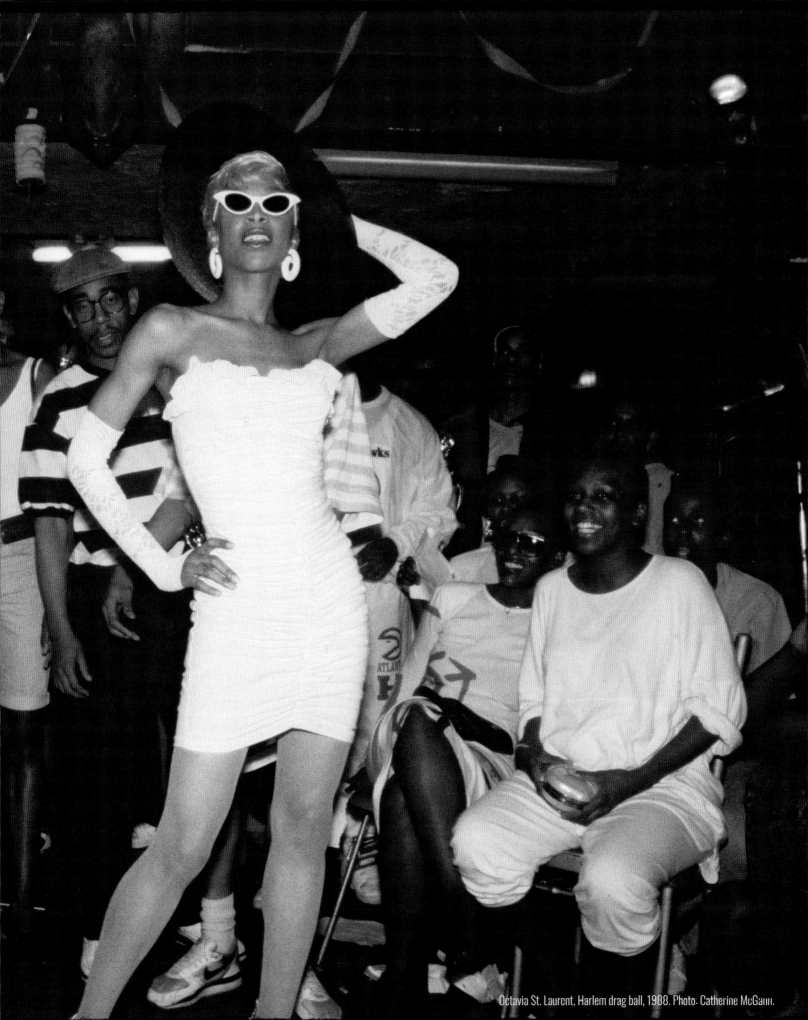

Octavia St. Laurent, Harlem drag ball, 1988. Photo: Catherine McGann.

Cardi B's "Money" (2018). House ballroom and hip hop are joined in the ways that fashion and style are deployed in the reccurring motif of aspirational wealth and an embrace of capitalism, but also in the ways some of these performances, particularly in early house-ballroom culture, also activate a critique of such socioeconomic positions by way of parody.[14]

The way in which house ballroom and hip hop fashion is most aligned is how each deploys "logomania" to represent luxury in the aesthetics and systems of the culture. The origins of monogrammed apparel fabric began during the 1960s, although the 1980s is generally regarded as the era in which logomania took off, largely due to hip hop.[15] Logomania refers to clothing, accessories, and lifestyle items with a brand's logo and label emblazoned excessively all over it.[16] One of hip hop's great contributions to the vocabulary and history of fashion, its unique take on logomania, was innovated in ways never seen before by designer Daniel Day, known as Dapper Dan.[17] Designing custom garments for rappers, athletes, and hustlers, Day's designs included jackets, pants, and even car interiors with the logos of European luxury fashion labels such as Gucci, Louis Vuitton, MCM, and Fendi.[18] The aesthetic is among the most copied in the history of fashion.

House ballroom engaged in its own practice of logomania. This is most evident in the names of many of the houses in the culture, which take the names of luxury fashion designers and labels as their monikers, such as the House of Mugler, founded by David, Raleigh, and Julian Mugler and named after couturier Thierry Mugler; House of Mizrahi, founded by Andre Mizrahi and named after American designer Isaac Mizrahi; and the Gorgeous House of Gucci, founded by Jack Mizrahi Gucci, Kelly Mizrahi Gucci, Marlon Mizrahi Gucci, and Trace Gucci.

Jacket with counterfeit Louis Vuitton monogram.
OPPOSITE TOP: Louis Vuitton purse, circa 1996

Femme Masculine Fashion and Other Misdemeanors

There is something about Missy. From the moment I first saw her as a member of early '90s girl group Sista, to her becoming a solo hip hop superstar with her debut album *Supa Dupa Fly* (1997), the now iconic Missy "Misdemeanor" Elliott was serving a style of dress and beauty that always looked like freedom to me. Her look paved the way for many to define beauty for themselves and present it on their own terms. Some of Elliott's earliest looks reflected a hip hop tomboy aesthetic. She wore oversized tops—hockey jerseys, basketball jerseys, knit sweaters, and jackets—paired with baggy jeans and Timberland boots or the latest sneakers, and several earrings. Her hair, makeup, and nails were always on point: slick finger waves or short pussycat cropped hairdos with a bang swooped over one eye (à la her friend and collaborator R&B princess, Aaliyah), freshly snatched eyebrows and a natural makeup glow—always with a glossy lip. Even her arguably most iconic fashion moment may be regarded as genderless hip hop dress. Styled by June Ambrose for the video "The Rain," her first single as a solo artist, Elliott wore an extra-large trash bag blown up to the limit.[19] She appears as though she were a chic black hot-air balloon that might float away. She was and is always ahead of her time.

Elliott was not alone in her look, as tomboy fashion was on trend in the early and mid-1990s when she was first becoming known within the culture. So many of the "It" women of hip hop—from Mary J. Blige and Aaliyah to R&B groups Xscape and TLC—were sporting some version of the tomboy look. But, as Emil Wilbekin reminds us, "What is unique about the aesthetics of hip hop style is that the look changes as quickly as the sound does—which is to say, constantly."[20] As 1990s hip hop fashion moved on to set new trends, and hip hop artists were increasingly courted by the luxury fashion industry and starting labels of their own, the tomboy look was set aside by some or elevated to a version that was so high femme that it was no longer tomboy—that is, all except Elliott, who persisted in her signature look, only shifting with the budget, silhouettes, and palettes of the times, evidencing a femme masculine aesthetic that was clearly not a trend. It was her all the time. Elliott's sartorial legacy is quite evident in the looks of many rappers today, such as Princess Nokia. Genderqueer, Afro-Indigenous, Puerto Rican, and bisexual, when queried as to whether her fashion is activism, she concurs:

> When I was a kid, I always used forms of eccentric ways of dressing to be resistant to the opposition of judgment around me. And I was always really comfortable with being androgynous. I loved androgyny, and I was a self-identified queer child growing up … I loved to wear ties very much. And I liked to wear ugly boxy trenchcoats. I didn't realize that I was dressing like a stud … I realized that that was not typical for where I come from. I was never intimidated. I was doing it for me and being a cocky kid and making people roll their eyes because they're going to roll their eyes anyway.[21]

The visual influence of Elliott and femme masculine dress is clear in Princess Nokia's look on the cover of the deluxe edition of *1992*, her 2016 mixtape. On the cover, Princess Nokia wears a baggy long-sleeve red shirt underneath an extra-oversized navy blue T-shirt with "NYC" emblazoned across the top. Her hair is blown out long and silky, and she rocks a natural "no-makeup makeup" look as she grins holding a basketball in her hands with manicured white fingernails. Another rapper illustrating Elliott's sartorial influence is Young M.A (Young Me Always). A New Yorker, Young M.A was born to a Jamaican American mother and Puerto Rican father. Gaining chart recognition with her Top 20 single "OOOUUU" (2016), Young M.A became equally as known for her recognizable hairstyle: the crown of her head smoothed into four, long box braids and the rest of it lined up into a sharp fade.[22] Named 2019's *Out* magazine "Rapper of the Year," Young M.A appears in an accompanying fashion editorial styled by Yashua Simmons and photographed by Quil Lemons[23] wearing a full Dior Men's look—a pale pink trench-coat over a shirt and shorts each in a newspaper print—finished with pink Dior socks

Missy Elliott, 1998.

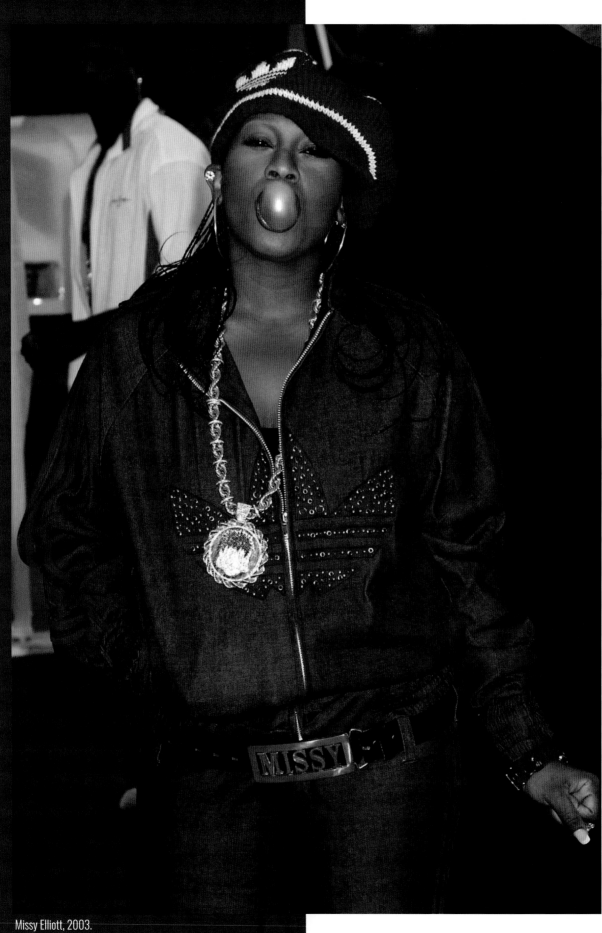

Missy Elliott, 2003.

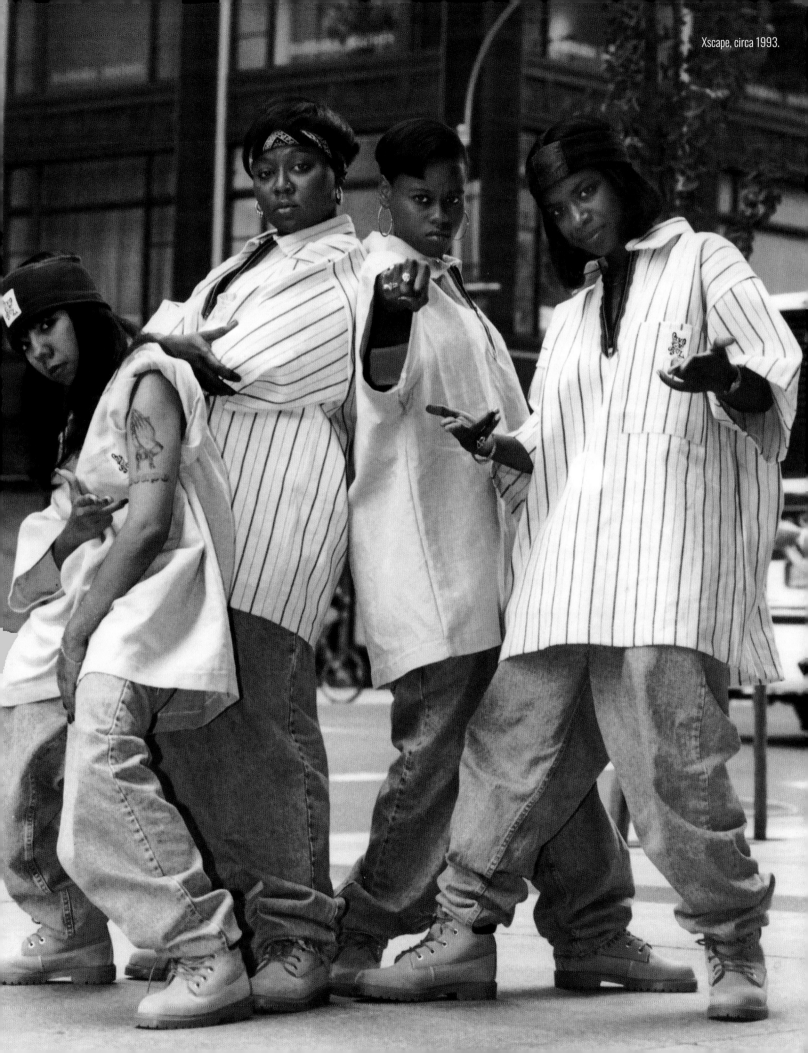

with white Nike sneakers. The look is completed with diamonds, diamonds, and more diamonds: a large pendant on a chain, a huge ring, and watch. Here, Young M.A, a masculine woman, creates a style moment in which pink and gender collide to create a moment that disrupts norms through hip hop fashion. Long before Young M.A wore this look, pink was claimed for men by rapper Cam'ron in 2002 at New York Fashion Week.[24]

Material Gworrrllls

It is only within the last five to seven years of a fifty year-old art form that Black and Latinx LGBTQ people in hip hop have successfully seized the stage and grabbed the mic for themselves, with fashion and beauty central to the interventions made through their larger corpus of sonic and visual artistry. Among these artists is transgender musician, visual and performance artist, Mykki Blanco. From her debut album, 2016's *Mykki* and its follow-up 2021's *Broken Hearts and Beauty Sleep*, Blanco has persisted in creating music that defies lazy categorization. Inspired by several legendary figures, including Lauryn Hill and Lil' Kim (whose alter ego, Kimmy Blanco, is referenced in Blanco's name), Blanco uniquely blends rap, punk, riot grrrl, and other genres to construct an emerging oeuvre across her albums and singles. Blanco's fashion—as daring and outside the box as her music—queers gender in ways that expand what is possible in hip hop fashion.[25, 26, 27, 28]

Performing at the 2013 Lovebox Festival in London's Victoria Park, Blanco took to the stage in a baseball hat with a slight peek of a hair bang clipped with a large hot-pink barrette. She performed topless with only two glitter floral pasties covering her nipples, a pair of satin Everlast black-and-blue boxer shorts with a pale turquoise floral and lace overskirt worn over the boxers with a large bow exposing the boxer waistband.

Most recently, Florida-based rapper Saucy Santana, who is gay, has become incredibly popular through the intersection of his music, high fashion, and beauty looks circulating all over social media. Known for his always glamorous makeup worn with

Princess Nokia, 2017.

Mykki Blanco, 2013.

a perfectly coiffed beard, Santana started out as the makeup artist for rap duo City Girls. Since then, his 2020 single "Walk" made him a viral success when the popular #WalkChallenge began on TikTok and Instagram. Another single, 2021's "Material Girl," has become Gen Z's version of the Madonna song of the same name and a go-to song for the soundtrack of those displaying their luxury fashion, accessories, cars, and homes on social media.[29, 30]

Perhaps no artist today better exemplifies the paradigmatic shift that hip hop has taken in relation to queering gender and fashion than Atlanta-born Lil Nas X. Amid his seemingly unstoppable and skyrocketing career of Billboard record-breaking hits, the Grammy Award–winning rapper, who began his career with a chart-topping country rap song, has since continued a path of history-making moments. He has become the most successful Black gay rapper in history and a popstar.[31] In live performances of his 2021 singles "MONTERO (Call Me By Your Name)" and "Industry Baby," Lil Nas X is surrounded by an all-Black male dance crew adorned in outfits made of sequins, leather, and harnesses. They perform dance routines that one has come to expect only of women in hip hop. They conclude these performances with a kiss, group embrace, or other sexually suggestive gesture. The result is a depiction of queer Black masculinity and sexuality unlike we have ever seen on some of music's most venerable stages.

More recently, Lil Nas X's performances have transported from the concert stage to the stage of the red carpet. Aided by his stylist Hodo Musa, Lil Nas X has crafted memorable moments in which he continues to queer norms. At the 2021 Met Gala, he arrived in a three-in-one outfit. The initial look transformed into three looks, each more exuberant and ostentatious than the last. He arrived in a gold Versace cape—a tribute to Liberace—which he unfurled to reveal full-body gold armor. Then, he removed the armor to show he was wearing a skin-tight beaded bodysuit. Each look was designed to go from concealing oneself, to protection, to living free and openly in one's authenticity, telling "an LGBTQ+ American fairytale" [32] for the Gala's American fashion theme.

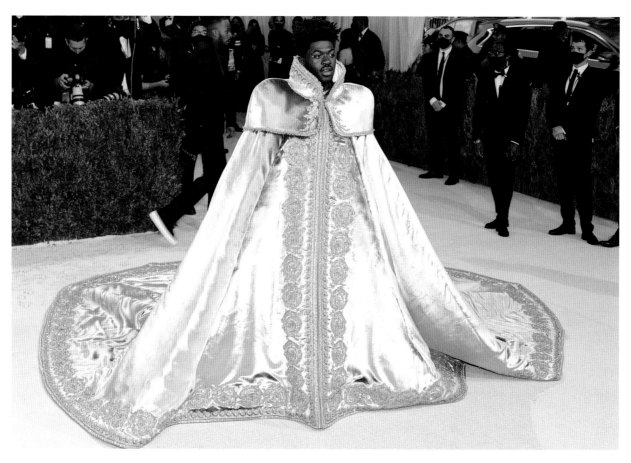

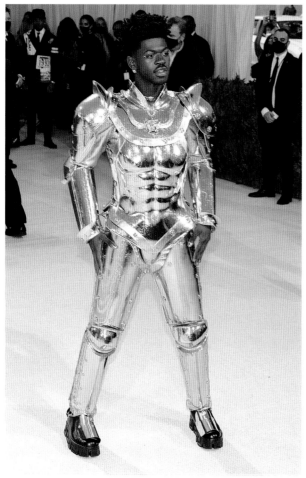

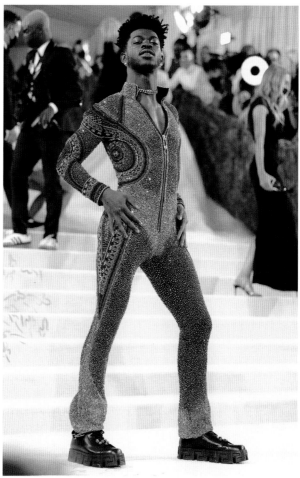

The Met Gala is no stranger to hip hop artists making grand entrances (or exits, for that matter). And thanks to Billy Porter's entrance at the 2019 Met Gala, it is not even unfamiliar with a Black queer man slaying the red carpet.[33] What is new, however, is that the red carpet was owned by a Black queer male rapper, clad in a genderqueer confection—an artist who happens to also be one of the most commercially successful and viable artists in hip hop and the music industry today. Further exploration of the historic ways that genderqueer fashion and dress have expanded and been expanded by hip hop culture is imperative. Additionally, some focus on the many ways that trans, queer, and gender-nonconforming people of the hip hop generation and subsequent generations have labored to make a much more exciting sartorial environment for the culture historically and today would prove helpful to documenting the long history of hip hop fashion as individual practice, artistic movement, and industry.

Notes
[1] "You already know" is a phrase often used and popularized by Big Freedia. She has used it in several of her songs, the introduction to her reality television series, and other media.
[2] Throughout this chapter, I use "LGBTQ people" to refer to a wide variety of individuals whose gender and sexuality are nonnormative; however, no phrase can ever fully capture the totality of all the folx within the LGBTQ community, including our varying identities. Please know that when I say "LGBTQ," I am using it in the most expansive, inclusive sense of the many gender and sexual identities therein.
[3] C. Riley Snorton, "As Queer as Hip Hop," *Palimpsest: A Journal on Women, Gender, and the Black International* 2, 2 (2013): vii.
[4] Valerie Steele, *A Queer History of Fashion: From the Closet to the Catwalk* (New Haven, CT: Yale University Press, 2013).
[5] Elena Romero, *Free Stylin: How Hip Hop Changed the Fashion Industry* (Santa Barbara, CA: Praeger, 2012).
[6] Bakara Kitwana, *The Hip Hop Generation: Young Blacks and the Crisis in African American Culture* (New York: Basic Civitas Books, 2003).
[7] William Hawkeswood, *One of the Children: Gay Black Men Harlem* (University of California Press, 1996).
[8] James Wilson, *Bulldaggers, Pansies, and Chocolate Babies Performance, Race, and Sexuality in the Harlem Renaissance* (Ann Arbor: University of Michigan Press, 2010).
[9] Hawkeswood, *One of the Children.*
[10] Jennie Livingston, *Paris Is Burning*, Off White Productions, Inc. film, 1990.
[11] Emily A. Arnold and Marlon M. Bailey, "Constructing Home and Family: How the Ballroom Community Supports African American GLBTQ Youth in the Face of HIV/AIDS," *Journal of Gay & Lesbian Social Services* 21 (2009): 171–88.
[12] Michelle Lhooq, "20 Tracks That Defined the Sound of Ballroom, New York's Fiercest Queer Subculture," *Vulture*, July 20, 2018, https://www.vulture.com/2018/07/20-tracks-that-defined-the-sound-of-ballroom.html
[13] Marlon Bailey, "Gender/Racial Realness: Theorizing the Gender System in Ballroom Culture," *Feminist Studies* 37 (2011): 365–86.
[14] Livingston, *Paris Is Burning.*
[15] Ariele Elia, "Dapper Dan: The Original Streetwear Designer and Influencer," in *Black Designers in American Fashion*, ed. Elizabeth Way (London: Bloomsbury, 2020), 173.
[16] Ruth La Ferla, "What Gives the Logo Its Legs," *New York Times*, November 7, 2018, https://www.nytimes.com/2018/11/07/fashion/logos-gucci-fendi-supreme.html.
[17] David Marchese, "Dapper Dan on Creating Style, Logomania and Working with Gucci," *New York Times Magazine*, July 1, 2019, https://www.nytimes.com/interactive/2019/07/01/magazine/dapper-dan-hip-hop-style.html.
[18] Elia, "Dapper Dan."
[19] Vincent Boucher,"Music's 'Secretary of Style': June Ambrose Reflects on 30-Year Career, Creating Iconic Looks for Missy Elliott, Diddy and Others," *Hollywood Reporter*, June 8, 2021, https://www.hollywoodreporter.com/lifestyle/style/june-ambrose-stylist-jay-z-puma-1234961092/.
[20] Emil Wilbekin, "Great Aspirations: Hip Hop and Fashion Dress for Excess and Success," in *The VIBE History of Hip Hop*, ed. Alan Light (New York: Three Rivers Press, 1999).
[21] Zahara Hill, "Princess Nokia on Being Sexually Fluid and Making Music for Girls with the 'Delusional Confidence of Barbra Streisand,'" Blavity.com, August 15, 2018, https://blavity.com/princess-nokia-on-being-sexually-fluid-and-making-music-for-girls-with-the-delusional-confidence-of-barbra-streisand?category1=culture&category2=music.
[22] Tweety Elitou, "OOOUUU! Young M.A Debuts Her Natural Hair and It Has Major Hang Time," *BET*, July 23, 2018, https://www.bet.com/article/q2xlji/young-m-a-shows-off-natural-hair-and-it-has-major-hang-time.
[23] Tre'Vell Anderson, "Out100 Rapper of the Year: Young M.A Is Herstory in the Making," *Out*, November 19, 2019, https://www.out.com/print/2019/11/19/out100-young-ma-herstory-acting-porn.
[24] Alex Wong, "Cam'ron Is Very Particular When It Comes to the Color Pink," *GQ*, November 22, 2016, https://www.gq.com/story/camron-dipset-interview.
[25] Michael Schulman, "From Runaway Teenager to Hip Hop Queen," *New York Times*, July 17, 2012, https://www.nytimes.com/2012/07/19/fashion/the-evolution-of-michael-quattlebaum-jr-a-k-a-mykki-blanco.html.
[26] Alex Chapman, "The Multiplicities of Mykki Blanco," *Interview*, April 4, 2012, https://www.interviewmagazine.com/culture/mykki-blanco.
[27] Dorian Lynskey, "Mykki Blanco: 'I Didn't Want to Be a Rapper, I Wanted to Be Yoko Ono,'" *The Guardian*, September 15, 2016, https://www.theguardian.com/music/2016/sep/15/mykki-blanco-i-didnt-want-to-be-a-rapper-i-wanted-to-be-yoko-ono.
[28] Sasha Geffen, "Mykki Blanco Is Her Own Problematic Fave," *MTV News*, October 19, 2016, http://www.mtv.com/news/2944602/mykki-blanco/.
[29] Marissa Matozzo, "There's a New Material Girl in Town," *Paper*, January 15, 2020, https://www.papermag.com/saucy-santana-material-girl-premiere-2644822687.html.
[30] Marquin Stanley, "Saucy Santana Wants to Lead by Example for Other Aspiring LGBTQ Rappers," *Billboard*, February 4, 2020, https://www.billboard.com/culture/pride/saucy-santana-wants-to-lead-by-example-for-other-aspiring-lgbtq-rappers-8549550/.
[31] Jazmine Hughes, "Hot Boy Summer: The Subversive Joy of Lil Nas X's Gay Pop Stardom," *New York Times Magazine*, July 11, 2021, 30–39.
[32] Erika Harwood, "Lil Nas X's Three-in-One Met Gala Outfit Is an LGBTQ+ Fairytale," Byrdie.com, September 13, 2021, https://www.byrdie.com/lil-nas-x-met-gala-2021-5201166.
[33] Christian Allaire, "Billy Porter Just Made the Most Fabulous Entrance in Met Gala History," *Vogue*, May 6, 2019, https://www.vogue.com/article/billy-porter-met-gala-2019-the-blonds.

Three outfits that Lil Nas X wore at the Met Gala, 2021. Photos: John Angelillo and Charles Guerin.

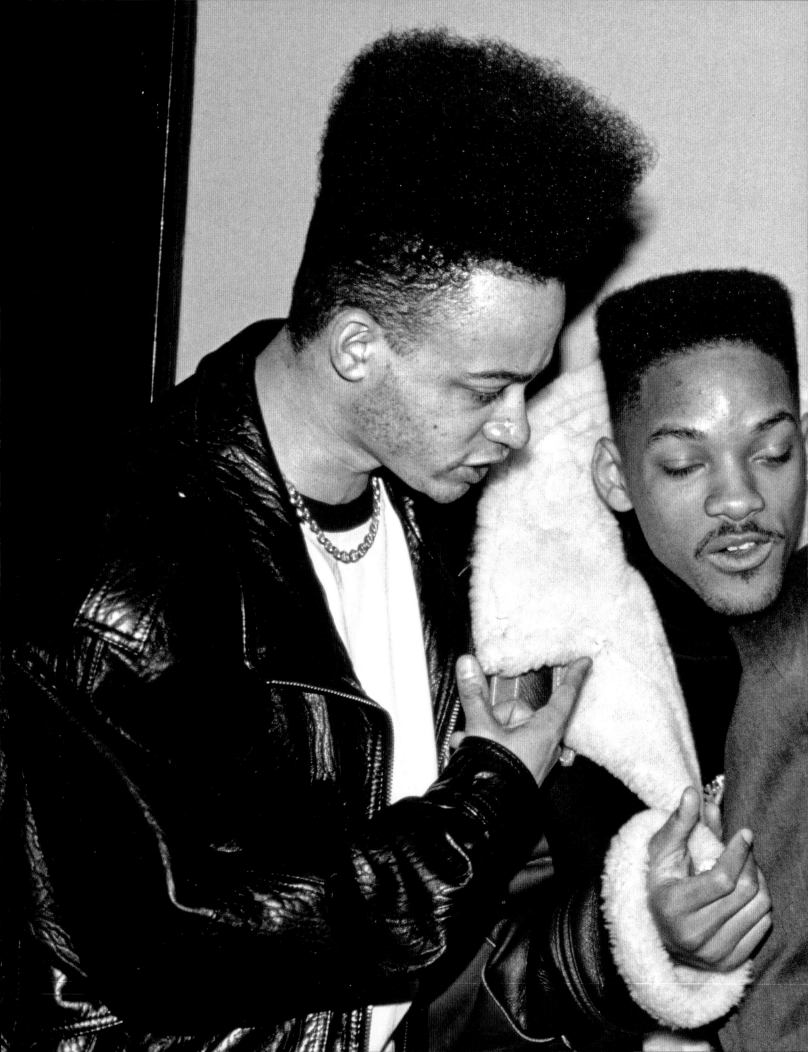

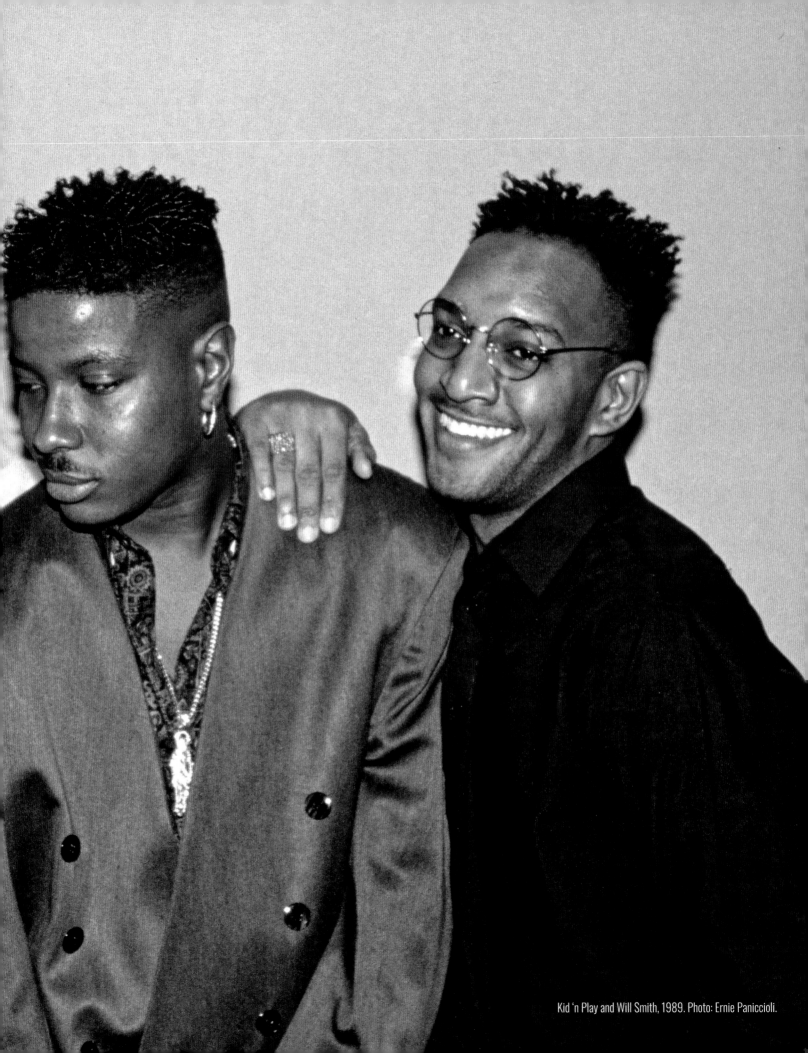

Kid 'n Play and Will Smith, 1989. Photo: Ernie Paniccioli.

HIP HOP HAIR by Elena Romero

From braids, locks, twists, and baldies to Afros, wigs, dyed hair, and finger waves, hair has always been an integral part of hip hop style. Hairstyles for both men and women over the years have given hip hop culture its own memorable looks. While the '70s was the decade of the Afros for Black hair, the '80s brought the popularity of the Jheri curl with West Coast rappers like Easy E, Ice Cube, Snoop Dogg, and DJ Quik. The '90s was the decade of the hi-top fade, flattop, and Gumby for men, while the ladies rocked the asymmetrical mushroom cut à la Salt-N-Pepa. We can thank the likes of Onyx, Naughty by Nature's Treach, Tupac Shakur, Common, Malik Yoba on *New York Undercover*, and Tyson Beckford for the baldie embrace. A special thank you goes to The Notorious K.I.M. (aka Lil' Kim) for her unapologetic, feminine style—from her pink highlights and colorful wigs to luxury logo stenciled hair.

"Hip hop impacted the way we dressed and how we wore our hair especially," said New York barber Greg "the Groomer" Cooper Spencer in *Ebony*. "Before this period, we relied heavily on Black leaders such as Martin Luther King, Malcolm X, and Muhammad Ali, who sported Afros, to influence how we engaged in society in addition to our look."[1] Here is a look at some of hip hop's most popular hairstyles.

Men of Faith, New York City, 2019. Photo: Jamel Shabazz.

Jheri Curls

Jheri curls were named after white hairstylist Jheri Redding, who aimed to convert straight white hair into curly styles, but his two-step, permanent process resulted in glossy, loose curls for African Americans.[2] The look, which was invented in the '70s, regained popularity thanks to hip hop. The wash-and-wear look was seen on West Coast rappers like Snoop Dogg and Easy E, as well as Ice Cube, who wore them during the early days of N.W.A. The popularization of Jheri curls also stemmed from TV shows and films, including Keenen Ivory Wayans's character Frenchie on *In Living Color* (1990), the coming-of-age hood drama *Boyz n the Hood* (1991), and the fictionalized Jheri

curl hair product "Soul Glo" in Eddie Murphy's classic film *Coming to America* (1988).[3]

Fades, Flattops, and the Gumby

According to the book *Hair Story: Untangling the Roots of Black Hair in America*, the style derived from the Philly fade, a hairstyle with roots in the city of Philadelphia and seen as early as the 1950s.[4] The fade became one of the most defining hairstyles for Black men in hip hop in the 1980s.[5, 6] Black barbershops were known for the sculpted, geometric, box-like hairstyle, which came in several varieties including

Dreads

Lil Wayne, J. Cole, Busta Rhymes, Chief Keef, T-Pain, Lil Uzi Vert, Waka Flocka Flame, 2 Chainz, Wale, Future, A$AP Rocky, Fetty Wap, Ty Dolla Sign, and Lauryn Hill are all well known for their locks. Rappers such as Young Thug added experimentation with color to the style, wearing dreads in blonde and bubblegum pink, whereas Lil Yachty is best known for his red tresses. Snoop Dogg has worn his hair in just about every hairstyle imaginable—from braids, pigtails, and straight and silky to a mini-Afro. In 2012, locks became his newest hairstyle after a trip to Jamaica, where he adopted his new Rastafarian alias "Snoop Lion." While Busta Rhymes wears his hair short in 2023, during the '90s and 2000s, he was known for wearing his locks bunched up. Before having them snipped at a New York barbershop in 2005, Busta said it had taken him fifteen years to grow them out. "I started growing these sh-s in December '89. I was 17," said Busta. "I signed my deal and said, 'I ain't combing my hair no more. I don't have to.'"[10]

Jay-Z is a newcomer to the world of locks. Although he was known for his super short hair, he began to wear free locks in 2018 after experimenting with a mini-Afro. Wearing them in a similar fashion to artist Jean-Michel Basquiat, Jay-Z, according to lyrics that he contributed to Meek Mill's "What's Free" (2018), said his dreads are a symbol of freedom. For women, Lauryn Hill takes top prize for her locks, memorialized on the cover of her Grammy-winning solo album *The Miseducation of Lauryn Hill* (1998).

Braids

Braid patterns can be traced back hundreds of years in various African cultures, traditions, and styles. They have long been a staple style in hip hop, from box braids to zig-zag cornrows.[11] Popular braided rappers include Snoop Dogg, Bow Wow, Ol' Dirty Bastard, Ludacris, A$AP Rocky, Xzibit, Ja Rule, Jim Jones, Pusha T, Coolio, Lil Yachty, Travis Scott, Meek Mill, Brand, and Yo-Yo.

Snoop Dogg can be credited for making cornrows mainstream. A$AP Rocky has been known

Double Date, Harlem, 2014. Photo: Jamel Shabazz.

the fade (low cropped cut with the side of the head closely shaved) and the hi-top (also called the flattop fade). Tramlines (lines shaved into the hair) and etched artwork also provided a varied fade look.[7] Big Daddy Kane, Doug E. Fresh, Jazzy Jeff and the Fresh Prince Will Smith, and Christopher "Kid" Reid from the hip hop duo Kid 'n Play in the film *House Party* (1990) brought the style to popular culture.[8] Variations included the Gumby, named after the animated character, which was sported by Bobby Brown and Tupac Shakur in the movie *Juice* (1992). A few women tried their own variation of the hairstyle, including Queen Latifah in the video for "Ladies First" (1989) from her debut album *Hail to the Queen*.[9]

to wear his braids in a variety of ways, especially in box braids and in a ponytail. Lil Yachty is known to wear his braids dyed in bright red and styled with beads, and Fetty Wap is known to highlight his locks. Although Ludacris has gone from big Afro to buzzcut to braids over the years, his cornrows will always be considered his signature style.

Black Girl Fly: Mushroom Cut

There was no fly girl in hip hop who did not don the asymmetrical mushroom cut. Salt-N-Pepa made the cut the "it" hairstyle for Black women in hip hop by 1986, and MC Lyte wore her own variation of the asymmetrical bob.[12, 13]

"I remember being inspired by hip hop female artists," said Elizabeth Wellington, fashion columnist for *The Philadelphia Inquirer,* whose youthful hairstyles were inspired by MC Lyte and Salt-N-Pepa. "Every hairstyle was inspired by hip hop—whether it was Yo-Yo and her braids or Salt-N-Pepa and their asymmetrical bobs to Lisa Lisa and Cult Jam— until Halle Berry came out."

For Wellington and so many young girls who were into hip hop, hair became their most important form of expression:

> At every school dance, we all wanted hair inspired by them. It was one of the few ways women could be a part of hip hop in their own way without mimicking guys … It was the first way girls could be creative. We could be ourselves by wearing our hair like that—with our dark red lipstick and big hoop earrings. We drove those terms … Even if you didn't have the clothes, you couldn't afford the labels, you could have the hairstyle and fake everything else and still be part of the culture. If your hair was right, you could still be part of the culture … Girls couldn't get the cut without a relaxer. It was high maintenance. It didn't matter because we wanted it. It was radical.[14]

Blonde Ambition

While Black women have always experimented with hair and hair color—singer Etta James was known for her blond hair in the 1960s—hip hop would bring blond ambition to new heights. Wellington remembers Salt, who introduced her blond hair to hip hop with Salt-N-Pepa's album *Hot, Cool & Vicious* (1986): "Salt had blond in the 'Shake Your Thing' video, and you also had people like Lil' Kim, Foxy Brown, and Nicki Minaj."

Other female emcees to rock blond tresses include Adelina Martinez (aka The Real Roxanne) who wore her blond hair in a "poodle perm" ready to battle as she released her recorded answer to UTFO's "Roxanne Roxanne" in the late '80s.[15] The '90s became the decade of blond expression for many in the rap game, starting with the Queen of Hip Hop and R&B Mary J. Blige, who wore platinum blond hair on the cover of her second album *My Life* (1994). She has worn her hair in a variety of hues ever since. On the cover of *My Life,* fans saw Blige wear her hair in long braids, but she has since worn her hair in bobs, ponytails, and cropped styles. Other emcees, such as Eve and Lil' Kim, and songstress Faith Evans have also sported golden locks in this decade. Nicki Minaj, known for her pink expression, is equally known for her admiration of blond hair.[16]

Blonde hair in hip hop has never been a female-exclusive trend. Kwamé had a blond streak on his hi-top during his polka dot fashion era, and Wiz Khalifa rocked a blond patch in his hair. Sisqó, most commonly known for his "Thong Song" (2000), is also known for his blond hair and other occasional dye experiments, including silver. For some rappers, like Chris Brown, Soulja Boy, Kid Cudi, Young Thug, OG Maco, Royce Rizzy, and Kanye West, dying their hair blonde has become part of their look well into their careers. On July 4, 2021, Soulja Boy proclaimed on Twitter: "I was the first rapper with blonde hair and the Nike Air mags."[17]

Salt-N-Pepa, 1988.

Lil' Kim attends the Versace Spring/Summer 2001 fashion show.

Wigs

Wigs have helped certain looks withstand the test of time. Celebrity stylist Misa Hylton credits Lance Rivera for the idea used in the video for "Crush on You" (1997).[18] According to Hylton, the video was inspired by the film *The Wiz* (1978), with each scene changing colors. "I thought it was dope to have everyone wear all blue, yellow, red, and green with matching hair," said Hylton, who styled the iconic music video. "It made a huge impact on our culture that you still see today."[19]

Dionne Alexander is the hairstylist who put Lil' Kim in the logo wigs in her "In the Air Tonight" (2001) music video. Among Kim's logo styles was a turquoise wig with a Chanel logo placed on the bangs, which was photographed for *Manhattan File* magazine.[20] Alexander was also responsible for the blond wig Lil' Kim wore to the Spring/Summer 2001 Versace couture show in Milan.[21]

"Somebody called me from Europe and was like, 'Yo, that's all people are talking about is this wig,'" said Alexander. "I just remember the voice message Kim sent me, because she freaking loved this wig. She was like, 'Oh my god, Dee-Dee. I love this!' I kept that message for the longest."[22] In 2019, Nicki Minaj continued the style, wearing a blond wig with hot pink Fendi logos.[23]

Finger Waves

Although the style dates back to the Jazz Age, no hip hop persona can claim finger waves as their definitive look better than Missy "Misdemeanor" Elliott. She popularized the style in the '90s. From the cover art for "Hit 'Em Wit Da Hee" from the album *Supa Dupa Fly* (1997) to her epic video for "The Rain (Supa Dupa Fly)" (1997), finger waves defined Elliott's hairstyle. Over the years, she would go on to sport other hairstyles, including the pixie, mullet, long ponytail, and braids.

Notes

[1] Princess Gabbara, "The History of the Fade," *Ebony*, December 27, 2016, https://www.ebony.com/style/history-fade-haircut/#ixzz4kONwBy1N.

[2] Ayana D. Byrd, and Lori L. Tharp, *Hair Story: Untangling the Roots of Black Hair in America* (New York: St. Martin's Press, 2001).

[3] "Rappers with Jheri curls," *Ranker*, November 9, 2019, https://www.ranker.com/list/rappers-with-jheri-curls-ranker-hip-hop.

[4] Byrd and Tharp, *Hair Story*, 113.

[5] Antwaun Sargent, "The Fierce Return of the Sculptural, Political Flattop: A Brief History of one of hip hop's most influential hairstyles," *i-D*, June 23, 2017, https://i-d.vice.com/en_uk/article/a3vvpp/the-fierce-return-of-the-sculptural-political-flattop.

[6] Elizabeth Wellington, interview with author, June 6, 2022.

[7] Sargent, 2017.

[8] Sargent, 2017.

[9] Gabbara, "The History of the Fade."

[10] Angela Johnson, "Black Hairstyles from the '90s That We Will Never Forget," *The Root*, April 14, 2022, https://www.theroot.com/black-hairstyles-from-the-90s-that-we-will-never-forget-1790868584.

[11] Byrd and Tharp, *Hair Story*.

[12] Antwaun Sargent, "Black Music Month: Female MC Hairstyles," *Essence*, October 28, 2020, https://www.essence.com/news/black-music-month-female-mc-hairstyles/.

[13] Elizabeth Wellington interview.

[14] Elizabeth Wellington interview.

[15] Nandi Howard, "Real Fashion Confessionals: Misa Hylton Dishes on the Most Iconic Lil' Kim Looks," *Essence*, December 6, 2020, https://www.essence.com/fashion/real-fashion-confessionals-misa-hylton-dishes-on-the-most-iconic-lil-kim-looks/.

[16] Sargent, "Black Music Month."

[17] Soulja Boy (Big Draco) post, July 4, 2021, Twitter, https://twitter.com/souljaboy/status/1411887842855321600[18] Howard, "Real Fashion Confessionals."

[19] Howard, "Real Fashion Confessionals."

[20] Aria Hughes, "Meet Dionne Alexander, the Hair Stylist Behind Lil Kim's Designer Logo Wigs and Mary J. Blige's 90s Updos," *Complex*, August 10, 2020, https://www.complex.com/style/2020/08/li-kim-hair-stylist-dionne-alexander-designer-logo-wigs.

[21] Hughes, "Meet Dionne Alexander."

[22] Hughes, "Meet Dionne Alexander."

[23] Lauren Rearick,"Nicki Minaj Created a Capsule Collection for Fendi," *Teen Vogue*, October 14, 2019, https://www.teenvogue.com/story/nicki-minaj-fendi-capsule-collection.

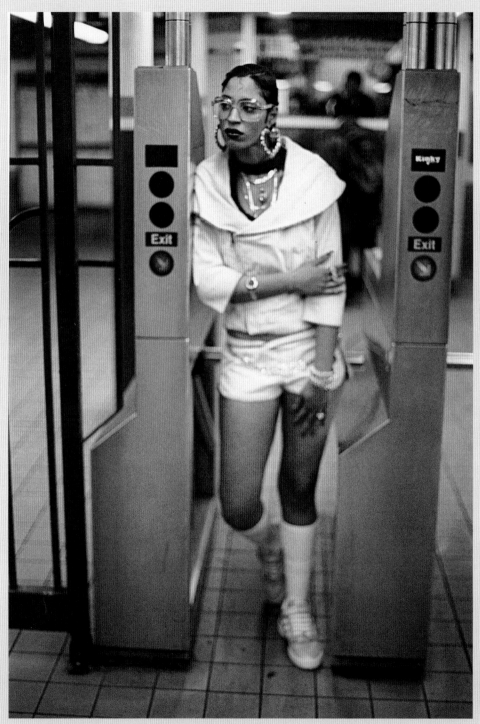

Kisha, New York City, 2000. Photo: Jamel Shabazz.

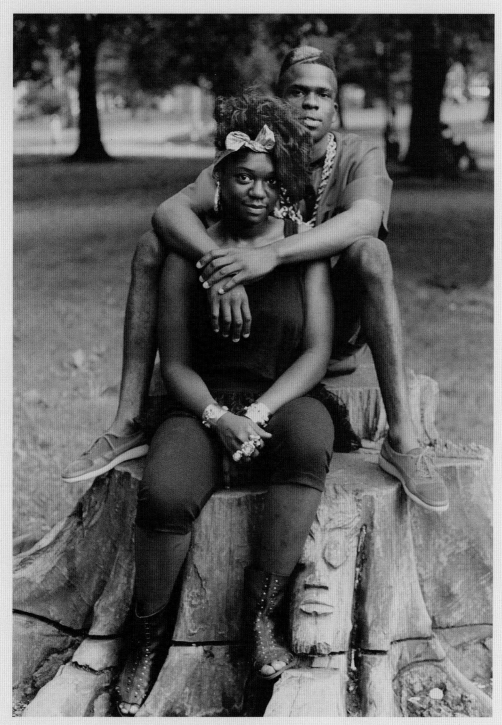

A Natural Reflection, Prospect Park, Brooklyn, 1988. Photo: Jamel Shabazz.

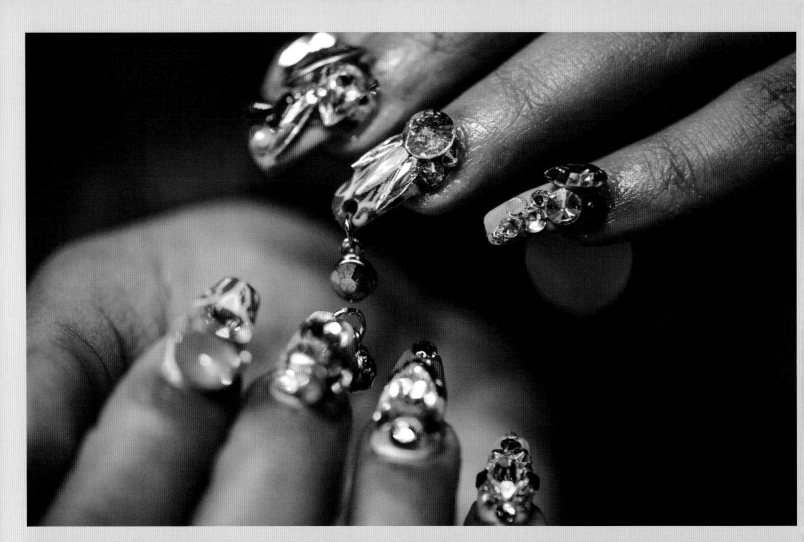
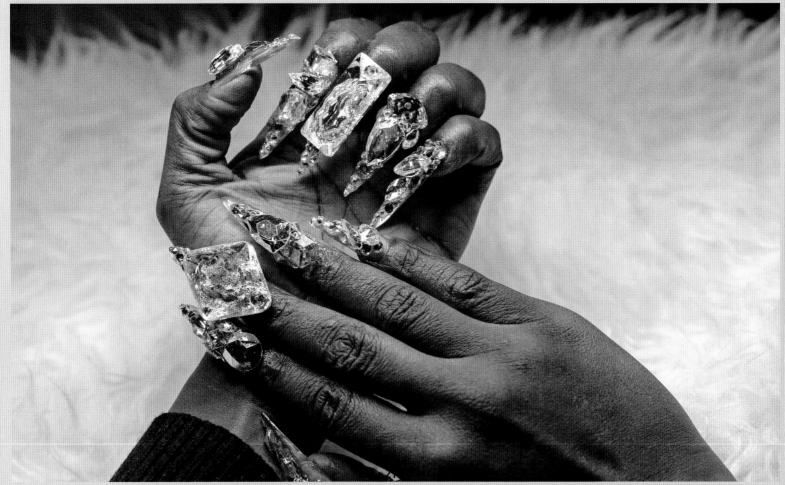

HIP HOP NAILS by Elizabeth Way

Hip hop style is about the details, and every piece contributes to the whole. For women in the culture, and more generally for women of color in America, nails are as important as hair, makeup, or any item of clothing. Writer Ryan Blocker recalls his mother's habit of complimenting Black women's nails whenever she encountered an adorned set. Her greeting, "Girl, who did your nails?" demonstrated a reality she knew intimately. When systems of oppression intersect around your body, fingernails are not just fingernails.[1] For Blocker's mother, acknowledging the creative labor that other women of color put into their nails was an act of solidarity and sisterhood. It was a way of saying, "I see you as you wish to be seen."[2]

Hip hop nails embody the same characteristics that make hip hop style authentic and enviable by the mainstream. They reflect an ingenuity and standard of beauty within Black and Latinx communities that embraces creativity, aspiration, and customized individuality over respectability and assimilation. Like all hip hop styles, they were dismissed as tacky and over the top before they were appropriated and incorporated into mainstream fashion. Nail artist Bernadette Thompson notes, "Black girls always added things to nails, like they added things to clothes ... It was huge in our community. I'm not the first to create nail art. I've been around a whole bunch of creative nail artists who are Hispanic [and] black."[3]

As hip hop culture gained exposure through music videos during the 1990s and social media during the 2000s, hip hop nail artists made their innovative ideas felt in fashion. Thompson famously cut up real currency to adorn Lil' Kim's nails, inspired by her feature on Junior M.A.F.I.A.'s "Get Money" (1995), and she led nail art into "high" fashion, working first with Louis Vuitton and later Marc Jacobs and Calvin Klein.[4] Journalist Robin Givhan explains, "Today, thanks in large measure to Thompson, manicurists are regularly credited in fashion shoots. And nail art is as common on a European runway or corporate fashion shoot as it is in a Detroit or Harlem nail salon."[5]

Fabulous nails are about empowerment, and this is as true for the women wearing them as the women creating them. Jenny Bui, the "Queen of Bling" behind Cardi B's signature opulent and bejeweled manicures, is a survivor of the brutal Khmer Rouge regime in Cambodia. She is one of multiple generations of women who immigrated to the United States and created stable lives in a profession that required entrepreneurship and long hours, but not perfect English or expensive overhead.[6] Bui, inspired by Japanese designs, helped popularize long, multidimensional, crystal-encrusted styles that embody a revival of the bling era and hip hop's glamorous femininity. As Bui states, "I'm not trying to be cocky, I [just] know in the whole world nobody puts diamonds [on nails] like me."[7] Scholar Suzanne Shapiro equates women's nails to the hip hop male's conspicuous consumption of cars and sneakers (though women certainly collect these as well).[8] Although gender fluidity has made room for men to paint their nails, trendsetting, eye-catching, Instagram-worthy manicures remain a female-identified domain.

Notes
[1] Ryan Blocker, "Who Did Your Nails?" in *Paint & Polish: Cultural Economy & Visual Culture from the West Side*, ed. Helen Maurine Cooper (Eindhoven, Netherlands: Onomatopee, 2017), 22–23.
[2] Blocker, "Who Did Your Nails?"
[3] Robin Givhan, "How Lil' Kim's Most Memorable Manicure Ended Up in the Museum of Modern Art," *The Washington Post*, November 14, 2017, https://www.washingtonpost.com/news/arts-and-entertainment /wp/2017/11/14/how-lil-kims-most-memorable-manicure-ever-ended-up-in -the-museum-of-modern-art/.
[4] Kate Sullivan, "Manicurist Bernadette Thompson on Mary J. Blige, the Man-Manicure, and More," *Allure*, January 1, 2013, https://www.allure.com/story /manicurist-bernadette-thompson.
[5] Givhan, "How Lil' Kim's."
[6] Suzanne E. Shapiro, *Nails: The Story of the Modern Manicure* (Munich: Prestel, 2014).
[7] Heather R. Morgan, "Not Just Cardi B's Nail Artist: Jenny Bui Explains How Surviving Khmer Rouge Gave Her Fearless Determination as an Entrepreneur," *Forbes*, November 27, 2019, https://www.forbes.com/sites /heathermorgan/2019/11/27/not-just-cardi-b-nail-artist-jenny-bui-surviving -khmer-rouge-fearless-determination-entrepreneur/?sh=5048bb9142f3.
[8] Shapiro, *Nails: The Story of the Modern Manicure*.

Nail design by Jenny Bui, @nailson7th. Photo: Jeffrey Henson Scales. Stylist: Rebecca Pietri.

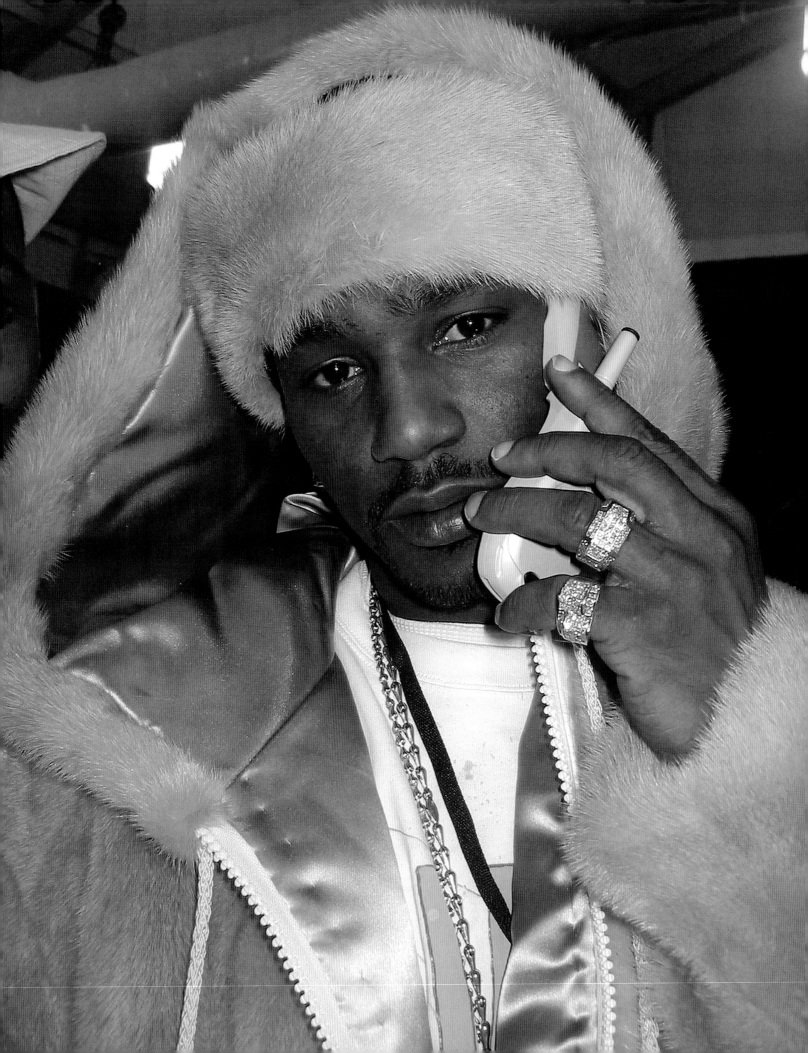

HIP HOP & PINK

Cam'ron, 2003.

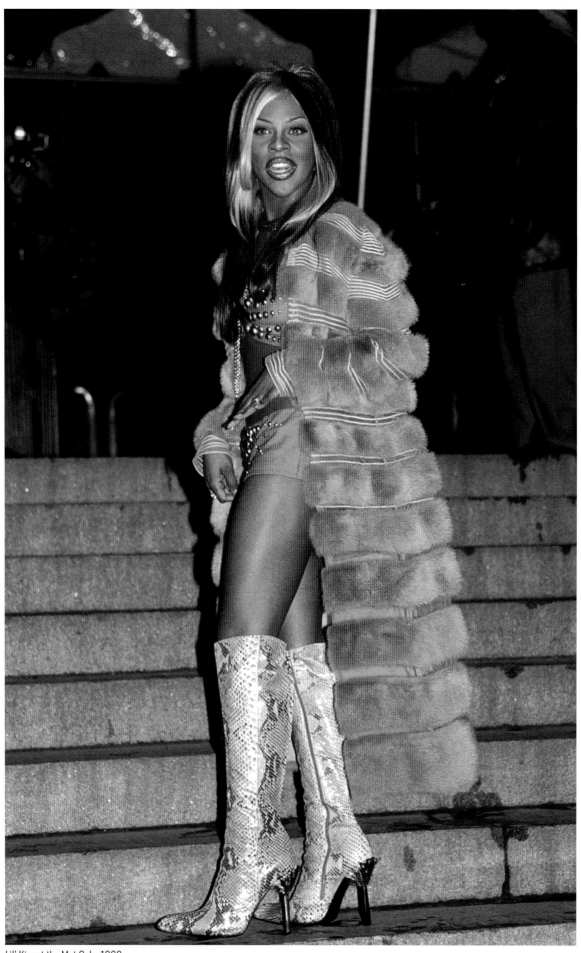

Lil' Kim at the Met Gala, 1999.

"Why would anyone pick blue over pink? Pink is obviously the better color."[1] —Kanye West

Pink Impact: Cam'ron

Harlem rapper Cam'ron (a member of The Diplomats) is synonymous with hip hop's thrust into pink culture. Cam'ron cemented his pink legacy by wearing his most famous conversation piece: a pink mink fur coat with a matching hat and cellphone to the Mercedes-Benz Seventh on Sixth Fashion Show in 2002.

"When I first started wearing pink, it wasn't nothing I planned on doing or strategized," he told *GQ*. "But people showed me so much love for the pink mink I wore, I had to go out to Pantone and create my own color which is called Killa Pink."[2] Cam'ron's pink status had been part of his signature style well before his famous and iconic pink moment. Pink seemed to appear in everything from his Timberlands to his custom pink Range Rover.

"For me, the color pink almost didn't exist in hip hop," said Dr. Don Sawyer III, associate vice president for academic affairs and chief diversity officer and associate professor of sociology at Quinnipiac University. "It was Cam'ron who brought pink back with the pink Lamborghini, bandana, and everything. Later on, it was Kanye and the pink polo shirts."[3]

Sawyer, a hip hop aficionado from Harlem, did not incorporate pink into his wardrobe until he became a "grown man." Now, he regularly wears a pink dress shirt with a gray suit. Sawyer credits Cam'ron and his confident swagger for changing the narrative around pink. "Part of it is that you are starting to see men in this place, artists, getting into high fashion," said Sawyer.[4]

Although Cam'ron has been most synonymous with hip hop's relationship to pink for men, it was an Atlanta-based rap duo named OutKast that introduced pink and its Southern flair to fans in 2001, keeping the association constant throughout their career. Both André "André 3000" Benjamin and Antwan "Big Boi" Patton of OutKast wear pink in different ways to complement their individual styles. Big Boi draws from a more street-influenced, pimp-inspired flair, whereas André 3000, the loudest pink dresser of the group, references multiple sources—from Jimmy Hendrix's psychedelic period to the preppy era and dandyism.

History of Pink to the 1980s

When Cam'ron stepped onto the red carpet in his Killa Pink mink, he recalled and advanced a conversation about how Black people represent themselves, their ambitions, and their often defiant and playful understanding of how they are perceived by the mainstream culture via fashion and style. Pink has had a long, fascinating semiotic history. Although we most often associate it with women, femininity, and youth, the color has also been worn by men from the eighteenth century, when it conveyed "elegance, novelty, and aristocratic status."[5] It was not until the mid-twentieth century that pink became more indelibly associated with women as gender roles solidified in post–World War II America.

Fashion historian Valerie Steele notes that African American and Afro-diasporic people have always had a complicated relationship to wearing bright, bold, and vibrant colors with the many hues of pink included.[6] Given that majority societies often consider Black people, in particular musicians and entertainers, to be "excessive," prone to extravagance, oddity, or the outré in clothing and style, their love of and use of pink is not unexpected. This is certainly true in hip hop. Pink is part of the hype and hustle—simultaneously a strategic tool in an artist's self-expression and an inquiry about what is proper to the self, the art, and the culture.

Wearing pink in the Black community has been, on the one hand, a defiance of a respectability politics that equated sober and somber dress with fitness for citizenship and, on the other hand, an expression of how good it could feel to "get on over," or to find and create success on one's own terms. One of the first Black public

André 3000, 2004.

figures to fully embrace the power of pink was boxer Sugar Ray Robinson who adopted it as his signature color after a visit to the Hialeah Race Track near Miami, which had a resident flock of flamingos living in the middle of the track.[7] On his return to New York City, Robinson ordered a pink Cadillac convertible. In a famous photograph from 1950, he can be seen leaning on his car in an equally fabulous pink suit in front of his Harlem restaurant, Sugar Ray's. A symbol of the hard work and unusual route to success that enabled Ray to cultivate a life of leisure, pink broadcast his achievement of his version of the American dream.

In the 1950s, '60s, and '70s, Black musical icons like Little Richard, James Brown, and Sylvester anticipated the appeal of pink to hip hop in the '80s and '90s. Their wearing of pink signaled their perceived difference and otherness. All three "owned" pink as a badge that stated they were powerful without being white and conventionally masculine. Clandestinely announcing his sexual difference in his hit song "Tutti Frutti" (1955), Little Richard knew that his appeal was based not only in his groundbreaking crossover music, which anticipated rock and roll, soul, and funk, but also in his incredible, boundary-defying charisma. In addition to his pompadour, meticulous makeup, pencil mustache, and high-watt smile, Richard wore pink—suits, sequins, scarves, sashes—to exhibit his exuberance. "Sex Machine" James Brown also had an affinity for dark, saturated pink pants-suits—an outfit that enhanced and eased his signature shuffle and slide on stage.

This pink color was also used in posters announcing Brown's concerts, often with a contrasting color of black, broadcasting his frenetic energy and bombastic (hetero) masculinity. Feeling "mighty real" for "Queen of Disco" Sylvester meant expressing his sexuality and androgyny in both bold and subtle ways via color and costume. Always photographed in soft focus, often sporting a soft Jheri curl and expert makeup that enhanced the dreaminess of his face, Sylvester was an out gay man who was not afraid to convey his own desires and that of the gay community of the '70s and '80s. The answer to his question "Do Ya Wanna Funk" (1982) was a resounding "Yes!"

Any club where Sylvester played was filled with people funking it up in terms of gender, sexuality, and race.

The hip hop generation, Generation X, got its pink cues from a number of other, perhaps unexpected, places: the surf culture of the West Coast, punk music, and newly popular preppies. In the 1950s, as the G.I. Bill made college more accessible, "college wardrobes" became de rigueur for women and men, and elites and first-generation students trying to fit in. Brooks Brothers popularized the pink buttoned-down shirt for men and pink as the ultimate preppy color. Lisa Birnbach's 1980 book *The Official Preppy Handbook* extended this legacy and painted a detailed pink-and-green picture of the lifestyle of the elite, as did Robin Leach's 1985–95 TV show *Lifestyles of the Rich and Famous*, which broadcasted the extravagant lifestyles (including the closets and wardrobes) of entertainers, athletes, and business moguls.

In the 1960s, California and its surfing subculture similarly promoted a pastel pink, associated with the beach and tropical climes, as part of a new leisure culture that was dominated by young people defying the work ethic of their parents. Jimi Hendrix's pink boa, his deep pink satin shirts, and velvet suits all signaled his countercultural proclivities. In 1969, Hendrix played his startling, electrified rendition of "The Star-Spangled Banner" at Woodstock in a pink headband as a symbol of his rejection of the Vietnam War and martial masculinity. Punk musicians in England also promoted pink as protest, using the color to amplify their devotion to "bad taste," and critique of authority in fashion, culture, and politics.[8]

The attraction to pink for hip hop artists also has origins more specific to Black cultural geographies. In Africa and the diaspora—in particular, the Caribbean—pink as a color for dress, decoration, and even architecture is a longstanding part of the culture. Pink was a hue/tint in the natural environment that was imported into the built environment and into clothing and dress. In the Caribbean, traditional dress and carnival finery feature every shade of pink. The color evokes dignified formality (and colonial nostalgia), as

well as exuberant sexuality and play associated with African survivals and Indigenous religion. In Africa, a vibrancy and saturation of color have long been associated with African wax fabric and other color and dying traditions, as well as pointed appropriation of (and play with) Western dress, as seen in Congo with modern dandies like the Sapeurs, or South African Swenkas.

When 1980s African American hip hop stars put on pink, they were wearing multiple histories, signaling across the binaries of gender, race, and class beyond national borders. As such, they were recalling not only extravagant white wealth and privilege but also defiant, sometimes subtle, and sometimes bold oppositional Black histories and behavior.

Ladies First (1990s)

As women broke barriers in hip hop and went mainstream, the '90s gave way to a new wave of female emcees who not only embraced full-heartedly the color pink but also highly played off their sexuality as a way to dominate and capture the market space. The 1996 debut studio album *Hard Core* by the first lady of Junior M.A.F.I.A, Lil' Kim, thrust the Brooklyn native to the forefront of hip hop and fashion. She quickly became the "Queen of Rap" while simultaneously becoming pink's number one promoter and one of the most iconic pink pop culture figures. From statement pink wigs to one of her most iconic pink looks—a Versace pink fur coat, bra, and hot pants paired with pastel python boots (an ode to the theme "Rock Style" at the 1999 Met Gala), Lil' Kim placed the capital "P" in Pink muse for designer Donatella Versace. No question, it was the Queen herself, Lil' Kim, who put pink on the hip hop map.

No matter how many years have gone by, the notorious Lil' Kim stays true to her pink hip hop roots. Continuing to make pink glamorous, Lil' Kim wore her hair in pink finger waves while wearing a metallic rose gold Dapper Dan for Gucci dress at the 2019 BET Hip Hop Awards. She wears pink in all shades. In 2021, she rocked a Dolce & Gabbana neon-pink crop top and leggings with

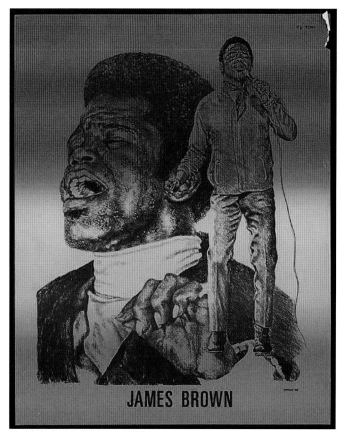

David Mosley, James Brown, 1969.

223

matching fluorescent wig to Megan Thee Stallion's BET Awards afterparty. Her monochromatic pink adoration was a visual turning point that would pave the way for other female rappers, including Foxy Brown, Nicki Minaj, Cardi B, and Megan Thee Stallion.

2000s and Beyond: Nicki Minaj, the Pink Barbie

Nicki Minaj has become synonymous with the color pink; it is part of her brand DNA. The "Pink Barbie" has been seen in everything from pink hair streaks to pink wigs and countless pink outfits. Her album titles include *Pink Friday* (2010) and *Pink Print* (2014). "It became so synonymous with me that a lot of people gave me endorsement deals, so I think that actually helped me a lot in the long run," Minaj told Ellen DeGeneres on the latter's self-titled TV show.[9] Minaj claims a fairytale lifestyle instilled a deep-rooted love of the audacious color:

> When I was younger, I didn't have much financially—like, we couldn't afford a lot of stuff. And I remember seeing little girls' rooms on TV, and they'd all be pink. I didn't have my own room—I shared with my brother—so I would have this daydream and imagine that one day I could have my own room and it would all be pink, like Cinderella's. So I guess pink takes me back to that time, and it just feels euphoric when I wear it. I love it.[10]

This fantasy takes differently gendered fantastical forms. Whereas Minaj dreams of Barbie and what it would mean to live in a Barbie world, other groups experimented with pink as a sign of otherworldliness—a Black avant-garde, chameleonic aesthetic reminiscent of Sun Ra and Bootsy Collins.

Legends and Moguls

Legends are as much about "realness" as they are about marketing. Like the musicians they represented, hip hop CEOs adopted pink for themselves personally and for their brands. In the 1990s, hip hop took over the world. MTV and VH1 democratized and expanded the culture. Musical styles and fashions that were once East Coast and West Coast became international and global. The legends of hip hop transformed themselves into fashion moguls, providing the culture with music, clothing, and accessories that telegraphed hip hop's popularity and deep reach into the mainstream. Def Jam cofounder and brother of Run-DMC's Rev. Run, Russell Simmons heavily promoted pink as part of his fashion label Phat Farm and later Baby Phat brands. For Simmons, pink became a way to promote his hip hop Hamptons lifestyle—a remix of preppy and street fashion. As an astute cultural historian, Simmons knew very well the connotations of pink as it related to race, class, and gender. Other moguls like Jay-Z, Sean "Puffy" Combs, and Kanye West also saw the power of pink as both a personal statement and marketing magic. Each of them worked pink statement pieces and remixed versions of the old-made-new-again: Kanye wore a classic polo shirt in fuchsia in 2004, and Jay-Z wore an impeccably tailored mauve (not pink) suit in 2021.

Pink Beyond Polos

Pharrell Williams, Tyler, the Creator, and Nas have proved that the admiration for pink could move beyond polos and continue to interrogate and interrupt how we think about gender and sexuality in hip hop. Pharrell, who is known for his signature streetwear styles with his own brand, Billionaire Boys Club, and more recent collaborations with Louis Vuitton and Adidas, gets credit for blending the West Coast skater/rock lifestyle look into hip hop while, at the same time, not conforming to traditional gender roles whether designing for others or dressing himself. His 2014 outings in a bubblegum pink Celine duster coat remain legendary.

In 2015, Tyler, the Creator told *Vogue* that "colors play such a big part in my music and the

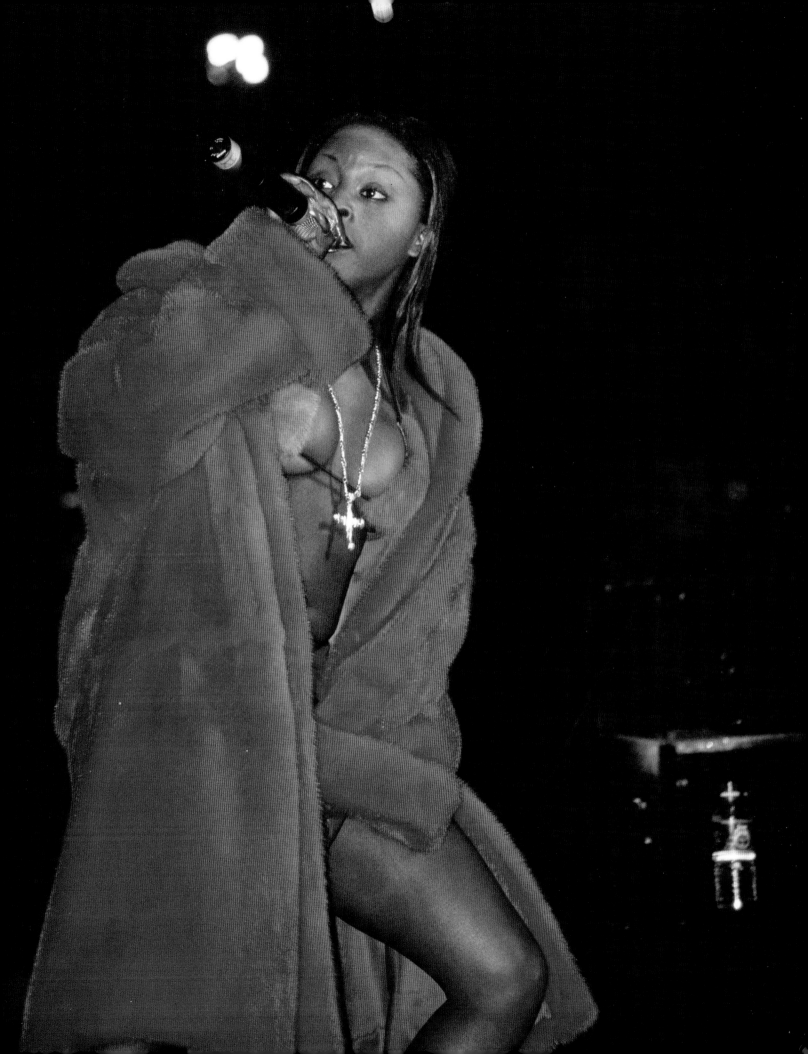

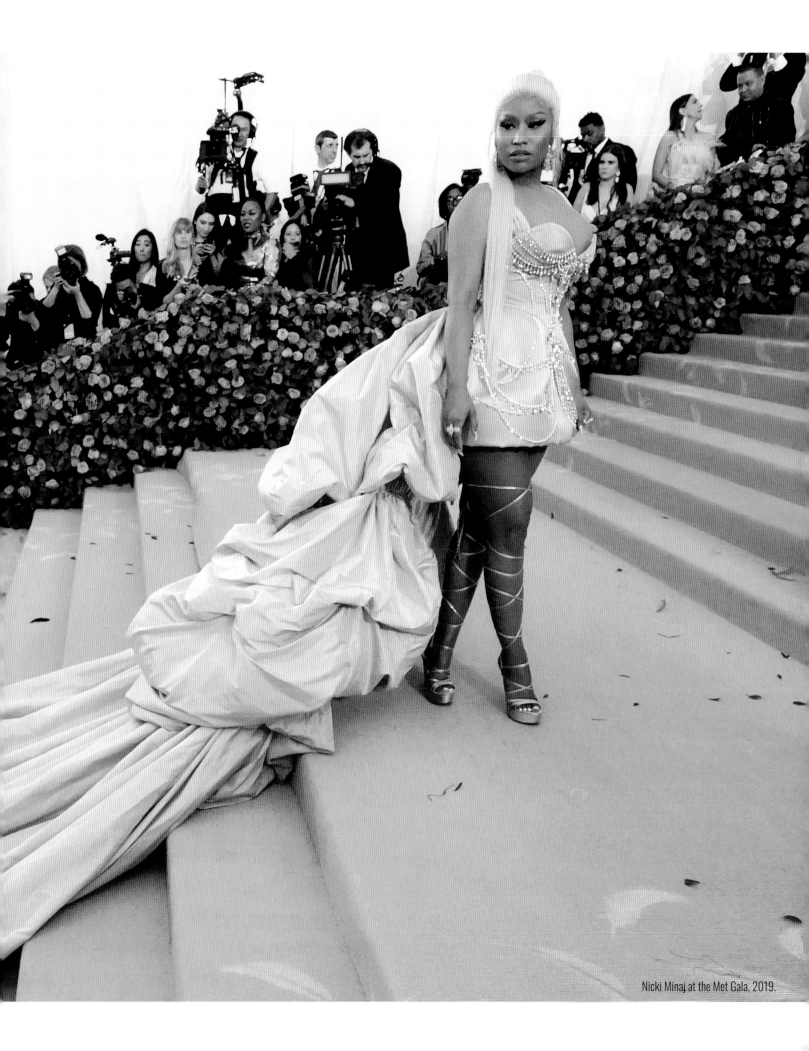

Nicki Minaj at the Met Gala, 2019.

way I think about things … Pink is my favorite. It's just a calming color to me."[11] Tyler, the Creator frequently sports Chanel bags, Converse sneakers, eclectic printed shirts, and costumes (for the stage and the street) in his favorite color—some for his own brand, Golf Wang. In 2013, Queens Nasir bin Olu Dara Jones (aka Nas) kept it traditional in a pink tuxedo jacket on his fortieth birthday—a choice befitting the namesake of the Nasir Jones Fellowship at Harvard University. The outfit was a step up from the pink polyester suits that he wore in his "Street Dreams (Remix)" music video in 1996. Again, audacity and vulnerability meet versatility in these looks.

Queens of Pink: Solange and Janelle Monáe

Just as pink is being bought and sold within hip hop and amplifying the relationship between hip hop and commercialism, it also represents an underappreciated aspect of hip hop artistry: its contemplative, soul-searching aspects and its function as a mode of communicating the streetwise intellectualism of Black people. Younger artists and their fans do not see the world through rose-colored glasses, and their use of pink reflects this vision. Beyoncé's sister Solange stepped out of her shadow with her 2016 album *A Seat at the Table* and its single "Cranes in the Sky." In dialogue with the Black Lives Matter movement and contemporary Black youth activism, the song's video shows Solange wearing pink as a response to the violence to which Black lives are subject. Her reaction is nonviolent, thoughtful, and soulful. It calls on Black history, centers Black lives, and highlights Black people's vulnerability to state violence and histories of trauma and abuse. In the "Cranes in the Sky" video, Solange's pink wardrobe is protective yet it emotes sensitivity and concern.

In 2018, Janelle Monáe's album *Dirty Computer* gave us the song "PYNK," her own unabashedly sexy shade of pink. A breakthrough album for the artist, *Dirty Computer* propelled Monáe to multiple Grammy nominations. The video for "PYNK" featured Black femme (self) love,

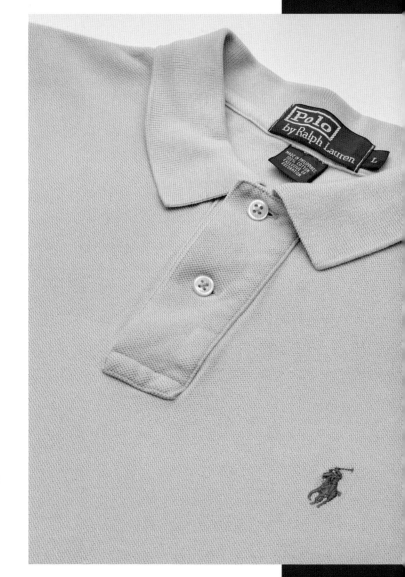

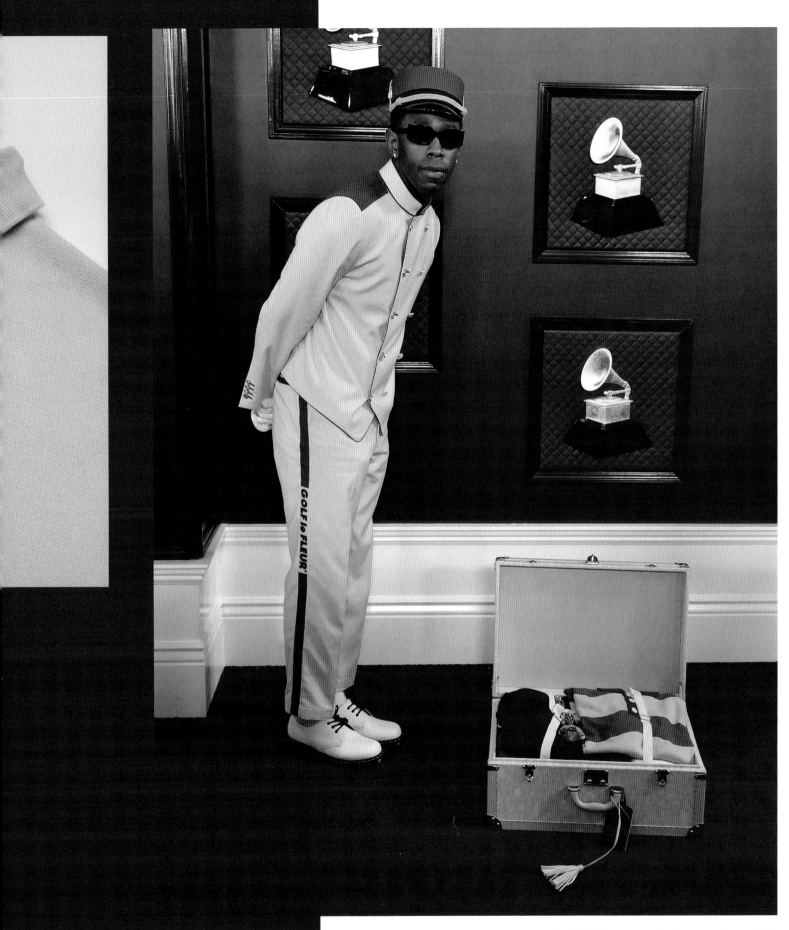

OPPOSITE: Polo shirt, circa 2000 (original design, 1972).
Tyler, the Creator at the 2020 Grammy Awards.

expressed through fashion: pink, ruffled pants designed to look like a vagina. "PYNK is a brash celebration of creation. Self-love. Sexuality and pussy power!," explained Monáe. "PYNK is the color that unites us all, for PYNK is the color found in the deepest and darkest nooks and crannies of humans everywhere. PYNK is where the future is born."[12] For both Solange and Monáe, pink is powerful. The color perfectly expresses the strength, vulnerability, and joy of a Black feminist point of view. Pink has become a color with multiple meanings within the hip hop world, open to personal and group interpretation.

Millennial Rappers and Future of Pink

Millennial rappers from Lil Pump and Lil Uzi Vert to 6ix9ine (formerly Tekashi69) have proven that there is no longer a stigma attached to the color for men. Many brands have also fully embraced the color, including Ed Hardy, Supreme, A Bathing Ape, Billionaire Boys Club, ICECREAM, and Adidas. Brands recognized that youth culture was pink-ready and embraced designs made through a pink lens.

Lil Uzi Vert is such a fan of pink that he had a large pink "10, almost 11-carat" diamond surgically implanted in his forehead in 2021. He spent a whopping $24 million on the stone, which eventually became dislodged during a performance at the hip hop festival Rolling Loud in Miami.[13] Although that seems to be an extreme "pink move," he is not alone. Canadian rapper Drake often sports a small pink diamond on a front tooth.

At the 2020 Grammy Awards, Lil Nas X wore a custom hot-pink cowboy-meets-bondage outfit made by Versace. That same year, he covered himself entirely in pink glitter after teaming up with designer Christian Cowan to promote their spring 2021 collection, which was inspired by the queer and punk movements of the 1970s. These moments marked the first of several bold in-your-face pink fashion statements made by the performer. Fans caught another pink moment with the release of his debut album *Montero* (2021). In the music video for the title track, Lil Nas X wears a baby-pink wig, a diamond choker, and fur as he sings

behind the backdrop of ancient Greek inspired heavens and hell. It is a visually stark contrast to his song "Industry Baby," which was coproduced by Kanye West and appears on the *Montero* album. The backdrop to this music video is based on the fictional Montero State Prison, where Lil Nas X has been sentenced for five years for being gay. Paying homage to the films *The Shawshank Redemption* (1994) and *Escape from Alcatraz* (1979), Lil Nas X and prison dancers wear fuchsia prison garb. In a July 2021 headline, *GQ* declared, "Lil Nas X has anointed 'Industry Baby Pink' the official hue of our hot boy summer."[14]

By this point pink has an established history in hip hop; "Pink all on its own for guys, it was Cam'ron. He entirely did pink. He basically became the street guy who was pretty in pink," said tastemaker Bruce "Blue" Rivera, also known as the Urban Mixologist. "Now, before that, the acceptability of pink [in hip hop] was ushered in with Lil' Kim. It wasn't soft—so feminine. It was pink hardcore. That was visually a turning point."[15] The color pink, once deemed female-exclusive, has broken the norm as hip hop loyalists and cisgender and nonconforming people alike gravitate to the power and prowess of pink. A$AP Rocky, Playboi Carti, Lil Uzi Vert, 6ix9ine, Young Thug, and others have fully embraced the color and its interpretations of expression. If the present is any indication of the future, pink in hip hop is here to stay. It will continue to be a go-to color for all hip hop fashion risk-takers and undergo redefinition by the next generation to come.

Duran Lantink pants designed for Janelle Monáe's "Pynk" music video, 2018.

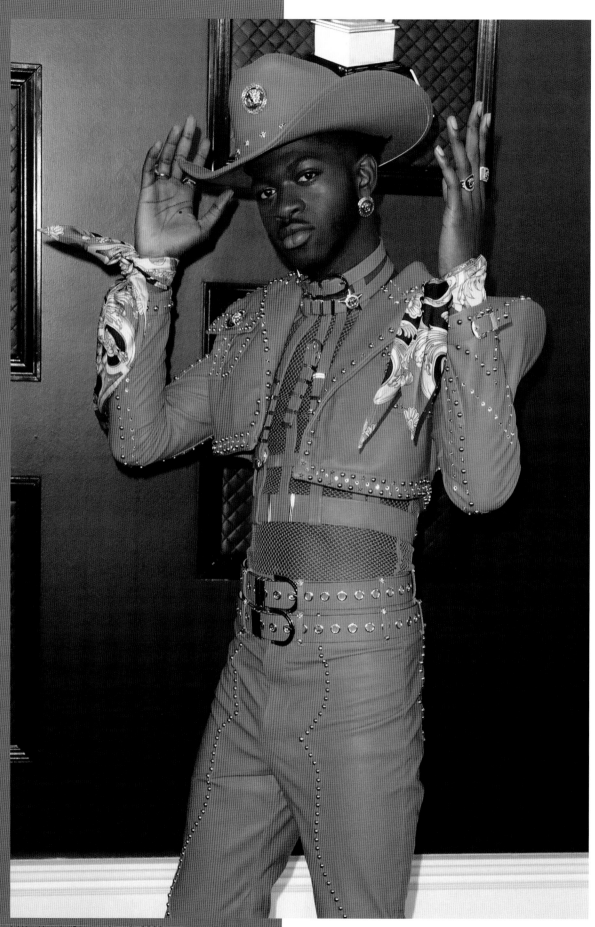

Lil Nas X at the Grammy Awards, 2020.

Notes

[1] "Kanye West Unedited: The Complete FADER Interview, 2008," *Fader,* October 23, 2013, https://www.thefader.com/2013/10/23/kanye-west-unedited-the-complete-fader-interview-2008.

[2] Alex Wong, "Cam'ron Is Very Particular When It Comes to the Color Pink," *GQ,* November 22, 2016, https://www.gq.com/story/camron-dipset-interview.

[3] Don Sawyer III, interview with Elena Romero, October 1, 2018.

[4] Sawyer interview.

[5] Valerie Steele, "Pink: The History of a Punk, Pretty, Powerful Color," in *Pink: The History of a Punk, Pretty, Powerful Color,* ed. Valerie Steele (London: Thames and Hudson, 2018), 16.

[6] Valerie Steele, "Pink."

[7] Joe Henry, The Most Famous Car in History," NJ1015.com, September 4, 2020, https://nj1015.com/the-most-famous-car-in-history/.

[8] Valerie Steele, "Pink."

[9] Tricia Gilbride, "Nicki Minaj Says Getting Really Into the Color Pink Was the Peak of Her Creativity," *Mashable,* April 8, 2016, https://mashable.com/article/nicki-minaj-pink.

[10] "Nicki Minaj Explains Her Love of the Colour Pink," *Press Party*, April 23, 2012, https://www.pressparty.com/pg/newsdesk/londonnewsdesk/view/45362/.

[11] Alex Frank, "Why You'll Want to Be Online Sunday before Tyler, the Creator's New Collection Sells Out," *Vogue,* December 11, 2015, https://www.vogue.com/article/tyler-the-creator-golf-wang-fall-collection.

[12] Nicole Beilke, "Her New Video," *88Nine,* April 10, 2018, https://radiomilwaukee.org/discover-music/music-news/janelle-monae-new-video-pynk/.

[13] Lennon Cihak,"Lil Uzi Vert Says His $24 Million Pink Diamond Was Ripped Out of His Head at Rolling Loud," EDM.com, September 8, 2021, https://edm.com/news/lil-uzi-vert-24-million-diamond-ripped-out-of-head-rolling-loud-miami.

[14] Teo Van den Broeke, "Lil Nas X Has Anointed 'Industry Baby Pink' the Official Hue of Our Hot Boy Summer," *GQ,* July 23, 2021, https://www.gq-magazine.co.uk/fashion/article/lil-nas-x-industry-baby-pink.

[15] Bruce Rivera, interview with Elena Romero, October 1, 2018.

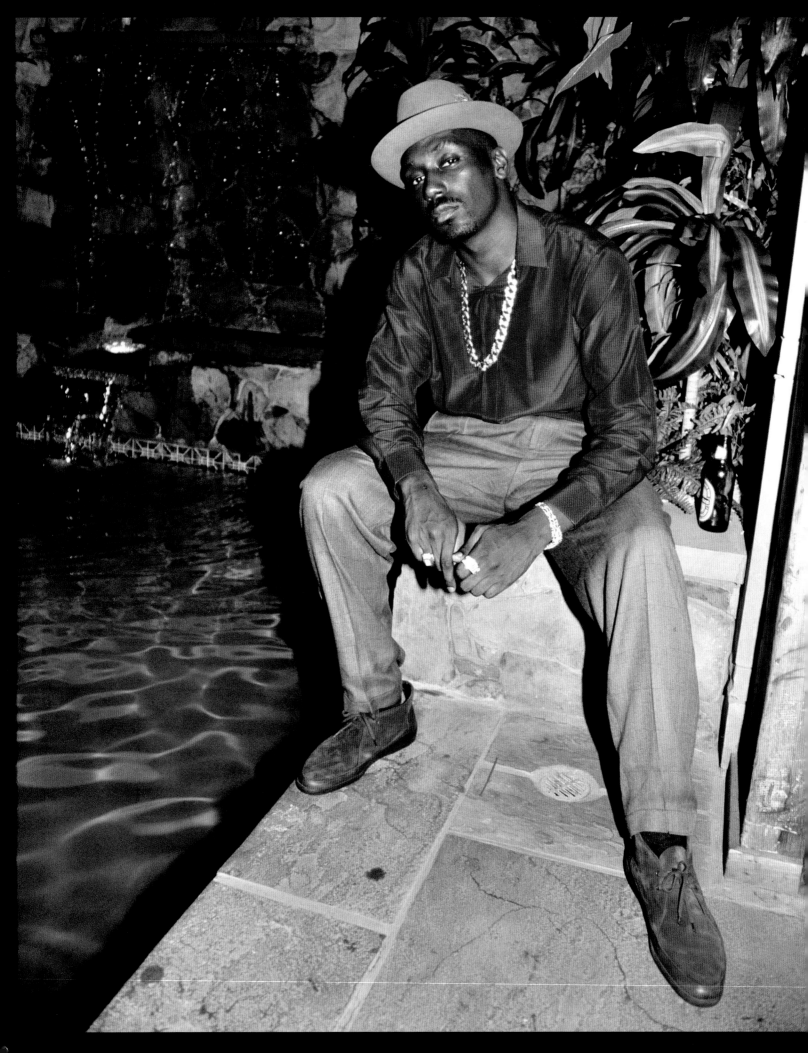

THE SHOE GAME: THE ALMOST FORGOTTEN FOOTWEAR OF HIP HOP

Big Daddy Kane, 1990s. Photo: Ernie Paniccioli.

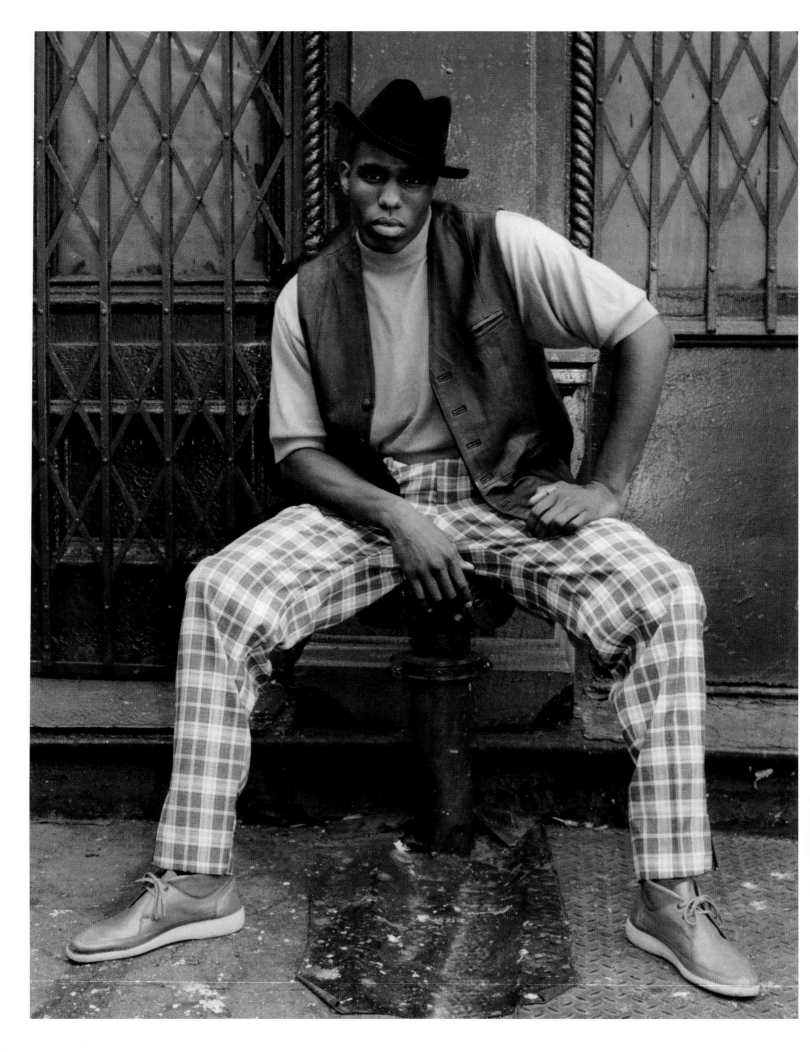

In 2005, historian and music critic Jeff Chang wrote, "If Blues culture had developed under the conditions of oppressive, forced labor, hip hop culture would arise from the conditions of no work."[1] Despite Chang's astute-yet-dismal observations, during the first days of hip hop, the young men who became its primary focal points frequently completed their daily ensemble with a "fly" pair of shoes. DJ Bobbito Garcia, writer Scoop Jackson, and a few others deserve a degree of gratitude for turning our attention to sneakers and their connection to hip hop. They suggested that we look down and start paying closer attention to footwear and its relationship to the genre.[2, 3]

I am not surprised at the quizzical looks I receive whenever I reminisce about British Walkers. "B-Dubs," as the shoe brand was known, originated in England in the 1950s, and was relaunched by Lakeview Apparel Group as B Walkers of London in 2015.[4] Unlike Pro-Keds or Chuck Taylor sneakers, shoe brands that were worn by hip hop's first generation in New York City are either forgotten or simply unacknowledged as a matter of any significance in the story of hip hop.

Shoes sometimes do not have the same practical utility as sneakers or work boots, but they can carry a wide range of significances. When looking at the role shoes played in the story of hip hop, I like to use Dylan Miner's appropriation of Marx's "use value" concept to assess the importance that young men created around shoes: "A commodity must be or seem useful if anyone is to buy it. But usefulness is not the only issue, or even the main issue, for a product that is treated and regarded as a commodity."[5] Miner's nuance states that "the use value of sneakers was also connected to … their juice value: the ability for these mass-produced commodities to be both transformative for the individual as well as transformed by the individual themselves."[6] Miner's "juice value" is far more apropos to the abstract qualities that some shoes represented in New York City during this era. The fact that Black and Brown men in New York wore more than sneakers and sweatsuits during the early 1980s is a necessary

corrective. Looking at the foot apparel of Black and Brown men during the formative years of hip hop's identity requires asking questions: What do the shoes convey about the shared values of the artists and hip hop's first devotees? What do they say about the era and how people imbued the space with meaning?

Undergirding, or better yet, foregrounding this work is my practical application of hip hop's Masters of Ceremony as uniquely valuable arbiters and illustrators of style. I see Rakim Allah, a hip hop lyricist, as a useful model for a walk through hip hop's first years. Long-time hip hop music lovers recognize that the place Rakim occupies is far beyond most lyricists—especially in the innovative ways that he constructed rhymes. Author Steve Huey notes that Rakim "raised the bar for MC technique higher than it had ever been, helping to pioneer the use of internal rhymes—rhymes that occurred in the middle of lines, rather than just at the end."[7] Lyrics from Eric B. & Rakim's "In the Ghetto" (1990) epitomize a highly complex conception of place refracted through a hip hop lens. Music writer Murray Forman said, "It can be observed that space and race figure prominently as organizing concepts implicated in the delineation of a vast range of fictional or actually existing social practices that are represented in narrative and lyrical form."[8] Through his practice, Rakim tests the ways that ideas can be taken apart then reappropriated for other means. His lyrics and flow present an avowedly improvisational technique of making use of what is available. As shoes are such a neglected item, I in turn must develop uniquely appropriate excavation and explication methods.

Caribbean cultural and English scholar Carole Boyce Davies notes an intentionally unconventional intellectual model akin to Rakim's technique. She does not find it necessary to follow established academic theories to their stated ends:

Untitled, New York City, 2000. Photo: Jamel Shabazz.

I want to engage all these theories as visitors. This comes from the recognition that going all the way home with many of these theoretical positions—feminism, post-modernism, nationalism, Afrocentrism, Marxism, etc.—means taking a route cluttered with skeletons, enslavements, new dominations, unresolved tensions and contradictions ... Going all the way home with them means being installed in a distant place from my communities.[9]

This discussion, like so many about the first generation, is almost exclusively about men, but it focuses on their preoccupation with style. (Fashion, like beauty studies, has been disproportionately about the experiences and behaviors of women, but it is peculiar that even in a field usually focused on women, they are largely absent in past studies on hip hop fashion.) Particular attention has always been paid to Black and Brown males' use of clothing in hip hop. In his song "9 Elements" (2003), KRS-One lists fashion as a foundational element of hip hop and alludes to its significance among men. In Doug E. Fresh and Slick Rick's "La Di Da Di" (1985)—one of the greatest stories ever told on wax—Slick Rick describes a fashion and beautification routine of great care and significance involving moisturizing with Oil of Olay, filing his fingernails, taking a bubble bath, drying off, and finally donning a new pair of underwear designed by Gucci. Slick Rick's lyrics in "La Di Da Di" present a beautification ritual that should warrant far more attention to Black and Brown men in beauty studies.

The foregrounding and marketing of emcees gave them the kind of visibility that made for excellent fashion conduits, especially for shoes. In the video for Dana Dane's 1987 hit song "Nightmares," director Rolando Hudson focuses the camera directly on the "fly" Bally shoes as the legendary storyteller slowly strides onto the scene. Bally is a Swiss luxury brand founded in 1851.[10] In recent years, legendary hip hop artists Slick Rick and the Wu-Tang Clan collaborated with Clarks Shoes on signature editions of the Wallabees, which have been worn for years by Black and Brown men in New York City.[11] The Clarks brand began in 1925 in England and introduced the Wallabees in 1970.[12] Big Daddy Kane lent his acclaim to an old-school shoe brand with the signature release of the classic British Walkers.[13]

Each shoe mentioned thus far achieved its own recognition, but almost exclusively within the enclosed geographic space of New York City. According to author Murray Forman, "These geographies are inhabited and bestowed with value. They are understood as lived places and localized sites of significance, as well as being understood within the market logic that includes ... a product and a consumer base ... of distinct market regions."[14] It is widely acknowledged in the hip hop world that there are regional styles. For example, in The Game's 2008 song "Let Us Live," he describes wearing Timberlands in Brooklyn, recognizing the brand's local resonance.

British Walkers, Clarks Wallabees, and classic suede Bally boots spread throughout the five boroughs, parts of New Jersey, and Long Island. Local market circuits developed through word of mouth. The shoes on your feet spoke a language familiar to the young men who cohabitated and congregated in this small region of the United States. Getting fly represented a potential elevation of social status to others who recognized the cost or ingenuity it took to cop a pair of B-dubs (British Walkers) in brown and beige suede. The consumer habit of shopping brought young men, who saw their housing projects or local park as a more significant source of identity, together around more expansive allegiances. In 1987, Dana Dane penned a whole song about Delancey Street in the Lower East Side of Manhattan, where the relatively well-traveled B-boy from different locations in New York City learned to go for the freshest "Walkers." Journalist Russ Bengtson notes that places "in the Bronx had all the Air Force 1s."[15] For the record, the same small stores that knew to stock the flyest sneaker also had fresh styles of British Walkers.

TOP: The Delancey Street Connection, 1985. Photo: Jamel Shabazz.
BOTTOM: MC Busy Bee at the Bronx River Projects Zulu Nation anniversary concert, circa 1981. Photo: Joe Conzo.

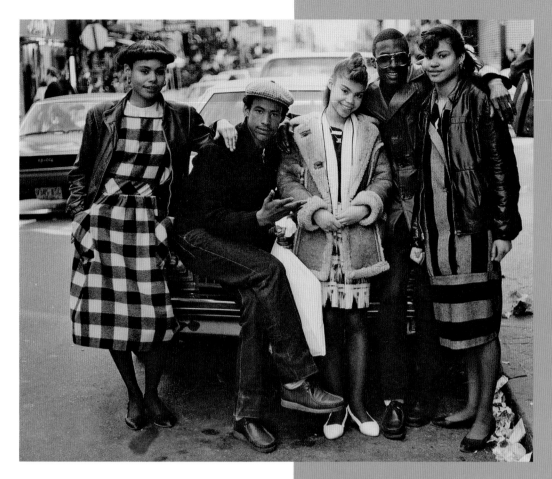
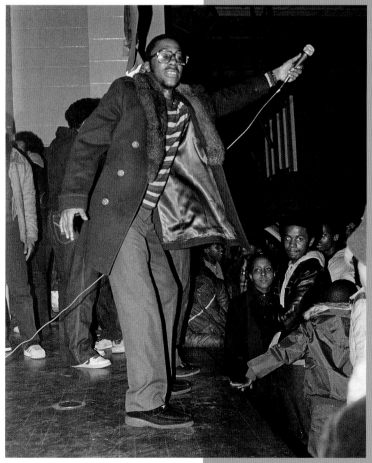

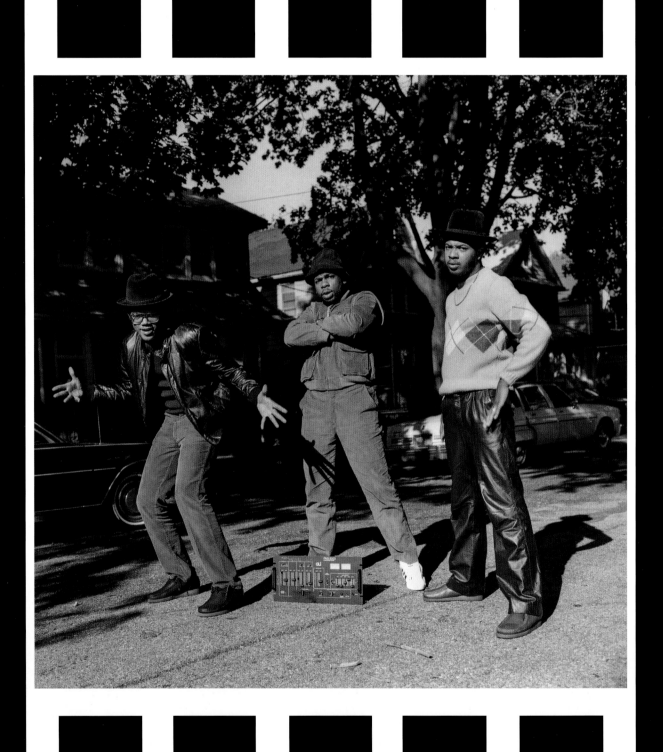

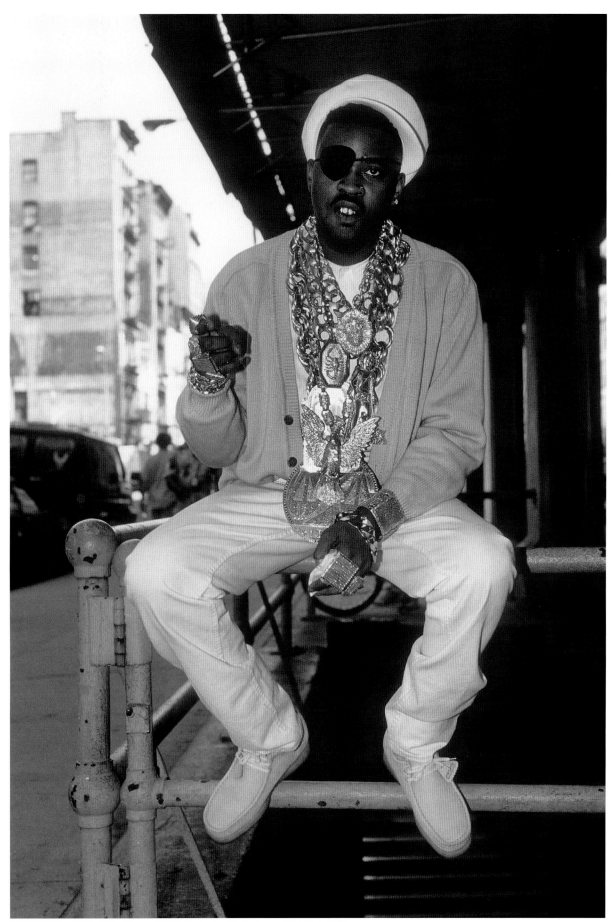

OPPOSITE: Run-DMC, Hollis, Queens, 1984. Photo: Janette Beckman. Slick Rick, 1991.

New York City is acknowledged as the birthplace of hip hop and subsequently the earliest incarnation of its elemental identity. Many will agree that the unique circumstances that birthed it are partly the result of the cross-fertilization of the various Black and Brown ethnic groups that resided in the five boroughs and adjacent communities. It is also widely noted that the different ethnicities from the Caribbean and beyond imbued the space with familiar yet dynamic creative energy that extended even to the soles of the feet. Two of the three shoe brands previously mentioned are from English companies that likely traveled to New York with Black people who had lived in England and Jamaica, where Clarks already had a special significance. It is not a coincidence that young people like Clive Campbell (aka DJ Kool Herc) and Jamaican sound systems appear in the Bronx around the same time. Therefore, we should not be surprised that Slick Rick and other Black people born in England contributed to the "routes" by which stylish shoe brands flowed to fellow subjects of Western imperialism on the streets of New York. Author William Hogan writes:

> Paul Gilroy ... has proposed that traditional geographical models of the community/place relationship do not apply to the particular situation of African Americans. He argues for a political/sociological/geographical model of race called the Black Atlantic, in which communities of color on both sides of the Atlantic cohere not according to rooted connection to one particular place, but according to a kind of flowing connection between and among communities. The idea of a geographically grounded African American community, in other words, is less significant for Gilroy than the notion of a hybrid, interconnective racial identity that crosses national boundaries.[16]

In his 1988 song "Vapors," Biz Markie raps about a man who wore low-slung pants, untied sneakers, and a side-tilted Kangol hat in a Rasta style, lending credence to the flow of styles of varying Black ethnic groups. Emerging from New York City in the latter half of the 1970s, Black and Brown folk walked into the uncertain future with an irrepressible creativity. The rubber soles of all these shoes had to handle the concrete streets and playgrounds with an admirable adroitness and style. B-boys could purchase British Walkers in leather or suede and in as many color variations as Run-DMC's Adidas were offered. Clarks could communicate fresh and fly in the Bronx or Manhattan, but might not translate in the Southern states during the 1980s. Colors and textures illustrated individual creativity to peers. How many variations you possessed conveyed social and economic status. As Biz Markie reminds us in "Vapors," as he raps about a style makeover to attract women with Bally boots, in addition to gold truck jewelry and suits in leather and silk, shoes could also change your social status. Hip hop lyrics continue to serve as valuable resources to learn more about the hip hop nation.

Notes
[1] Jeff Chang, *Can't Stop Won't Stop* (New York: St. Martin's Press, 2005), 13.
[2] Bobbito Garcia, *Where'd You Get Those?: New York City's Sneaker Culture, 1960–1987* (New York: Testify Books, 2013).
[3] Robert "Scoop" Jackson, *Sole Provider: Thirty Years of Nike Basketball* (New York: powerHouse Books, 2002).
[4] Sha Be Allah, "The Iconic B Walkers of London Brand Impacts the Younger Hip Hop Generation," *The Source*, January 28, 2015, https://thesource.com/2015/01/28/the-iconic-british-walkers-of-london-brand-impacts-the-hip-hop-generation/.
[5] David Smith, *Marx's Capital Illustrated* (Chicago: Haymarket Books, 1982), 36.
[6] Dylan A.T. Miner, "Provocations on Sneakers: The Multiple Significations of Athletic Shoes, Sport, Race, and Masculinity," *The New Centennial Review* 9, no 2. (Fall 2009): 73-107.
[7] Steve Huey, "Biography: Rakim," AllMusic.com, 2008, https://www.allmusic.com/artist/rakim-mn0000389137/biography.
[8] Murray Forman, "Represent: Race, Place and Space in Rap Music," in *That's the Joint!: The Hip-Hop Studies Reader,* ed. Murray Forman and Mark Anthony Neal (New York: Routledge, 2004), 202.
[9] Carole Boyce-Davies, *Black Women, Writing and Identity: Migrations of the Subject* (New York: Taylor & Francis Group, 1994), 34.
[10] "About Us," Bally.com, https://www.bally.com/en_us/about-us.html.
[11] Keenan Higgins, "Clarks Finally Does the Wallabee Wu-Tang Clan Collab That We've Been Waiting For...Forever!" *The Source*, November 9, 2018, https://thesource.com/2018/11/09/wu-wear-clarks-originals-wallabee-wutang25/.
[12] Sarah Atkinson, "The History of Clarks Shoes," AllSoles.com, 2016, https://www.allsole.com/blog/fashion/the-history-of-clarks-shoes.
[13] John Q. Marcelo, "Big Daddy Kane Has a Super Limited Footwear Collaboration That Just Dropped," *Complex*, December 1, 2014, https://www.complex.com/sneakers/2014/12/big-daddy-kane-british-walker-collaboration-available.
[14] Forman, "Represent," 203.
[15] Russ Bengtson, "A Brief History of New York's Defunct Sneaker Stores," *Complex*, March 25, 2015, https://www.complex.com/sneakers/2015/03/new-york-defunct- sneaker-stores.
[16] William Hogan, "Roots, Routes, and Langston Hughes's Hybrid Sense of Place," *The Langston Hughes Review* 18 (Spring 2004): 3–23.

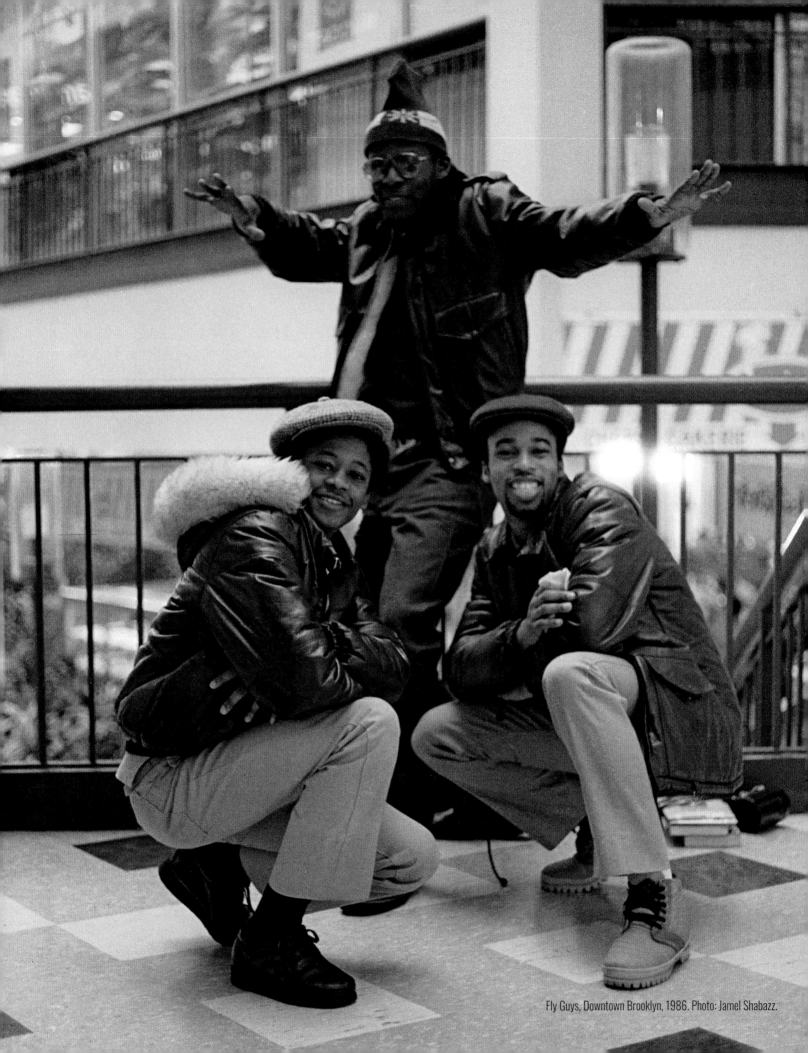

Fly Guys, Downtown Brooklyn, 1986. Photo: Jamel Shabazz.

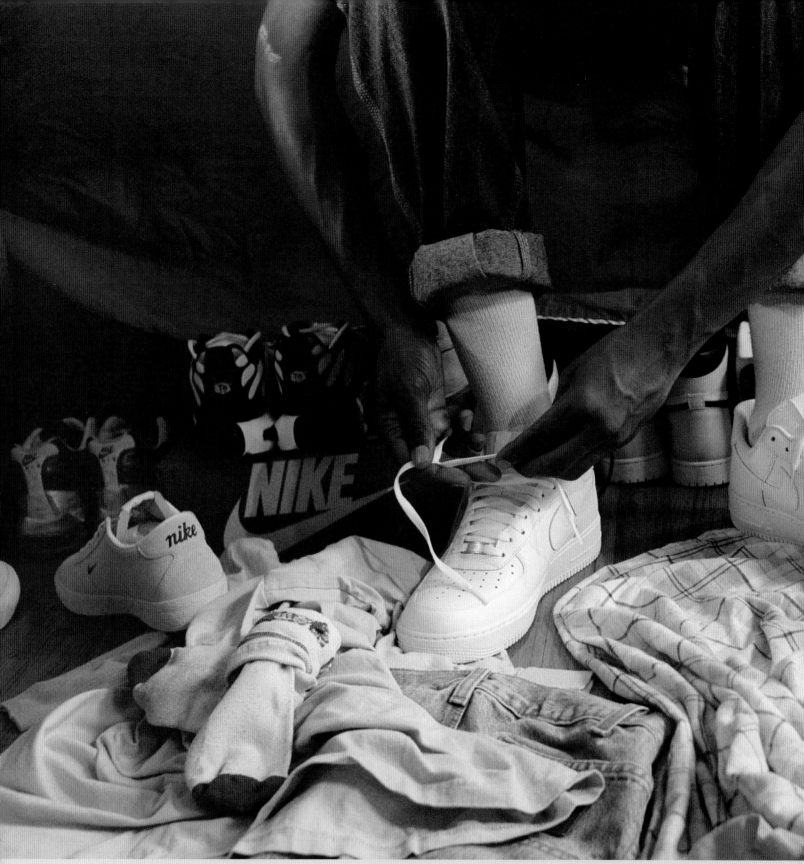

Nike Air Force 1s. Photo: Mayan Toledano.

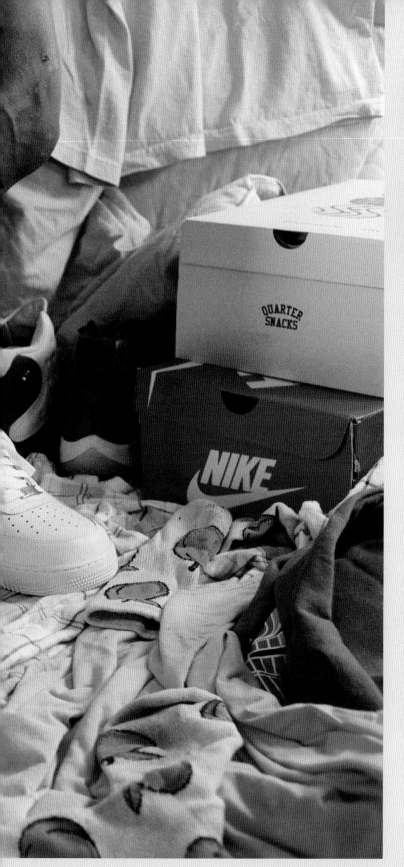

Baltimore and The Nike Air Force 1 Connection by Elena Romero

Nike has the city of Baltimore to thank for the popularity and success of its Air Force 1s. In the early '80s, three local sporting goods retailers—Downtown Locker Room (DTLR), Charley Rudo Sports, and Cinderella Shoes—collectively became responsible for bringing the shoe back to life and making the Nike Air Force 1 what it is today. Antonio Gray, vice president/designated market maker of Downtown Locker Room in Baltimore, Maryland, attributes the shoe's success to the retail trio and the business acumen of "Mr. Shoe": Harold Rudo, co-owner of Charley Rudo Sports.

According to Rudo's obituary, published in *The Baltimore Sun* in 2017, Nike planned to discontinue the Air Force 1 a few years after its introduction in 1982.[1] However, Rudo found the shoe to be a top seller among his customers. "In Baltimore, the Air Force 1 was the go-to shoe when most places might've not cared about it," said Gray.[2] A Baltimore native, Gray heard first-hand accounts of the legendary story from Rudo himself and others involved. He said Rudo approached Phil Knight, the cofounder and then-chairman and CEO of Nike Inc., about the idea of keeping the shoe and letting Baltimore sell it exclusively. "Phil's quote was 'If you're dumb enough to buy production, I'm dumb enough to sell it to you,'" said Gray.[3]

The three retailers' formula for success focused on a "color of the month" strategy, introducing the white hi-top Air Force 1 with a different color swoosh and matching strap:

> The first was a gray swoosh and a gray strap. Then, they would come back with the white shoe with a yellow swoosh with a yellow strap. That was the color of the month Air Force 1 exclusive to those three retailers in the entire world, all Baltimore-based retailers. That was how the Air Force 1 stayed in business.[4]

Without that impetus, the Nike Air Force 1s might have never made a comeback. Said Gray:

During Easter, we'd put on our Easter outfit, and we would all congregate in downtown Baltimore or go to a skating rink like Shake & Bake or Rhythm Skate, which became 4604. At any [of] those places, what we would do was, if you had a white Air Force 1 with green swoosh then you wore the green sweatsuit. If you had the one with the gray, then you wore the gray sweatsuit. If you had the red, you wore the red sweatsuit. That was sort of the uniform for my West Baltimore neighborhood and other neighborhoods. This shoe, over some years, continued to be meaningful in Baltimore—so much so, that folks from New York would drive down to buy it. Folks from DC would drive up to buy it.[5]

Eventually, Nike would decide to let other retailers in on the sales. According to Gray, the Nike Air Force 1 has been the best-selling shoe at DTLR, one of the leading sports retailers in the Baltimore area, and the sneaker is now seen around the world—from neighborhood corners to fashion weeks. In 2017, Nike introduced the Nike SF AF-1 Mid, "For Baltimore," a shoe that fuses two of Nike's most iconic designs—the Special Field Boot and the Air Force 1—in honor of the Baltimore connection. The limited-edition shoe, which is known simply as the SF AF-1, was designed with adjustable ankle straps, premium full-grain leather, rip-stop ballistic nylon, and a double-zipper entry at the heel.

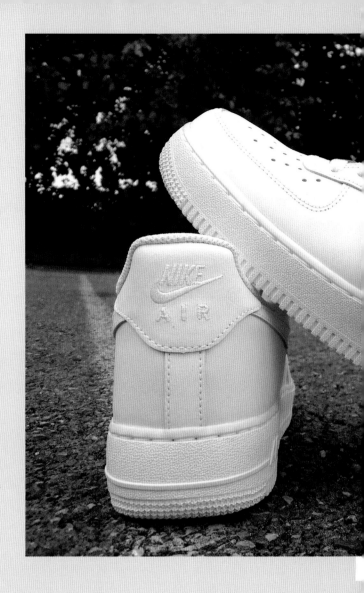

Notes
[1] Jacques Kelly, "Harold Rudo, Known as 'Mr. Shoe.'" *Baltimore Sun*, April 4, 2017, https://www.baltimoresun.com/obituaries/bs-md-ob-harold-rudo -20170404-story.html.
[2] Antonio Gray, interview with author, September 25, 2021.
[3] Gray interview.
[4] Gray interview.
[5] Gray interview.

Nike Air Force 1s, 2019.
Nike SF AF-1 Mid "For Baltimore."

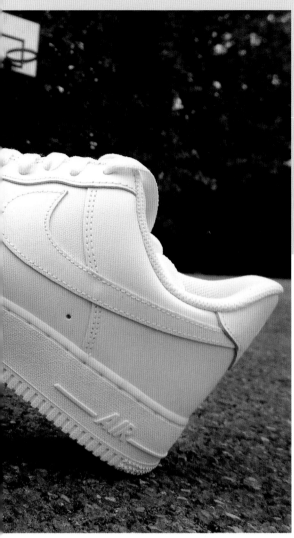

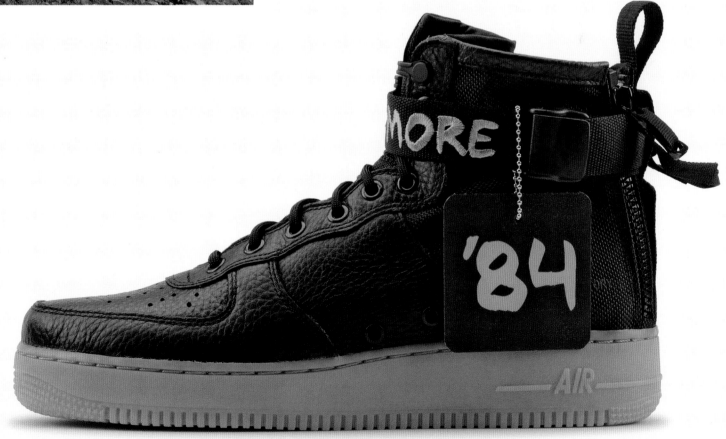

STRICTLY FOR THE LADIES: Reebok Freestyle "5411s" by Elena Romero

The aerobic craze of the '80s birthed our love of leotards, leg warmers, and, of course, aerobic footwear.[1] We fell in love with fitness icon Jane Fonda and her workouts, *Fame* (1980) took over our TV sets, and steel mill worker-turned-dancer Alex Owens, portrayed by actress Jennifer Beal, captured our hearts in the 1983 cult film *Flashdance*. Thanks to Cubano Angel Martinez, a West Coast sales rep for Reebok at the time, we also have the Reebok Freestyle, the first exclusive athletic sneaker for women.[2] It was a sneaker designed like a running shoe with a dancewear-like fit. The upper part was soft like a ballerina's shoe, which wrinkled around the toe, and the sneaker provided comfort and support through three puffy ankle panels and two thin Velcro straps.

"I grew up in the sneaker realm, and you wore the sneakers that everyone had," said Sharon Velez-Diodonet, a Puerto Rican native of Bushwick, Brooklyn, who got her first pair of Freestyles while attending junior high school. "I was a dance kid. It was the best sneaker to have if you were a dance kid. People saw you wear that sneaker, and they knew you were from the hood."[3]

Reebok has New York and the five boroughs to thank for the Freestyle's nickname and popularity. Dubbed "5411s," the sneaker's hip hop name was inspired by its price tag, retailing for $49.99 plus New York State sales tax for a grand total of $54.11. The lightweight, flexible, basic high-top sneaker was marketed in the classic white and later in a variety of colors, including black, red, banana yellow, bubblegum pink, electric blue, purple, orange, and green, among others.[4] The more colors offered, the more the shoe hit with the ladies—both in mainstream culture and within hip hop. The shoe was seen on everybody from Cybill Shepherd (of *Moonlighting* fame with Bruce Willis), who wore a pair of orange Reebok Freestyle high-top sneakers to the Emmy Awards in 1985, to rappers Roxanne Shanté and Salt-N-Pepa.[5, 6] The classic soft sneaker became a favorite of the "around the way girl," and other soft leather sneakers would also join the mix, including those by L.A. Gear and Avia.

Reebok Freestyle, 2019.

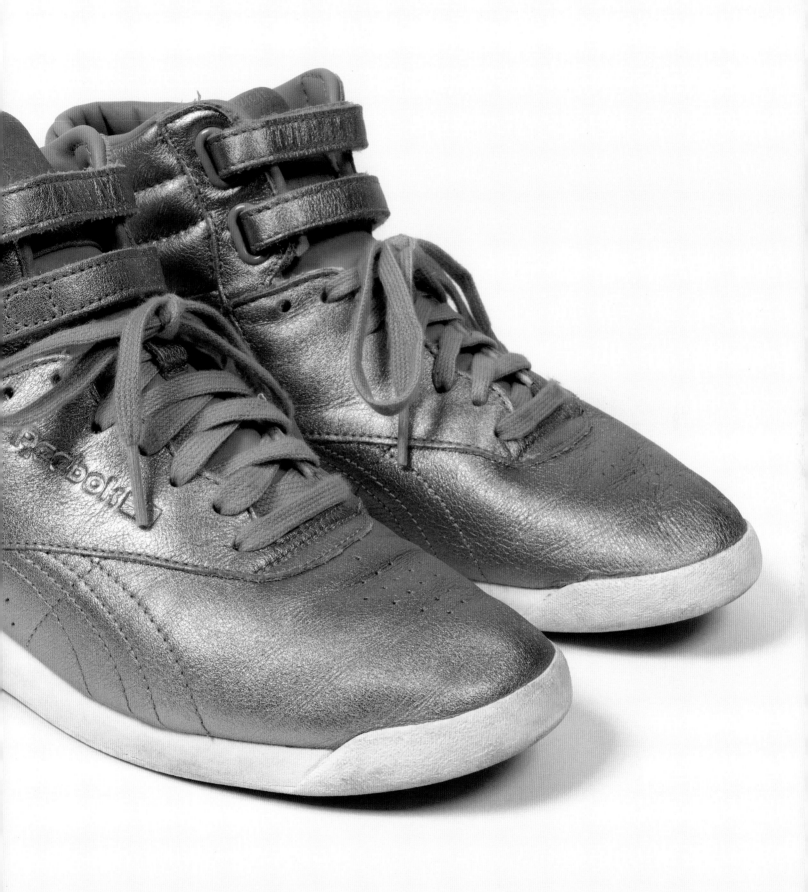

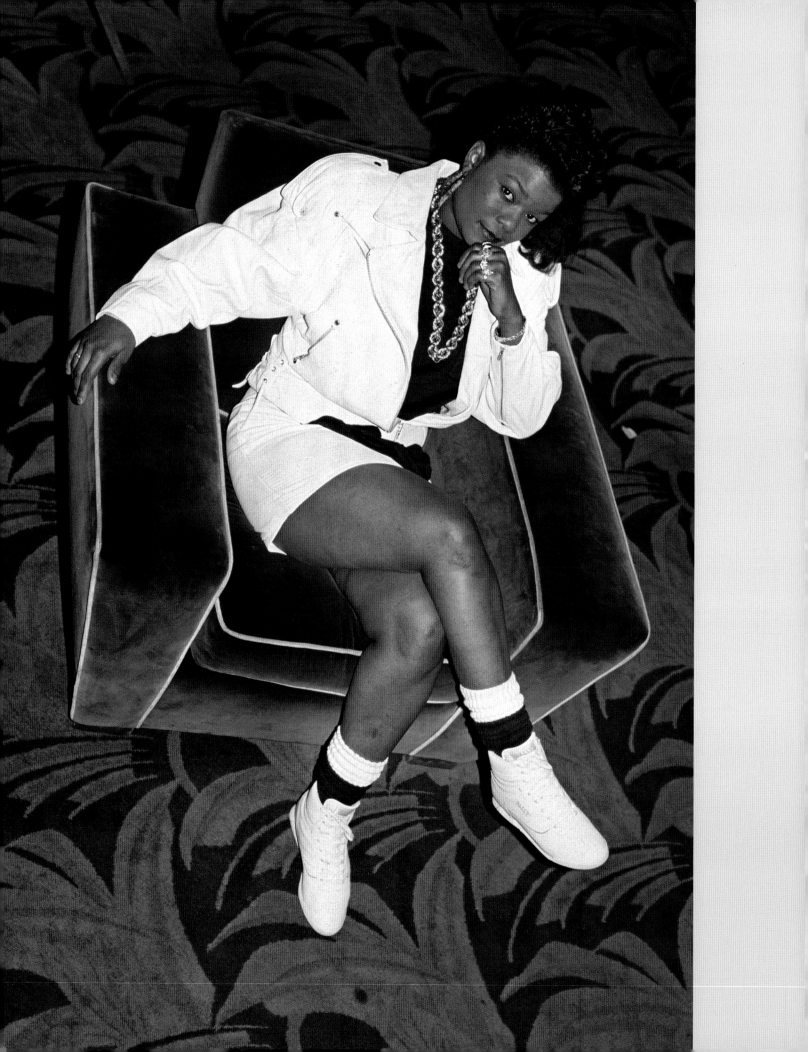

Velez-Diodonet owned a pair of classic black 5411s, which her mom purchased on Knickerbocker Avenue in Brooklyn. "If you didn't find your size at VIM, you went [to the] next store—to Sportivo," she recalled. "I was into hip hop and back in those days I'd go to the underground parties. I would cut school to go to the parties and I would dance battle in these sneakers."[7] Velez-Diodonet credits the sneaker's popularity in hip hop to its functionality. "Girls needed be able to dance and rap. They had to combine dancing and the rapping. It was the house party era and dance battles."[8] Dawton Thomas, editor-in-chief of *Vibe* magazine and vice president of cultural media for MRC adds, "If a girl was checking you out and she was trying to see what type of Jordan's or Air One's you had on, then fellas were seeing what colors the girls had in these [Reebok 5411s]."[9]

Fashion designer Kianga "Kiki" Peterson of Netflix's *Next in Fashion* (2020) fame has designed for FUBU and FUBU Ladies, Sean John, Rocawear, Baby Phat, AppleBottoms, the Nikki Minaj Collection sold exclusively at Kmart, and Beyoncé's House of Deréon. She distinctly remembers her purple 5411s:

> Growing up in Atlanta, it was a little bit different. 5411s was more of a New York thing. We were doing Tretorns and Adidas [in Atlanta]. I was a little of a tomboy too. I only saw Reebok Freestyle when I visited family in New York. Reebok's Freestyle had more colors, better colors than anybody. I remember falling in love with purple. That was my color, and I couldn't believe there were purple Reebok sneakers. Nobody was doing that.[10]

Peterson got her pair of 5411s at age 15—size 7—on a visit to New York:

> I don't remember seeing them in Atlanta. My mother purchased them. Girls wore bright-colored 5411s and acid-wash jeans. If they weren't tied at the ankle, we would fold the pants at the ankle. Having that pop of color was everything. You had to complete the outfit with that sneaker.[11]

Grammy Award winning singer, songwriter, and producer Alicia Keys signed with Reebok to launch a Fall/Winter 2012 limited-edition sneaker collection that included her version of the Reebok Freestyle Hi featuring a black shoe with a city background and piano keys. "I've been a Reebok fan ever since I put on my first pair of 5411s," said Keys.[12]

In 2017, singer, actress, choreographer, and model Teyana Taylor partnered with Reebok to introduce the Freestyle sneaker in the "Color Comb Pack," which included a supersaturated hot pink sneaker, called Pink Craze, and a blue teal colorway, titled Mineral Mist. "The 5411s really opened the door to get more creative with women's sneakers," said Taylor in the "Free Your Style" Reebok commercial.[13] Today, the old-school sneaker, which is referred to as the Freestyle Hi, continues to come in a variety of colors, but retails for $75.

Notes
[1] Nicholas Smith, "How Jane Fonda Helped Inspire Reebok's Freestyle Fitness Sneaker," *Time*, April 30, 2018, https://time.com/5254605/jane-fonda-reebok-freestyle-history/.
[2] "Bring Human Direction to the Corporate World—Angel Martinez," *Latino Leaders*, July/August 2021, https://www.latinoleadersmagazine.com/julyaugust-2021/2021/10/12/bring-human-direction-to-the-corporate-world-angel-martinez.
[3] Sharon Velez-Diodonet, interview with author, April 18, 2022.
[4] Gregory Babcock, "From Aerobics to Hip-Hop: How the Reebok Freestyle Became the 5411," *High Snobiety*, 2017, https://www.highsnobiety.com/p/reebok-freestyle-history-5411/.
[5] Nia Groce, "5 Times Reebok Made an Impact on Pop Culture," *Footwear News*, July 17, 2018, https://footwearnews.com/2018/focus/athletic-outdoor/reebok-best-pop-culture-shoe-moments-1202602403/.
[6] Jane Carlson, "Emmys Flashback: When Stars Styled Themselves for the Red Carpet," *Hollywood Reporter*, September 14, 2017, https://www.hollywoodreporter.com/lists/emmys-flashback-stars-styled-themselves-red-carpet-1038526.
[7] Velez-Diodonet interview.
[8] Velez-Diodonet interview.
[9] Bobby Garcia, director, *It's the Shoes*, ESPN, 2006.
[10] Kianga Peterson, interview with author, April 18, 2022.
[11] Peterson interview.
[12] Brandon Richard, "Alicia Keys x Reebok Classics Collection," *Sole Collector*, September 6, 2012, https://solecollector.com/news/2012/09/alicia-keys-x-reebok-classics-collection.
[13] Danielle Rines, "Teyana Taylor's Sneaker Style," *Reebok*, January 2017, https://www.reebok.com/us/blog/301495-teyana-taylors-sneaker-style.

Roxanne Shanté, 1988.

Editors

Elena Romero is a hip hop fashion journalist, author, and cocurator of the *Fresh Fly Fabulous: 50 Years of Hip Hop Style* exhibition at The Museum of FIT (2023). Covering hip hop style since the 1990s, her work has appeared in *DNR, WWD, Honey, Savoy, Vibe, Latina, Urban Latino, Sportswear International, remezcla.com, USA Today,* and *The New York Post.* Romero's expertise has been highlighted in the documentaries *Fresh Dressed* (2015) and *The Remix: Hip Hop x Fashion* (2019). Romero is the author of *Free Stylin: How Hip Hop Changed the Fashion Industry* (Praeger, 2012) and is an assistant professor of marketing communications at the Fashion Institute of Technology (FIT).

Elizabeth Way is associate curator of costume at The Museum at FIT (MFIT) and cocurator of the *Fresh Fly Fabulous: 50 Years of Hip Hop Style* exhibition at MFIT (2023). Her past exhibitions include *Global Fashion Capitals* (2015), *Black Fashion Designers* (2016), *Fabric in Fashion* (2018), and *Head to Toe* (2021). Way's personal research focuses on the intersection of African American culture and fashion. She edited and contributed chapters to the book *Black Designers in American Fashion* (Bloomsbury, 2021). Way holds a master's degree in costume studies from New York University.

Contributors:

Christopher Emdin is the Robert A. Naslund Endowed Chair in curriculum theory and professor of education at the University of Southern California. He is the author of numerous award-winning works, including *Urban Science Education for the Hip-Hop Generation* (Sense Publishers, 2010), *The New York Times* bestseller *For White Folks Who Teach in the Hood… and the Rest of Ya'll Too* (Beacon Press, 2017), and *Ratchetdemic: Reimagining Academic Success* (Beacon Press, 2021).

Isabel Flower is a writer and editor based in New York City, and the executive editor of *Deem.* She is the cohost of the *Top Rank* podcast and coeditor with Marcel Rosa-Salas of *The Nameplate: Jewelry, Culture, and Identity* (Clarkson Potter, 2023).

Syreeta Gates is a Queens native who is committed to immortalizing hip hop so that it lasts forever. (Forever, ever, forever, ever?) Art collector, archivist, and founder of The Gates Preserve, she was introduced to the culture by way of Misa Hylton and June Ambrose's styling and films and music videos shot in her neighborhood. She produces live culinary competitions that bridge hip hop with food and beverage, elevates hip hop culture through LEGO, and celebrates Black life as a filmmaker and writer. Gates holds degrees in urban youth culture and moving image archiving and preservation. #QGTM

Claudia Gold, who for years was known as Claw Money, is a pioneering graffiti writer, artist, designer, retailer, curator, stylist, costume designer, fashion editor, archivist, marketing and branding expert, author, agitator, mentor, and arbiter of downtown NYC culture. She lives and works in NYC... still! Her website is www.clawmoney.world.

Monica Lynch is the former president of influential hip hop and dance label Tommy Boy Records, where she helped launch Queen Latifah, De La Soul, Digital Underground, House of Pain, Naughty by Nature, Stetsasonic, RuPaul, Afrika Bambaataa & Soul Sonic Force, Force M.D.'s, Coolio, the Jock Jams and MTV Party to Go series, and soundtracks for *New Jersey Drive, 54, Music & Voices of NFL Films,* among others. She has also helped to curate and organize two Sotheby's auctions dedicated to hip hop. She has been a deejay staff member on renowned free-form radio station WFMU since 1997.

Alphonso D. McClendon is the author of *Fashion and Jazz: Dress, Identity, and Subcultural Improvisation* (Bloomsbury, 2015). The book explores the social, racial, and political intersections of jazz and dress. McClendon contributed "Black Male Identity and the Embodiment of Early Jazz Improvisation" in *Interactions: Studies in Communication & Culture* (Intellect, 2015) and "Fashionable Addiction: The Path to Heroin Chic" in *Fashion in Popular Culture: Literature, Media, and Contemporary Studies* (Intellect, 2013). He is a graduate of Drexel University and North Carolina A&T State University with ongoing research at the Schomburg Center for Research in Black Culture, the Institute of Jazz Studies, the Hogan Jazz Archive, and the National Archives Center.

Monica L. Miller is an Ann Whitney Olin professor of Africana Studies and English at Barnard College, Columbia University. A specialist in contemporary African American and Afro-diasporic literature and cultural studies, she is the author of the award-winning book *Slaves to Fashion: Black Dandyism and the Styling of Black Diasporic Identity* (Duke University Press, 2009). A grantee from the Andrew W. Mellon Foundation, the Schomburg Center for Research in Black Culture, and the Institute for Citizens & Scholars, she is a frequent commentator in the media and arts worlds, and she teaches and writes about Black literature, art, performance, and fashion cultures, as well as contemporary Black European culture and aesthetics.

Warren Orange is an adjunct lecturer at the City College of New York, teaching courses in African American history and Black popular culture. In February 2010, he cofounded the "Is Hip Hop History?" conference with Elena Romero. Orange also developed the "Reading Hip Hop: Off the Records, In the Books" public lecture series with Romero, which allowed students from the City College of New York's Center for Worker Education to explore various texts on and about hip hop and to discuss the works with the authors. He created the "History, Culture, and Politics of Hip-Hop" course, a favorite among the upper-division interdisciplinary offerings.

Kim Osorio is a Bronx-born hip hop journalist, executive producer, author, and media personality. Osorio spent her formative years covering hip hop in the 1990s, before landing her dream job at the "Bible of Hip-Hop." As the first female editor-in-chief of *The Source*, she helmed the magazine for some of its highest-selling issues before releasing her memoir, *Straight from the Source* (Gallery Books, 2013). Osorio continues to represent hip hop in her role as executive producer on television shows like *Love and Hip Hop* and *Growing Up Hip Hop*, while also serving as a media consultant for Kanye West.

Rebecca Pietri is an artist who has worked with Jay-Z, Beyoncé, Kayne West, Questlove, and The Roots. She started her career in publishing at *Vanity Fair* and has worked with Condé Nast, Hachette Filipacchi Media, and Time Inc. She is a contributor to *The New York Times* Sunday Style and Opinion sections. Pietri's collaborative practice encourages one to consider alternative and often-overlooked social and historical narratives through the lens of styling, archiving, and storytelling. Whether working with an iconic brand or an individual, curating, lecturing on art, or coordinating archives for clients, she aims to build a diverse, equitable, and transparent collaborative community.

Eric Darnell Pritchard is an award-winning writer, cultural critic, and Brown Chair in English Literacy and associate professor at the University of Arkansas. They are the author of *Fashioning Lives: Black Queers and the Politics of Literacy* (Southern Illinois University Press, 2016) and numerous publications on fashion, beauty, and its intersections with popular culture, rhetoric, language, and literacy. Their biography about 1980s fashion design superstar Patrick Kelly, *Abundant Black Joy: The Life and Work of Patrick Kelly*, is forthcoming from Amistad/HarperCollins.

Marcel Rosa-Salas is a cultural anthropologist, scholar, and documentarian from Brooklyn. She is the cohost of the *Top Rank* podcast and coeditor with Isabel Flower of *The Nameplate: Jewelry, Culture, and Identity* (Clarkson Potter, 2023).

Vikki Tobak is an author, journalist, and curator whose work has appeared in *Complex, Rolling Stone, The FADER*, ESPN's *The Undefeated, Mass Appeal, Paper, Vibe, i-D*, and the *Detroit News*, among others. She is the author of *Contact High: A Visual History of Hip-Hop* (Clarkson Potter/Random House, 2018) and *Ice Cold: A Hip-Hop Jewelry History* (Taschen, 2022). She was a contributor to *Fade to Grey: Androgyny, Style & Art in 80s Dance Music* (Design-Diversity.org, 2021) and *Rebels: From Punk to Dior* (DRAGO, 2021). Tobak is the curator of the traveling exhibition *Contact High*, which has been exhibited at the Annenberg Space for Photography, The International Center of Photography, Manarat Al Saadiyat (MAS) in Abu Dhabi, and Museum of Pop Culture. She is a former producer and columnist for CBS, CNN, and Bloomberg News. Tobak got her start as a culture editor for *Paper* magazine before going on to work at Payday Records/Empire Management, working with Gang Starr, Jay-Z, Mos Def, Showbiz and A.G., among others. She has lectured about music photography at American University, The Schomburg Center, The Kennedy Center, and the Museum of Contemporary Art Detroit.

Elizabeth Wellington is a long-time lifestyle columnist and essayist for the *The Philadelphia Inquirer* where she writes about race, gender, fashion, pop culture, and wellness. She has won awards from the National Association of Black Journalists, Keystone Press, and the Society of Professional Journalists. Her work has appeared in *Ebony* and *Medium*. She has a bachelor's degree in journalism from New York University. Her favorite hip hop group is A Tribe Called Quest, her favorite emcee is Rakim, and she still thinks she can do the wop without getting dizzy.

Emil Wilbekin is a New York City–based media professional who produces and curates digital, print, social media, and event-based content. He has appeared on television discussing pop culture for outlets such as VH1, MTV, CNN, and *The Today Show*. He was the managing editor and editor-at-large at *Essence* magazine, and editor-in-chief of *Vibe* magazine when it won the National Magazine Award for General Excellence. In 2016, Wilbekin founded Native Son, an advocacy and networking group for professional Black gay men.

ACKNOWLEDGMENTS

For my daughters Gabriela, Gionna, and Grace, who inherited my love of hip hop and fashion, and who each found their unique style along the way.

- Elena Romero

We would first like to extend our thanks to Dr. Joyce Brown, president of the Fashion Institute of Technology (FIT), for her support on this project. This book and its related exhibition would not be possible without FIT's leadership and the generosity of The Museum at FIT's Couture Council. We are also deeply grateful to Dr. Valerie Steele, director and chief curator of MFIT, and Patricia Mears, deputy director of MFIT, for their support. We would also like to thank Shannon Maher, dean of the School of Business and Technology at FIT, and Loretta Volpe, chair of the Marketing Communications Department at FIT.

We would like to give a very special thanks to Courtney Sloane and the entire team at Courtney Sloane Design, especially Aryam Figueroa, and an enormous thank you to the entire *Fresh, Fly, and Fabulous* advisory committee, all of whom have donated their time and knowledge to guide this project from the beginning. A special thank you as well to Loren Olson at Rizzoli.

We would not have been able to complete this project without the support of the entire MFIT staff, but we would like to extend special gratitude to those who helped with this book: Eileen Costa, photographer; Ann Coppinger, senior conservator; Alison Castaneda, associate conservator; Thomas Synnamon, installation assistant; Nateer Cirino, administrative coordinator; Sonia Dingilian, senior registrar; Jill Hemingway, associate museum registrar; and Tanya Melendez-Escalante, senior curator of education and public programs. We would also like to thank Amanda Barlow and Suzanne Baer from FIT's Media and Event services. A special thanks goes to our wonderful interns Frida Loyola and Maurizio Marrero for their tireless research and enthusiasm for this project.

Last, but not least, we would like to thank all of the contributors who made this book possible through their written words, interviews, the use of their photographs, and the lending or donating of their hip hop objects.

Photo Credits

Page 11, courtesy of Jamel Shabazz; page 13, The Museum at FIT, gift of Sean John; page 14, The Museum at FIT, gift of WilliWear, Ltd.; page 16, The Museum at FIT, gift of Jeff Bailey; page 17, The Museum at FIT, gift of Mrs. James Levy; page 18, The Museum at FIT, gift of Richard Martin; page 19 (top and bottom), The Museum at FIT, gift of Antonio Gray; page 21, © Manolo Blahnik International Limited; pages 22–23, The Museum at FIT; page 24, The Museum at FIT, gift of Jill Hemingway; page 25, The Museum at FIT; page 26, Alex Berliner. ® Berliner Studio/BEImages. Aaliyah™ is a trademark of Aaliyah, LLC. www.AALIYAH.com; page 28, © Janette Beckman; page 32,Lisa Haun/Michael Ochs Archives/Getty Images; pages 34–35, The Museum at FIT, gift of Michael Hoban, North Beach Leather; page 37 (top and bottom), The Museum at FIT; pages 38–39, The Museum at FIT, gift of Orli Spanier; page 40, Al Pereira/Michael Ochs Archives/Getty Images; page 41,Cross Colours - est. Los Angeles (USA), 1989; page 43, © FirstView/IMAXtree; pages 44–45, The Museum at FIT, gift of Gucci; pages 46–47, Carlo Allegri/Reuters; page 49, The Museum at FIT, gift of Puma; page 50, courtesy of West Rubinstein; pages 50–51, courtesy of Erni Vales, Carlos Mare, and Robert Lund; page 52, courtesy of Tracy Daniels; pages 55, 56–57, courtesy of Fever Records; page 58, © Albert Watson; page 62, courtesy of Jamel Shabazz; page 63, John Lamparski/WireImage; page 65, Claw Money Archive Collection © Claudia Gold; page 66, The Museum at FIT; page 67 (top), Claw Money Archive Collection © Claudia Gold; page 67 (bottom), The Museum at FIT, gift of Rebecca Pietri; pages 68–69, courtesy of Jamel Shabazz; pages 70–71, Claw Money Archive Collection © Claudia Gold; page 73 (left), from the archive of Tracy Daniels; page 74, Vinnie Zuffante/Getty Images; pages 76–77, Dimitrios Kambouris/Getty Images for The Met Museum/Vogue; pages 78–79,courtesy of Jamel Shabazz; pages 80–81, The Museum at FIT, on loan from Rebecca Pietri; pages 82–83, The Museum at FIT, gift of Dapper Dan of Harlem; page 84, courtesy of Jamel Shabazz; pages 86–87, David Corio/Redferns; page 88, Lawrence Schwartzwald/Sygma via Getty Images; page 89, Cross Colours - est. Los Angeles (USA), 1989; page 91, The Museum at FIT, gift of Cross Colours; page 93, Cross Colours - est. Los Angeles (USA), 1989 page 94, © RTJohnson/MediaPunch; page 96, courtesy of Jamel Shabazz; page 98, Michael Ochs Archives/Getty Images; page 99, The Collection of Eileen Costa; page 100, The Museum at FIT, gift of Mr. Calvin Klein; page 101, courtesy of Jamel Shabazz; page 102, The Museum at FIT, gift of Janet Waring; page 104, Kevin Mazur/WireImage; page 106, The Museum at FIT, gift of Judith Corrente and Willem Kooyker; page 107 (top), courtesy of Versace; page 107 (bottom), The Museum at FIT, gift of Veronica Webb; page 108, © Rick Mackler/Globe Photos; pages 111 and 112, Retro AdArchives/Alamy; pages 112–113, Matt Wing/Alamy; page 114, Ralph Lauren Corporation; page 115 courtesy of Luis "Scrams" Vasquez; page 116, Ralph Lauren Corporation; page 117 © Thirstin Howl The 3rd, with a special thanks to Koe Rodriguez; page 118, © FirstView/IMAXtree; page 120, Ralph Lauren Corporation; page 122, courtesy of Jamel Shabazz; page 123, The Museum at FIT, gift of Timberland; pages 124–125, courtesy of Jamel Shabazz; page 127, i4images/Alamy; page 128, The Museum at FIT, gift of Sean John; page 129 (top), © FirstView/IMAXtree; page 129 (bottom), courtesy of Nike, Inc.; pages 130–131, Randy Brooke/Getty Images for Kanye West Yeezy; page 132, Al Pereira/Getty Images/Michael Ochs Archives; pages 135–137, courtesy of Monica Lynch; page 138, courtesy of April Walker; page 140, © Thirstin Howl The 3rd, with a special thanks to Koe Rodriguez; page 142, Ralph Lauren Corporation; page 145 (left), © Edwin Phade Sacasa (aka Shirt King Phade); page 145 (right), © Thirstin Howl The 3rd, with a special thanks to Koe Rodriguez; page 146, © Janette Beckman; page 148, Mychal Watts/WireImage; pages 152-153, Gilbert Carrasquillo/Getty Images; page 153, Matthew Eisman/Getty Images for AWXII; pages 154–155, courtesy of Jamel Shabazz; page 156 and 157 (bottom), courtesy of Alphonso McClendon; pages 158–159, courtesy of The Gates Preserve; pages 160–161, The Museum at FIT, gift of Antonio Gray; pages 162–163, The Museum at FIT, gift of Converse Inc.; page 166, The Museum at FIT, gift of Elena Romero; page 168, courtesy of Jamel Shabazz; page 169, © 1983 Jenny Holzer, member Artists Rights Society (ARS), NY. Photo: © 1983 Lisa Kahane NYC; pages 170–171, © Janette Beckman; pages 172–173, courtesy of Jamel Shabazz; page 174, © 1989 Universal City Studios, Inc.; pages 176–177, © Catherine McGann; page 178, © Janette Beckman; page 179, Prince Williams/Wireimage; page 183, Edward Berthelot/Getty Images; page 186, Paras Griffin/Getty Images; page 188, Noam Galai/Getty Images; page 190, © Janette Beckman; pages 192–193, © Catherine McGann; pages 194–195, The Museum at FIT, gift of Rebecca Pietri; page 195, The Museum at FIT, gift of Dorothy Lieberman, MD; page 197, David Corio/Redferns; page 198, AFF/Alamy; page 199, Al Pereira/Getty Images; page 200, Gonzales Photo/Alamy; page 201, Burak Cingi/Redferns via Getty Images; page 202 (top and bottom left), John Angelillo/UPI, (bottom right) Abaca Press/Alamy Live News; pages 206–207, courtesy of Jamel Shabazz; page 209, Michael Ochs Archives/Getty Images; page 210, Jeremy Bembaron/Sygma/Sygma via Getty Images; pages 212–213, courtesy of Jamel Shabazz; page 216, Djamilla Rosa Cochran/WireImage; page 218, Ron Galella/Ron Galella Collection via Getty Images; pages 220–221, Frank Micelotta/Getty Images; page 223, Library of Congress; pages 226–227, PA Images/Alamy; page 228, Ralph Lauren Corporation; page 229, AFF/Alamy; page 230, The Museum at FIT exhibition Pink: The History of a Punk, Pretty, Powerful Color, 2018; page 232, Image Press Agency/Alamy Live News; page 236 and page 239 (top), courtesy of Jamel Shabazz; page 239 (bottom), © Joe Conzo, with a special thanks to Koe Rodriguez; page 240, © Janette Beckman; page 241, Al Pereira/Getty Images/Michael Ochs Archives; page 243, courtesy of Jamel Shabazz; pages 246–247, Wiki Commons; page 247 (top and bottom), courtesy of Nike, Inc.; pages 248–249, The Museum at FIT, gift of Gabriela Durham; page 250, Michael Ochs Archives/Getty Images; title page, courtesy of Jamel Shabazz.

Front: LL Cool J, NYC, 1987 © Janette Beckman
Back: Missy Elliott, 2003. AFF / Alamy Stock Photo / Tammie Arroyo

Cover Photo:
Page 2: The Twins, New York City, 2002. Photo: Jamel Shabazz.

Published on the occasion of the exhibition *Fresh Fly Fabulous: 50 Years of Hip Hop Style* organized by The Museum at FIT, curated by Elena Romero, assistant professor, Advertising and Marketing Communications, and Elizabeth Way, assistant curator of costume at The Museum at FIT.

The Museum at FIT, New York:
February 8–April 23, 2023

First published in the United States of America in 2023 by:
Rizzoli Electa
A Division of Rizzoli International Publications, Inc.
300 Park Avenue South
New York, NY 10010
www.rizzoliusa.com

in association with:
The Museum at FIT
227 West 27th Street
New York, NY 10001
www.fitnyc.edu/museum/

Publisher: Charles Miers
Associate publisher: Margaret Chace
Editor: Loren Olson
Production manager: Colin Hough Trapp

Art director: Courtney Sloane
Designer: Aryam Figueroa
Cover designer and design coordinator: Olivia Russin

2023 2024 2025 2026 / 10 9 8 7 6 5 4 3 2 1

Printed in Hong Kong

ISBN-13: 978-0-8478-9931-9
Library of Congress Control Number: 2022945456

Facebook.com/RizzoliNewYork
Twitter @Rizzoli_Books
Instagram.com/RizzoliBooks
Pinterest.com/RizzoliBooks
Youtube.com/user/RizzoliNY
Issuu.com/Rizzoli